HERE AND ELSEWHERE

HERE
AND
ELSEWHERE

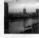

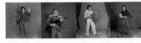

 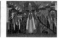
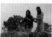 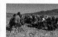
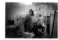

 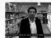

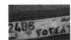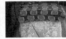

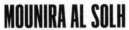

DIRECTOR'S FOREWORD

The New Museum is proud to present "Here and Elsewhere," the first exhibition in a New York museum of contemporary art from and about the Arab world. The exhibition brings together forty-five artists from twelve countries working in disparate mediums and emerging from distinct cultural contexts. Although this is by no means the first exhibition to address the contentious concept of Arab contemporary art, the curators of the exhibition have taken a thoughtful approach that seeks to highlight the tremendous diversity of practices that have developed over the past several decades, rather than create false categories or overarching regional stereotypes. "Here and Elsewhere" is therefore not an attempt to circumscribe the participating artists solely by geography. Instead, it presents a collection of under-recognized figures and innovative works that explore history, politics, and social life across the Middle East and beyond. This intergenerational selection of artists does more than provide access to a much scrutinized part of the world—they imagine new modes of representation that both capture and transform the world around them.

"Here and Elsewhere" follows a number of recent group shows at the New Museum including "Ostalgia," "Ghosts in the Machine," and "NYC 1993," which have attempted to reimagine how exhibitions address broad themes of history, geography, and memory. These presentations have all prompted a reconsideration of the way individuals and groups of artists have been thematized and opened up new lines of inquiry for future curators and scholars. I am pleased that "Here and Elsewhere" extends the New Museum's tradition of boldly experimental and thought-provoking exhibitions, as well as introducing a remarkable group of artists and their work to a New York audience for the first time.

I would like to thank the New Museum's curatorial team for their vision, especially Massimiliano Gioni, Associate Director and Director of Exhibitions, who conceived of this exhibition and oversaw the curatorial

team in all aspects of its realization. Natalie Bell, Curatorial Associate, did an enormous amount of research for the project and worked closely with numerous artists in the show—the exhibition reflects all of her tremendous hard work and insight. Gary Carrion-Murayari, Kraus Family Curator, Helga Christoffersen, Assistant Curator, and Margot Norton, Assistant Curator, also contributed to the exhibition and catalogue throughout.

We would like to thank the Andy Warhol Foundation for the Visual Arts for their lead support and for recognizing the significance of this exhibition and enabling its realization. We are also exceptionally grateful for the generous support of Elham and Tony Salamé, International Leadership Council Members, who enthusiastically engaged with the project from its earliest stages. We are deeply appreciative of the generous contributions of Sirine and Ahmad Abu Ghazaleh, LibanPost, Saradar Collection, and Maria and Malek Sukkar, as well as our Airline Partner Etihad Airways. Patrick and May Merville, the Robert Mapplethorpe Photography Fund, and the Standard, East Village, generously provided additional support to the exhibition as did the J. McSweeney and G. Mills Publications Fund at the New Museum.

As always, I would like to thank the numerous galleries who helped with individual artist's projects and the international lenders who made it possible to show so many outstanding works in New York for the first time. Finally, I would like to thank the artists themselves for participating in the show and for sharing their unique visions and groundbreaking practices with us.

—Lisa Phillips, *Toby Devan Lewis Director*

CURATORS' ACKNOWLEDGMENTS

This exhibition would not have been possible without the support and assistance of a number of individuals, institutions, and galleries. At the New Museum, we would first like to thank Lisa Phillips, *Toby Devan Lewis Director*, for her enthusiastic encouragement. We would also like to thank Regan Grusy, Associate Director and Director of Institutional Advancement, Karen Wong, Deputy Director and Director of External Affairs, and their respective teams for their continued support of our research and exhibitions. We are also incredibly grateful to Joshua Edwards, Director of Exhibitions Management, who shared technical insight on many details in preparation, oversaw all aspects of installation, and as always, solved a number of complicated technical challenges. We additionally wish to thank his entire team for their role in executing the installation, in particular, Walsh Hansen, Chief Preparator, and Kelsey Womack, Exhibitions Assistant, who graciously coordinated a staggering number of audiovisual works. Our gratitude extends also to Melisa Lujan, Registrar, who handled many international loans and shipments. Throughout the exhibition process, we have been fortunate to have the support of Curatorial Interns Alison Coplan and Simone Krug, who collectively spearheaded our lengthy period of artist research and outreach.

The exhibition catalogue was also a collective effort, and we would like to thank coeditors Negar Azimi, Kaelen Wilson-Goldie, and Babak Radboy of *Bidoun* magazine for commissioning the essays and round-tables in the following pages. We are grateful to both Media Farzin and Yasmine El Rashidi for their essay contributions, as well as to all the artists who participated in the catalogue's roundtable discussions. *Bidoun*'s Project Assistant Ben Tear and intern Betty Rosen supported these contributions through their research and coordination. As always, we owe great thanks to Sarah Stephenson, Editor and Publications Coordinator, who worked tirelessly on all aspects of this book. We are

immensely thankful for her time, stamina, and keen editorial eye. Adam Michaels, Prem Krishnamurthy, and Anna Rieger of Project Projects created a thoughtful design for the catalogue that reflects the ideas behind the exhibition.

"Here and Elsewhere" includes a number of artworks that come from private collections and institutions. For their generosity and cooperation, we wish to thank the following lenders: Arab Image Foundation; Nayla Bustros; Diala al Jabiri; Ghassan Khatib; Nadour Collection, Düsseldorf; Rare Books and Special Collections Library, the American University in Cairo; Saradar Collection, Beirut; the Khalid Shoman Collection, Amman; Tate; and Wassim Rasamny.

We are also grateful to the following galleries and institutions for their assistance in securing works in the exhibition: Albert Baronian Gallery, Brussels; Athr Gallery, Jeddah; Callicoon Fine Arts, New York; Galleria Continua, San Gimignano/Beijing/Le Moulin; Ikon Gallery; Galerie Imane Fares, Paris; Galerie Polaris, Paris; Gallery Isabelle van den Eynde, Dubai; Gypsum Gallery, Cairo; Kalfayan Galleries, Athens/Thessaloniki; Pi Artworks, Istanbul/London; Ruya Foundation for Contemporary Culture in Iraq; Selma Feriani Gallery, London; Sharjah Art Foundation; Sfeir-Semler Gallery, Beirut/Hamburg; Galerie Tanit, Munich/Beirut; and Thomas Dane Gallery, London.

A number of individuals worked closely to help us obtain individual loans for the show. We extend our great thanks to: Barrak Alzaid, Zeina Arida, Negar Azimi, Tessa de Caters, Tamara Chalabi, Maud Cherbonnel, Lina Kiryakos Chidiac, Philip Croom, Eda Derala, Tom Dingle, Laurence Dujardin, Tara Eckert, Reem Fadda, Imane Fares, Jumana Ghouth, Photios Giovanis, Judith Greer, Mohammed Hafiz, Aleya Hamza, Ulrike Heidelbach, Yuli Karatsiki, Maya El Khalil, Noura Al Khasawneh, Charif Kiwan, Zain Mahjoub, Hassan Ali Mahmood, Hazem Malhas, Jules McDevitt, Laura Metzler, Lutz Meyer, Rima Mokaiesh, Akim Monet, Denise Moser, Marc Mouarkech, Ramez Mufdi, Christian Nagel, Ralph Nashawaty, Anna Nowak, Sheikha Hoor Al Qasimi, Javier Robledo, Charbel Saad, Nicola Sburlati, Sven Christian Schuch, Ola Seif, Andrée Sfeir-Semler, Reem Shadid, Mohammad Shaqdih, Suha Shoman, Aiden Simon, Yesim Turanli, Inga Uppenkamp, Eline van der Vlist, Jonathan Watkins, and Diana Wiegersma.

In addition, a number of our curatorial colleagues (many of whom are also artists) offered feedback and advice in our curatorial process, guiding us in our travels, suggesting paths of research, and introducing us to other artists and curators. For their knowledge, insights, and generosity, we are indebted to: Basel Abbas, Ruth Abel, Jumana Abboud, Ruanne Abou-Rahme, Said Abu Shakra, Julien Amicel, Rana Anani, Yazid Anani, Zeina Arida, Joseph Audeh, Sam Bardaouil, Anne Barlow, Yto Barrada, Omar Berrada, Emma Chubb, Brian Conley, Hassan Darsi, Reem Fadda,

Mahnaz Fancy, Till Fellrath, Adalet Garmiany, Shuruq Harb, Raouf Haj Yehia, Samah Hijawi, Khaled Hourani, Maud Houssais, Lamia Joreige, Hiwa K, Fawz Kabra, Nisreen Kaj, Abdellah Karroum, Hicham Khalidi, Yazan Khalili, Daniella Rose King, Moukhtar Kocache, Faouzi Laatiris, Nadira Laggoune, Léa Morin, Ruth Oppenheim, Jack Persekian, Elizabeth Piskernik, Holiday Powers, Walid Raad, Younes Rahmoun, Nora Razian, Florence Renault-Darsi, Alya Sebti, Zineb Sedira, Tina Sherwell, Batoul Shimi, Ania Szremski, Aneta Szyłak, Christine Tohmé, Issa Touma, Toleen Touq, Inass Yassin, and Ala Younis.

We would like to thank the Andy Warhol Foundation for the Visual Arts for their generous support and for recognizing the significance of this exhibition. We are also exceptionally grateful for the major support of Elham and Tony Salamé who enthusiastically engaged with the project from its earliest stages. We are appreciative of the generous contributions of Sirine and Ahmad Abu Ghazaleh, LibanPost, Saradar Collection, and Maria and Malek Sukkar, as well as our Airline Partner Etihad Airways. Patrick and May Merville, the Robert Mapplethorpe Photography Fund, and the Standard, East Village, generously provided additional support to the exhibition and we are also thankful for the J. McSweeney and G. Mills Publications Fund at the New Museum, without which this catalogue would not be possible.

Finally, we extend our gratitude to all of the artists in "Here and Elsewhere" for their vision, their willingness to share their ideas and opinions, and their generosity in sharing their works with a new audience.

HERE AND ELSEWHERE
NATALIE BELL & MASSIMILIANO GIONI

The exhibition "Here and Elsewhere" presents the work of forty-five artists who share roots in the Arab world and a critical sensibility with regard to images and image-making. The title of the exhibition is borrowed from a 1976 film-essay by directors Jean-Luc Godard, Jean-Pierre Gorin, and Anne-Marie Miéville. Their film, *Ici et ailleurs* [Here and Elsewhere] began in 1970 when Godard and Gorin, then working as the Dziga Vertov Group, were commissioned to make a film about the revolutionary Palestinian movement by the Information Service Bureau of Fatah, the militant political group dedicated to the liberation of Palestine through armed struggle. Originally conceived under the more propagandistic title of *Jusqu'à la victoire: Méthodes de pensée et de travail de la revolution palestinienne* [Until Victory: Thinking and Working Methods of the Palestinian Revolution], the film includes footage shot by Godard and Gorin over a number of months in Palestinian refugee camps in Jordan, Lebanon, and Syria.

The Dziga Vertov Group's objective was not to make political films, but to "make films politically"—a slogan that identified their process as one defined by inquiry and study rather than unquestioningly incorporating political content or ideology. For Godard and Gorin, this method entailed working against the politics of representation embedded in a film's modes of production, and among their ambitions was the plan to discuss footage with the Palestinian *fedayeen* before they edited. These plans were hindered, however, when the political situation changed dramatically in September 1970: Jordan's King Hussein authorized raids on Palestinian refugee camps in an effort to rid the country of the Palestinian Liberation Organization (PLO), and many of those who were a part of the film were killed. Godard and Gorin ended their collaboration soon after and *Jusqu'à la victoire* was shelved. Godard, burdened with the knowledge that most of the Palestinians he and Gorin filmed were now dead, was uncertain about how to edit or finish the

film. But three years later in 1973, Godard returned to the footage in collaboration with Anne-Marie Miéville, and the two of them developed a new approach. With the revised name *Ici et ailleurs*, the film became a montage of footage shot in Jordan, Lebanon, and Syria in 1970, and in Grenoble in 1974. Combining this with intertitles, footage of slideshows, shots of broadcasts on TV monitors, and a voiceover narration by Godard and Miéville, *Ici et ailleurs* develops a complex reflection on the status of images, on their function as instruments of political consciousness, and on the ethics of representation.

From its inception, the exhibition "Here and Elsewhere" was subject to concerns about the politics of representation, and it came as no surprise that during the course of the show's preparation, our decision to group together artists from Arab countries was met with a fair amount of criticism and scrutiny. Certainly, it is not the first exhibition to occasion such a response. Over the course of the last ten to fifteen years, dozens of museums in Europe, Asia, the US, and in Beirut, Doha, and Abu Dhabi have produced group shows that, with relatively common thematics, focus on contemporary art from the Arab world.[1] Many skeptics have viewed this period of increased interest in contemporary Arab art as one marked by a particular institutional response to the 9/11 attacks in 2001, while others have linked it to a fast-growing market driven by affluent collectors and the patronage of ruling families, particularly throughout the Gulf region. At the same time, and entirely apart from art markets or suspected campaigns for cultural sensitivity, the efforts of artists and institutions in Alexandria, Algiers, Amman, Beirut, Cairo, Casablanca, Dubai, Jerusalem, Marrakech, Ramallah, Sharjah, Tangier, and Tunis, to name a few, have made these cities vibrant points of international access, whether as sites of biennials, hosts of residencies, or home to communities of artists and curators who themselves are organizing exhibitions and often moving between countries and continents. Yet, the continued interest in Arab art persistently draws criticism and skepticism from some artists, curators, and critics who feel objectified or pigeonholed as a result. Often at the core of this critique is a dissatisfaction with what is perceived as an institutional mandate to redress a lack of exposure, or an impulse to diversify programming and broaden institutional authority. Edward Said's groundbreaking critique of colonial methods of representation in the Middle East, *Orientalism*, rightly haunts Western representations of the non-West, and hangs over all these endeavors, making the stakes, suspicions, and accusations daunting and at times scathing for both curators and artists alike.

In an essay about the dilemmas facing what she dubbed the "diaspora artist," Media Farzin identified several conflicts that foreground many artists' misgivings about geographically or culturally defined exhibitions. On one hand, there is a loathing of representation in the service of

1 Among these, "Breaking the Veils: Women Artists from the Islamic World," which drew from the permanent collection of the Jordan National Gallery of Fine Arts and traveled to over twenty venues in Europe, the United States, and Australia (2002–11); "Contemporary Arab Representations. Beirut/Lebanon," Witte de With, Rotterdam, Fundació Antoni Tàpies, Barcelona, and BildMuseet, Umeå (2002–03); "DisORIENTation: Contemporary Arab Art Production from the Near East, Egypt, Palestine, Lebanon, Jordan, Syria and Iraq," Haus der Kulturen der Welt, Berlin (2003); "Contemporary Arab Representations. Cairo," Witte de With, Rotterdam, Fundació Antoni Tàpies, Barcelona, BildMuseet, Umeå, Centro José Guerrero de la Diputación de Granada (2003–04); "Word into Art: Artists of the Modern Middle East," British Museum, London (2006); "Without Boundary: Seventeen Ways of Looking," Museum of Modern Art, New York (2006); "Contemporary Arab Representations. The Iraqi Equation," Universidad Internacional de Andalucía, Seville, KW Institute, Berlin, Fundació Antoni Tàpies, Barcelona, BildMuseet, Umeå (2005–06); "Reorientations: Contemporary Arab Representations," European Parliament, Brussels (2009); "Unveiled: New Art from the Middle East," Saatchi Gallery, London (2009); "Tarjama/Translation: Contemporary Art from the Middle East, Central Asia, and Their Diasporas," Queens Museum, New York (2009); "Arabicity," Beirut Exhibition Center, Beirut (2010); "Disorientation II: The Rise and Fall of Arab Cities," Manarat Al Saadiyat, Abu Dhabi (2010); "Told/Untold/Retold: 23 Stories of Journeys through Time and Place," Mathaf, Doha (2010–11); "Future of a Promise," collateral event of the 54th International Art Exhibition of the Venice Biennale (2011); "Arab Express: The Latest Art from the Arab World," Mori Art Museum, Tokyo (2012); "Light from the Middle East: New Photography," Victoria and Albert Museum, London (2012–13); "25 Years of Arab Creativity," Institut du Monde Arabe, Paris (2012–13); "Cross-border: Contemporary Female Artists from the Arabian Mediterranean Region," ZKM, Karlsruhe (2013); "Safar/Voyage: Contemporary Works by Arab, Iranian, and Turkish Artists," Museum of Anthropology, University of British Columbia, Vancouver (2013); "Ici, Ailleurs," La Friche de la Belle de Mai, Marseille (2013); "Terms and Conditions," Singapore Art Museum (2013); "She Who Tells a Story: Women Photographers from Iran and the Arab World," Museum of Fine Arts, Boston (2013–14); and "View From Inside," FotoFest 2014 Biennial, Houston (2014).

diplomacy or good-willed cultural edification: "For an artist to make it into a museum, her work must anticipate its ambassadorial function, representing whatever is happening Over There." On another count, there is an anxiety about gratifying the audiences' pre-existing expectations that artists represent a certain attitude or condition—perhaps accidentally catering to viewers' desires "for roots, for poetic depth, for historic and political relevance," and, above all, for a traumatic backstory resolved "with a neat visual twist." Geographically or culturally defined exhibitions are invariably loaded because they presuppose some "essential cultural rootedness" or the artists' "desire to reunite with, speak for, support, and/or extend the cultural Imaginary of the homeland."[2] Speaking more generally of invitations to shows with a culturally defined remit, Rasha Salti asks what seems to be on the tip of many others' tongues: "Is this the only way we are able to penetrate museums and galleries—as 'Arabs,' not as photographers, installation artists, or performance artists?"[3] In other words, the feeling is that any interest is not only a limited-time exception, but amounts to curiosity more than a truly sustained investment: a temporary looking Over There, as Farzin would have it. In this regard, Salti highlights one of the most outstanding concerns, which is that artists' works continue to be ignored or overlooked, save for Arab-specific or perhaps Middle East-specific exhibitions—a point that many might argue continues to be the case.

It is true that despite an increased visibility of the rich art scenes in Beirut, Cairo, and Amman, and biennials in Sharjah, Marrakech, and Palestine that draw larger international audiences each year, many artists remain underexposed or limited to biennial circuits. Indeed, only a fraction of the artists included in "Here and Elsewhere" have previously shown in New York. It is, in a sense, a corrective impulse that has guided this exhibition, not only in our perception that the New York art world lacks exposure to artists from the Middle East and North Africa, but also in finding the New York art world uninterested in works that engage social and political histories outside of the US, that decipher or scramble current events beyond our borders, or that challenge dominant media representations.

In his introduction to *Ethnic Marketing*, writer and curator Tirdad Zolghadr refers to Hal Foster's identification of the two primary drives of late nineteenth- and early twentieth-century art history. One sought to demonstrate the autonomy of art and another to connect art to a social or cultural history (according to Foster, a Kantian impulse versus a Hegelian imperative).[4] Or in Bassam El Baroni's formulation, "The artistic canon of modernism managed to use its individuality as the medium of the universal, while considering the particulars of time, place, ethnicity, gender and so on to be of a secondary nature."[5] Among critics and theorists promoting art-for-art's-sake or the paramount individuality of

2 Media Farzin, "Imaginary Elsewhere," *Bidoun* (Summer 2012), 44–45.

3 Sandra Dagher, Catherine David, Rasha Salti, Christine Tohme, and T.J. Demos, "Curating Beirut: A Conversation on the Politics of Representation," *Art Journal* 66:2 (Summer 2007), 112.

4 Tirdad Zolghadr, *Ethnic Marketing* (Zurich: JRP/Ringier, 2006), 11; Hal Foster, "Antinomies in Art History," in *Design and Crime (and Other Diatribes)* (London: Verso, 2002), 85.

5 Hassan Khan, "005.02 Bassam el Baroni (Part I)," ArtTerritories, April 25, 2011 <http://www.artterritories.net/?page_id=2063> (accessed March 5, 2014).

the artist, isolating works from their social histories allowed a sense of objectivity in which to anchor their aesthetic judgments. Zolghadr, following Foster, sees these positions in tension. The question he begs in this regard appears to be something like the following: If autonomy is the signature of the avant-garde's art-for-art's-sake, then is art that is explicitly linked to a social or political reality doomed to be excluded from the avant-garde? Though Zolghadr is critical of the framing of non-Western cultures for Western consumers of goods or "culture" (i.e., contemporary art), he gestures toward one of the standard arguments used against exhibitions that have cultural specificity—namely, that artists should be recognized for their work and not distinguished by their origins.[6]

However, dissociating artists and their works from any origin presents a challenge to the future of the discipline of art history, which in many ways remains invested in and dependent upon national and cultural taxonomies.[7] Although art historians working today are continuing to broaden the scope of a canon that, in the West, has largely neglected art beyond Europe and America—bettering our knowledge of Surrealism in Egypt, modernism in Morocco, and Abstraction in Syria, to name just a few—these same scholars are encouraged to specialize based on what are often cultural or geographic distinctions. Of course, the discipline itself has historically relied on discrete definitions of culture, often defined by ideas of ethnicity or nationality, and it has also accommodated an idea of artistic movements that were closely tied to ideas of nationalism (in some places, this was once a utopian and even euphoric connection). Beginning in the early nineteenth century in Europe, the fine arts provided an ideal field in which to build a shared cultural tradition in the service of a national identity, or to court interest in a given nationality or identity. (The national pavilions of early twentieth-century art biennials and international expos are exemplary in this regard.) It is also worth noting the ways in which nationalism persists as a reminder or reinforcement of a political or cultural identity, whether in exile or in the absence of a state—a tendency that has been strong for Kurds since the late nineteenth century, Armenians since 1915, and Palestinians since 1948.

In the perhaps inevitable conclusion to Nada Shabout's *Modern Arab Art*, titled "Arab Art Today," the author, a leading historian of Arab art in the US, grapples with the question of the contemporary, and with rather uncomfortable essentialist problems. "The question remains: How does Arab art express Arab experiences?" Shabout asks, not entirely rhetorically.[8] While she doesn't evade the supposition that "contemporary Arab artists" exist, she wonders what access they have to a collective memory or whether they could possibly be conditioned by similar surroundings now that Arab cities no longer resemble each other and Arab

6 Artist Latifa Echakhch reflects on this issue: "I made the decision in the beginning of my career to never take part in exhibitions related to the Arab world. Growing up in France, I was all my life suffering from being considered first as an Arab artist. The context of immigration, especially in France, in a way always reduced things to my origin as a Moroccan and as a woman. I just want to be considered for my choices as an artist and not because of things I cannot choose like my gender or origins." Latifa Echakhch, email to Massimiliano Gioni, January 14, 2014. Or, putting it more concisely, artist Adel Abdessemed quips, "I left the Arab world long ago and I have not come back yet..." Adel Abdessemed, email to Massimiliano Gioni, February 14, 2014.

7 Monica Juneja, "Global Art History and the 'Burden of Representation,'" in *Global Studies: Mapping Contemporary Art and Culture* (Ostfildern: Hatje Cantz, 2011), 276.

8 Nada M. Shabout, *Modern Arab Art: Formation of Arab Aesthetics* (Gainesville: University Press of Florida, 2007), 146–49.

culture (once relatively unified, her argument seems to suppose) is now subject to an onslaught of Western influences. Shabout cannot help but read contemporary art through an art historical lens, and stands by the notion that artists are concerned with responding to the canon she and other art historians have identified as Arab: "Ultimately contemporary Arab artists are faced with the central challenge of integrating the diverse elements of their inherited past traditions with their imported Western present."[9] Shabout's project is surely one more focused on modernism, and we might forgive her over-simplified speculations as an attempt to bridge an impossible gap between modern and contemporary practices, but her dilemma points to a challenge for future art historians: Can art history ever completely let go of artists' origins or cultural affinities? For many contemporary artists, *this* is precisely the trouble with shows that have a cultural or geographic remit.[10] But is it possible to imagine a history of art that is completely divorced from cultural or social histories?

Beyond the challenges for the art historians of the future, the argument that artists should be dissociated from their origins also suggests that contemporary art is a sort of international grammar, an Esperanto that one learns to "speak" by shedding a sense of belonging to a specific culture or nationality. In other words, in order to be contemporary, one must not only be international, but international and without roots or origins. Consequently, those who aren't international, origin-free artists are, necessarily, lesser artists—to be marginalized or, worse, tokenized.[11]

Supposing that there might be such a thing as an international grammar of contemporary art also seems to suppose something like an *Internationale* of taste—resembling both the socialist anthem's ideal of universal deliverance from injustice and the myth of a world-wide artist community rooted in the utopian aspirations of the early twentieth-century avant-garde. Yet, rather ironically, this image of an *Internationale* of taste—promoted by biennials and art fairs alike—has been appropriated and radically transformed by the immaterial and pervasive flow of global finance. As Hal Foster noted nearly thirty years ago in his 1982 essay "Against Pluralism":

> The pluralist position plays right into the ideology of the "free market"; it also conceives of art as natural, when both art *and* freedom consist entirely of conventions. To disregard this conventionality is dangerous: art seen as natural will also be seen as free of "unnatural" constraints (history and politics in particular), in which case it will become truly autonomous—i.e., merely irrelevant.[12]

In the pluralist, free-market economy, goods and artworks move as if free of any connections to their origins. For artworks, this absence of context signals autonomy (perhaps coveted for some), but in both economy and art, it indicates a separation from the context of production—

9 Ibid., 149.

10 To use the words of Palestinian photographer Ahlam Shibli, who declined to participate in the exhibition, "I don't want my work to be framed by an exhibition that takes the Arab World as its issue. The perspective will be wrong if my work is considered an example of Arab Culture and part of a variety of manifestations of the Arab World. I don't want my work to be discovered by people who go to the museum to discover the Arab Culture…I want my work to have a place of its own, where it can be appreciated or dismissed for the issues it really tries to address." Ahlam Shibli, email to Massimiliano Gioni, March 21, 2014.

11 As artist Jimmie Durham posed it, "Suppose we were not doing 'international' art, and were doing what must amount to 'ethnic' art instead?… Does that leave us doing art that has an accent?" In Jimmie Durham, "A friend of mine said that art is a European invention," in *Global Visions: Towards a New Internationalism in the Visual Arts*, ed. Jean Fisher (London: Kala Press, 1994), 113–19.

12 Hal Foster, "Against Pluralism," (1982) in *Recodings: Art, Spectacle, Cultural Politics* (Port Townsend, Wash: Bay Press, 1985), 15.

a renunciation of specificity that entails a distancing from the artist and the conditions that may have inspired a work's creation.

Barring instances in which stereotypical qualities can be deployed to enhance the exotic appeal of commodities or artists themselves, the system of internationalism has entreated artists to shed their nationalities, ethnicities, cultures, and traditions in a rite of passage that promises access to the global game of contemporary art. Indeed, many artists yield to this logic and see their inclusion in any exhibition that suggests a connection to their geographic or cultural identity as a threat to their international credibility. Yet the mistake of universalism or of *Internationale*-style internationalism is that it proposes something too closely aligned with pluralism and, as Foster reminds us, dangerously undermines the fact that art and freedom are notions that are determined by convention: they are malleable concepts that do not mean the same thing to everyone.

Furthermore, much as we might imagine it to be otherwise, art *is* tied to "unnatural" constraints like history and politics. Universalism, as an alternative to more specific understandings of artworks and practices, is not dangerous because it is pluralistic or because it entails something like a universal standard of taste; it is dangerous, as Foster argues, because it abstracts art from lived, human experience. Free of the diverse codes that contribute to understanding and meaning, and free from politics, social norms, or history, how could art convey anything of substance at all? And how could such an autonomous or universal art provide different experiences to individual viewers, who necessarily come to it with widely varying backgrounds or degrees of knowledge? If everyone is bound to have the same experience, how can art ever effect anything but a deadening consensus? The potential outcome is not only aesthetic autonomy on the brink of irrelevance, as Foster notes, but a new homogenous landscape of art that is as flat as it is shallow.

In this sense, the cultural specificity of "Here and Elsewhere" is not so much an essentialist framing of the work of artists who, to varying degrees, are connected to the Arab world. It is rather a refusal of a pluralist, neoliberal paradigm that reduces difference in the name of a universality that only recapitulates the homogenizing forces of the global economy. Indeed, "Here and Elsewhere" exhibits the work of artists who operate in diverse networks that extend beyond their countries of origins: In this sense, it is an international exhibition. These artists hail from more than twelve countries in the Arab world, but "Here and Elsewhere" does not propose the usual frictionless mix of global quotas characteristic of biennials and international art fairs. Indeed, as Rasha Salti notes, "The social and political meanings of 'Arab' are plural and contradictory in different locales... 'Arab'

resonates with the criminal in France, whereas it resonates with arro-gant hegemony in Amazigh Maghreb, or with the defeated oppressor in Kurdish Iraq."[13] With this heterogeneity in mind, "Here and Elsewhere" presents a diversity within a specificity seldom seen in international biennials and art fairs, or in the context of New York's exhibition offer-ings. This specificity is entirely counter to universalism: It recognizes and affirms individual relationships to particular histories or places. It is concrete and unequivocal, but not suggestive of any sense of unity or internationalist equivalence. However, it is through this specificity that the exhibition illuminates similar insights and affinities as well as dramatic differences, tracing and deconstructing the contours of an imagined geography[14]—to paraphase the words of Edward Said—in multi-ple social and aesthetic landscapes.

Godard, in his filmmaking practice, may not have been con-cerned with autonomy or universalism, but he did tire of the figurative *Internationale*—or what he perceived as a kind of international vocabu-lary of leftist filmmaking. Mostly, though, he continued to grapple with the risk inherent in the foundational convention of film and photogra-phy—namely, the dogma that photographic images enjoy a privileged, truth-bearing relationship to the subjects they depict, and therefore, are most capable of depicting the truth of a situation, a landscape, or perhaps a revolution. This purported indexicality also entails a particu-lar relationship to representation, and those who use the photographic medium encounter its special representational burden.

For some artists, the issue of representation bears a similar construc-tion when faced with exhibitions that are organized around an allegedly shared identity. Is an Egyptian artist's work fixed as a representation of Egypt or Egyptian contemporary art? Does a Moroccan artist's work more authentically represent present-day Morocco than work by an artist from another country? If we were to accept such reductions, artwork would function merely as an icon of the artist's identity. What is at stake is not just the danger that artists are treated as vehicles of content, but that, as such, they are put in the service of stereotypical images or clichés.

Lebanese artist Akram Zaatari has pointed out the need to differenti-ate between images that serve as clichés promoting preconceived ideas, and images that further an understanding of complexity. For Zaatari, in the context of exhibitions, the difference often has to do with the close link between clichés and audience expectations. Curator Catherine David, commenting on her experience with the series of exhibitions she organized in Europe between 2003 and 2006 under the descriptive but clinical title "Contemporary Arab Representations," admitted, "We can't deny that people have some very specific expectations . . . When we first presented "Contemporary Arab Representations" with works from Beirut, there were many comments like: 'This is not authentic; this is

13 Sandra Dagher, Catherine David, Rasha Salti, Christine Tohme, and T.J. Demos, "Curating Beirut: A Conversation on the Politics of Representation," *Art Journal* 66:2 (Summer 2007), 98–119.

14 Said writes of an "imaginative geography" in Edward Said, *Orientalism* (London: Penguin, 1978), 54.

not Arab,' and not only from our audience in Rotterdam. This had to do with lack of knowledge . . ." But as Zaatari noted, "Expectations are not only signs of knowing too little about a place. They can be signs of knowing too much." Zaatari cites filmmaker Ghassan Salhab, who might on one hand, hear from Lebanese audiences, "Oh, you've done your film for a European audience," and on the other, hear from European audiences, "No, your film is not really Lebanese"—in other words, it defied both Lebanese and European expectations of what Lebanese filmmaking should be or look like.[15] Considering the potential for audience expectations (however well-meaning they may be) to become representational double standards, many artists fear becoming doubly pigeonholed and trapped.[16]

Knowing very well what is at stake in representation, both in photographic media, global image circulation, and art world practices, the artists in "Here and Elsewhere" share a critical attitude toward images, a healthy skepticism toward simplified representations, and a commitment to questioning the role that images play in the fabrication of historical narratives. For some, this may take the form of a narrative resistance that challenges the torrent of images supplied by international media, which continue to typecast life in many Arab countries, particularly with regard to the uprisings, revolutions, and conflicts that have frequently monopolized media attention worldwide. For others, the central issue is photography's complicated relationship to truth and representation, and their works reveal a distinct skepticism toward avowals of truth in photography or even in photographic archives.[17]

Consequently, at the core of this exhibition is an interrogation of the transparency of images and a questioning of their ability to capture and relay the truth of a situation. The works in the exhibition are caught between refusing any presumed objectivity and actively using images to criticize mainstream media or ideological propaganda. Just as Godard in *Ici et ailleurs* acknowledges the different modes of constructing filmic images, he also makes the case for these manipulations being as real as any of the footage: Images and editorial decisions are equally capable of manipulation or deceit. Godard reminds us in his film: "You always see the one who is directed and never the one directing." In emphasizing this as a matter of fact, Godard points to how history too passes through an editorial stage—a theme addressed in many of the works in "Here and Elsewhere."

Also visible in many artists' works is the legacy of colonial-era images, and the long history of colonial subjects serving as the object of image-making practices within each set of drawn borders. Godard was well aware of this crisis of postcolonial image-making prior to 1970, but he confronts it head-on in *Ici et ailleurs* by calling the viewers' attention to the process of images being made and consumed, both in the "here"

15 Akram Zaatari, "On Travelling," in *Public Time: A Symposium,* ed. Suzanne Cotter (Oxford: Modern Art Oxford, 2006), 46. This publication consists of edited transcripts from the series of panel discussions that followed Cotter's 2006 exhibition "Out of Beirut" at Modern Art Oxford, which featured the work of fifteen Lebanese artists.

16 Egyptian artist Basim Magdy attests: "I've been living in Europe for seven years and during that time I've seen a number of shows that present Arab or African or Egyptian artists together…. The problem for me is not the curatorial aspect, but the viewers. In my experience, every person I talked to after an opening of one of these European shows managed to reduce the work to just being about where the artist comes from. This became the starting point for understanding any work of art in the show in addition to what seemed like a set of preconceived ideas and stereotypes that were imposed on the work." Basim Magdy, email to Massimiliano Gioni and Margot Norton, March 30, 2014.

17 Among recent art historians and curators who have surveyed and interrogated the political and philosophical discourse around photography and documentary practices with a particular focus on contemporary artists in the Arab world is T.J. Demos in *The Migrant Image: The Art and Politics of Documentary During Global Crisis* (Durham: Duke UP, 2013). Ariella Azoulay has looked at the contested status of images, particularly in relation to global politics and in the Palestinian and Israeli context; see *Civil Imagination: A Political Ontology of Photography* (London: Verso, 2013), *The Civil Contract of Photography* (New York: Zone Books, 2008), and *Death's Showcase: The Power of Image in Contemporary Democracy* (Cambridge: MIT Press, 2003).

of the Palestinian camps and the "elsewhere" of France. Without necessarily highlighting a colonial relationship, Godard emphasizes a one-way flow of images from the Middle East to Europe, and the fact that these images are highly constructed, even for the sake of a supposedly liberal cause and in the hands of a progressive filmmaker. Throughout *Ici et ailleurs*, Godard reflects on the activity of filmmaking and the distortions generated by a commerce in images that is never unmediated. "Poor revolutionary fool, millionaire of images," Godard intones as the film cuts between scenes of Palestinian fighters and a leftist French couple following events from their living room. Images, Godard seems to say, had become a sort of futile currency for these Palestinians; a currency that could never buy them anything, insofar as they were prevented from being makers or keepers of their own images. As the film's cuts roam again from the idle French radicals to a group of Palestinians holding posters and guns, Godard uses repetition in the voiceover and the ambiguity of reference to suggest that both suffer from the same excess: "Poor revolutionary fools, millionaires of images of revolution."

The artists in this exhibition share Godard's complicated awareness of the danger inherent in the economy of images. Deploying a variety of strategies, the works on view move to reappropriate representation— to refuse the monopoly of mainstream media, and to annotate and interpret history as it spools by in real time. In many ways, "Here and Elsewhere" is an exhibition about the act of witnessing. Just as Godard confesses in *Ici et ailleurs*—"I, you, he, she, we went to the Middle East . . . they showed me . . . I saw . . ."—for many artists, the first person singular similarly stresses the centrality of the role of the artist in witnessing the events captured in their works. Through the voice and the eyes of the artist, subjectivity is reclaimed and insistently pushed to the fore, making the works both personal and partial, and, as such, political. Accordingly, the works in the exhibition explore the intersections of the deeply internal and the public: What is the role of the artist in the face of historical events? How can one create works that are deeply tied to a place or to a particular event, but are simultaneously capable of extending well beyond that specificity?

The videos and photographic works in the show test new modes of lyrical documentary and personal reportage, combining private memories, confessions, and elliptical narratives. The legacy of the French film-essay is refashioned in several artists' reflections on how our fascination with images remains fraught with our misgivings about their influence. Both visually and conceptually, the videos of artists like Basma Alsharif, Mounira Al Solh, and Maha Maamoun, reveal references to the films of Godard and Chris Marker, but insist on the continued relevance of images in contexts unexplored by these latter two filmmakers. Several of these works assume suspended narrative states, quickly shifting

perspectives or obscuring the identity of narrators whose speech sometimes blurs the past and present tense. In the early shots of Alsharif's video *We Began By Measuring Distance* (2009), photos take on a loaded significance as hands flip through a book of Palestinian landscapes. "We indulged in a book memorializing our homeland," the anonymous narrator confesses. In Al Solh's video *Now Eat My Script* (2014), visual and temporal disjunctions stretch open as the narrator observes the wares of newly arrived Syrian refugees in Beirut while recalling her own family's experience fleeing Lebanon's civil war decades earlier. Maamoun's video *2026* (2010) negotiates an ambiguous relationship to fiction and to the future: The title projects a future date and the film's shots directly recall the time-traveling character in Marker's experimental short *La Jetée* (1962), but Maamoun's narrative alludes to a social and economic situation in Egypt's present.

Although the videos of Khaled Jarrar and Bouchra Khalili differ in specifics of setting, both narrate tortuous personal odysseys and attempt portraits of individuals who are seeking a new place for themselves in the currents of history. The migrants in Khalili's "The Mapping Journey Project" (2008-11) and the Palestinian residents of the West Bank in Jarrar's *Infiltrators* (2012) are similarly subject to geographic, ideological, and socioeconomic obstacles that encumber their job opportunities, keep them from seeing their loved ones or supporting their families, and ultimately limit their ability to find stability in their lives.

A particularly poignant example of personal reportage can be found in the short videos produced and distributed by Abounaddara, a collective of self-taught filmmakers dispersed throughout Syria. Their videos offer testimonies from the country's current civil war and, like Godard, the collective is not interested in making political films, but in making films politically. For Abounaddara, this means letting the very conditions of production and distribution—dictated by the complex and changing situations in various Syrian cities—shape the content and qualities of their films. The political engagement espoused by Abounaddara is one embedded fully in Syria, but not defined by a particular alignment in the civil war. And for the anonymous filmmakers who contribute short films, there is no self-doubt concerning the authenticity of their narration. The diversity of positions, and the raw forthrightness of their films' subjects—however the various individuals are aligned in the conflict—sets these videos in sharp contrast with the production of propaganda within Syria.

Photography is both the medium and subject for many of the show's artists, who are intimately preoccupied with the question of truth and the reportage, documentation, or spectacularization of historical events. Many have found themselves in the paradoxical position of adopting photography not to produce and disseminate exacting and faithful images,

but rather, to treat photographic images as sites of opposing perspectives, exposing them as territories for conflicting narratives. To borrow from the title of Yto Barrada's photo series dedicated to life on the Strait of Gibraltar, the photographs in "Here and Elsewhere" are "full of holes."[18] These images refuse to play omniscient narrator or to provide complete and definitive facts. Instead, they are oblique, fragmentary, and lacunose. Perhaps most explicitly in the case of Barrada's work, they take the very notion of absence as their structuring principle, always preferring an interrogative mode to an assertive tone. Barrada's photos are always exhibited in ensembles, suggesting a narrative that is as intricate as it is incomplete. They depict sites of privation, not simply because they refer to migratory desires, but because at their very core, in the crumbling walls or in the geological panoramas that anchor her iconography, they are perforated by fractures and traversed by fault lines that literally open up her images to an absence.

Also exemplary of this wistful attitude are the photographs of Ziad Antar: His inventory of buildings shot with expired film composes an imaginary city built of a phantom architecture. In his photos, the image itself seems to doubt its own existence as it floats to the surface with ectoplasmatic evanescence. Absence is also central to Fakhri El Ghezal's series "Chokran ya siédété al raiis" [Thank You Mr. President] (2011), in which he uses a simple vertical format and black-and-white film to document the conspicuous disappearance of the image of ousted president Zine el-Abidine Ben Ali from public buildings, café walls, and private spaces in Tunis—a symbolic absence that literally evidenced the country's recent revolution. Ghostly presences likewise haunt the photos of Beirut's downtown district shot by Fouad Elkoury at the end of the Lebanese Civil War, as well as his photos of everyday life in Beirut in the war's early years in the late 1970s and early '80s. In Hrair Sarkissian's "Execution Squares" (2008), other specters are conjured up in images of public spaces that served as sites of hangings in Damascus. Yet, available as they are, these Gothic metaphors fail to fully capture the troubling, complex, layered, and still unfolding histories evoked by these pictures. While completely distinct, the photos of Elkoury and Sarkissian share a cold, almost forensic aesthetic—both artists shoot as though collecting evidence around a crime scene. But Elkoury's skewed camera angles and Sarkissian's eerily empty urban landscapes function as distancing devices, once again complicating the objectivity of their images.

A number of artists alternatively experiment with proximity. Throughout the exhibition, photographs appear to be inscribed within other photographs, and pictures of bodies are inscribed within other bodies. In the photos of Tanya Habjouqa, the video of Marwa Arsanios, the collages of Ali Jabri, and in the portraits of Jamal Penjweny, for

18 Yto Barrada's *Life Full of Holes: The Strait Project* (London: Autograph APB, 2005) takes its title from *A Life Full of Holes* (New York: Grove Press, 1964) by Moroccan author Driss ben Hamed Charhadi, a novel tape-recorded and translated by Paul Bowles.

example, we witness artists lunging toward a *mise en abyme* of images. In this doubling, the artists heighten a physical relationship with images, suggesting an almost talismanic belief in their power: Against the presumed objectivity of media representations, these artists seek an empathic relation with images.

In the self-portraits of Van Leo and in the portraits of Hashem El Madani, we see another kind of inscription of imagery in the posturing of the sitters. The works of these studio photographers document the construction of identity at a time when studio photography flourished as a powerful and prolific site of individualized image-making. Many of the photos and negatives of Van Leo and El Madani are now part of the Beirut-based Arab Image Foundation, one of the most extraordinary archival projects initiated in recent history. A nonprofit collective founded by a group of artists that included Elkoury and Zaatari, the Arab Image Foundation has counted among its members and collaborators artists Lara Baladi, Yto Barrada, Yasmine Eid-Sabbagh, Simon Lourié, Walid Raad, and Zineb Sedira, and writers and curators Negar Azimi and Samer Mohdad, among others. In the sixteen years since its inception, the Arab Image Foundation has amassed a vast visual archive of photography in the Middle East, North Africa, and the Arab diaspora with more than six hundred thousand photographs, many drawn from family albums. In its archeology of the photographic gaze, the Arab Image Foundation has illustrated not only the increasingly pervasive presence of photography since the early twentieth century, but also the ways in which identity and representation have been shaped through different visual codes and genres. Just as importantly, the work of the Arab Image Foundation has shed light on photography's dual relationship to colonial and postcolonial strategies in various Arab countries.

The pioneering work of the Arab Image Foundation points to another recurring strategy visible in the exhibition: Many artists are not makers of images, they are keepers of images. They archive, catalogue, and analyze them—and literally and metaphorically reanimate them and bring them back to life. Much like the deconstructive approach Godard takes in his 1972 film *Letter to Jane*—an hour-long digression on a single snapshot of Jane Fonda in Vietnam—the artists in "Here and Elsewhere" treat found images as repositories of stories and myths, as tools for rewriting histories, and as time capsules in which entire cultural moments have been captured and only later can be unpacked and deciphered.

As cofounder of the Arab Image Foundation, Zaatari is certainly among the most devoted and fastidious researchers of photographic practices in Lebanon and beyond. In one project running parallel to his own artistic practice, Zaatari has been cataloging, reproducing, and organizing the archive of El Madani. In "Here and Elsewhere," Zaatari

presents two recent videos that feature El Madani in his studio along with a large photographic triptych documenting the interior of Madani's Studio Shehrazade in Saïda, Lebanon. This triangulation of moving and still images unravels as a rhapsody on representation and history, personal and collective archives, and image-making practices that are almost obsolete.

Shuruq Harb tells another story in which photography, memory, and a collective image culture are intimately interwoven. In her installation and video *The Keeper* (2011-13), Harb displays a selection from the several thousand prints she received from an image vendor in the streets of Ramallah, while the related video narrates the ups and downs of the young man's sales as political events and cultural trends shaped the way printed images circulated in Palestine.

Rokni Haerizadeh practices another form of iconophilia in his excessive consumption of images. His drawings of political protests and demonstrations are executed on enlarged printouts of thousands of stills from YouTube videos of media broadcasts. His hand-drawn video animations, which are made using thousands of these painted-over images, produce a kind of hallucinatory rotoscopic effect through a layering of media, events, and processes.

With experimental approaches to archival materials, and through rewriting personal and collective traumas, other artists in "Here and Elsewhere" weave fragments both real and imagined into their work. This archeology of recent history takes on an even more urgent role in countries where sectarian conflicts have precluded any consensus on historical events. This impulse has been particularly present in the work of an entire generation of Lebanese artists who, since the end of the Lebanese Civil War in the early 1990s, have been analyzing modes of representation and dissecting images and objects to expose the impossibility of a common narrative of a shared past—a concern in many ways particular to Lebanon in the wake of its history of sectarian tensions. Particularly in the works of artists whose practices were rooted in Beirut in the 1990s, real and fictional historical fragments are combined to create a peculiar aesthetic that is equally fascinated by investigative journalism and speculations on the ontology of images.[19] In "Here and Elsewhere," Lamia Joreige's series "Objects of War" (1999-ongoing), an archive of objects and testimonies relating to Lebanon's various conflicts, is emblematic of this important chapter in Lebanese art.

Similar strategies of excavation can be seen in the work of others who unearth histories, cultural traditions, or objects imbued with individual and collective memories. Kader Attia, for example, has been constructing a private archive dedicated to various forms of what he calls "cultural re-appropriation." Through his research he has amassed a motley collection of found objects—many from both North and

[19] Two important exhibitions in the early 2000s brought increased attention to this loose generation of artists and highlighted many of their shared concerns with regard to image-making and historical narration: "Contemporary Arab Representations. Beirut/Lebanon" (2002–03), organized by Catherine David, and "Out of Beirut" (2006), organized by Suzanne Cotter.

sub-Saharan Africa—that have been repaired crudely, frequently mirroring the poorly mended wounds of colonial-era soldiers. Often juxtaposing these unusual finds—in the case of this exhibition, a stone tablet his Berber-speaking father used to learn Arabic—with images of fractured bodies culled from colonial-era medical literature, Attia points to the complex and layered processes of violence, syncretism, and assimilation that haunt colonial histories around the world.

Rheims Alkadhi also engages found objects, many of which she acquires through her transactions at various urban markets in Palestine, Jordan, and Iraq, where the street vendors are often peddling their personal belongings—a jacket or shirt, a tire tube, or an old tambourine. Through her alterations to these objects (mastic gum silences the tambourine; a taxidermied housefly rests on the spout of the kettle), Alkadhi produces fragile, almost coincidental sculptures that re-envision the utility of these items, but also retain traces of the lives of their owners.

This form of tactile biography—in which human stories are inscribed in materials rather than in words—also informs the work of Marwan Rechmaoui, whose concrete sculpture *Spectre (The Yacoubian Building)* (2006-08) reflects the waves of changes that have affected this building in Beirut since its construction in the early 1970s. Rechmaoui portrays the building deserted and exposed following its evacuation during the 2006 military conflict with Israel, a grim portrait that seems to refer to the city's many architectural phantoms.

Hassan Sharif, a pioneering conceptual artist in Dubai, UAE, works by accumulating surplus materials and found objects, but in contrast to the archeological atmospheres pursued by other artists, his systematic catalogues of industrial waste objects seem to reflect on the use value of contemporary detritus. Bundled up and piled in arbitrary clusters of redundant objects, Sharif's sculptures speak not only of the cheaply produced commodities that travel the globe on cargo ships—he often incorporates bulk plastics typically sold by Chinese manufacturers—but in calling attention to these networks, also refer to the rapidly changing economic, cultural, and physical landscape of Gulf cities, of which Dubai has become paradigmatic. As he incorporates these materials that in some way are products of the Emirates's construction boom, Sharif plays both contemporary archaeologist and critic of wasteful consumption. Scraps of commodities transformed to maximum uselessness pronounce his skeptical take on the recent transformations that have shaped many states in the Gulf.

Abdullah Al Saadi, a fellow pioneering conceptualist in the UAE, has also been registering the changes to the landscape and culture in the Emirate of Sharjah. In past works, Al Saadi has incorporated objects used by his illiterate mother to leave messages for him on his doorstep, the codes of which he studied and documented, while in other works,

he has cataloged the living things and found objects around him, whether the lumpen shapes of sweet potatoes or the contours of his donkey. *Camar Cande's Journey* (2010-11) chronicles a twenty-day expedition he took on foot with his dog and donkey, throughout which he documented the undulating desert terrain in photos, diaries, and sketches. Al Saadi's landscape paintings from this trip retain an intentionally naïve, dreamlike quality, which makes them both nostalgic and endearing as records of an old-fashioned adventure.

Ahmed Mater similarly engages with the contemporary changes that he is currently witnessing in Saudi Arabia. Mater grew up in Asir, a rural region in the country's southwest, and has maintained a particular awareness of changes to the social and economic landscape of Saudi cities—"cities of salt" as Saudi writer Abdulrahman Munif described them in his celebrated cycle of novels. In *Leaves Fall in All Seasons* (2008-13), Mater compiled footage shot by construction workers in the city of Mecca, the sacred and historic center of the Islamic world, which has undergone radical development in the last decade. In short and casual vignettes, Mater draws from these workers' handheld mementos to bear witness to this tremendous shift in the city's physical and economic landscape, offering a range of perspectives that include both labor protests and breathtaking feats of construction.

With their network of nodes and vectors, the drawings of Susan Hefuna can be described as blueprints of oddly distorted cities, in which she registers her perception of architectural details. In her ongoing series of cityscapes, Hefuna traces various urban and domestic motifs, focusing in particular on shapes that recall both *mashrabiyas*—the carved wood lattice screens that often serve as window coverings—and the gridded layout of cities as seen from an aerial perspective. Yet Hefuna's drawings also read as the diagrams of a nervous system or as personal psycho-geographies, in which the city's contours extend from the artist's perception of them.

Anna Boghiguian's dense and meditative drawings are also connected to her everyday urban experiences. Among the works included in the exhibition are a number that Boghiguian created in Cairo during the 2011 uprisings that led to the overthrow of President Hosni Mubarak, who had ruled for twenty-nine years. Like the oscillations of a seismograph or an EEG recording, Boghiguian's drawings appear to measure the voltage and spasms of a collective unconscious, tracing, if not channeling, the physical and emotional energy of the city's multitude.

Artist Mohamed Larbi Rahali similarly charts the pulse of daily life in his hometown of Tétouan, Morocco, repurposing empty matchboxes to serve as miniature sketchbook pages on which he registers the diverse scenes and characters around the city's ancient medina. Though he draws on a range of sources and everyday observations, his project *Omri*

[My Life] (1984-ongoing) has taken on an autobiographical significance as his collection of matchboxes has grown to number several thousand.

A similar accumulative impulse—in this case fueled by adrenaline and the threat of danger—can be detected in the comics of Mazen Kerbaj, which chronicle his thoughts and activities during the thirty-four days in July and August 2006 in which Beirut was subject to air strikes from the Israeli military. Both diaristic and confessional, Kerbaj's works—which began as a blog so he could share them internationally—use drawing and painting as tools for both coping with the disquiet of this time and narrating a personal experience that could never be depicted in mainstream media accounts.

Kerbaj's drawings reveal the artist's sense of responsibility for serving as a witness, an aspect that many of the artists in the exhibition seem to share. It is an attitude that is perhaps best encapsulated in the works of celebrated artist Etel Adnan. Born in Lebanon and active between Sausalito and Paris throughout her decades-long career as a professor of philosophy, Adnan has turned to writing, drawing, and painting to record not only the dramatic events of the Lebanese Civil War, but also to capture the subtlest changes of perception, reflected in the ever-shifting color and light of her landscape paintings. At first, Adnan's interests can appear almost schizophrenically conflicted, divided as they are between political engagement and pure aesthetic enjoyment. However, the competing strands of Adnan's work converge in a way that is perhaps emblematic of the work of all the artists in "Here and Elsewhere." What unites their diverse interests and sensibilities is each artist's lucid awareness of her or his own presence in the world, capturing the subtlest palpitations of a single human heart and the vast forces at work in the maelstrom of history.

THE PAST

YTO BARRADA, ANNA BOGHIGUIAN, ROKNI HAERIZADEH, WAEL SHAWKY MODERATED BY BIDOUN

At its best, the past provides us with a series of compelling stories from which we can begin to think about where we came from, what is to be done, and where we are going. In some places, history casts a longer shadow than in others, inspiring a generation of heroic skeptics who come to question its over-confident truths. The magic, in these cases, often lies in the gaps and the details: the unintended shadow on a photograph; the minor character in a play; the family history that is endlessly retold, but never twice in the same way; the historian whose treatise was either lost or never managed to get published in the first place. For artists in a part of the world in which contestation feels *de rigueur*, this makes for rich material—history as confidante, muse, lie, and quite possibly, prophecy. For what is history, if not the Cassandra of its own existence?

The following roundtable conversations never actually took place as such, but rather unfolded over several weeks in April 2014 by phone, email, and Skype.

—Bidoun

BIDOUN Anna, we thought we might start by talking about Constantine P. Cavafy, the Greek Alexandrian poet who was born in 1863 and has made an appearance in so many of your drawings and paintings. How did you come to adopt him?

ANNA BOGHIGUIAN When I was eighteen, I read Lawrence Durell's *The Alexandria Quartet.* In it, Durell cites a poem by Cavafy called "The City." I was interested in the poem and the way it penetrated the history of Alexandria. It includes the lines, "New lands you will not find, you will not find other seas. The city will follow you," addressing how the city inevitably, inescapably, becomes a part of you. Much later, I found the notations I had originally made about the poem in my notebook. It was 1980 and I was living in Montreal, and it just came to me one day: I should think about Cavafy. I started drawing images of him, but then I ended up illustrating his texts. His descriptions of the city were very beautiful—historical, social, nostalgic. But he also captured a certain alienation.

B That alienation has a specific history in Egypt.

AB Yes, I find Cavafy to be a symbol of an Egypt that doesn't exist any longer. Something has died. So much changed after Gamal Abdel Nasser's revolution in 1952 and after the Suez Crisis in 1956. Alexandria might have stayed a bit more cosmopolitan than Cairo—because

the Italians and Greeks weren't exiled and the city was more English, French, and Jewish—but it inevitably changed. Many people left Egypt and the country lost its cultured outlook after the mid-1960s. When I came back after studying abroad for a decade, I felt, and still feel, very alienated.

Cavafy opens up a historical part of the city or a situation that has been blocked, a history that people refuse to accept or even remember, like the Greco-Roman history. Imagine, the Greco-Roman Museum in Alexandria is completely closed—it was an important museum that opened during Cavafy's lifetime. Cavafy was a poet of history, or you could say, a historical poet. People like the painter David Hockney explored Cavafy's erotic stuff, but that was just one part of his work—the '20s and '30s were a Golden Age all around the world, and people were more open with their sexuality. But to me, his importance is much more than that. That specific historical blockage is what interests me.

B The changing fortunes of a Mediterranean city also makes us think of Tangier. Yto, for some time, your work has addressed life in and around your Moroccan hometown.

YTO BARRADA The character of Tangier is special. Maybe it's because we're at the edge of a world. There's something about reacting to the tragedies of this place that draws me in: the abuses of power, the decisions

that are irreversible. For a sleepy place that people forgot about for a very long time, the sudden overwhelming attention is tragic. There are so many *grands projets*: building a brand new port, a press center, even the TGV express train is coming. Nature is being destroyed. New museums are being planned—much like in other places in the Arab world—but not being finished. Morocco has recently given $16 million to the Louvre, but we don't have enough to finish our own museums. At the same time, people are pouring in from the countryside as cheap labor. There's human tragedy all around us. Of course, some of this comes into my work, but it also happens very naturally because I grew up with history and politics as part of the daily bread at home.

I was actually born on the day of a coup d'etat in Morocco— July 1, against Hassan II. My uncle, a former ambassador, was at the king's garden party when soldiers started firing on guests at random. Anyway, it was a failed military coup, so I was born on the day of a failure. My father, on the other hand, was a leftist leader; he replaced Ben Barka at the [1966] Tricontinental Conference in Havana after Barka was assassinated. When I was younger, we lived in Paris for some time, in an environment that Chilean kids might relate to. The house was full of men and women smoking and talking about politics. The kids would go from one house to another. Imagining what the

world could be was a natural way of being for us: it wasn't extravagant, it was normal, something we talked about all the time. So of course, I'm going to interrogate those *grands projets* and narratives that are handed down to us as fact.

B Wael, you've also been thinking about a rapidly shifting landscape for some time.

WAEL SHAWKY I grew up in Saudi Arabia from the age of four onward because of my father's work. This was in the mid- to late 1970s and it was impossible not to notice the gap between the old world of nomadism and the modernization that was creeping in. You'd see a bedouin wearing a *galabeyya* and riding a donkey to school, but then his father would be driving a Cadillac. You suddenly were witness to a very American modernity in this Bedouin society. At one point, we moved to Mecca, and the Haram was walking distance from our home. All of this affected me, which is partially why the work *The Cave* (2004-06) is a kind of self-portrait.

B An earlier work of yours, *Asphalt Quarter* (2003), also touches on those shifts.

WS When I was invited to take part in the 50th Venice Biennale, I had already been thinking a lot about my experiences in Saudi Arabia and this gap between tribal Bedouin society and the expanding modernization. I did some research, and along the way read *Cities of*

Salt, the novel by Abdulrahman Munif. What struck me in the first chapter was the encounter between a Bedouin fishing village and the British oil companies that suddenly move in—it was the 1930s, I think. Munif writes about the first time these bedouins see white, blond men, and so on. The bedouins were conscripted to build oil platforms without even understanding what they were doing. I decided to translate this idea into a film shot in the desert in Egypt. I went to a Bedouin community, not far from Siwa, and asked kids to construct an asphalt runway—we told them it was for an airport. The kids believed it and finished it in one day. *Asphalt Quarter* documents that day.

B Rokni, the Iran-Iraq War was sort of a coming-of-age moment for you, just after the Iranian revolution. What was your visual universe like as a kid? How did it inform your work, if at all?

ROKNI HAERIZADEH More than anything, we spent a lot of time at home playing games and watching television during the war. The national television was so limited. There were the predictable religious programs, because these were the first days of the Islamic Republic, but also some strange treasures, like Tarkovsky. I remember watching *Nostalghia* during the war. There was some Kurosawa, too, and among the Iranian directors, Kiarostami. His film *Where is My Friend's House?* had a huge impact on me. Beyond the TV, we had some videotapes around

on clunky NTSD. I remember *My Uncle Napoleon* and *Shahr-e Qesseh* [City of Tales] the most. Everyone had the same shitty, grainy copy of *Shahr-e Qesseh* in black and white. It was the kind of thing our parents would put on just to keep us quiet.

B *Shahr-e Qesseh*, as an animal-human parable, was one of your inspirations for a series you've been working on for some time, "Fictionville" (2009-ongoing).

RH I was completely stuck on the appearances of the characters in the play, especially their masks. The rhymes were funny, but the masks fascinated me the most. They were kind of grotesque. There was the camel that had eyes in his neck. And then there was the bear that was a fortune-teller and the mouse that fell in love with the cockroach. The most memorable character is, of course, the elephant whose tusks are cut off by members of the town because he doesn't fit in. Part of the success of the play was that it had a local feel about it; it played on an oral culture that was so old and so familiar. Like the fox that played the *mullah* [religious leader] who made everyone laugh. All of the characters played on vernacular figures and storytelling. When it first came out, people interpreted the play as a comment against the Shah, and then even later, against the Islamic Republic. But it was much more than that. Of course, it was very political. It had this vaguely

communist sensibility—a revolutionary Third Worldism—but the larger point is that it makes sense in just about every political period. One set of leaders doesn't differ from another set too much. That is what makes it interesting to me.

B Yto, your work *Hand Me Downs* (2011), where you narrate over a series of archival films, speaks to your interest in the history of photography as a member of the Arab Image Foundation—the idiosyncratic Beirut-based archive of which many artists are members—but also to a precise mode of history telling. How did this piece develop?

YB I grew up with fabulous stories all around me. When we were kids I'd have to hear the family history every time someone new came over to the house—and it would literally change every time, so much so that we had a joke about how we should have guests draw the family tree from all that they had heard and each one would be different. My mother used to tell a story about how she was raped by a goat. It was like a bead necklace—always told in a different way. I wanted to work with that. I had been collecting family photos and doing some research with the Arab Image Foundation archive, and began to put these images together with stories. Eventually, an opportunity came up to work on an archive in Marseille of a Pied-Noir population in North Africa. Though the politics of this institution's approach didn't interest me, I ended up deciding to work

with their Moroccan collections. The stories I attached to the images, which drew on my own family's stories, function a bit like the way the Moroccan storyteller Mohamed Mrabet or others would tell stories—ours is an oral culture after all. The stories don't have an end, and they don't all have a moral.

B It speaks to that rich oral culture that the writer Paul Bowles picked up on during his five decades in Tangier.

YB Yes, Bowles would collect tales from [Driss Ben Hamed] Cherhadi, who was a house servant. If you read the introduction to *Life Full of Holes*, you see that they used to sit together in the afternoons, and if Cherhadi had just been to the cinema, he'd tell Bowles that Cairo had burned and was in flames! Bowles would explain that it wasn't actually burning, but Cherhadi would say that he saw it in the cinema and ask if they had been lying.

If they're lying, I can lie, too. Then everyone can write stories; my mother can write stories. That's the basis of the tales that Bowles recorded and also, in a way, what *Hand Me Downs* is about.

B This reminds us of your ongoing film series "Cabaret Crusades," Wael—the weaving of tales from multiple perspectives over centuries. Can we talk a bit about your research in and around the Crusades and how it culminated in these films starring marionettes?

WS The starting point of "Cabaret Crusades" was my reading Pope Urban II's speech from 1095, which supposedly launched the Crusades. It turns out, it was only documented after the fact, so there are at least four different versions of the speech—historically, the most important speech of the Middle Ages. It was an amazing window onto how we believe in written texts, how they take on an air of truth, no matter what their origins. That's why, as I approached "Cabaret Crusades," I worked on the script in a very precise way. I didn't create a new story, I used the archive, even with its mistakes, gaps, and inconsistencies. The film I made doesn't have cinematic conclusions; I mean, it's not very Hollywood. Sometimes, you feel the scenes don't even make sense with each other—but this is how history is written, and I find this interesting.

B What sources did you consult?

WS I started with Amin Maalouf's *The Crusades Through Arab Eyes* and then started to move into deeper research based on some of the sources he had used, like Ibn al Qalanisi or Usama Ibn Munqidh. From there, I began constructing a script.

B Did the accounts correspond or contradict each other?

WS They absolutely contradicted each other at times. For example, in the story of Emmadeddine Zangi, an important Arab crusader, most people believe he was killed when drunk—at least

according to Maalouf or Al Qalanisi. But the Salafi scholar Ragheb al Sergani recounts the history of the Crusades from a Sunni point of view, and for him, Zangi is one of the *muja-hedeen* and would never have been drunk. It's one small example, but shows how you can allow the contradictions to live side by side.

B Speaking of history as being not much more than a series of stories, Anna, for you, walking is a big part of your mode, your way of being. Often, you'll be walking and then stop, sit in the street or in a cafe, and start drawing. It's an incredible means of accessing micro-histories, tall tales, myths, and multiple versions of events.

AB I walk a lot. But it's not that different from taking taxis, which I also do. It's about the eyes and the ears. I don't hear very well any-more, but still, when I do, it's always interesting. I recently heard a *makwagi* [someone who irons clothing] say that the last real revolution in Egypt was that of 1919.

B That's the wisdom of the street—people knowing that official narratives can be nothing more than semantic games or lies.

AB The whole history of the world is made by the powerful in a way that is convenient for the people to believe.

B Can artists—writers, visual artists, and so on—play any role in pushing back on those grand narratives?

RH I think so, by creating moments of subjectivity. Or rather, new subjectivities. I think about Iran and how the dominant story for the past few months is that Iran is "opening up." What does that mean? Has the government really changed? Has its soul changed? It's just talk, especially when you open the newspaper—like today—and on the front page there are two things: one is a story about how Afghans and Pakistanis carry malaria and other dis-eases, and another is about how some Islamic Republic offi-cial won some prize in the US. Is that opening up? The real opening up happens through individuals, and a lot of it happens through art. A poem, a painting—it can change the way you see.

B Wael, what about more recent history—a history you've actually lived through—and the historical re-creation that was at the heart of your work *Telematch Sadat* (2007)?

WS Like everyone around me, I was watching TV as a kid when Sadat was assassinated. Suddenly, the reception was cut and a Koranic recitation began. The same happened with the radio. I still remember the feeling of going out on the streets after that, and rumors spreading, and no one under-standing what was going on.

What's interesting about the assassination recordings is that, with all the movements of the cameras there that day, you almost lived through it all. When I decided to re-create the event with children, I tried to be faithful to the angles of the original three cameras from the footage to which we have access. For me, those tapes were like historical texts. When you watch the assassination numerous times, it begins to lose its meaning, like any-thing else—like our revolution of 2011. When you see the same scene of killing repeated over and over, it's not the same thing you saw the first time. Re-enacting the event allows for a certain shift and enables you to see the whole thing in a new light.

B You worked with kids again. Why is that? How did they react?

WS They were Bedouin kids who had no idea who Sadat was or had been, and of course, they hadn't seen the tapes. Because they didn't have our dramatic memory, they didn't act, and that was interesting to me.

B In your experience, does work-ing on historical material in any way yield clues as to the current moment—how to negotiate it; how we got here?

WS It's much more beautiful to deal with a thousand-year-old history than to even begin to try and react to today. I started "Cabaret Crusades" in 2010, but of course, it ends up being read as a reaction

to the current moment and what happened all around the Middle East beginning in 2011. It wasn't meant to have anything to do with the current moment, but somehow it became a reference for what is happening today, which is fine. Even for me, it was surprising to know that in 1102, there was a huge demonstration in Syria, and the demonstration moved from Aleppo to Baghdad in 1111. Imagine, all these demonstrations were happening against leaders, who were mostly cowards just trying to protect their property. Many of them didn't care about their people or even want to fight the crusaders, and some even wanted to befriend them. You look at this history, and you begin to see what is happening today.

YB I'm doing work at the moment on street plumbers who create sculptures with leftovers from their plumbing to draw attention to their businesses. They set up elaborate sculptures in Tangier's Grand Socco with signs saying, "I'm available, I'm a plumber." The sculptures look amazing, they make these heads that look a bit like medusas. They are strategies of resistance—standing up to the big foot overhead, hustling to get work. It's not a new story, it's a very old one. It reminds me of the character Madame Defarge in *A Tale of Two Cities* who is a knitter during the French Revolution. As a ruthless *tricoteuse*, she witnesses the guillotine coming down and proceeds to knit the names of the dead in Morse code!

AB Cavafy once wrote a poem about an empire that had gone bankrupt. There had been a coronation, and instead of real jewels, they used artificial stones. Yet, everyone knew they were fake. It reminds me of a lot of things happening in the world now. We know things are not as they seem. [Gamal Abdel] Nasser came on television one day and claimed that he had won the 1967 war, but the BBC announced that he had lost. So he took it out on the radio—you couldn't listen to it anymore in Egypt. And then when it became clear that we had lost, Nasser said he would leave the presidency, but we all knew he would return. It's all theater in the end.

ABOUNADDARA–HAMADEH

ABOUNADDARA

ABOUNADDARA

ETEL ADNAN

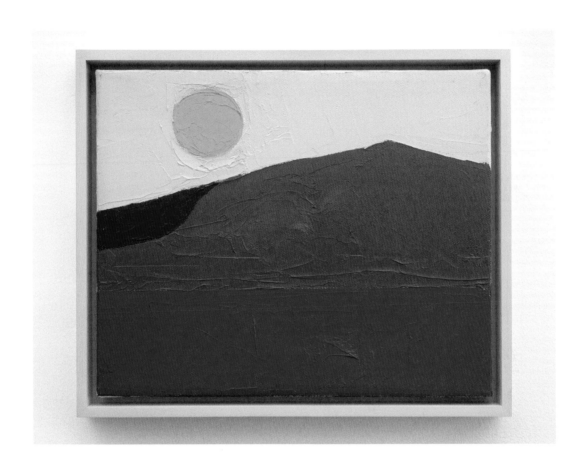

a solar Hopi an Indian (solar) reddening an (Arab) solar darkening
a solar cord a musical Greek a rosace solar a sun in an old sky
a sun in the room a room in a sun rolling on the sky
a blue sky for a yellow sun a yellow sky for a blue sun
a blue tattoo in the sky a sun tattoed with sins solar sins
a Bedu sunstruck a sun-sick and the sea drowning the sea
a sun alarmed alarming the color yellow the yellow alarming sun moon and sea
a militant tattoo a militant sun in a warm universe a straight sun
a solar craft under the Nile the Nile crossing a sun the sun laughing
a solar imbecile a lunar cloud a polar woman a sun ultra brave
a sun solar nocturnal fluvial bestial choleric and yellow as yellow
an egg yolk sun confined to an asylum tearing its skin into lightning
a solar craft under the Nile the Nile crossing a sun the sun laughing
A (tattoo) sunlike and solar is an Arab eye in the middle of the Milky Way
A maddeningly yellow another peacefully green a blue terror O moon!
A yellow and quiet sun on a horizon (quiet and soft) next to flowers.Everyday
A sun victory of the yellow on the green of the green over the yellow in
 the meadow of tears.

leave space

VI

Sun of Wichitah! ~~burns~~ burns the single corn stalk in Wichitah! The mayor's
One sun in Wichitah Three bulls in Cheyenne STOP my thoughts emerge phallus
O disaster STOP O sun STOP O bliss STOP STOP a broken engine
an eye rounded and yellowed by the prison STOP San Quentin streams under the sun
a solar boat in the refrigerator and the Cordilleras under my arm

a palm tree

(sun's)

Voyage to the ~~bottom~~ _hollow_ of a valley in the center of my memory sulfuric burns

is story

I tell the sun it answers I decode it sends new messages I decode

From the center of the sun a tree sends a message BZZ BZZ BZZ BZZZZ a cancer grows

On its neck the tree carries cancer but a solar cancer solar baby ●
A yellow sun ~~crammed~~ in a boat a vessel with melon-soft belly a kiss

Sharp-edged

Lagoon La Paz the Sea of Cortez blue ink on a rock. ~~Diamond~~ is the ocean
The sea is green so is the mother with tooth-ache and amputation . Artaud-Torture .

A sun from Diarbekyr a gully under the ramparts and sonorous boats
a sun from Mardin and the spring exploded the purple velvet of the hills !
a Turkish sun an Arab sun a Kurdish sun a Hindu-owlish sun

Hindu-owlish

11

RHEIMS ALKADHI

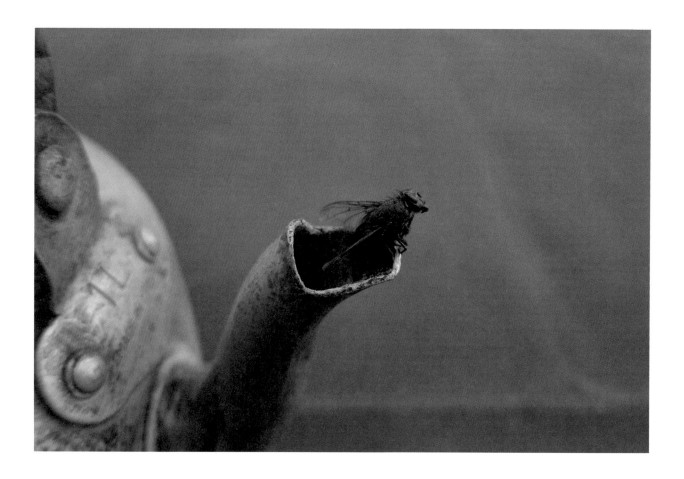

OPPOSITE
Costume for a fly (teapot), 2013.
Aluminum kettle, housefly, 10 × 9 $\frac{7}{8}$ × 5 $\frac{7}{8}$ in
(25.5 × 25 × 15 cm)

ABOVE [TOP]
*Refugee comb-seller with empty pockets,
she was dressed as a man (combs among those
collected for new Syrian refugees in Abu
Alanda)*, 2013. Synthetic shirt (*jalabiyya*)
and plastic and metal combs, 48 × 19 $\frac{5}{8}$ in
(122 × 50 cm) (approx.)

ABOVE [BOTTOM]
*Rubber tube, once inflated carries the
weight of a vehicle (from a Palestinian man
late on a Friday, along Saaf il Sayl)*, 2013.
Tire inner tube (collapsed), 13 × 13 × 7 $\frac{7}{8}$ in
(33 × 33 × 20 cm)

BASMA ALSHARIF

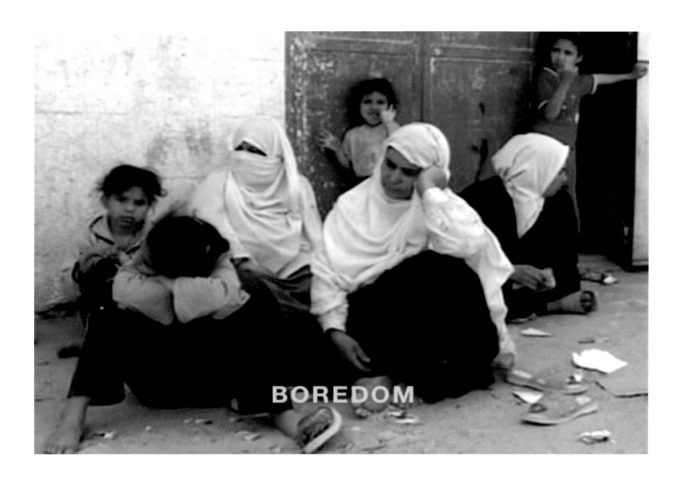

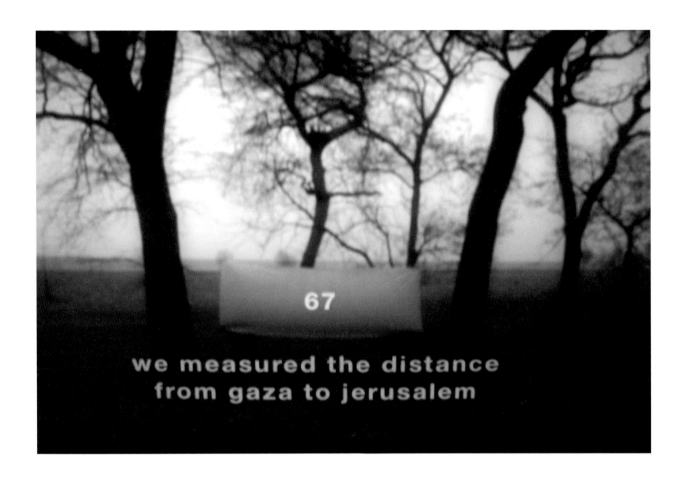

We Began By Measuring Distance, 2009
(stills). Video, color, sound; 19 min

ZIAD ANTAR

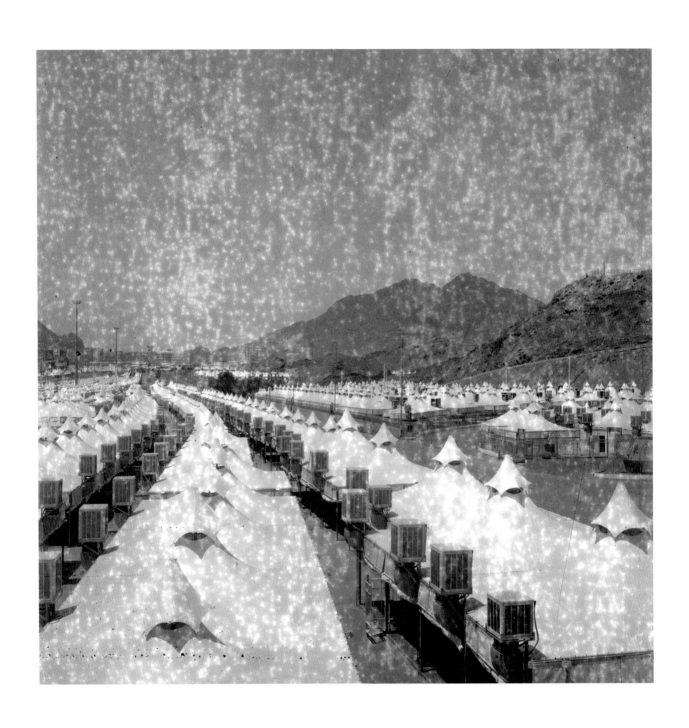

PREVIOUS SPREAD
LEFT
Burj Khalifa III, from the "Expired" series,
2011. Gelatin silver print, 19 ¾ × 19 ¾ in
(50 × 50 cm)

RIGHT
Hajj Tents, from the "Expired" series, 2005.
Gelatin silver print, 19 ¾ × 19 ¾ in
(50 × 50 cm)

OPPOSITE
Pine Trees, Jessine, from the "Expired"
series, 2003. Gelatin silver print,
19 ¾ × 19 ¾ in (50 × 50 cm)

ABOVE
TV and Radio Station, Cairo, from the
"Expired" series, 2005. Gelatin silver print,
19 ¾ × 19 ¾ in (50 × 50 cm)

MARWA ARSANIOS

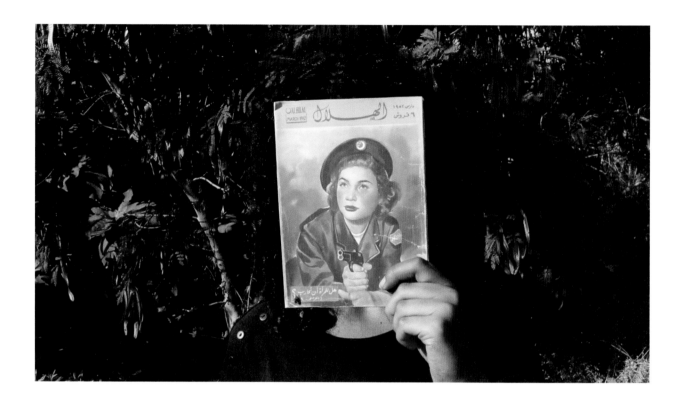

*Have You Ever Killed a Bear? Or Becoming
Jamila*, 2013-14 (stills). Video, color,
sound; 28 min

KADER ATTIA

OPPOSITE
Soldat Blessé, masque malade (Lega), 2013.
Marble sculpture, wooden antique mask, two
wooden bases, bust: 31 ½ × 20 ⅛ × 13 ⅜ in
(80 × 51 × 34 cm), mask: 13 ¾ × 7 ¾ × 2 ¾ in
(35 × 20 × 7 cm)

ABOVE
Act 2: Politics. THE REPAIR'S COSMOGONY,
2013. Metal shelves, teak wood sculptures
(Dakar), white marble sculptures (Carrara),
archival documents and photographs,
dimensions variable

YTO BARRADA

BARRADA

ANNA BOGHIGUIAN

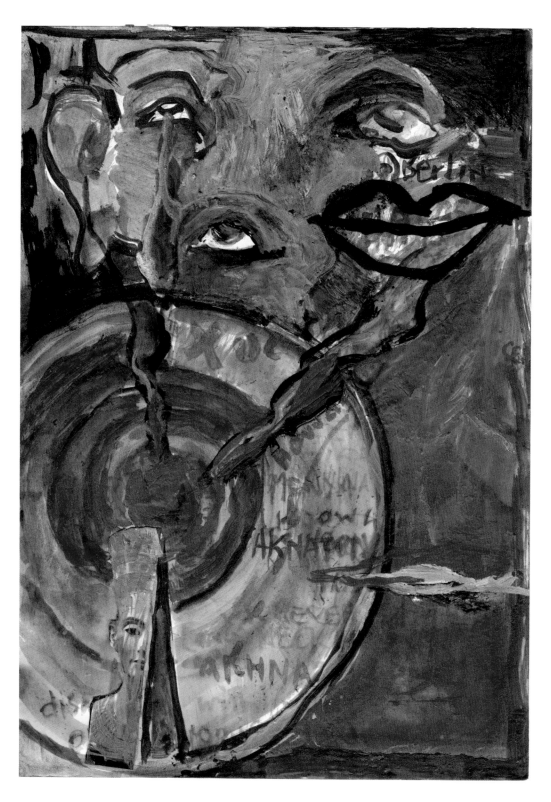

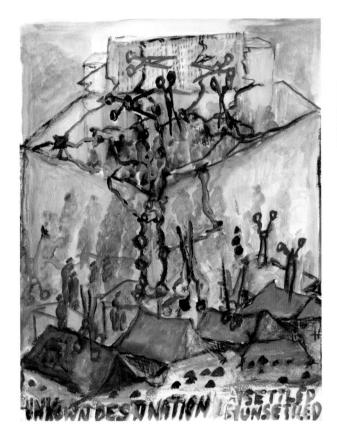

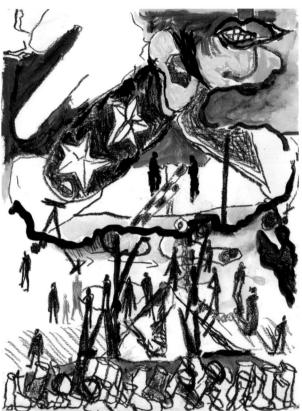

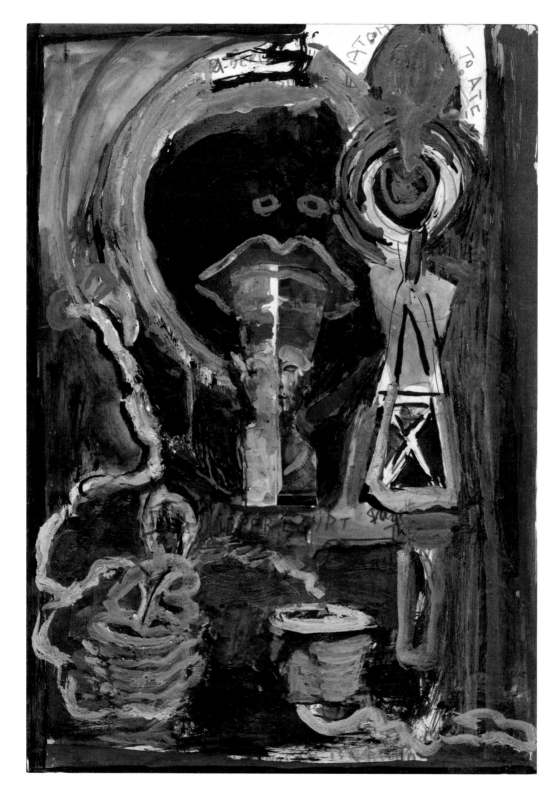

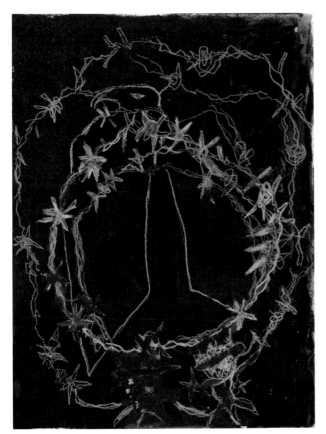

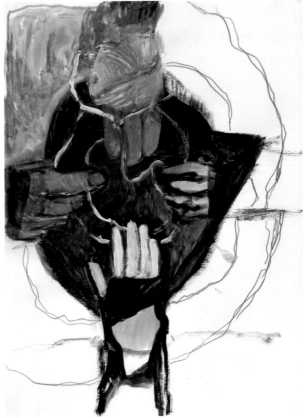

PREVIOUS SPREAD
LEFT
Untitled (Nefertiti), 2013. Paint, pencil, sand, and collage on paper, 16 ½ × 11 ¾ in (42 × 29.8 cm)

RIGHT [LEFT]
Untitled, 2011. Paint on paper, 15 ½ × 11 ¾ in (39.5 × 30 cm)

RIGHT [RIGHT]
Untitled, 2011. Paint, crayon, and pencil on paper, 15 ½ × 11 ¾ in (39.5 × 30 cm)

OPPOSITE
Untitled (Nefertiti), 2013. Paint, pencil, sand, and collage on paper, 16 ½ × 11 ¾ in (42 × 29.8 cm)

ABOVE [LEFT]
Untitled, 2011. Paint and white pencil on paper, 15 ¾ × 11 ¾ in (40 × 30 cm)

ABOVE [RIGHT]
Untitled, 2011. Paint and pencil on paper, 15 ¾ × 11 ¾ in (40 × 30 cm)

FOUAD ELKOURY

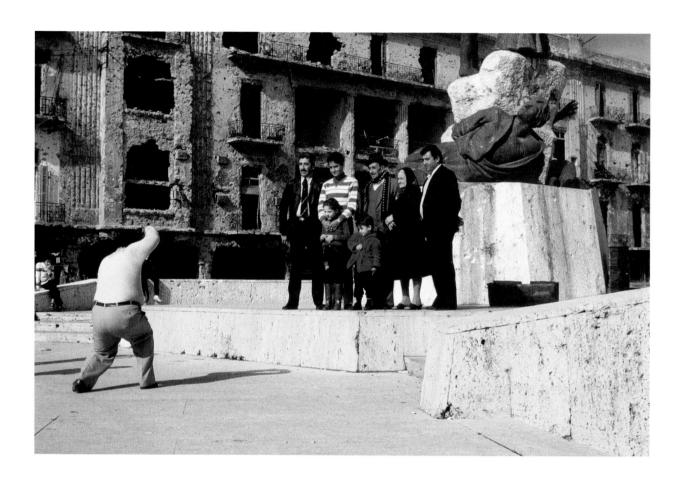

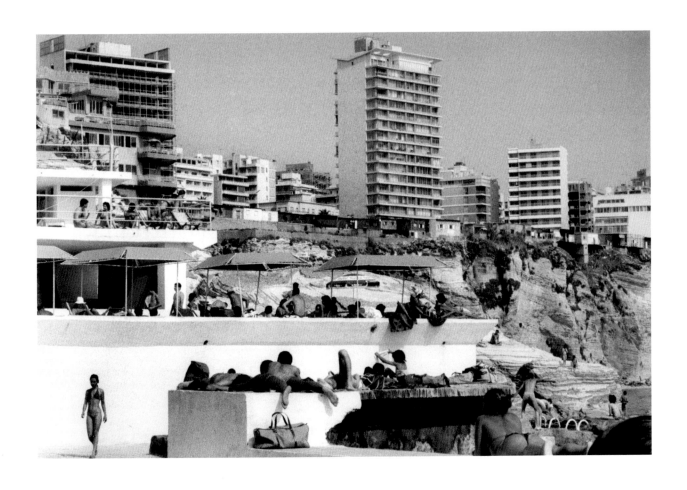

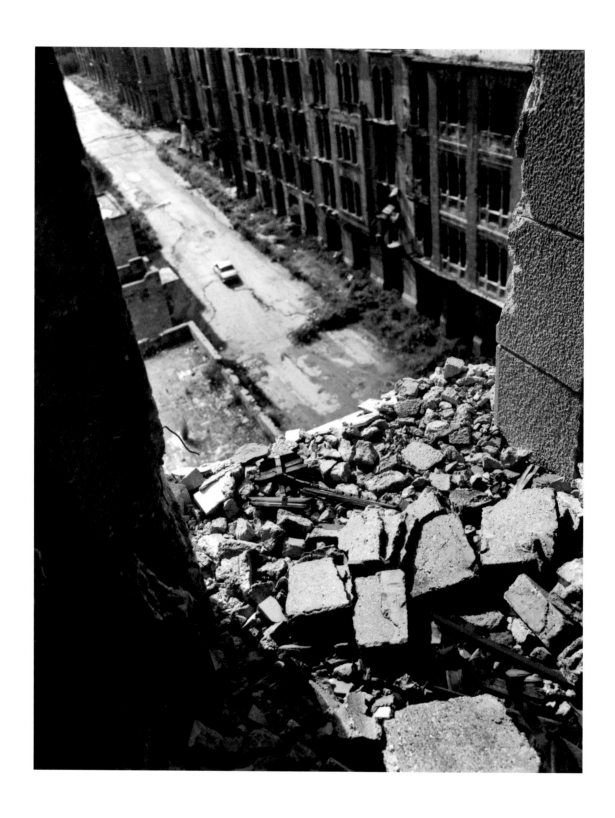

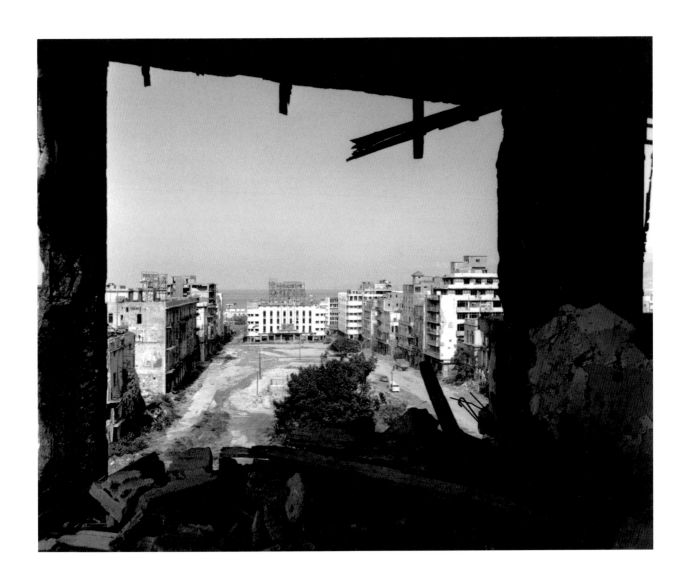

PREVIOUS SPREAD
LEFT
*Color snapshot, Place des Canons
(Beirut 1982)*, 2014. Chromogenic print,
15 ¾ × 23 ⅝ in (40 × 60 cm)

RIGHT
*Sporting Club a few days before the Israeli
invasion (Beirut 1982)*, 2014. Gelatin
silver print, 15 × 23 ⅝ in (40 × 60 cm)

OPPOSITE
The Sniper, Allenby Street (Beirut 1991),
2014. Gelatin silver print, 22 ⅛ × 17 ¾ in
(56.3 × 45 cm)

ABOVE
Overlooking Place des Canons I (Beirut 1991),
2014. Gelatin silver print, 22 ⅛ × 17 ¾ in
(56.3 × 45 cm)

SIMONE FATTAL

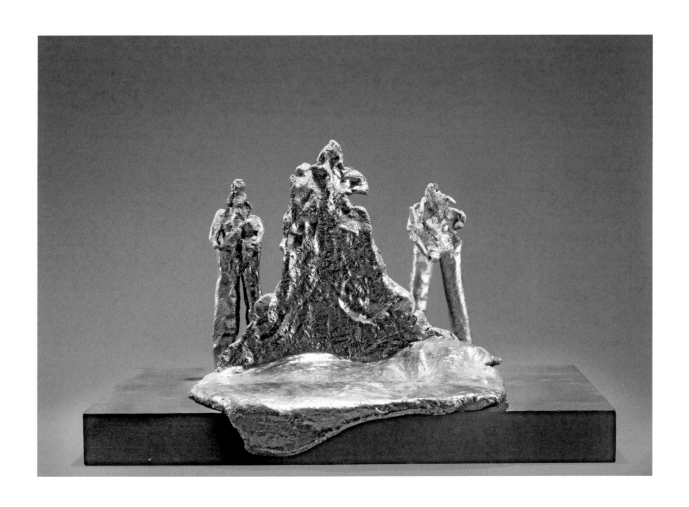

OPPOSITE
Untitled, 2006. Terracotta,
20 × 11 $\frac{7}{8}$ × 6 $\frac{5}{8}$ in (51 × 30 × 17 cm)

ABOVE
La Reine de Tyr, 2008. Terracotta,
11 $\frac{3}{8}$ × 6 $\frac{1}{4}$ × 6 $\frac{1}{4}$ in (29 × 16 × 16 cm)

MEKHITAR GARABEDIAN

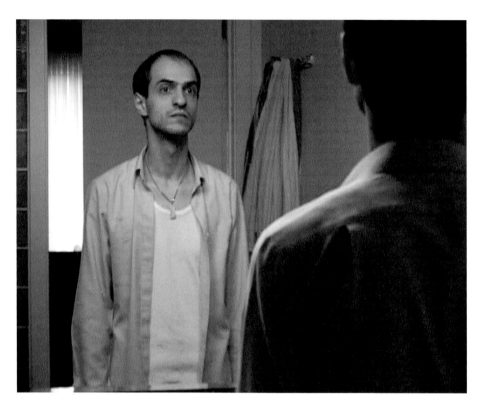

MG, 2006 (stills). Video, color, sound;
2:05 min

GCC

The One and Only Madinat New Museum Royal Mirage, 2014. Digital photo as part of wallpaper and sound installation, dimensions variable

FAKHRI EL GHEZAL

OPPOSITE

[LEFT]

The Attic or The Remains of my Circumcision Party, from the "Weld Mén" series, 2011. Gelatin silver print, 8 ¼ × 5 ½ in (21 × 14 cm)

[RIGHT]

Hamma's Room 4, from the "Weld Mén" series, 2011. Gelatin silver print, 8 ¼ × 5 ½ in (21 × 14 cm)

ABOVE

[LEFT]

Retour chez Abdelbasset l'encadreur 1, from the "Chokran ya siédété al raiis" series, 2011. Gelatin silver print, 8 ¼ × 5 ½ in (21 × 14 cm)

[RIGHT]

Retour chez Abdelbasset l'encadreur 2, from the "Chokran ya siédété al raiis" series, 2011. Gelatin silver print, 8 ¼ × 5 ½ in (21 × 14 cm)

EL GHEZAL

TANYA HABJOUQA

"Tomorrow there will be apricots
[بكرة في المشمش]," 2012–13. Chromogenic prints,
13 $\frac{1}{8}$ × 19 $\frac{3}{4}$ in (33.3 × 50 cm) each

ROKNI HAERIZADEH

 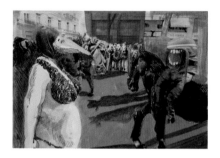

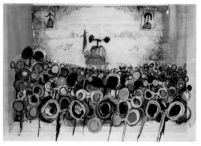 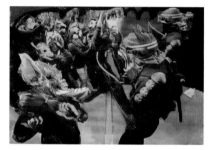 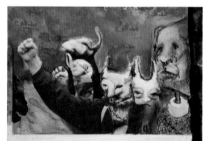

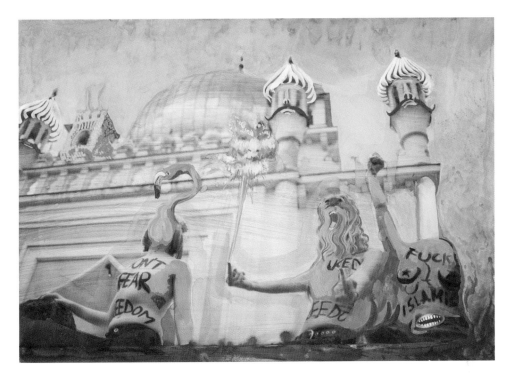

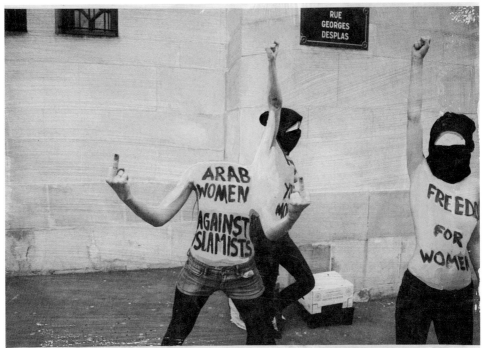

PREVIOUS SPREAD
LEFT
Fictionville, Adrenaline Runs in Armpits,
2011. Gesso, watercolor, and ink on printed
paper, portfolio of nine works, 8 ¼ × 11 ¾ in
(21 × 30 cm) each

RIGHT
Subversive Salami in a Ragged Briefcase, 2014.
Gesso, watercolor, and ink on printed
paper, from a selection of thirty works,
11 ¾ × 15 ¾ in (30 × 40 cm) each

ABOVE & OPPOSITE
Subversive Salami in a Ragged Briefcase, 2014.
Gesso, watercolor, and ink on printed
paper, from a selection of thirty works,
11 ¾ × 15 ¾ in (30 × 40 cm) each

RANA HAMADEH

The Big Board or *And Before It Falls It Is
Only Reasonable To Enjoy Life A Little*, 2013.
Performance and stage set with various
objects, 118 × 59 × 27 ½ in (300 × 150 × 70 cm)

EXHIBIT A: ON THE HISTORY OF CONTEMPORARY ARAB ART SHOWS

MEDIA FARZIN

We might start our exhibition history with a cautionary tale. The Museum of Modern Art's 2006 exhibition "Without Boundary: Seventeen Ways of Looking" was in many ways a mild-mannered affair: seventeen artists, all familiar names, respectably attractive and intelligent work, grouped around a vague thematic category, and installed to superb formal effect. So far, so MoMA. And yet the very vagueness of the theme— loosely defined as artworks that engaged with the past and present of the Islamic world—was its undoing. The show was lambasted from every corner, beginning in New York with the artists themselves.

"[H]ow could anyone today discuss art made by contemporary Muslim artists and not speak about the role...contemporary politics play[s] in the artists' minds?" Shirin Neshat demanded to know in the *New York Observer*. "Historically, any Palestinian narrative is regularly censored in [the US].... This makes it extremely challenging to show work here," Emily Jacir explained patiently in the same article.[1] *Art Monthly* criticized how the show "gently elided" politics in favor of an "easygoing universalism," while *Frieze* condemned the exhibition catalogue for its "fundamental, almost willful, blindness to the conditions of its dated theoretical posturing."[2]

There could be any number of morals to this story, but it testifies above all to the complexity of demands placed on regional representation. The art scenes of the Middle East and North Africa have been defined for Euro-American audiences through a number of group shows in the past decade, most involving a potent combination of peripatetic and ambitious curators, artists eager for (if conflicted about) access to broader audiences and markets, institutions eager to embrace the Other, and the inexorable logic of globalized economies. This essay traces a path through some of these projects for the purpose of thinking about what concepts and conditions define their curatorial approaches, and what justifications (if any) motivate their critical responses.

1 Tyler Green, "MoMA Keeps the Walls Clean; Islamic Show Sans Politics," *New York Observer*, April 3, 2006.

2 Pryle Behrman, "Here There and Elsewhere," *Art Monthly* #298 (July–August 2006), 2; and Roland Kapferer, "Without Boundary: Seventeen Ways of Looking," *Frieze* #99 (May 2006) <https://www.frieze.com/issue/review/without_boundary_seventeen_ways_of_looking/> (accessed April 22, 2014).

Where to begin? MoMA's 1984 "'Primitivism' in 20th Century Art: Affinity of the Tribal and the Modern," the first major exhibition to present the Other in the context of modern art, is important to acknowledge. Aiming to demonstrate the influence of the "tribal arts" on "modern painters and sculptors," it paired anonymous objects with the museum's finest Giacomettis and Brancusis. The curators of "Primitivism" may have had the grace to include quotation marks in the title, but the critics were damning. Then as now, the problem was less the failings of the exhibition's premise than its blinkered approach to political realities: In the absence of any meaningful discourse on non-Western art in a museum context, MoMA's story took on inordinate canonical importance. Viewed through the lens of representation (rather than, say, modernist morphology), "Primitivism" portrayed the indigenous communities of Africa, Oceania, and the Americas floating in a mysterious, timeless orbit around dynamic Western centers of modernity and modernism.

The curatorial response to "Primitivism" was a few years in the making, and came from two very different directions. In Paris, "Magiciens de la terre" [Magicians of the earth], organized by the Centre Pompidou's Jean-Hubert Martin in 1989, was designed to showcase the spiritual truths that Martin felt were denied the non-Western objects in "Primitivism." To that end, he pitted conceptual critiques by the likes of Barbara Kruger, Hans Haacke, and Lawrence Weiner against the modern craft traditions of regions ranging from West Africa to Nepal. Despite considerable curatorial fieldwork by Martin as well as the artists (Weiner was packed off to Papua New Guinea to "initiate dialogue"), there were glaring gaps between the two categories of artworks. "Magiciens" provoked an onslaught of vociferous responses, culminating in an entire dossier of criticism from the recently established journal *Third Text*. Nevertheless, Martin's somewhat immodest description of his own endeavor stuck: The show is still referred to today as "the first truly international exhibition of worldwide contemporary art."[3]

And then there was "The Other Story: Afro-Asian Artists in Post-War Britain," which opened later in 1989 at London's Hayward Gallery, and was curated by Pakistani writer and artist Rashid Araeen, the founder of *Third Text* and, as it happened, one of the most outspoken critics of "Magiciens" (he was also one of the featured artists in Martin's show). As befits a project by a former member of the Black Panther Party, "The Other Story" had an unswerving dedication to opening a space for minority art outside the "magical" or folkloric. The show's artists were all diasporic—British residents of African, Caribbean, and Asian descent—and they all worked within the legacies of modernism (many, such as David Medalla and Mona Hatoum, have since become

3 Jean-Hubert Martin, "The Whole Earth Show: An Interview with Jean-Hubert Martin by Benjamin Buchloh," *Art in America* #77 (May 1989), 156.

canonical figures). The British press missed those subtleties completely: "The real question," asked the *Sunday Telegraph*, "is why, given all these opportunities, is the recent art in 'The Other Story' so mediocre?"[4]

The crucial political battles leading up to these exhibitions and their receptions will inevitably remain unexplored here. Araeen's stance, for example, should be understood against the backdrop of Britain's Black Arts Movement and its thorny relationship to the Commonwealth. In the same way, "Magiciens" must be contextualized within the forces set in motion by the end of the Cold War and Apartheid, the rise of economic neoliberalism (which quickly embraced cultural globalization), and the beginnings of cultural and postcolonial studies at universities in the United Kingdom and the United States—academic departments that were themselves influenced, particularly in America, by the culture wars that were raging in the 1980s between right-wing politicians and the National Endowment for the Arts.

In large part as a result of these social and political transformations, the "multicultural" '90s were born, and with them the emergence of identity and difference—race, class, gender, and sexuality—as key issues. The 1993 Whitney Biennial reflected the social critique that was increasingly visible in the work of US artists, especially in their installations and videos. The beating of Rodney King was a part of the exhibition (courtesy a ten-minute video by a man named George Holliday, who captured the violence with a camcorder from his patio in Los Angeles), as was the Gulf War (via the Gulf Crisis TV Project, a series of videos documenting antiwar demonstrations and testimonies). The response, predictably, was almost unanimously negative: "Political sloganeering and self-indulgent self-expression," sniffed Michael Kimmelman in the *New York Times*.[5]

Few critics of the Whitney's so-called political biennial had the foresight to see that by the end of the decade, the political would become one of art's dominant themes. The French curator Catherine David's 1997 Documenta X showcased precisely this turn. David was interested in "works and positions" rather than artists, "spaces of inscription" rather than mediums, and "contemporary cultural practices" rather than objects (Documenta's press pack famously didn't mention a single artist). Variously criticized for being too intellectual, too spectacular, too dominated by new media, and too full of sober people dressed in black, David's approach nonetheless established the idea of discursive frameworks and works in progress being central components of a mega-exhibition. It also featured many of the strategies she would carry over to her ambitious multipart project, "Contemporary Arab Representations," which established her as the high-theory doyenne of art from the Middle East.

But first, there were the terrorist attacks of September 11, 2001. For all the tragedy of the event and the aggressiveness of US foreign

4 Peter Fuller, "Black Artists: Don't Forget Europe," *Sunday Telegraph*, December 10, 1989.

5 Michael Kimmelman, "At the Whitney, Sound, Fury and Little Else," *New York Times*, April 25, 1993.

policy that followed, 9/11 somehow heralded what we might call the Great Middle Eastern Art Rush. The early years of the millennium saw a number of landmark regional shows that had already been some years in the making, including Okwui Enwezor's 2001 "Short Century: Independence and Liberation Movements in Africa 1945-1994," which put forward a political and historical agenda that anticipated his curatorial vision for Documenta 11 in 2002 (aka "the globalization and identity" show); Walid Raad and Akram Zaatari's "Mapping Sitting: On Portraiture and Photography," a curatorial project by the Arab Image Foundation that toured sixteen European and American cities (plus São Paulo and Singapore) between 2002 and 2005; and David's "Representations," which, in the same years, unfolded in three parts and traveled to half a dozen art centers in Europe. Simultaneously, market forces and other actors were slowly but steadily transforming peripheries into centers, with biennials, festivals, art fairs, and other more context-responsive events in cities such as Beirut, Cairo, Alexandria, Jerusalem, Amman, Dubai, Sharjah, and Istanbul catering to the roving curatorial class. Local artists and institutions were also, in the meantime, staking their own claims and building their own audiences.

David's "Representations" was one of the first large-scale curatorial projects to bring contemporary art from the Arab world into a Western context. In 2002 and 2003, "Beirut/Lebanon" and "Cairo," respectively, opened at the Witte de With in Rotterdam (where David had been working as the institution's Artistic Director and Chief Curator). In 2005, the "The Iraqi Equation" opened at Berlin's Kunst-Werke Institute for Contemporary Art. All three exhibitions traveled to subsequent European venues. David defined her project as long-term, discursive, and interdisciplinary: Seminars preceded each exhibition, and publications almost always followed. Exhibitions leaned heavily on video and were interspersed with television documentaries and interview footage.

In Beirut, David found an art scene ripe for the curating: a close-knit, cosmopolitan, and articulate community of artists with a proclivity for experimental video, as well a front-row seat to one of the most complicated conflicts in the Middle East (about which Western art audiences knew almost nothing). Much of the material from "Beirut/Lebanon" even made its way to the Venice Biennale, slotting into Francesco Bonami's collaborative "Dreams and Conflicts" exhibition in 2003, where it was lauded as one of the highlights. From there, David's project grew muted and diffuse. "Cairo" emphasized works on paper (prints, drawings, cartoons), while "The Iraqi Equation" included very little of what would conventionally be recognized as art, opting instead for home videos, news clips, films of political opposition meetings, and footage of war crimes tribunals.

The US invasion of Iraq in 2003 coincided to the day with the opening of "DisORIENTation: Contemporary Arab Art from the Middle East," at Berlin's House of World Cultures. A project by the Jerusalem-based curator Jack Persekian, it was perhaps the first such high-profile show to be organized by an arts professional who still lived and worked in the Arab world. Despite the infelicitous pun of its title, the show wisely disregarded pro- or anti-orientalism debates, focusing on new video, photography, and installations by Arab artists, and producing "a florid visual essay in Arab dissatisfaction," as *Time Out Abu Dhabi* remembers it.[6] Persekian would go on to curate a far more specific follow-up, in 2009, with "Disorientation II: The Rise and Fall of Arab Cities," on Saadiyat Island in Abu Dhabi, as well as two biennials in Sharjah.

Otherwise, 2003 was the year of the Middle Eastern woman. That February, a show called "Veil" launched a UK gallery tour, followed by "Harem Fantasies and the New Scheherazades" at Barcelona's Center for Contemporary Culture. Spearheaded by two London-based artists, the French-Algerian Zineb Sedira and the Irish-Iraqi Jananne al-Ani, "Veil" had been four years in the making. With its multicity itinerary and ambitious accompanying publication, the show appeared to be on a civilizing mission to counter negative connotations of Muslim veiling practices in post-9/11 news media. Most of the artworks were contemporary, and a great many featured women costumed in the titular article. While there was bit of a dustup in the first venue—officials in the West Midlands town of Walsall insisted on removing two photographs by the Russian-Jewish collective AES, featuring a photoshopped image of the Statue of Liberty in face-covering *hijab* and the UK's Houses of Parliament with a dome and two mosque-style minarets—the exhibition was generally regarded as a pedagogic statement, either appreciated for interrogating a fraught contemporary issue through tasteful poetic critique, or dismissed for capitalizing on a fraught contemporary issue with tasteless neo-exotic opportunism.

"Harem Fantasies," curated by eminent Moroccan feminist and sociologist Fatima Mernissi, was an unabashed neo-orientalist tour de force. Mernissi, to do her justice, grew up in a harem herself and has since spent a career researching the lives of Muslim women, including peasants, workers, cosmopolites, and clairvoyants, across rural and urban Morocco. But her approach is perhaps best described as pre-critically chronological: Ingres preceded Neshat, Matisse followed Persian miniatures, and the result was a crowd-pleasing festival of otherness where the work of the contemporary artists (all Middle Eastern women) appeared an afterthought. Both "Veil" and "Harem Fantasies" seemed motivated by the same intersection of pedagogic activism and personal taste now familiar from the majority of exhibitions of Middle Eastern art that took place in the early 2000s.

6 "Disorientation," *Time Out Abu Dhabi*, October 27, 2009 <http://www.timeout abudhabi.com/art/features/11280-disorientation> (accessed April 22, 2014).

Dissenters of this trend weren't necessarily watching from the sidelines, though. Iranian curator Tirdad Zolghadr's 2004 "Ethnic Marketing: Art, Globalization, and Intercultural Supply and Demand," at Geneva's Centre d'Art Contemporain, was a tongue-in-cheek response to the curatorial clichés of the post-9/11 art world. The culprit, Zolghadr suggested, was less orientalist than capitalist, and the solution was an ethnic marketing campaign targeted at the Euro-American exotica-consuming classes. The exhibition included European, Middle Eastern, and entirely fictional artists, whose humorous over-identifications were organized in the booth layout of a trade fair. The show subsequently traveled to Tehran, where it was hotly debated among the arts writers of the local website Tehran Avenue, who concluded that the non-Western artist is best off "doing her own thing, without either being reactionary or indulgent."[7]

Photography—that perennial instrument of representing the Other—was gradually becoming one of the most recognizable mediums of art from the Middle East. In 2002, the three-part exhibition "Between Word and Image: Modern Iranian Visual Culture" opened at New York University's Grey Art Gallery. Co-organized by Fereshteh Daftari, who would go on to curate "Without Boundary," the show featured an eclectic grouping of revolutionary posters, modernist paintings, and images by the Magnum photographer Abbas. In 2005, the newly opened Aperture gallery in Chelsea hosted "Nazar: Photographs from the Arab World," a traveling exhibition organized for a Dutch photography festival the year before. And finally, Raad and Zaatari's "Mapping Sitting" arrived in New York in 2005 (also at the Grey). All three projects were markedly historic, bringing the everyday life of twentieth-century Arab and Iranian cities out of the archives and into apparent dialogue with the region's various avant-gardes and their contemporary social contexts.

A similar impulse was at work in "Out of Beirut," a critically well-received exhibition at Modern Art Oxford curated by Suzanne Cotter in 2006. The theme here was the historic violence of Lebanon's wars, portrayed through the distinctly Beiruti tropes of confusing fact and fiction, appropriating documentary and archival display, and foregrounding trauma and memory. The heated political climate of that summer—the show coincided with the 2006 Israeli attacks on Lebanon—may have mollified the editors of US art journals who rarely dedicate column space to such regional thematics, but "Out of Beirut" was also one of the first exhibitions of its scale in the Anglophone art world. "Far from being solely responsive to its local context, the exhibition...offered a microcosm of concerns that are paramount in contemporary art around the world today," declared a critic for *Artforum*, which gave Lebanese artists a special portfolio in the magazine's October 2006 issue (followed by *Art Journal*'s more academic special issue on Beirut in the summer of 2007).[8]

7 Negin Motamen, "Some Thoughts on Ethnic Marketing," Tehran Avenue, July 2006 <http://tehranavenue.com/article.php?id=587> (accessed April 22, 2014).

8 T.J. Demos, "Living Contradiction," *Artforum* #45.2 (October 2006), 234

Several institutional shows vied for bicontinental attention in the winter and spring of 2006. "Without Boundary" opened in February, "Out of Beirut" in May, and five days later the British Museum debuted "Word into Art: Artists of the Modern Middle East." The subject here was calligraphy, specifically the possibilities of Arabic and Farsi script as an abstract formal language. While politics were not entirely eclipsed by form, the show's organization (with sections such as "Sacred Script" and "Deconstructing the Word") made its aesthetic priorities clear. "Word into Art" was a distinctly old-school affair, more interested in the grandiloquent notions of Truth and Beauty that still have great currency in Middle Eastern art circles.

"Word into Art" was also evidence of the British Museum's years of acquiring contemporary works on paper from Islamic countries. In many major museums (at the Los Angeles County Museum of Art, for example), it was medievalists in the Islamic departments who most actively followed the work of contemporary artists and proposed acquisitions of then-unknown Arab and Iranian modernists (the unfortunate consequence being that their collections are almost exclusively built around objects that carry formal connotations of ancient tradition and older ideologies). The auction houses didn't take long to tap into the new market: Christie's established its Dubai outpost in 2005, and Sotheby's held its first London sale of "Arab and Iranian Contemporary Art" in 2007, setting record prices for the so-called old masters of the 1960s and '70s. A new history was being written by an unlikely combination of curators, dealers, artists, medievalists, and auction house specialists.

By 2009, the Middle Eastern art-show-in-the-diaspora usually fell into one or more recognizable categories: group shows of promising younger artists whose work appealed to the collector class, exhibition projects with less assertive ambitions, but more critical savvy, and institutional endeavors that placed their primary emphasis on formal correspondences. If the first group was airily ignorant of the pitfalls of regional identification, the second often turned that knowledge into a self-reflexive premise. The final set, which included many a local museum, put their best foot forward and gingerly avoided discursive dilemmas. Mega-shows and biennials were also influential, especially the new national pavilions at the Venice Biennale—Lebanon in 2007, the United Arab Emirates in 2009, Iraq in 2011, plus "Palestine c/o Venice," which was relegated to the status of a collateral event, and "Future of a Promise," which billed itself, somewhat anachronistically, as "the first pan-Arab exhibition."[9]

In 2009, the Saatchi Gallery in London presented "Unveiled: New Art from the Middle East," a report from the front lines of the art market. Drawn from Charles Saatchi's private collection, the show's

9 "Exhibition Overview," Future of a Promise <http://www.thefutureofapromise.com/index.php/about/view/exhibition_overview> (accessed April 22, 2014).

sparse hanging in vast white galleries—and its unfortunate title—left stranded bodies of work that would have benefited from more coherent curatorial framing (though one viewer, recognizing Marwan Rechmaoui's *Beirut Caoutchouc* [2004-06] from "Contemporary Arab Representations," was relieved to see it "liberated from the company of Deleuzian texts and yet another grainy video of someone's aunt.")[10] Still, many considered "Unveiled" another manifestation of Saatchi's "art-as-tourism act," mirroring all too closely the "New Art from China" show that preceded it.[11]

"Tarjama/Translation," which opened at the Queens Museum in 2009, had a more thoughtful premise, suggesting that the artists' distance from their points of reference could serve as a productive theme rather than a representational conundrum. "Translation," alas, is a very broad concept, and it became clear upon viewing that the subtitle—"Contemporary Art from the Middle East, Central Asia, and Their Diasporas"— had taken precedence. The show made sense for the multinational audience of a museum that had also organized the groundbreaking 1999 "Global Conceptualism: Points of Origin 1950s-1980s," but "Tarjama" was first and foremost a regional show, even though its ambitious range meant that it was "geographically speaking, hard to get a grip on," as Holland Cotter noted in the *Times*.[12]

The year 2009 is, in many ways, an organic endpoint for this chapter. If the global economic recession only muted the frantic pace of the Art Rush, geopolitical coordinates were more deeply affected by the uprisings that took hold of the Middle East and North Africa, beginning in 2009 and exploding fully in the early days of 2011—the so-called Arab Spring that moved from Iran to Kyrgyzstan, from Tunisia to Cairo, from Libya to Yemen to Syria, to Occupy and beyond. The uprisings marked all kinds of endings and beginnings, involving the productive (and regrettable) ways that artists, curators, and institutions negotiated and named the subsequent transformations. Many of the most visible projects after 2009 were either more local affairs and solo projects, or conversely, statements on the biennial and triennial level. Perhaps it was a sign of collective stocktaking, or perhaps a hopeful indication that we are entering a more reflective moment.

Does the story, ultimately, have a moral? During a public event that accompanied "Without Boundary" in 2006, the theorist Gayatri Spivak tried to delineate the dilemma more precisely. "The curator here has really tried to complicate, to thicken, the way in which a museum produces a truth about a national art," she reasoned with artist Walid Raad. "But at the same time you come back again and again to the material realities which allow a general audience to give you a name."[13] The question of representation, in other words, seems to already be embedded in the artworks, of which very little has been said in this essay.

10 Karl Sharro, "Individualism Versus Identity," Culture Wars, February 13, 2009 <http://www.culturewars.org.uk/index.php/site/article/individualism_versus_identity/> (accessed April 22, 2014).

11 Jackie Wullschlager, "Saatchi and Middle East Art," *Financial Times*, January 30, 2009 <http://www.ft.com/intl/cms/s/0/f86bea7e-ee5a-11dd-b791-0000779fd2ac.html> (accessed April 22, 2014).

12 Holland Cotter, "Tarjama/Translation," *New York Times*, August 13, 2009.

13 Gayatri Spivak, "Without Boundary: Meditations on Truth" at the Museum of Modern Art, New York, May 4, 2006 <http://www.moma.org/explore/multimedia/audios/248/38> (accessed April 22, 2014).

"Islamic, Middle Eastern, I don't know what name if any is adequate to the rich and complex psychic life that we inhabit," Raad responded. "One is constantly today addressed as an empirically determined person, as a social person." (Raad was, ironically, challenged on that very basis when, during the subsequent discussion, an audience member pointed out that he is not, himself, Muslim.) "So the question," he continued, "is how to refuse.... Will you proceed from the assumption of the absence of this empirically determined addressee? ... [Should we] hold the idea of writing or art as always a collaboration with an unknown albeit determined addressee? ... How does one then shatter these determinations?"[14]

The exchange above suggests a preliminary interpretation of the events outlined here: not as an account of truth or failure to adequately represent an amorphous and shifting entity, but as evidence of how art and artists have persistently pushed back against being named with strategic assumptions, knowing manipulations, and contrary refusals; a Bartleby-like obdurateness in the face of describing, mapping, unveiling, veiling, "empirically determining," or otherwise being made sense of. (Being commodified, however, seems rather more acceptable—apparently, you have to give in somewhere.) Any exhibition, by definition, is an act of submission to an act of making visible. But a more serendipitous reading of this exhibition history would seek continuities among what was, in each case, precisely *not* placed on view: personal aspirations and taste, social and economic connections, institutional imperatives, ideological boundaries, and everything that contributes at a certain moment in time to the feasibility and legibility of a cultural statement.

14 Walid Raad, "Without Boundary: Meditations on Truth" at the Museum of Modern Art, New York, May 4, 2006 <http://www.moma.org/explore/multimedia/audios/248/38> (accessed April 22, 2014).

THE PRESENT

ETEL ADNAN, BASMA ALSHARIF, BOUCHRA KHALILI, JAMAL PENJWENY, HRAIR SARKISSIAN
MODERATED BY BIDOUN

There's a dilemma that artists all over the world often face, which is the extent to which they use their work to engage or establish a critical distance from the political realities of their time. In the Arab world, this has been a particularly acute problem for artists to deal with. Contemporary art has become a productive space for political discourse and debate—especially in the absence of more meaningful forms of political participation in the region's pseudo-democracies, absolute monarchies, and dictatorships of once radical, revolutionary parties. As such, the stakes are high. At the same time, outside interest in the potential of Arab culture—as a marketplace, a destination for curatorial fieldwork, and a recipient of foreign aid—has been rising steadily. For this reason, artists often find themselves tasked with doing the work of journalism.

Since 9/11, and even more so since the advent of the ill-fated Arab Spring, artists across these vast and complicated territories have been asked, even expected, to explain to foreign viewers, who have little to no grasp of the historical factors, the turmoil, upheaval, and religious strife that have shaped the states and societies of the Middle East and North Africa. That dilemma is compounded by the fact that to be a politically engaged artist, writer, or intellectual in the Arab world is to participate in a very specific history of placing one's art in the service of political struggle—epitomized by the novelist Ghassan Kanafani and the poet Mahmoud Darwish.

Still, the critic and art historian Media Farzin, whose essay precedes this roundtable, once told us, during a long conversation that took place in the summer of 2013, that the best narratives tend to hinge on the artists who refuse to fit in, and refuse to be emblematic of their eras. "The figures who really need to be written into the history of art tend to be the figures who were out of their time and misunderstood," Farzin explained. "The really interesting artists are the ones you can't extricate from their anonymity, because they are so single-minded, so intense."[1] Here, five such intense and single-minded artists delve into what it means for them to re-examine acts of witnessing and engagement in their work.

—*Bidoun*

1 Kaelen Wilson-Goldie, "Rumours & Recognition," *Frieze* #158 (October 2013), 214.

BIDOUN Although the five of you work in the widest possible range of media—from film and video to photography, painting, drawing, and other works on paper—you've all been highly prolific since the so-called documentary turn in contemporary art, starting in the late 1990s, and you've all been involved in several medium- to long-term series and projects that could easily be considered documentary. This is either because of the urgency of the subjects you're dealing with, or because of the factual nature of the materials you're using in your work, or because the forms you've found explore and make visible the issues that have been of utmost concern for you. To what extent do you think of your own work as documentary, or is it just one among several tools you might turn to in a given piece?

BOUCHRA KHALILI For me, documentary practice is less a genre or a tool than the awareness that an image—no matter whether it reflects reality or imaginary visions—is, at the end of the day, subject to elaboration and construction while still documenting something. Documentary—at least documentary in the way I'm interested in it—is by essence ambiguous. It reflects reality, and yet it is subject to a visual and conceptual apparatus. I won't say that my work is documentary-based, but rather that I work with documentary as a kind of travel companion.

B Jamal, as someone who spent time as a photojournalist, how do you feel about the documentary function of your artwork?

JAMAL PENJWENY As a child, I used to make paintings and sculptures. At a certain point, I wanted someone to take pictures of my work, so I could have a record of it. I couldn't find anyone, so I did it myself. In that way, I started doing photography by accident. I became a war photographer in 2003. I lived in Iraq, and I grew up in the war. When I was eighteen or nineteen years old, I wanted to make some money and photojournalism was a way to do that. When the war started in 2003, I left Sulaymaniya, in Iraqi Kurdistan, and went to Baghdad. I didn't tell anyone I was going—not my mother, not my family. But as a photojournalist, you can only show what is happening. In the media, you can only show darkness. I wanted to do more. I wanted to show another side of the country, another angle. I wanted to show the lives of the people.

B When did you start working on the series "Saddam Is Here" (2009-10), which consists of color photographs of people going about their lives while holding black-and-white portraits of Saddam Hussein in front of their faces, like masks or memorials?

JP I started "Saddam Is Here" in 2007 or 2008. When Saddam was killed, I realized that you couldn't change a country by killing its leader. For better or worse, the people of Iraq made Saddam, either because they loved him or because they were afraid of him. For that reason, you see dictatorship in this country. I wanted to show that Saddam's death did not bring democracy. Iraq is still in really bad shape.

B Hrair, the story of your series "Execution Squares" (2008) is almost like a mirror image of Jamal's project, except that you took these haunting photographs of public squares in Syria before the war began, rather than after. What motivated you to make this work, and to make these ominous places visible?

HRAIR SARKISSIAN It all started when I crossed eyes with three people, already dead, who had been hanged in the middle of a square called Meysat, near my parents' house. It was in the early light of day, and I was on my way to school. I was twelve years old, and sitting on a school bus. More than twenty years later, the image of their empty eyes still haunted me. Their bodies were covered with white paper, something that stuck in my memory as well. I blindly trusted the ability of photography to reveal the truth, to show that outside of my own imagination, these bodies were no longer dangling in the air. That's why I decided to photograph the squares where public executions had taken place. It was a way to put those memories to rest, and to convince myself that a violent episode in our history had ended. Clearly, I totally failed in my intention. Another reason for creating this

work was to ask the public—not just the Syrian public, but also the public in other countries where capital punishment still takes place, and still takes place in public—whether these ghosts haunt them, too?

B Do you think the meaning of these images has changed in the years since the uprising in Syria began in 2011? What are your own thoughts about this work now?

HS Since the beginning of the events in Syria, I have had many requests from journalists, especially from the West, who wanted to use the images from this particular series to illustrate their articles and describe or visualize the brutality on the ground. Each time, I refused for personal reasons, but also because the meaning is not the same. The Ottomans implemented public executions almost five hundred years ago; the phenomenon was not created recently. People were executed because they were criminals, murderers, or rapists. What is happening now is that the entire country has effectively been turned into a huge execution square, where people's lives can end at any given moment, without notice or conviction. Once I started to follow the everyday killings on my computer screen—massacres of children and families—I had to admit that I didn't see these squares anymore, because the killing now is on such a wide scale, and the people being executed are innocent.

B Bouchra, many of your works deal with subjects, as in Hrair's "Execution Squares," that are known but remain hidden or underexposed, such as illegal migration, poor labor conditions, and the clandestine movements of goods and bodies through the global economy. What makes you, as an artist, able to see those issues so clearly, and what moves you to work on them for long periods of time?

BK I would say that the core of my practice consists of asking myself questions: What are the margins of power? Where are they located? Who inhabits them? What strategies of resistance do people develop and elaborate when they are forced to inhabit those margins? But honestly, I'm not sure those subjects are any more visible to me than anybody else. Most of the time, they are simply ignored, or misrepresented for various reasons. I would rather say that it is a matter of instinct. I've always been interested in un-narrated facts and stories, hidden realities, unheard voices. And beyond the questions I approach, it is about how to produce a representation of those margins of power, how bodies, words, languages, and orality can be articulated to create an image.

It's not even about urgency. It is more an act of constant questioning, a sort of obsession. That's why I don't see disconnections between "The Mapping Journey Project" (2008-11), a series of eight single-channel videos focusing on clandestine routes and singular trajectories; "The Speeches Series" (2012-13), three single-channel videos about language and orality as an act of resistance; *The Seaman* (2012), a digital film that explores the working class at sea, who are subject to constant displacement; and *Garden Conversation* (2014), a digital film that seems rooted in history, but is all about the ways in which history can be resuscitated and made contemporary. Ultimately, all those pieces have one simple question in common: What are the alternatives that are questioned and developed from a singular, minority perspective, yet still manage to be universal?

B Etel, you have a completely different approach to documentary practice. Your process of painting, decade after decade, a mountain in California or the Mediterranean Sea is a kind of close observation of a landscape and a subject over time.

ETEL ADNAN I consider everything I do an act of witnessing. If you read Tolstoy, he stands somehow for Russia. This is why archeologists speak of traces. Everything that everyone does speaks to his or her time. That's what gives value to things. That's what makes them equal to information and to knowledge, even if artists don't like to think of their work in those terms. For me, Jackson Pollock was expressing the dynamism of the United States. So in that sense, yes,

the work is a form of documentation. We tend to separate things. We think a documentary is one kind of film. But it's the eye that documents, and potentially everything we do is documentary. The work doesn't exist only for its aesthetic qualities.

I became a painter in California because California is very beautiful. In general, the world is beautiful, but in California, nature is so close. And in America, nature is wild. My paintings are about my love for that nature. I miss it now that I am in Paris. And I miss Lebanon, the Lebanon that I left, which, for my generation, was magical. I miss nature not in a romantic way, but physically. The little beauty that is left in the world is precious. These landscapes are a part of me. It's almost painful. We speak of exile, which makes it sound romantic, but for me, it's completely physical, and I hate the word exile.

B And yet, for all the beauty of your painting, your writing delves into much darker and more painful material, particularly the novel *Sitt Marie Rose* (1978) and the poems of *The Arab Apocalypse* (1989), both of which deal with the early days of Lebanon's civil war, or subsequent books that cover conflicts in Vietnam, Algeria, and Iraq. These are all highly political and politicized subjects. How do you balance the beauty of your painting and the brutality of your writing as two sides of the

same documentary endeavor, or as two views of the same world you love?

EA If I did only one thing, then maybe my work would be different. But Picasso did *Guernica*, and it wasn't everything he did, but he did it. So you can be political in your work. Words are social by their essence. I was moved to express my involvement in politics through words. Painting has always been far more peaceful for me. But the world doesn't shoot back at words, either. Words involve other people. Painting has its own necessity, its own pleasure.

B Do you think artists working in the Arab world today have a duty to act and to serve as witnesses to their time, and to use their work to capture and make sense of the kind of upheaval that has been surging through the region over the past three years?

HS I haven't been living in Syria since the beginning of these events, so all that I have witnessed over the past three years has come through the news, the stories of friends and family still living there, or video footage that has been uploaded and circulated online. And from the beginning, I have refrained from making work about the disastrous things that have been happening. Knowing that any piece about Syria will go directly into the art market definitely holds me back. I would have to think seriously before committing myself to any kind of work linked to the

present situation in Syria. Perhaps in the future, once everything is resolved, there will be more time to react, think, and realize what we are going through now, and time to digest all these images, crying voices, and falling bodies.

Two more recent series of mine, "Istory" (2010) and "Unexposed" (2012), deal with the Armenian genocide. These traumatic events have been passed on from one generation to another. As an Armenian born in the diaspora, we inherit all sorts of information, feelings, and trauma created by the genocide from the day we are born. We carry this weight on our shoulders as a burden through the present, and we transmit it through the future. Basically, I live with the past in the present tense. This has been one of the pillars of my work, facing the past in the present, drawing this thin line that binds these two phases, and making it visible and readable.

BASMA ALSHARIF I don't think cultural producers have any sort of responsibility in relation to contemporary conflict, upheaval, or change. It is absolutely a choice to address these issues. I feel that the most interesting and radical works are not necessarily those that address a current condition, although certainly there are many works that do so quite well. What I mean to say is that it is not an obligation by any means. I also feel that sometimes being

too close to our subject means operating from the mouth of the beast and, um, eating what it eats? I may have made this idiom up, though I think it may somehow be biblical.

B Does it seem, then, that the weight of the present is too heavy, and that as artists, you've been put under too much pressure to respond to the urgency of the so-called Arab Spring?

HS The pieces I made in Syria and Egypt, up until 2008, made me confront the complexity and gravity of the situation surrounding us. These are burdens generated both by historical events and contemporary times. It definitely affected me in the way I approached the topics that I worked on, particularly when they were related to religion and politics. As for now, I deliberately try to keep myself outside this circle and avoid being driven into this kind of engagement. I try to work on more personal experiences, or on future fears and expectations—things that may or may not happen on the ground.

BK The Arab world has been in a state of permanent crisis for at least a century or more. What we're experiencing now looks more like a new development within this old process. If one takes into consideration what the French historian Fernand Braudel defined as the *longue durée*, then the question is not how to react to urgency, but how to react to the long term: What is the nature of this new event within this long crisis? How does one define it with regard to the transformation in the region that started decades ago?

Garden Conversation, a video that takes as its point of departure an encounter that happened in historical fact, but was never documented—a meeting between Ernesto Guevara and Abdelkrim al-Khattabi, the old exiled hero of the Rif War, which took place in the garden of the Moroccan embassy in Cairo in 1959—can, of course, be considered a reaction to the Arab Spring, even though it was in my head for five or six years before I could produce it. But it is not a reaction. Rather, it is a meditation on the genealogy of utopia in the region. When the work was first shown, I was very interested in the reactions of viewers from Spain, Portugal, and India, who identified with the piece and made analogies between the situation in their countries and the film.

I have not yet had the chance to see *Thwara Zanj (Zanj Revolution)* (2013), the latest film by the talented Algerian filmmaker Tariq Teguia. But I was not surprised to read that he was taking as his point of departure the Zanj rebellion that occurred in Basra in the ninth century, to investigate the revolutionary spirit of the region and beyond. So if there's a sense of urgency to respond to the Arab Spring, then maybe it consists not only of engaging with the present, but also looking at history to interrogate potentialities for the future, as the past expresses them within the present. I think this is what Walter Benjamin, in "On the Concept of History," calls the "Angel of History."

B The notion of being a politically engaged artist has a very particular history in the Arab world, especially in relation to, say, the Palestinian struggle, or art in the service of Arab nationalism in the years of Gamal Abdel Nasser in Egypt. How do you position yourselves as artists in relation to that history, which is long and complicated and still plays a strong hand in how people speak about modern and contemporary art in the region?

BK Years ago, I was totally fascinated when I could read online, and for the first time, almost the entire print run of *Souffles*, a cultural magazine founded by the great Moroccan poet Abdellatif Laâbi in 1966. Until the early 1970s, the magazine gathered together the most talented Moroccan poets, novelists, filmmakers, and artists, such as Mohammed Khaïr-Eddine, Farid Belkahia, and Ahmed Bouanani, among many others. The magazine constantly explored these questions: What does modernity mean in a newly independent country? How can a specific and decolonized modernity be shaped in North Africa and the Middle East? What is the role of the artist in an era of social and political change? Some of the contributors to *Souffles* were also members of underground political groups, such as Laâbi, who

was also one of the founders of the Marxist organization Ila al-Amam. Laâbi spent eight years in jail, from 1972 to 1980. At his trial, to prove that Laâbi's ideas and actions were subversive, the prosecutor used *Souffles* as evidence.

Today, the archives of the magazine are hardly accessible in Morocco. I was able to read most of the back issues because American academics had uploaded them online. What impressed me most weren't necessarily the answers that were developed throughout the magazine, but rather the vitality demonstrated by all those wonderful artists through their constant questioning. None of them considered himself or herself a social agent. They were more concerned with the idea that art cannot remain on the outside of society and real life. So the issue was not to produce politically engaged art, but rather to rethink the inherent critical function of art, as a paradigm of modernity.

Even though I studied in Paris, I know I have "aunts" and "uncles" who, decades ago, tried to define a specific modernity still rooted in our region. Defining political art and engaged artists is a trap. Does it mean that to be engaged, artists should join political groups? Become activists? Or does it mean that they must produce useful art? This is somehow an old question, at least as old as the history of modernity in art. When Laâbi and his fellow poets and artists were asking themselves "What is poetry in a postcolonial era? What is

revolutionary art?," they were investigating the same questions as the Brazilian filmmaker Glauber Rocha in his essay "Tropicalism, Anthropophagy, Myth, Ideogram" (1969). These were also the same questions for Jean-Luc Godard in France after 1968, when he founded the Dziga Vertov Group. They were even the same questions that Baudelaire was asking during the revolution of 1848, when he accused the poets of his generation of being concerned only with art for art's sake. I don't think our generation has resolved these questions. We are inheriting them.

BA I may have a broad understanding of the term "politically engaged" when it comes to my work. If you are from a place of political turmoil, does everything you make somehow refer back to that place and its conflict? Unfortunately, yes, just as where a person is from—their background, history, and the context through which they have developed a practice—is a key to how we can understand their work. So in this regard, I have very much positioned myself within a history of politically engaged art "from" the Middle East— but perhaps through a position of trying to redefine that place through the images that are associated with it and by inviting others to experience a Palestinian perspective. I see this as a perspective from which to create a new image of the past that asks us to *rethink* the value of that past, of

history, the archive, knowledge, facts, etc., and to be active in our construction of the future. I've been discussing this very issue with the filmmaker Eyal Sivan, who defines it as post-Palestinian.

My work comes from a Palestinian perspective in the end, but what that means is specific to my personal history, and it becomes part of my work is in my attempt to re-create the image that a Palestinian produces, one in which there is a nomadic, multilayered perspective that looks at the rest of the world and takes agency through a position of being from a place that is slowly— or quickly—vanishing. What I mean is that we are held in a place as Palestinians because there is an insistence that we remain occupied and are aware of being occupied—aware of our limitations to travel, to move from neighborhood to neighborhood, to hold jobs, or build homes. It is a reminder that we are not a part of the land, and more significantly, not a part of its future. Regardless of whether we live on the land or not, the present condition is a reminder that we are nationless and somehow cannot be freed from this political cirumstance, even if we hold other passports. Given that, I have decided to operate from a position of agency, a position of being post-Palestinian.

It is not important what my political beliefs about the occupation are or what terms I use to describe it. This is not what my work is about in any explicit way. I am using my

position as a way to create a new image, to look at the world through Palestine and the very specific perspective this position offers in an attempt to engage with broader issues concerning the human condition and its future. In that way, I believe my work to be politically engaged because the question of Palestine is relevant even without being a subject of the work or engendering a call to action. I believe my generation has challenged the politically engaged work of the past, how it works, what it means, and how we give ourselves the agency to address certain subjects. I think that the genre of ethnographic filmmaking, the idea of the documentary, and the ways in which political issues are addressed is built on the history of politically activist work, but it is questioning the maker more so than the subject, or at least it is acknowledging that there is a very blurry line distinguishing one from the other.

B In very simplistic terms, it also seems that your generation is far more playful and experimental when it comes to questions of form. In your work, for example, the treatment of sound has changed tremendously from your earlier video *We Began By Measuring Distance* (2009), which, among many other things, distorts a great, old song by Abdel Halim Hafez, "Qariat al-Fengan" [The Fortuneteller]. How do you account for the faster pace, heavier manipulation, and more layered texture of sound in your work now and

how does it relate back to what you once described as your "disenchantment with facts"?

BA I have become more and more interested in sound as an environment, and in the use of sound as an essential element of a work, not limited to moving image works. I recently completed a short film titled *Deep Sleep* (2014), which uses a binaural beat soundtrack. The work deals with autohypnosis, and binaural soundtracks are useful in inducing hypnosis. For the exhibition of this work alongside others, I created an hour-long soundtrack for the gallery space, which was meant to produce a sensorial, though very subtle, experience of the works in the space, of the works' interaction with each other. Perhaps, more importantly, regardless of what you knew or understood cognitively about the construction of the space you were stepping into, your body would have a distinct experience that the soundtrack was essential in creating. I am definitely curious about what the body knows that is not necessarily obvious as a cognitive process. I believe that the deeper involvement with sound has emerged out of a more profound interest in nature and the environment. After being in Gaza during a major incursion by Israel that took place in November 2012, my relationship to sound became much more sensitive. I became more in awe of it I guess. I've started to really like noise music performances, as they re-create the physical

experience that war can create: the subtle oscillation between fear and pleasure in response to something invisible.

SHURUQ HARB

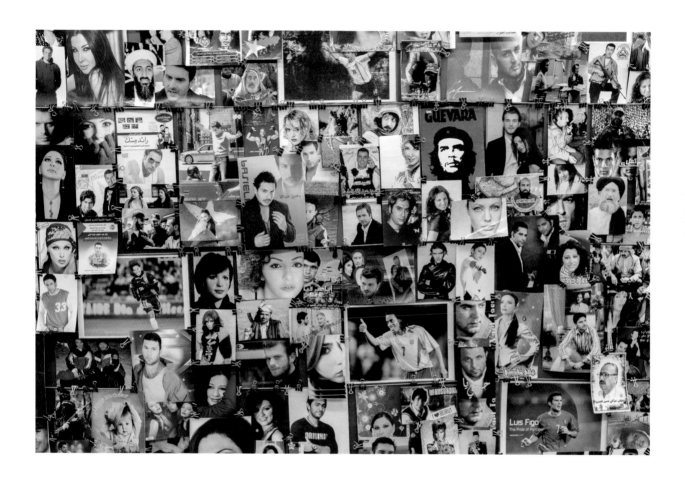

OPPOSITE
The Keeper, 2011-13 (still). Video, black
and white, sound; 5:45 min

ABOVE
The Keeper, 2011-13 (detail). Installation
with video, includes photographs, wires,
clips, and street sign, overall dimensions
variable

HARB

SUSAN HEFUNA

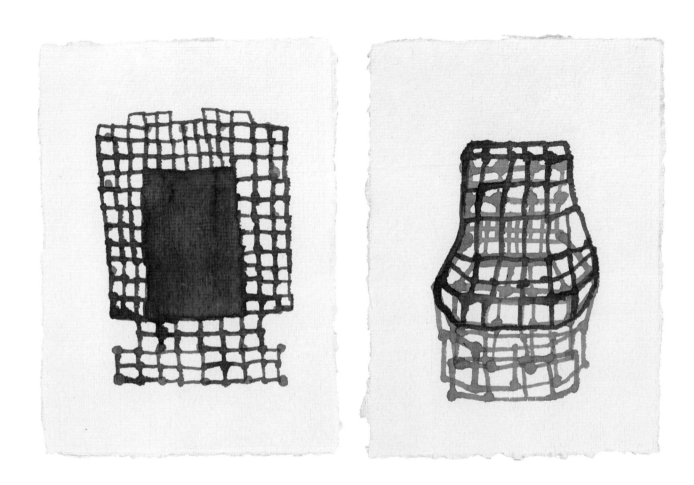

Cityscape Istanbul, 2011. Ink on paper,
sixteen works, 7 $\frac{1}{4}$ × 5 $\frac{1}{4}$ in (18.5 × 13.5 cm)
each

WAFA HOURANI

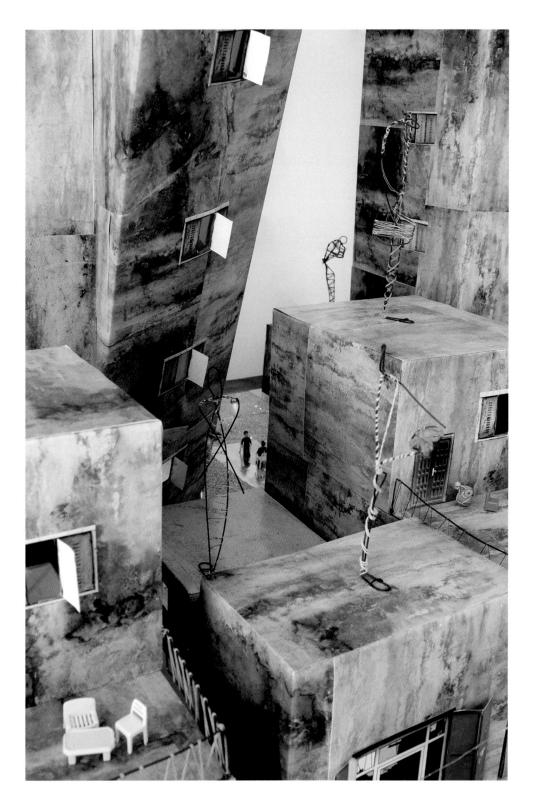

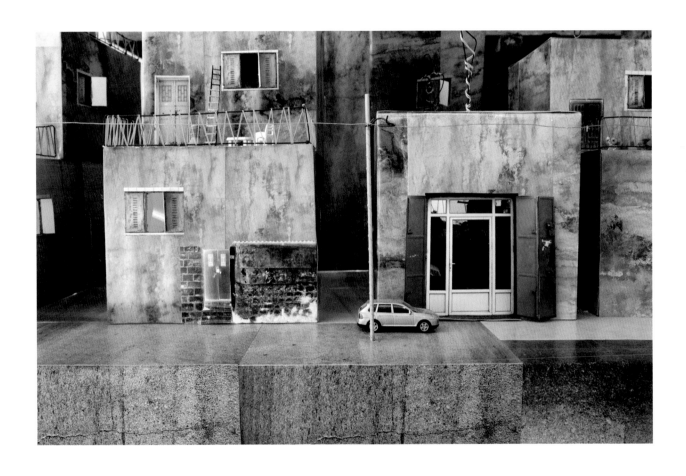

Qalandia 2087, 2009. Mixed media installation
in six parts, sound, 216 × 354 in
(550 × 900 cm). Installation view:
11th Istanbul Biennial

ALI JABRI

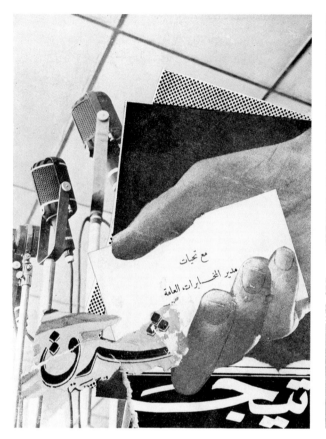

OPPOSITE
[LEFT]
With Compliments, from the "Nasser" series,
ca. 1977-83. Collage, 7 $\frac{7}{8}$ × 5 $\frac{3}{4}$ in
(20 × 14.8 cm)

[RIGHT]
Corps Diplomatique, from the "Nasser" series,
ca. 1977-83. Collage, 7 $\frac{7}{8}$ × 5 $\frac{3}{4}$ in
(20 × 14.8 cm)

ABOVE
[LEFT]
Prayer Call, from the "Nasser" series,
ca. 1977-83. Collage, 7 $\frac{7}{8}$ × 5 $\frac{3}{4}$ in
(20 × 14.8 cm)

[RIGHT]
Midnight Call, from the "Nasser" series,
ca. 1977-83. Collage, 7 $\frac{7}{8}$ × 5 $\frac{3}{4}$ in
(20 × 14.8 cm)

KHALED JARRAR

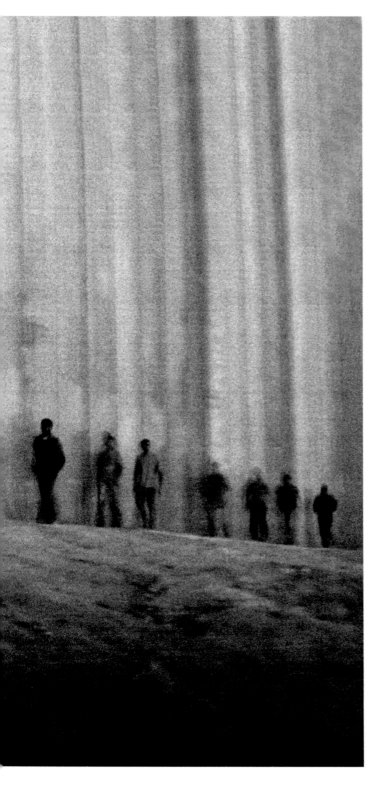

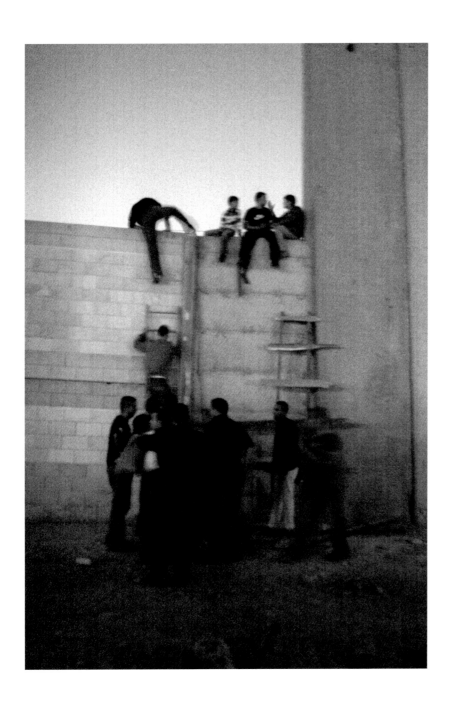

HERE AND ELSEWHERE

Infiltrators, 2012 (stills). Video, color,
sound; 70 min

LAMIA JOREIGE

I could barely follow the events
of the day except for the shelling I'd hear

PREVIOUS SPREAD
LEFT
Drawing/Mazen Kerbaj from *Objects of War Nº 4* (2006), "Objects of War" series, 1999-ongoing. Installation, video, and objects, dimensions variable

RIGHT
Walkman/Rasha Salti from *Objects of War Nº 2* (2003), "Objects of War" series, 1999-ongoing. Installation, video, and objects, dimensions variable

OPPOSITE
Identity Card/Chaza Charafeddine from *Objects of War Nº 2* (2003), "Objects of War" series, 1999-ongoing (still). Installation, video, and objects, dimensions variable; color, sound; 85 min

ABOVE
Mini DV Tape Case/Ghayth El Amine from *Objects of War Nº 4* (2006), "Objects of War" series, 1999-ongoing (still). Installation, video, and objects, dimensions variable; color, sound; 72 min

HIWA K

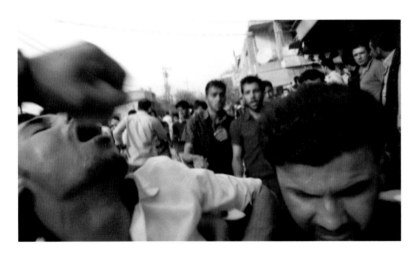

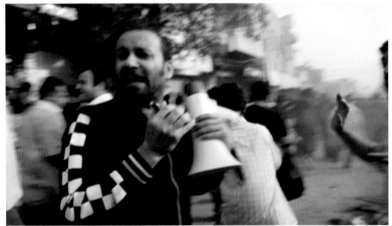

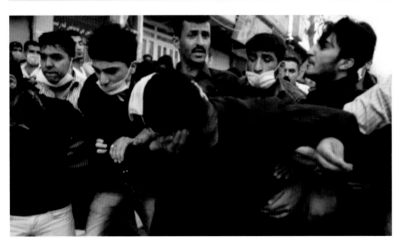

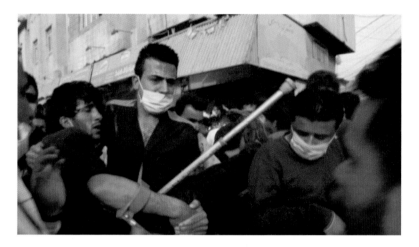

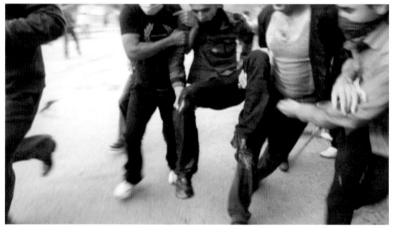

This Lemon Tastes of Apple, 2011 (stills).
Video, color, sound; 13:26 min

HIWA K

AMAL KENAWY

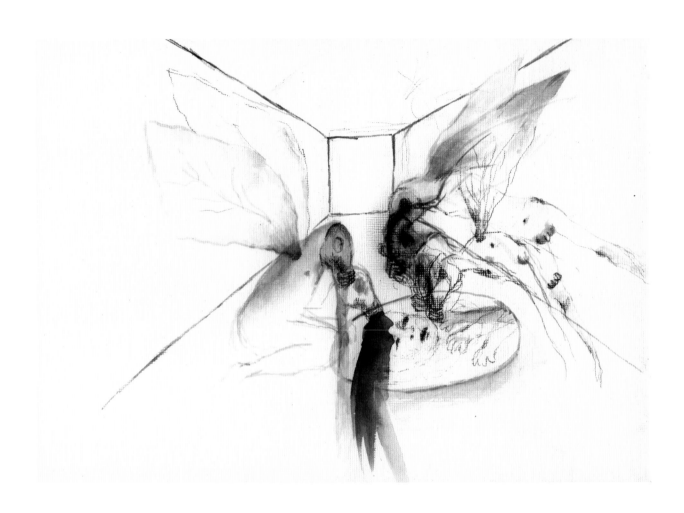

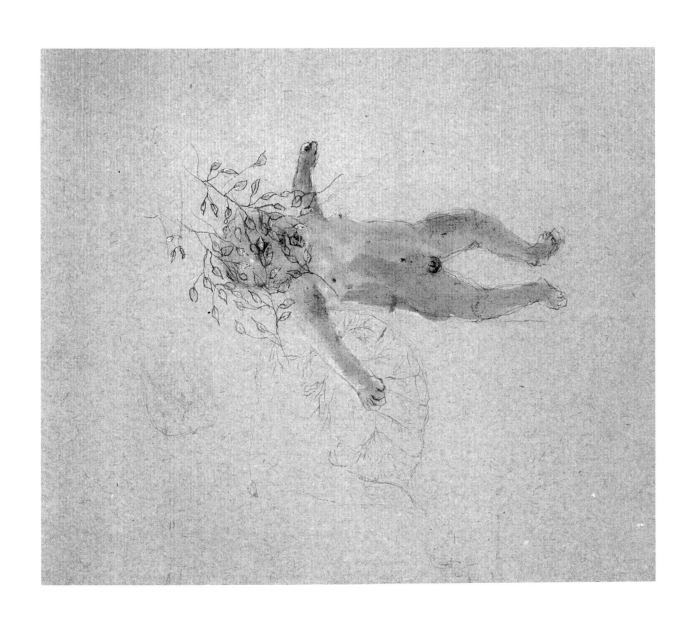

The Purple Artificial Forest, 2005 (stills).
Video, color, sound; 8:50 min

KENAWY

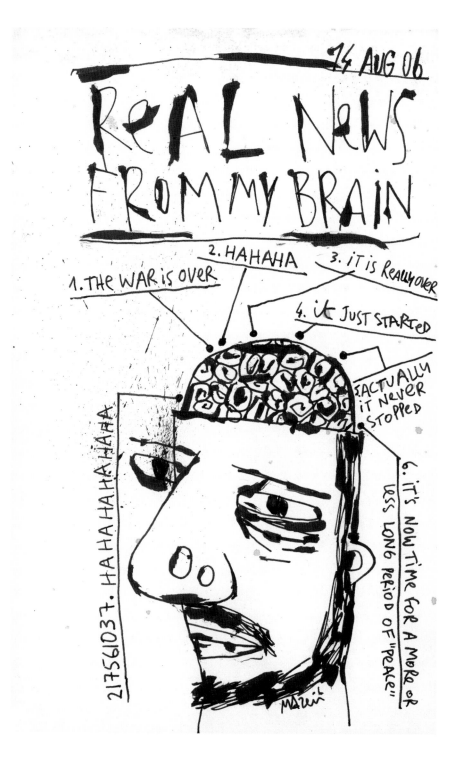

"Beyrouth, juillet-août 2006" [Beirut,
July-August 2006], 2006. Ink on paper,
selection of forty works, 5 $\frac{1}{2}$ × 3 $\frac{1}{2}$ and
8 $\frac{1}{4}$ × 5 $\frac{1}{8}$ in (14 × 9 and 21 × 13 cm) each

BOUCHRA KHALILI

HERE AND ELSEWHERE

Mapping Journey #7, from "The Mapping
Journey Project," 2008-11 (still).
Video, color, sound; 6 min

MAHA MAAMOUN

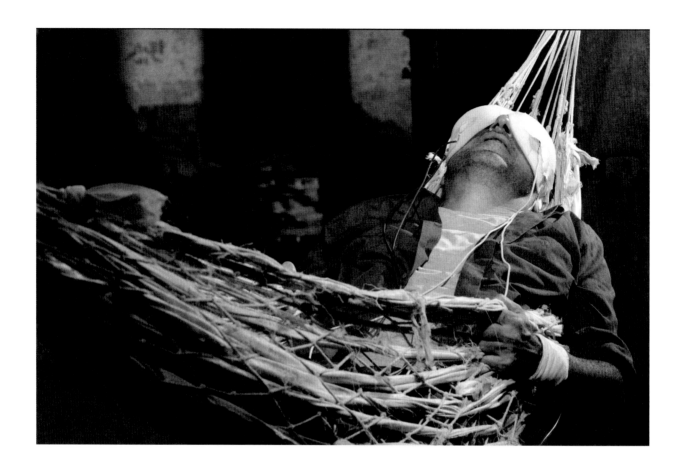

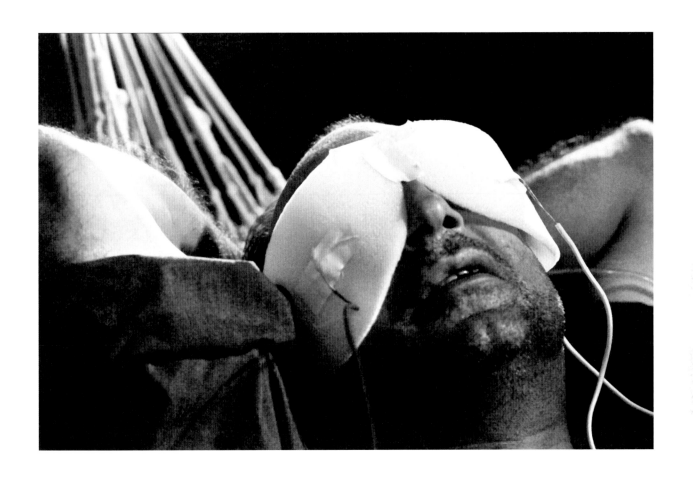

2026, 2010 (stills). Video, black and
white, sound; 9 min

MAAMOUN

HASHEM EL MADANI

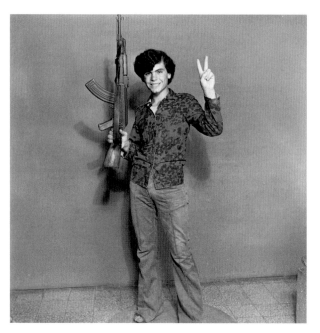

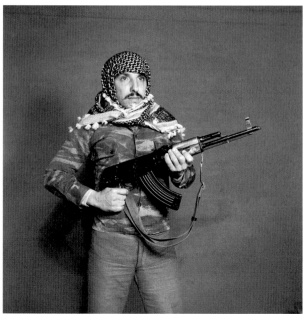

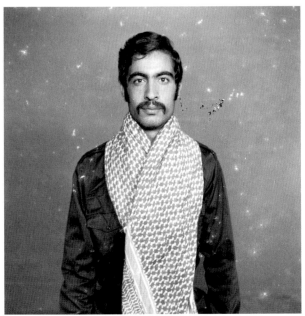
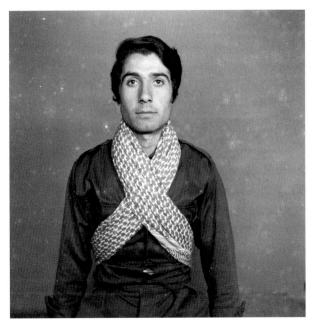

EL MADANI

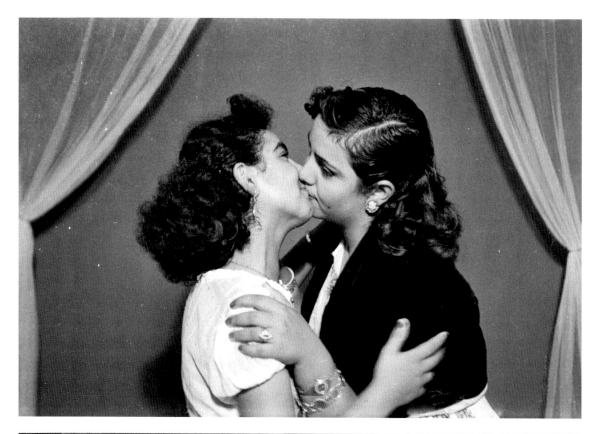

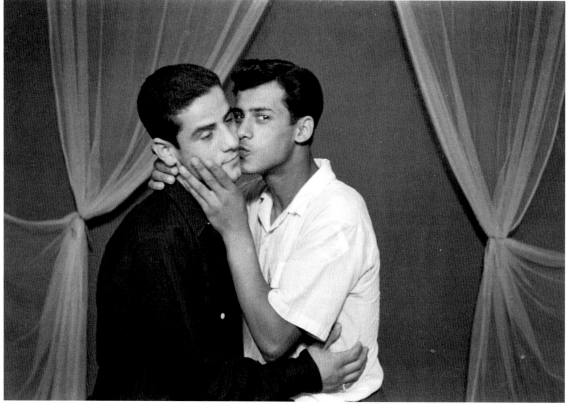

HERE AND ELSEWHERE

PREVIOUS SPREAD
LEFT
Palestinian resistants, Studio Shehrazade,
Saïda, Lebanon, 1970-72. From Akram Zaatari,
"Objects of study/The archive of Shehrazade/
Hashem el Madani/Studio practices," 2006.
Gelatin silver prints, 11 ½ × 11 ½ in
(29 × 29 cm) each

RIGHT
Syrian resistants, Studio Shehrazade, Saïda,
Lebanon, early 1970s. From Akram Zaatari,
"Objects of study/The archive of Shehrazade/
Hashem el Madani/Studio practices," 2006.
Gelatin silver prints, 11 ½ × 11 ½ in
(29 × 29 cm) each

OPPOSITE [TOP]
Bashasha (left) and a friend, Studio
Shehrazade, Saïda, Lebanon, late 1950s.
From Akram Zaatari, "Objects of study/
The archive of Shehrazade/Hashem el Madani/
Studio practices," 2006. Gelatin silver
print, 7 ½ × 11 ½ in (19 × 29 cm)

OPPOSITE [BOTTOM]
Tarho and el Marsi, Studio Shehrazade, Saïda,
Lebanon, early 1958. From Akram Zaatari,
"Objects of study/The archive of Shehrazade/
Hashem el Madani/Studio practices," 2006.
Gelatin silver print, 7 ½ × 11 ½ in
(19 × 29 cm)

ABOVE
Anonymous, Studio Shehrazade, Saïda, Lebanon,
early 1970s. From Akram Zaatari, "Objects
of study/The archive of Shehrazade/Hashem
el Madani/Studio practices," 2006.
Gelatin silver prints, 11 ½ × 11 ½ in
(29 × 29 cm) each

KHAMASEEN

YASMINE EL RASHIDI

There is a period of my life that is marked in my mind by the hot, red, sandy winds that blow through Cairo during the month known as *amsheer*. Slowing down time, they obliterate the sepia city of a skyline and dissolve it into something that, at its most extreme, feels like it might be the apocalypse. I was in the kitchen on one of those afternoons, when it seemed like a vast shadow had cast itself over the house, and when I peered out of the window all I could see was air thick to the point of opacity, like a canvas brushed with the palette of fire. For a moment, there was the sensation of not knowing what might be happening, or even where I was—a disorientation so severe, despite having lived in the house where I stood for the past twenty years. It was a feeling that perhaps spoke to the times.

Those were the years I began to dress differently, cautiously, with a particular attention to modesty. They were years that marked the end of high school for myself and many I knew, and the end of college for others. They were the years when both strange and terrible things seemed to happen. There was the earthquake that struck just after 3 p.m. on October 12, 1992, killing 545, injuring 6,512, and leaving 50,000 people homeless. I was in the living room trembling as the whole house shook, books slid off shelves, and glasses shattered. My brother was on a bus and felt nothing. The year that came after it was sometimes described as "savage," and was marked by successive militant attacks and confrontations—1,106 people were killed over the course of twelve months. There was the massacre of 1994 that left sixty-five people dead, and a series of smaller incidents of shootings and bombings in years before and after. A bomb went off near the downtown campus of my university one afternoon—an attack by militant Islamists on tourists. Our professors, that same day, warned us about exposing our limbs.

The papers carried stories about the arrival of the internet, presidential elections, Bill Clinton, and the Oslo peace accords. These were the

years leading up to and after the first Gulf War, and despite the short life of that conflict, almost everyone I knew was in some way affected. At the time, my father lived on the eastern coast of Saudi Arabia, where US troops were positioned; two Scud missiles just missed the roof of his house. During this time, a few college girls I knew began to spend afternoons at the makeshift street-side café by my campus, defiantly smoking *shisha*. My friends and I watched them wide-eyed and shied away, unaware that in a few years this would be our norm.

It was a period marked by national campaigns promoting economic reform and family planning. We were flooded with words and images about the private sector and a better quality of life. There was little mention of political change, but I heard people murmur that at least the government was offering free birth control. They were also, more tangibly and importantly, the years that defined who I, and others I know, came to be; a generation, you could say. Somewhere wedged into the latter end of those years was a crisp winter evening in 1998, when a group of friends, curly-haired, in jeans, sneakers, and loose-fitting shirts, the uniform Palestinian *keffiyeh* wrapped around each of their necks, made their way to the end of a dirt alleyway in the center of town, at a crossroads best known for its drug-dealers—the kind of place you stayed away from—to the first floor of a three-story building and the opening of Townhouse Gallery for Contemporary Art, one of the first, it was said, in the region. Few of us had heard the term "contemporary art" before, we were still in the time of the "modern."

The years I am thinking of—the '90s—are a fluid set in my mind, with no distinct incident that hinged them onto what was to come. They were the years when we suddenly seemed to have everything—a market flooded with imported goods like Swiss chocolates, Granny Smith apples, Sony gadgets—and yet equally and in tandem, much seemed to be taken away. A friend's father disappeared during these years, and to this day, no one is quite certain why. Absence became conspicuous. The crime pages of local newspapers seemed to grow more dense— perhaps that, or maybe as part of a psychology that was rooting itself, I was just paying closer attention.

Around me, I was beginning to hear of dissent, to see it, to experience it. A first protest, for Palestine. A first silent sit-in. Solidarity with Beirut. An essay I write for the college paper censored and attacked, followed by a death threat. A performance piece described as "blasphemous." My closest friend left for America one day at the end of this period. He packed his bags and told everyone he would be back soon, not sure how soon, but soon. That last night in Cairo, as we sat in his bedroom and I watched him perform the rites of passage that I've witnessed many times since—sifting through drawers and albums,

the stuff of time, memory—he whispered to me that he was never coming home. It was the first I had heard of political asylum. It's been over a decade, and he has returned only once.

To look back at that time is to be reminded of a narrative of history neglected and over-written by a prevailing and more pressing one—marked by words such as "revolution" and "Tahrir"—to which my life, our lives, have been ascribed. My friend left and found himself in California. At first, he wrote home with consistency, every day, a few days a week, a few times a month, until after a year, he stopped writing to us at all.

I took to the streets at some point after that, engaging people in casual conversation that I quickly realized made them fearful. I tried to draw stories out of them about their survival and day-to-day lives—narratives with which I could explain, somehow, through my writing, maybe for myself more than anyone else, what was happening in this city that many described as a colossus collapsing beneath the weight of its own history. "It's like when a person chooses to die," I was told one evening deep in the summer of 2003, sitting at a rustic downtown café, renowned for still serving beer. We, those of us who belonged to Cairo, for whom Cairo was who we were, felt as if we too were part of that slow decay.

During those years, I continued to collect stories. I spent weeks at street shelters for homeless children, trying, by whatever means I could, to get those young ones to trust me and open up. I had a sense that their lives, these fates hurtling toward the same extreme to which the city seemed to be plummeting, might hold some sort of clue. The official figure at the time was one hundred thousand children without homes, but it was whispered in almost the same breath that the number might have been closer to one million. *Or three.* Their cases ranged from being kicked out of homes by parents who couldn't provide for them, to running away on the back of incessant and incestuous beatings, rape, and forced drug-dealing and prostitution. Their stories of torment were plentiful—dozens, hundreds, more, held in dossiers labeled by first names; dates of birth and previous addresses were, without exception, unknown.

It was thought, during the early 2000s, that if you were asking questions, you might be an agent of the state. Skepticism and paranoia were at an all-time high, as high as the stagnation that oppression and poverty had brought. Despite all the talk of privatization and reform, the comparative struggle—as consumerism took root, bureaucracy grew, and the potential for corruption expanded rather than retracted—seemed worse. Many of us, those of us who could, sought to leave, to flee, in search of opportunity in places like the Emirates, flush with

oil wealth and promising Arab youth the lifestyles of the West without the bigotry. Dubai was described as "the Manhattan of the Middle East."

That yearning for another life took me there, to Dubai, and eventually onto the borders of Kuwait, where insurgents were bleeding out of Iraq, filtering into neighboring states, and forming affiliate Al-Qaeda sleeper cells. I had been lurking in chat forums, trying to get an *in*, to understand, to get a sense of what the devastation in Iraq might have meant for the countries beyond. My presence had been observed and noted. One day, a man from one of these groups sent me a message. He sought to register a domain name in Europe, to host an Al-Qaeda affiliate site that would post videos and messages. This man, whose real name I would never know, but who knew enough about me to pique my interest, asked if I could help. It seemed a clear exchange: I would register the domain and he would give me detailed information for a story. The idea, for a fleeting moment, electrified me. Somehow, this act, of serving as a witness in some sideways manner to the aftermath of a war, of being connected to something that was germinating rather than devolving, seemed a more manageable reality, a more hopeful one, than the one I had left behind.

In those years, something was shifting, opening, emerging. The countries of the Gulf seemed intent on repositioning themselves, using their wealth to sculpt and brand new national identities. There was talk of building cosmopolitan capitals to match and surpass London and New York. There was much discussion about culture. At some point during this time, I found myself in Doha, in a warehouse filled with artifacts worth millions on a military site in the middle of the desert, where Qatari soldiers would train each morning, doing jumping jacks and tepid sprints. We were given strict instructions not to stare as we drove past their trailers and training grounds to the end of the plot of barren land where our own bunker stood. There was a certain novelty to the idea of a country making a museum from nothing— "from *within* the culture"—and a sense of excitement, at the time, about what that might mean. There was a reality taking shape, that decade of the oil boom, in the countries of the Gulf—a part of the world that had once been defined and reigned over by my own home city, a Cairo once considered the cultural and political capital of the Middle East—where possibility seemed to have no bounds.

These places that we once looked upon with some disdain, these places our fathers, some of them, had gone to in search of work, places thought to have been void of both history and culture, they now attracted us too. During this decade that came to be marked by 9/11, many of us turned away from looking West and recalibrated our attention, our hopes, eastwards. In that windowless high-security complex in Qatar, a military bunker miles into the desert, a small group of us had been

brought together from around the world to help imagine a future culture, a social fabric for a next generation that would have its own world-class museums. This, the museum for which I had been contracted to help conceive, would be the first.

We each have a history we inherit, a narrative inscribed upon us, our sense of purpose, ideals, ideologies; a blueprint of the geographies around us with their longitudes of politics and latitudes of life's particulars. Circumstance. Even as we turned eastwards, with all its visions of those "cities of the future," and enjoyed what had never before been available to us as artists and writers—the opportunity to support ourselves, to connect globally—we seemed caught up in the contemplation of absence. We had never been taught to think about our lives beyond the present, but rather, always to dwell on what had been.

It was up to us to mitigate, to solve our parents' past, to lift the lull, the lethargy, the sting of their lost wars and failed revolutions. In us, this inheritance seemed to manifest as a listlessness and strange amnesia, and even as it kept us from looking forward, into a future, it also seemed to be the basis of survival in a country like ours—forgetting. It meant, at least, that we were also quick to forget about yesterday's losses.

This amnesia meant that many of us came home again not too long after we left. We lost sight of what it had been that first drove us away, and felt compelled to return to all that was now absent—things that had never been fulfilled, but we longed for nonetheless. I returned to Cairo, to write again. And for some years, I did so from a desk at the end of that alleyway, no longer dirt, no longer a drug sanctum, by then reputed as one of the foremost cultural spaces in the region. Townhouse had become the nucleus of a network that spanned borders, and now took up the entire building and some others next door.

For a short period of time that is hinged, in my mind, to the decade we are in now, a small group of us worked to renegotiate a space, a purpose, a necessity. In many ways, the gallery had grown beyond the city and was caught up in a market that was ever more aggressively defining a cultural topography. How, in the midst of this eastern art boom—which seemed able to buy itself anything and was proving as much (as I had witnessed)—could a small art space, a community center, an organic entity, survive? Did one even need to worry, we wondered, when the city around us, which spilled into this very space where we sat, was being gutted and torn apart each day? When poverty and human rights abuses were so rampant? When expression was stifled often out of the self-censorship that stemmed from fear? What was the meaning even, the purpose, or the value of such a space?

This—the gallery, its alleyways—was the place where a young man was dragged by his hair and beaten, the place where a friend was arrested

for spray-painting a stencil of a street-sweeper on public walls—he was blind-folded and interrogated repeatedly for days. Here was where I heard about the murder of someone I knew, that all of us involved in the arts knew, too, and where a crackdown took place, and where a boy disappeared. This was where a young man told me his story, showed me his scars, drifted off as he spoke of the torture and torment he had faced in an underground jail. Around a few corners and down a street, a friend was repeatedly stabbed and Tasered in his apartment, and left for dead.

It was in that gallery that I sat with a group of friends two summers ago to watch as the election commission counted out and announced the results of a presidential election. It was there, also, that I have had conversations about the subtle and sudden changes in the cityscape, to which we are still adjusting and adapting our lives. Money and opportunity seem to come and go as protests, clashes, and turmoil flare up and disappear again, as political change brings a glimmer of hope and then defeat, attracting institutions, funders, and visitors from abroad, and then scaring them away. Even the sounds of the city are changing; for every distant crackle or bang that, in the past, we ignored or perhaps never heard, we began to ask, in a panic in those first days, weeks, even months of revolution, "Is that gunfire?" Three years later, I now hear those sounds and feel nothing.

The last time I was at those crossroads, some months ago, that red, hot wind known as the *khamaseen* was once again raising itself against the city. A group of us—artists, a curator, a gallery director, a singer— were sitting in the alleyway drinking tea and smoking *shisha* when the first signs of it crept over the skyline. The colors above us changed, a wind picked up out of nowhere, and in a moment unnoticed, the day had turned. Café owners scrambled to gather glasses and cups and put them away as the gusts brought in sands. The shop next door closed and locked its doors, the workshops rammed down their metal garage portals in discordant clamor. In the gallery above, heads and hands appeared at panes and balconies to draw in shutters and wedge old windows shut. The alleyway was in commotion as its populace withdrew, dispersed, and retreated. It seemed, at the time, that the only thing that really mattered was not to let the sands, and the fleeting seasonal winds, carry us away.

THE FUTURE

MARWA ARSANIOS, SIMONE FATTAL, GCC, WAFA HOURANI, MAHA MAAMOUN
MODERATED BY BIDOUN

Six years ago, the writer and filmmaker Sophia al-Maria began working on an idea she referred to as Gulf Futurism. The idea grew into a performance, followed by an essay, for which Maria dressed up in the guise of a character named Sci-Fi Wahabi, and then led an uproarious, otherworldly tour around the sales halls of Art Dubai. Sci-Fi Wahabi has returned periodically in the years since then as a hologram. Gulf Futurism, in the meantime, has assumed a life of its own. Like, say, the Italian Futurists and Afrofuturism before it, Gulf Futurism's greatest asset—as a concept, it is quick and cute and perfectly timed—may also be its primary weakness. But perhaps what matters most are the ways in which it points to a combination of willful dissatisfaction, impatience, frustration, and rebellion when it comes to the relationship between representation and contemporary art. Gulf Futurism also gives a certain cover for brash as well as tender utopian ideas, and seems to give artists the time and space to make substantial shifts in their practice. In the following conversation, four artists and a collective of eight discuss their various approaches to imagination, invention, and projection, using the future as a formal and conceptual device for changing the terms of how their work—as well as their sense of place and their image of themselves—is experienced and understood.

—*Bidoun*

BIDOUN For a long time, artists in the Arab world seemed to be obsessed with archives and documents. Much of the work coming out of the region involved reworking narratives of the past, engaging with episodes in history and memory, and revising the stories that artists had grown up with and seemed doomed to repeat. Then something shifted, and it seemed as though a number of artists moved very deliberately from thinking about the past to working on the future. All of you have played some part in orchestrating that shift, which appears to be both symptomatic and strategic. How and why do you see yourselves working with the future as a concept, a trope, or an alibi?

MARWA ARSANIOS It is difficult for me to conceive of a regional interest. I think these questions are very particular to Beirut, which is not to say that there is any one scene in Beirut. What I mean is that they are particular to the contemporary art production that began in Beirut in the 1990s. Maybe it was the ghost of the war that pushed these questions forward, but I think it was also the combination of postcolonial studies and the beginning of a global art economy that allowed these discourses and questions to find a place beyond the small locality of the city. The turn toward the past is almost a linguistic turn. You take on the languages of older ideologies in order to erase them from your own present, or perhaps to reuse them. It is actually a

turn toward the present, I would say, in order to liberate the past, and to foresee the possibility of a future.

It is also a strategic turn in the political sense. When it is too difficult to directly act on your present day-to-day, you attack the past and project into the future. At least this is how it worked for me. It was necessary to work with subjects that demanded historical research. It was an important step, especially in the projects I did between 2007 and 2011, like the video animations *I've Heard Stories 1* (2008) and *I've Heard 3 Stories* (2009) and the mixed-media installation *All About Acapulco* (2010)—works that dealt with long-forgotten scandals that took place in a famous hotel (which was also a modernist icon and has since been torn down) and a beach resort that was occupied by refugees decades ago. It was a way to find a position for myself, and at the same time, to challenge that position, to embody different positions, different voices, different characters and histories, and so on. So perhaps it was a way to forget about the self, or simply to forget, and project.

B On the surface of things, you share several concerns with artists in the Arab world and, more specifically, in Beirut who have been working not only with documents and archives, but also with modernist architectural monuments. And yet you deal with the material in a way that isn't reflective or mournful, but rather imaginative and

provocative. Does that, in and of itself, signify a shift from using older material as a means of interrogating how history has been written to using that same material as a way of proposing a plan for the future?

MA Yes, and perhaps also to embody the different histories and to wear them in the here and now, in order to take hold of them or control how they are shaping the future. In most of my works, past, present, and future collide in a single moment, or they come together in the same frame, scene, narrative, or character. This is also a political position, in relation to a modernist project that conceived of time in a much more linear manner and also imposed a dominant idea of time, masculine time. These were the grand narratives of progress, but they also represented an exclusive temporality conceived of by the modernizing elite, for the modernizing elite. What happened to this project? We see material traces of it in architectural objects, how it was planned, how it is inhabited now. But how can we think of a potential proposal for a housing project—the subject of "After Doxiadis" (2013-present), an ongoing project based on the drawings of the Greek urban planner Constantinos Doxiadis, who, in the 1950s, was invited by the Lebanese government to devise a nationwide plan for affordable social housing—in a city that is being ravaged by the wild economy of private real estate development? To go back to the

question of the future—for me, the most interesting writers, such as the philosopher and theorist Rosi Braidotti, are not only thinking of futurity in a feminist manner. The very idea of the future becomes feminist, and feminism becomes intrinsically related to the potential for accomplishment in the future.

B Maha, your nine-minute video *2026* (2010), which is based on both Chris Marker's film *La Jetée* (1962) and the Egyptian writer Mahmoud Uthman's novel *The Revolution of 2053: The Beginning* (2007), portrays a man—a troubled time traveler of some sort—in a hammock as he narrates a vision of the Pyramids and the Sphinx. He dreams of an enchanted evening, and of surveying a lush, green landscape. But, as he begins describing some of the fanciful architectural details before him, his vision begins to darken into something more authoritarian and apocalyptic, where everything orderly is revealed to be a simulation hiding abject poverty and a terrifying surveillance regime. As such, the video seems to hinge as much on a vision of the future as it does on the ambiguity between imagination and madness. What is the significance of this seemingly pristine image gradually breaking down into more familiar fragments of paranoia, destitution, and fear?

MAHA MAAMOUN Well, the protagonist of *2026*, as portrayed in *The Revolution of 2053: The Beginning*, is sort of a mad

scientist, a dreamer, a believer in change, or a visionary—depending on where you stand as a reader. But I think *2026* is ambiguous in the sense that it's not clear whether that vision of the future is imaginative or not. It is also not clear where I stand, as the author of this video, in relation to the narrative presented. In terms of science fiction, it is actually almost entirely literal in its depiction of the present, in terms of economic and political realities, as well as in terms of how it articulates the problems of the present.

Later, when I spoke to Mahmoud Uthman, he told me, in effect, that he was writing about the present under the guise of the future. So on the one hand, the novel fails as a feat of imagination trying to articulate something beyond the exhausted language of the present. On the other hand, it details the multiple and pervasive levels of real corruption that plague Egypt, which will lead, in the novel, to a revolution in 2053. The book was written in 2007, and was followed by a revolution in 2011. When I was making *2026*, I was curious to see how the narrative would be received. Who would dismiss it as a failure of imagination or as weak literature, and who would appreciate it for that, for the present reality toward which it is pointing? In any case, you can see *2026* as a trap, where the future is promised, but then you look and realize it's the same old past.

Coming back to the question of archives, you could say that

the protagonists of *La Jetée* and *The Revolution of 2053* are both faced with a destitute present, which they try to undo by entering time, as a dimension, and by accessing an archive or a reservoir of images from the past and the future. So, digging into the image archive, in the form of visions from the past and future, is actually a way of saving the present and the future.

B Wafa, you've also played with projections of the future, imagining a very specific place—the Qalandia military checkpoint and refugee camp in the West Bank—in the years 2047, 2067, and 2087, which correspond to one hundred years after the loss of Palestine, the Six-Day War, and the first intifada. The "Qalandia" series consists of three incredibly intricate large-scale architectural models. As someone who also writes science fiction and deals with visions of the future in the form of stories and texts, what first prompted you to make these works as sculptures, which appear almost like dioramas?

WAFA HOURANI The "Qalandia" project began in 2004, when I lost my brother Hasan and my nephew Samer. They were both artists. They drowned in the sea off of Jaffa in the summer of 2003. After that, I quit filmmaking and moved into sculpture, poetry, and science fiction. "Qalandia" combines sculpture, photography, and several sound elements that are

embedded within the models. It also includes five live goldfish and a few tiny trees. What led me to imagine the future of Palestine was the reality of how limited our vision of the future is, given the social and political complexity of everyday life in Palestine now. It's definitely a way of critiquing the politics of the present. "Qalandia" is a vision of the future as a walk-through model, a scene full of imaginary layers, with light activating the potential of archival material and darkness questioning the lack of awareness on the part of the Palestinians, as well as the lack of strategy that has led us into wars in the name of religion instead of revolting on behalf of human rights. This projection of the future comes from a lifetime of experiences in Palestine, and several life-changing encounters with the Israeli occupation. Those experiences and encounters led me to have no faith in political parties, which are constantly failing. "Qalandia" predicts the arrival of a new political party, the Mirror Party, which appears in Palestine at some point in the future.

B Centering on a camp established in 1949, which was once the site of Jerusalem's airport and now houses some ten thousand people, your models feature miniatures of three settlements, the airport, and a border crossing, and are replete with light boxes and filmstrips. How is the idea of a new political party expressed in the architecture of these models?

WH There's a mirror on the wall in "Qalandia" that is meant to serve as motivation, so people take responsibility for themselves and for Palestine. The idea is that Palestine's current political parties will disappear as people look at themselves in the mirror and realize the danger they face—given the violence of the resistance and its lack of tactical action—as well as the desire they have to live in peace and dignity.

B Simone, your engagement with the future comes from a different place and time. Just over thirty years ago in California, you named your avant-garde publishing house Post-Apollo Press, after the Apollo space program, in a moment of genuine optimism about the future. Does that optimism persist?

SIMONE FATTAL Yes, naming the press Post-Apollo resulted from a great hope that a new era of discovery, and the expansion of the universe, would lead to a new mentality and a renewal of energy and love for the world. This feeling still exists, and space programs are still ongoing. Just the other day, I read that telescopes have now enabled scientists to see a planet that resembles the earth and turns around another sun. It's similar to ours, yet this planet is five hundred light years away. Of course, we can't go there, but to think that it is out there somewhere.... So space exploration continues. The general public talks about it

less—although I did once meet some young people in California who were convinced that they were going to live on Mars and were preparing for it—but it is still a source of endless joy and excitement for me. It is bewildering and opens the imagination to stories and images, like reading about Sinbad sailing away on his boat. But like all discoveries, space exploration has a downside. The planet is being neglected and mistreated as if humankind has already left it, and this is unbearable.

B Is that one of the reasons why your sculptures—of Gilgamesh and Astarte, for example, as well as of ancient warriors, bulls, and centaurs—turn to the myths and legends of a very distant past?

SF I don't turn to the past because I think it was a better time. I turn to the past because I think it is our eternal present. Our memory and culture coexist with what is being done and thought today. I don't see any gap between them. I live in both of these worlds at once. The fact that my sculptures seem to come from an ancient time and look archaic, archeological—this came as a surprise to me. I didn't intend for them to look this way. I was a painter before, and my paintings were abstract, very much on the edge. I remember working in my studio in Beirut and then seeing a small exhibition of Agnes Martin's work in New York, and I remember feeling that I was on the right track, painting white

on white. But when I started working with clay, it opened up another world, a world of archetypes and heroes. I actually started with Adam, who, in the mystical Islamic tradition, is a very tall and dashing guy. Eve followed, of course, but she was much smaller, ridden with mud and the weight of her suffering. I did those figures in bronze. They informed the figures that followed. I read a lot of history, a lot of archeology and mysticism. My reading is very important to my work. I was amazed myself when I made all of these tall figures, which were a cross between archetypes and the men who fought our incessant wars, gave a good fight, and are still standing—like witnesses for the future. It is also true that I am inhabited by these figures of archeology. Sometimes in a museum, I see a piece from 3000 BC and I feel a pang—I feel like I have made it myself, and I see no contradiction there.

B A project like the GCC, a collective or delegation of eight artists—Nanu al-Hamad, Khalid al-Gharaballi, Abdullah al-Mutairi, Fatima al-Qadiri, Monira al-Qadiri, Aziz al-Qatami, Barrak Alzaid, and Amal Khalaf—named after the Gulf Cooperation Council, seems almost entirely predicated on using notions of the future, in general, and Gulf Futurism, in particular, as both a sensibility and a strategy. If that's the case, what is the future of the GCC itself, as a project, as a body of work, as a group of friends and colleagues?

GCC The future was one reference point we kept returning to while producing a series of shows over the past year, culminating in a retrospective called "GCC: Achievements in Retrospective." In that exhibition, we intentionally adopted the format of a retrospective as a broad, in-depth survey of an artist's work by showing artifacts that are full of promise, but void of any material outcome: self-congratulatory trophies, the promo video *CO-OP* (2014), and even an endless ribbon-cutting ceremony on the world's largest handmade boat. This boat, located in Kuwait, is interesting because it was an achievement that was realized, and is still relevant today. However, the boat itself is an artifact of a past heritage of trade and pearl diving. The 360-degree pan across members of our collective holding this ribbon, but never cutting it, serves as a counterpoint to our other works, which are highly glossy, but refrain from actually materializing into anything. There is an opposition between this low-resolution, seemingly degraded video and the smooth, perfect images that abound in our work. The low resolution associates it with poor images, low in hierarchy and importance, whereas the super hi-res, hi-definition *CO-OP* video, which imagines future unrealized goals with a great deal of rhetoric, has a different kind of seductive magic. But talking about the future, or our future, isn't really relevant. The works we make collapse time into a finite

encounter. More than any particular tense, we're interested in the liminal states existing in between categories—spaces that aren't easily traced back to a specific concrete root. Work and leisure as counterpoints are an example of a blurry space we've looked into for our first cycle of shows. We do not seek to portray a time period or time periods, but to expose those things that are ever present, never ending, or never beginning.

B There's a great detail in your story, which is that the GCC was born in the VIP lounge of Art Dubai. What has that meant for the style and substance of your work? And how, as a group, do you choose the forms that you explore, embody, parody, and critique, such as the summit, tools of diplomacy, or advertising imagery?

GCC Corporate aesthetics and rituals can be conflated with arms deals and intergovernmental relations. Summits like Davos or the G8 Summit capture diplomacy as a vacation event. The resort and leisure aspect of Art Dubai features an absence of labor and the performance of work, but there are very serious deals being made over glasses of champagne. Spaces like Art Dubai don't hide the relationship between art and commerce and global exchange. Artists, curators, galleries, and arts organizations—as well, at times, as the artworks themselves—become signifiers and ambassadors of global, political, and economic power plays.

Government bodies and ministries of culture are named alongside banks and real estate developers, oil companies, and other corporations as headline sponsors of art fairs and museums worldwide: Tate, British Petroleum, Art Dubai, Jumeirah, Abraaj.... Our work uses the aesthetics of governmental bodies and global diplomacy to explore the way labor and business are performed in the Gulf. We excavate objects, rituals, and moods from a visual language that we find in our surroundings. But very often, these things have been normalized to a point that people don't give them a second look. We have decided to really contemplate them.

B How does the form of the regional or geographic group show at a contemporary art museum fit into that vocabulary of forms you're contemplating?

GCC It is important to engage with current, ongoing conversations in art emerging out of the GCC and the Arab world as a whole. This is the context in which much of our work is produced. Our work can definitely transcend its geographic context. There is a kind of universality to the topics we address, which is visible in the rituals and aesthetics of governments and businesses everywhere. Though our work focuses on the particular rituals and aesthetics we see in our region, the sentiment is global. But we are Arab after all. It is imperative to be engaged with this context and not perform the role of

native dis-informers, detached from our roots.

B Speaking of geographically specific material that has universal appeal, Marwa, many of your works involve the stories of forgotten or misunderstood women—from the cabaret dancer who disappears from a nightclub in *I've Heard 3 Stories* to Jamila Bouhired, the famous Algerian fighter who was portrayed in Gillo Pontecorvo's 1966 film *The Battle of Algiers* and formed the basis of your performance and video *Have You Ever Killed a Bear? Or Becoming Jamila* (2013-14). What draws you to these women and interests you in their stories? It doesn't seem as though you are reviving them to celebrate the achievements or lament the failures of feminism in the past, but rather to give feminism some power and visibility in the present.

MA Yes, I am not interested in these women because they are women. I am interested in them because the dancer, for example, was an unseen political subject. I am interested in how they became heroines, like Jamila, serving certain political agendas, and how they stopped. Here, too, I needed to look to a certain feminist legacy because I wanted to put the question of feminism today on the table, in a blunt manner, as a strategy to rethink politics in general, not only gender politics. This is definitely my main interest. I think the liberal legacy of the 1990s, when a certain economic prosperity made us believe

that gender equality had been somehow achieved, is not feasible anymore. Especially after the uprisings in the Arab world, and women's marginalization from the streets, but also beyond the binary divisions of man and woman and the intrinsic questions of equality in relation to the state and citizenship, I think that feminist discourse is the most dynamic in terms of what it encompasses and how it is being rethought, in a very active manner, by postcolonial feminists, cyber feminists, etc.

B Formally speaking, in the last few years you've also moved from making video animations to working with live actresses in performance and film. What prompted this change in your practice?

MA I didn't want animation to become just a stylistic gesture, so I wanted to try something else. Two years ago, I started thinking about performance as a way to bring in the body. And *Have You Ever Killed a Bear? Or Becoming Jamila* grew out of a performance, so I needed an actress to be present and to perform. But I am still very interested in dance, and animation was a good way to deconstruct movement and understand it. Perhaps I will go back to animation one day, when I need it.

B Simone, you started to make the film *Autoportrait* (1971/2012) four decades ago. After seeing an exhibition of artists' self-portraits, you decided to make one of and for yourself, using video

as a means to question your childhood in Damascus and your time as a painter in Beirut. Has it been strange for you to see that footage again, shown as a complete film in festivals and exhibitions, and suddenly embraced by the art world? Did you ever imagine then that it would be in circulation now?

SF At first, it was unbearable for me to see the film. Don't forget that the raw, unedited footage of that film had been dormant in my drawers for forty years. I could not see these images or hear my voice. But I let myself be convinced by the enthusiasm of the editor, Eugénie Paultre, who did a wonderful job. She worked with so much respect and discretion. Even then, I didn't want the film to be released. But it finally existed, so I let it go in the world. Now I accept it, but I still don't really look at it. On one hand, it's strange that it's become part of the art world, but on the other hand, that was my original intention. I saw younger artists presenting photographic self-portraits and I said to myself, why not film?

B Maha, you've also moved from photography to video and started working seriously with sound along the way. You have also mentioned that you've become bored with talking about the future as a trope or an entry point for looking and thinking about your work. What keeps you going, then, as you move from one medium to another

and avoid getting stuck in any one idea?

MM My move from working primarily with photography to video brought sound with it by default, without thinking. But moving back to photography from there made me more aware of the value of sound, and stillness, in my work. What developed later in a number of works was an interest in listeners and listening, rather than in sound per se. The first project through which I thought about this was for a series of books called "Manual for Treason," commissioned by Rasha Salti and Haig Aivazian for the Sharjah Biennial in 2011. The manual I worked on with the Egyptian writer Haytham el-Wardany was called *The Middle Ear*. We moved from rhetoric to the relationship between speakers and listeners and wondered, who engenders whom? Do listeners create their speakers? Or do speakers create their listeners? I picked up that thread again, later on, for the video *Shooting Stars Remind Me of Eavesdroppers* (2013). I start the video with a reference to an image, which is actually an image from the Qur'an, in which poets and their eavesdropping muses are differentiated from prophets, who receive direct, divine inspiration. I use this as a fleeting rhetorical entry point to a casual conversation between a couple in a park, a conversation that swings between formal figures of speech and flirtation, and that lightly evokes, albeit in a different context, the image or question

of eavesdropping's proximity to truth, poetry, and transgression. Which, incidentally, is a relevant question today.

MARWAN

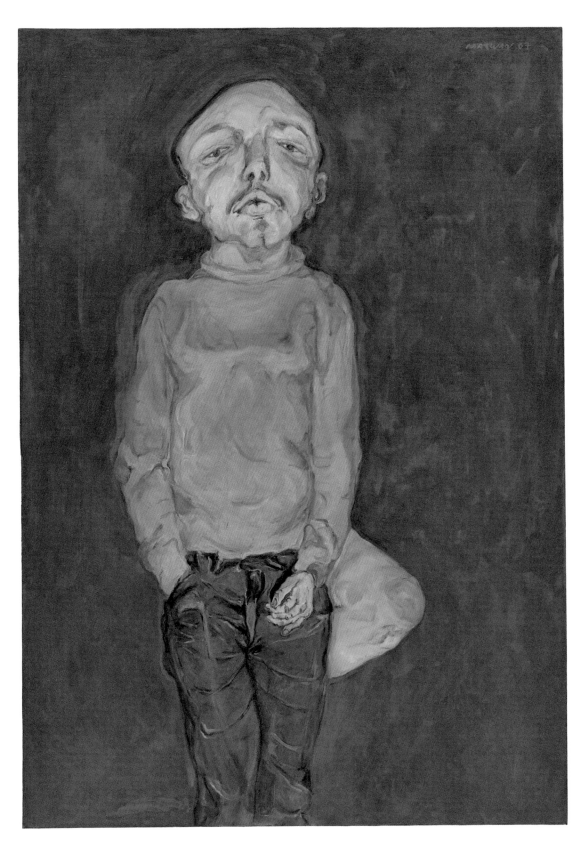

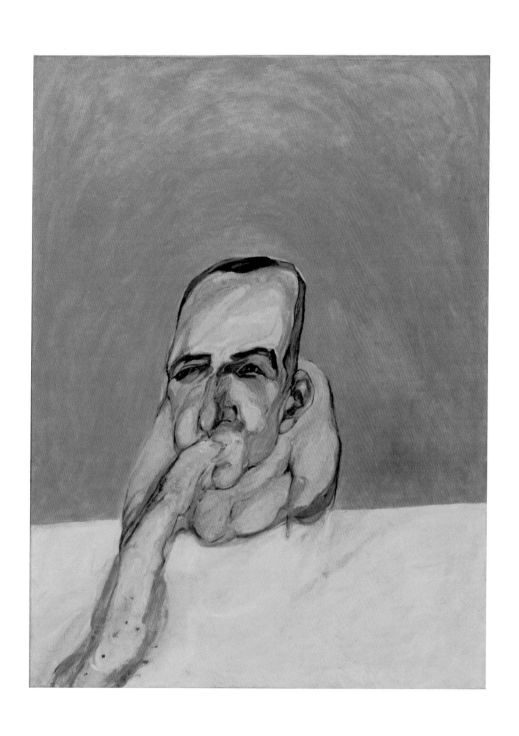

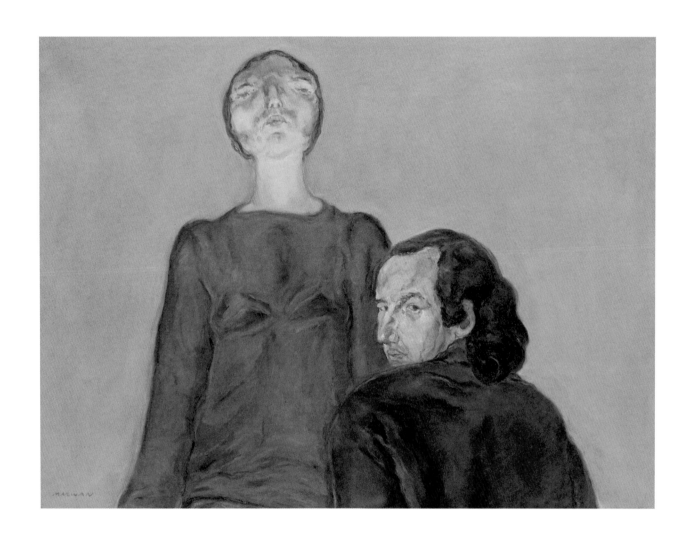

PREVIOUS SPREAD
LEFT
Das Knie [The Knee], 1967. Oil on canvas,
63 ¾ × 44 ⅞ in (162 × 114 cm)

RIGHT
Mann am Tisch I [Man at the Table I], 1966.
Oil on canvas, 51 ⅛ × 38 ¼ in (130 × 97 cm)

OPPOSITE
Khaddouch II, 1966. Oil on canvas,
51 ¼ × 35 in (130 × 89 cm)

ABOVE
Untitled, 1969-71. Oil on canvas,
37 ¾ × 51 ⅛ in (96 × 130 cm)

AHMED MATER

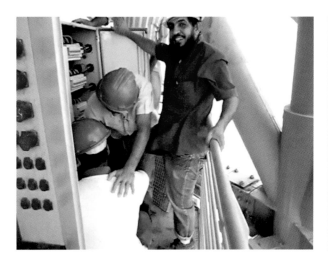 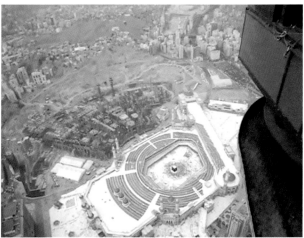

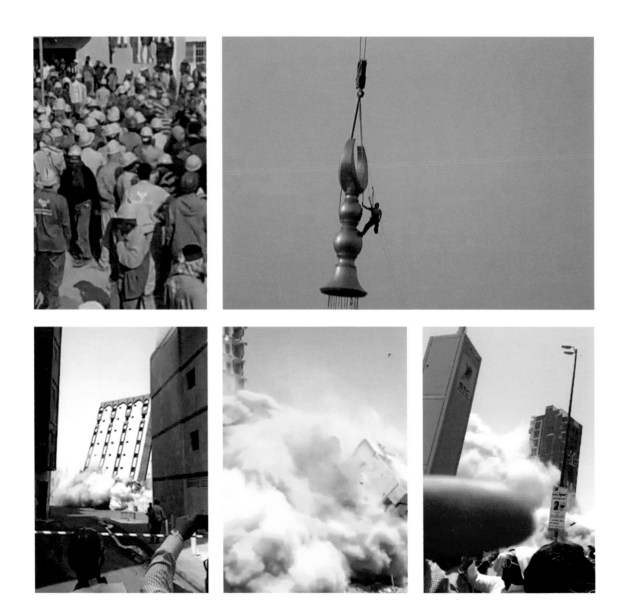

Leaves Fall in All Seasons, 2013 (stills).
Video, color, sound; 35:20 min

ABDUL HAY MOSALLAM

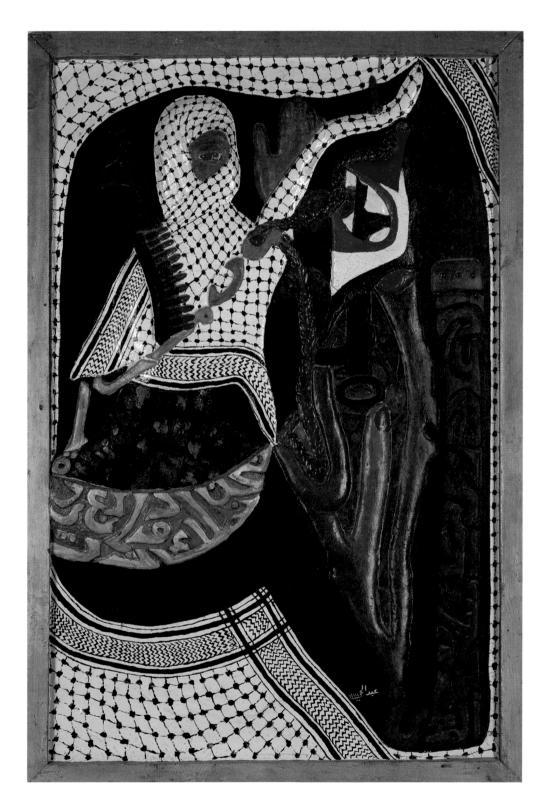

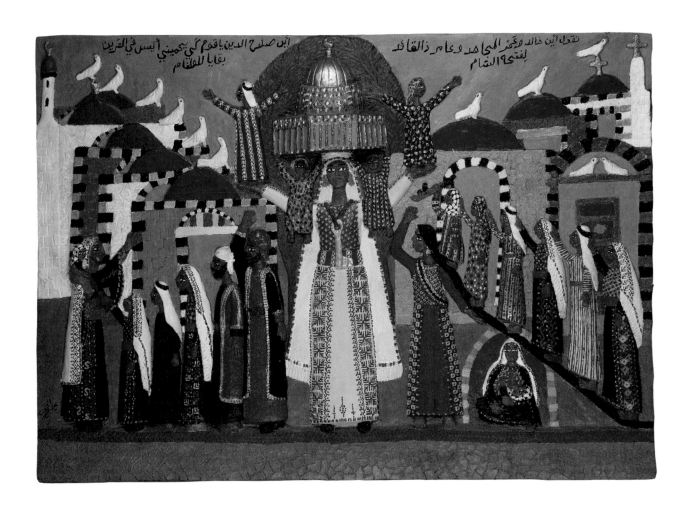

The Martyr Dalal Mughrabi, 1978.
Acrylic on sawdust and glue, 42 ¼ × 29 ½ in
(110 × 75 cm)

Jerusalem Calling, 2008. Acrylic on sawdust
and glue, 32 ½ × 47 ¼ in (83 × 120 cm)

SELMA AND SOFIANE OUISSI

Laaroussa, 2011. Performance documentation

OUISSI

JAMAL PENJWENY

"Saddam is Here," 2010. Chromogenic prints,
23 $\frac{5}{8}$ × 31 $\frac{1}{2}$ in (60 × 80 cm) each

MOHAMED LARBI RAHALI

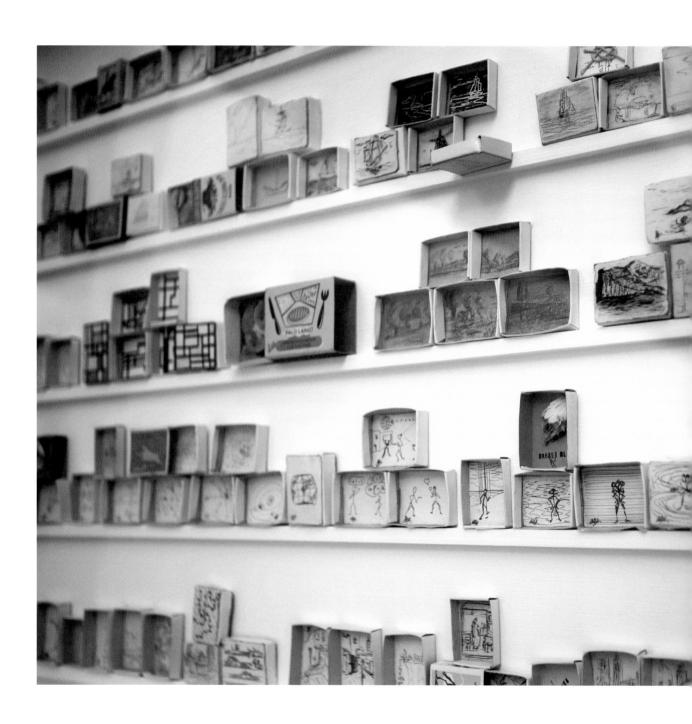

Omri [My Life], 1984-ongoing. Mixed mediums
on match boxes, dimensions variable

RAHAL I

MARWAN RECHMAOUI

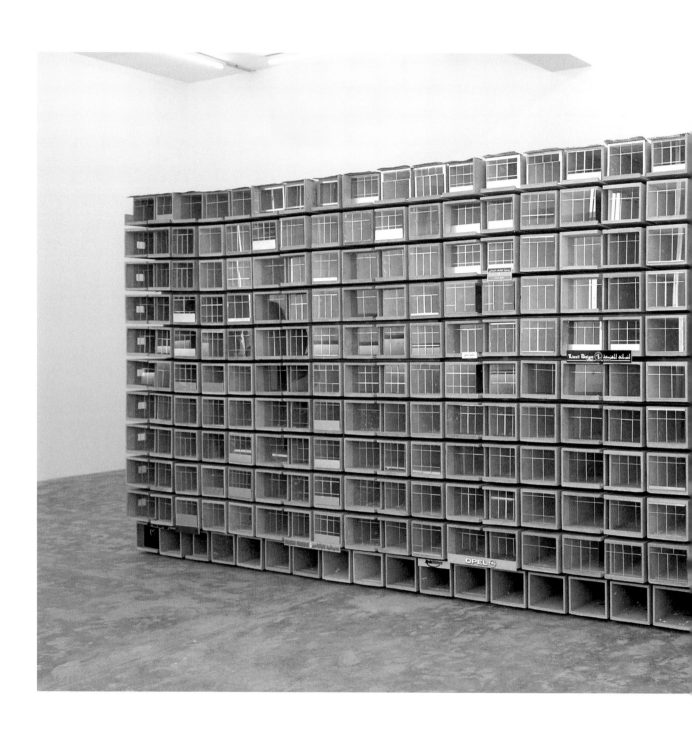

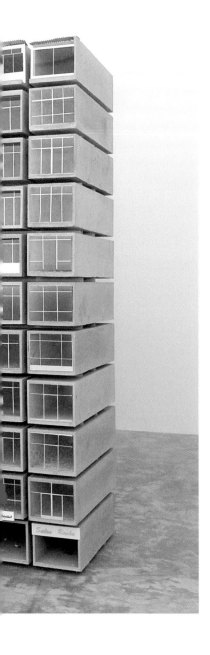

Spectre (The Yacoubian Building, Beirut),
2006-08. Non-shrinking grout, aluminum,
glass, fabric, 88 $\frac{1}{2}$ × 165 $\frac{1}{2}$ × 31 $\frac{1}{2}$ in
(225 × 420 × 80 cm)

ABDULLAH AL SAADI

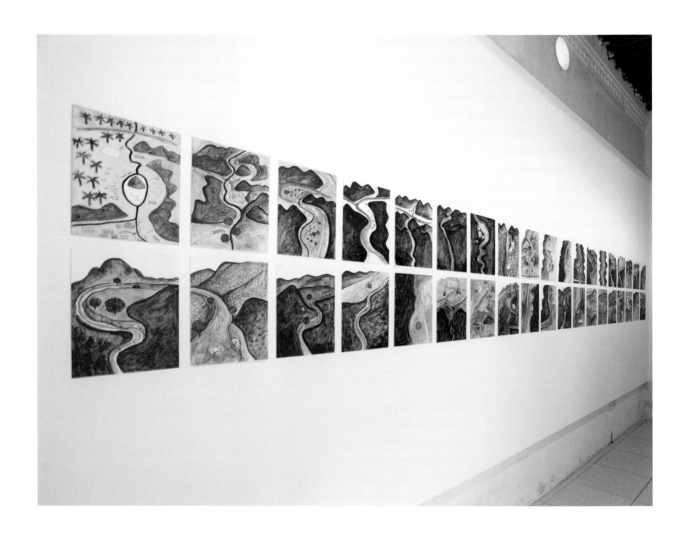

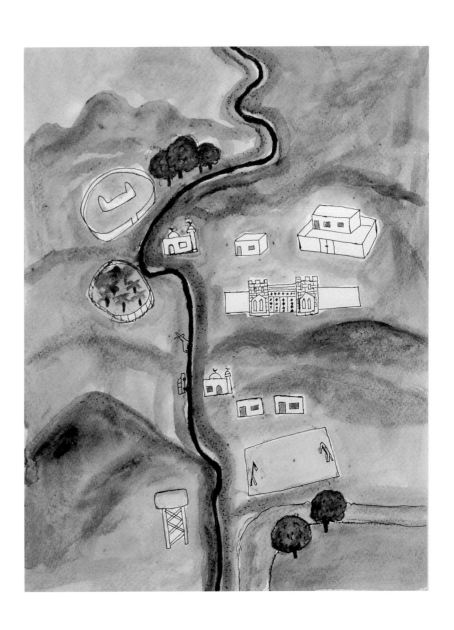

Camar Cande's Journey, 2010–11.
151 watercolor paintings, video, color,
sound, 59:41 min, overall dimensions
variable. Installation view: "Abdullah Al
Saadi: Al-Toubay," Sharjah Art Foundation,
2014

HRAIR SARKISSIAN

"Execution Squares," 2008. Archival inkjet
prints, 23 ¾ × 30 ½ in (60.5 × 77.4 cm) each

SARKISSIAN

HASSAN SHARIF

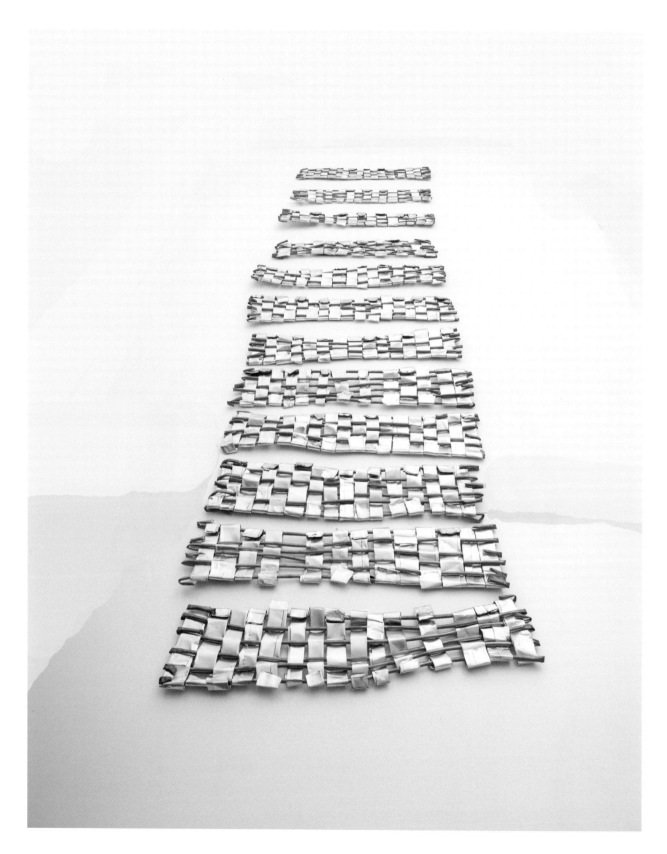

HERE AND ELSEWHERE

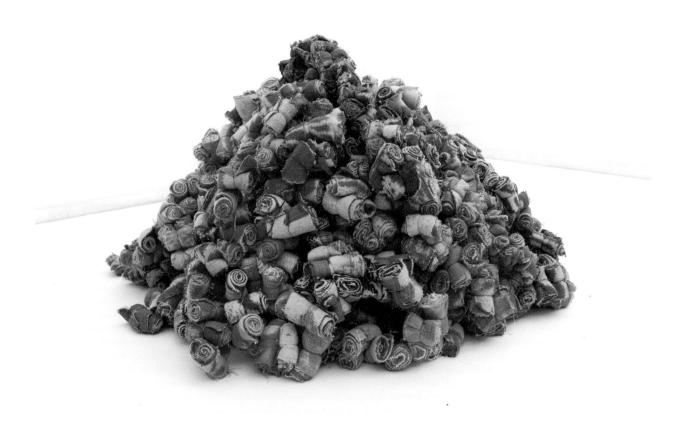

PREVIOUS SPREAD
LEFT
Palm, 1995. Palm tree leaves, dimensions variable

RIGHT
Cotton Rope No. 12, 2012. Cotton rope, rubber, and aluminum foil, dimensions variable

OPPOSITE
Dehydrated Copper, 2008. Aluminum and copper, group of twelve works, 4 × 37 $\frac{3}{8}$ × 8 $\frac{5}{8}$ in (10 × 100 × 22 cm) each

ABOVE
Blanket and Wire, 1995. Blanket and wire, dimensions variable

WAEL SHAWKY

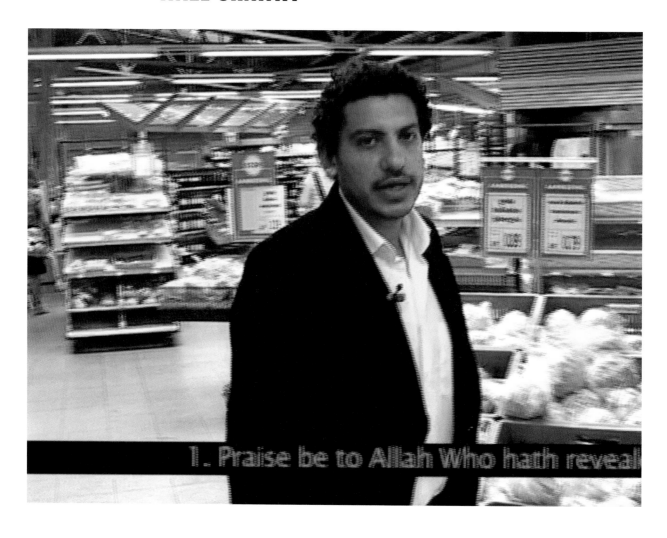

1. Praise be to Allah Who hath reveal

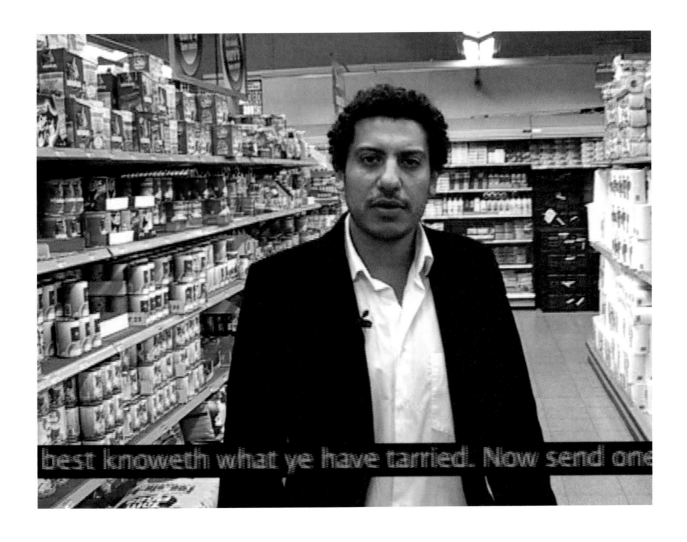

The Cave (Amsterdam), 2005 (stills). Video,
color, sound; 12:45 min

SHAWKY

MOUNIRA AL SOLH

The car was not very big, but it was heavily loaded

This is how the family of the pregnant writer

Beer was also rare,

And thus, the agony of the other becomes banal.

Now Eat My Script, 2014 (stills).
Video, color, sound; 24:50 min

AL SOLH

SUHA TRABOULSI

OPPOSITE
IJsbrand, 1949. Ink on paper, 8 ½ × 11 in
(21.5 × 28 cm)

ABOVE
Leila, 1949. Ink on paper, 8 ½ × 11 in
(21.5 × 28 cm)

TRABOULSI

VAN LEO

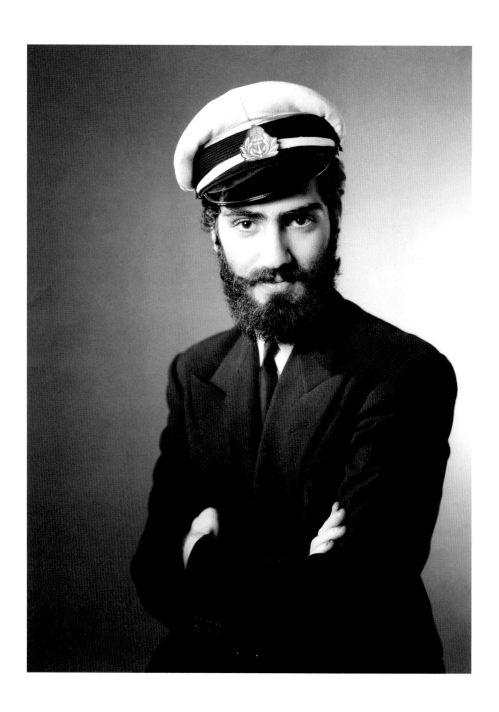

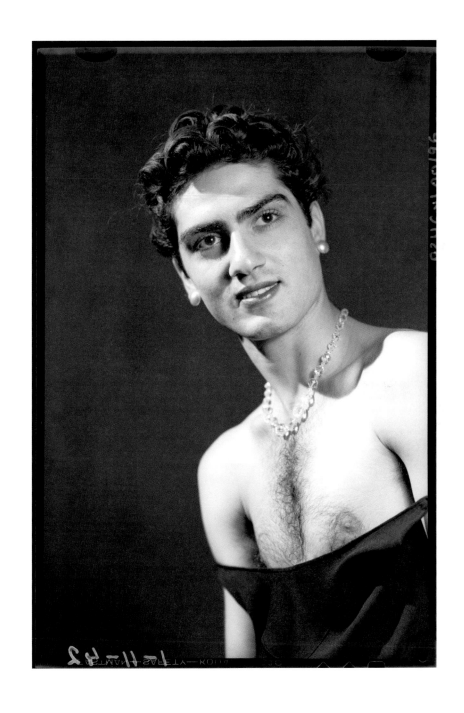

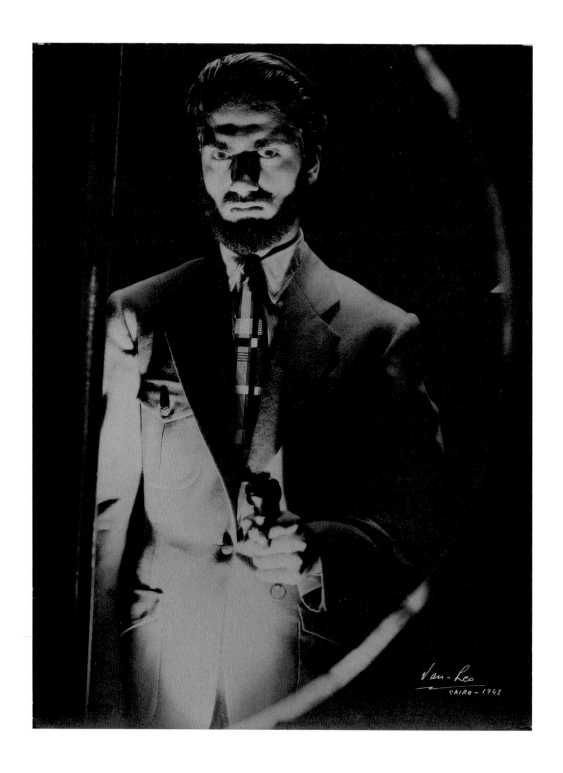

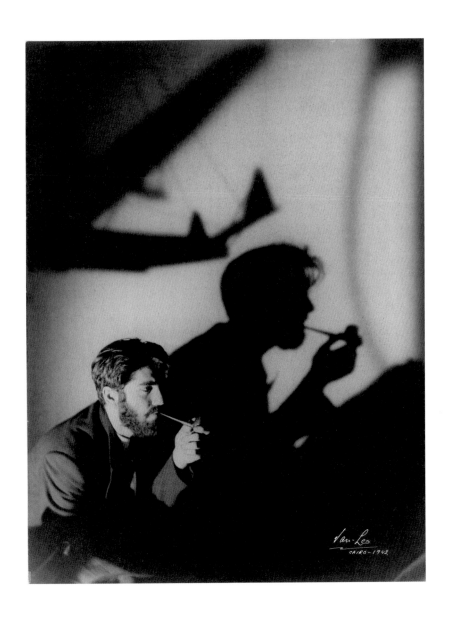

VAN LEO

PREVIOUS SPREAD
LEFT
Untitled, 1942. Gelatin silver print,
11 $\frac{7}{8}$ × 7 $\frac{7}{8}$ in (30 × 20 cm)

RIGHT
Untitled, 1942. Gelatin silver print,
11 $\frac{7}{8}$ × 7 $\frac{7}{8}$ in (30 × 20 cm)

OPPOSITE
Untitled, 1942. Gelatin silver print,
11 $\frac{7}{8}$ × 7 $\frac{7}{8}$ in (30 × 20 cm)

ABOVE
Untitled, 1942. Gelatin silver print,
11 $\frac{7}{8}$ × 7 $\frac{7}{8}$ in (30 × 20 cm)

ALA YOUNIS
A CURATORIAL PROJECT OF ARTWORKS
AND ARCHIVAL MATERIALS

People's Will
belief / existence / history
rulers / systems
crowds

Children forming the word
evacuation in Arabic during
the parade for Evacuation Day
[evacuation of foreign troops
in June 18, 1954]. Egypt. Arab
Image Foundation

Red Cross volunteers parading
at the Place des Canons, Beirut,
May 3, 1954. Arab Image Foundation

Happy crowds surround Gamal
Abdel Nasser and Shukri
al-Quwatli, Damascus, 1958,
upon declaring the United
Arab Republic (union between
Syria and Egypt)

The students raise their
handkerchiefs in the parade
for Evacuation Day [evacuation
of foreign troops in June 18,
1954]. Arab Image Foundation

Youth of the revolution, Egypt,
1960-69. Arab Image Foundation

Welcoming the militant Maarouf Saad, Saïda,
Lebanon, 1956. Arab Image Foundation. Founder
of the Popular Nasserite Organization in
1973, Saad was known to have a charismatic
and populist relationship with the residents
of Saïda and the adjacent Palestinian
refugee camps. Nonetheless, tensions developed
between Saad and the Palestine Liberation
Organization in the 1970s as they competed
for influence in Saïda. Saad's assassination
sparked the Lebanese Civil War

Jordan Reportage, 1968
Film shot by Hani Jawharieh
(scene in the iron factory)

1970
Police dispersing a demon-
stration in Jerusalem staged
by Arab students mourning
death of Nasser

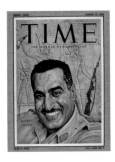

1956
Nasser, with a pharaonic
relief depicted, and figure
holding a rifle

1970
Mourning the death of Nasser
in Cairo

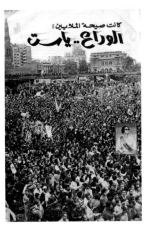

1975
Mourning Umm Kulthum, the
legendary singer, Cairo

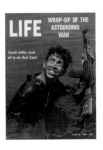

1967
Israeli soldiers favored
AK-47s, rifles captured from
Arab soldiers

1987

1979

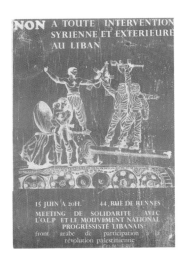

1976

Dr. Salam el Hassanda, the
hypnotist, Tripoli, Lebanon,
1950. Arab Image Foundation

Egyptian-American scientist Farouk El-Baaz (right)
worked with NASA in planning scientific exploration
and helped find safe landing sites for each of the
Apollo missions. The spaceship in Apollo 15 mission
was feared to fail in space. Before its launch,
El-Baaz placed a sheet of paper that has the first
chapter of the Qur'an as well as the names of his
daughters (for protection and good fortune), and
sent it with the astronauts to space

A Fallen Astronaut was placed at Hadley
Rille on the moon by crew of Apollo 15
on August 1, 1971, along with a plaque
bearing the names of eight American and
six Soviet astronauts who had died in the
advancement of space exploration. One
of these astronauts is Yuri Gagarin, who
was awarded the golden keys to the gates
of the cities of Cairo and Alexandria
and the Nile Order upon his visit to Cairo
in 1962

Apollo 15 on Umm Al Quwain
(a trucial state in the gulf, now
part of the United Arab Emirates)

Mustafa Akrim, *50DH*, 2013

defeat < Until Victory > hope
belief / self image / escape

Yto Barrada, *A Modest Proposal*, 2010-13

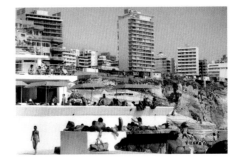

Fouad Elkoury, *Sporting Club a few days before the Israeli invasion (Beirut 1982)*

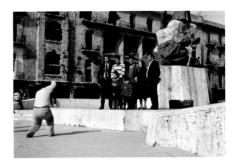

Fouad Elkoury, *Color snapshot, Place des Canons (Beirut 1982)*

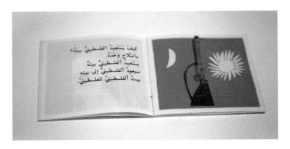

Home, published by Dar Al Fata Al Arabi, 1974, featured a story by Zakaria Tamer with illustrations by Mohieddine Al Labbad and was translated into many languages including English and Farsi

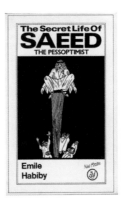

1970
On strategies taken by a Palestinian who lived under the occupying state

Public demonstration for
the promotion of education,
Casablanca, June 1, 1960.
Arab Image Foundation

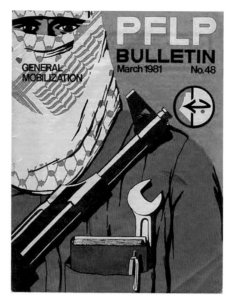

The Popular Front for the
Liberation of Palestine (PFLP)

Masao Adachi was commissioned by the
Popular Front for the Liberation of
Palestine (PFLP) to make a film on the
Palestinian revolution in 1970; like
Godard, he shot his film in Jordan and
Lebanon. Ghassan Kanafani (above), a
Palestinian writer and a leading member
of the PFLP, shaped Palestinian literature
for many years and was assassinated by a
car bomb in Beirut in 1972. His prominent
work *Men in Sun* (1963) told the story
of three men without visas who tried to
enter Kuwait to work. The novel is the
basis of Tawfiq Saleh's *The Dupes*, a film
produced by the Syrian Cinema Institute

**Political Work > Education
industrialization,
POWER**

Tawfiq Saleh, *The Long Days*, 1980
(still). In 1959, underground revo-
lutionaries tried to assassinate
Prime Minister Abd al-Karim Kassem
in Baghdad. News reports claimed
they had failed, and at first the
revolutionaries laid low, but as
the secret police continued to
comb the neighborhoods with house-
to-house searches, they fled to
the countryside. Among them was
Saddam Hussein

Tawfiq Saleh, *The Dupes*, 1972 (still)

Adel Abidin, *Three Love Songs*, 2010 (still)

> Prolonged^{War} <
LANDSCAPE.
Mountains. SANDS.
TREES. BIRDS.

Abdul Hay Mosallam, 1974

Neïl Beloufa, *Maya*, 2008

Youssef Chahine, *The Sparrow*, 1972 (still).
Viewers anticipating news on the 1967 war instead
watched as Nasser came on TV to announce his res-
ignation, leading thousands of people to flood the
streets demanding that he return to office

Mohssin Harraki, *Problem no. 5,* 2011-ongoing.
Family trees of Arab rulers

AKRAM ZAATARI

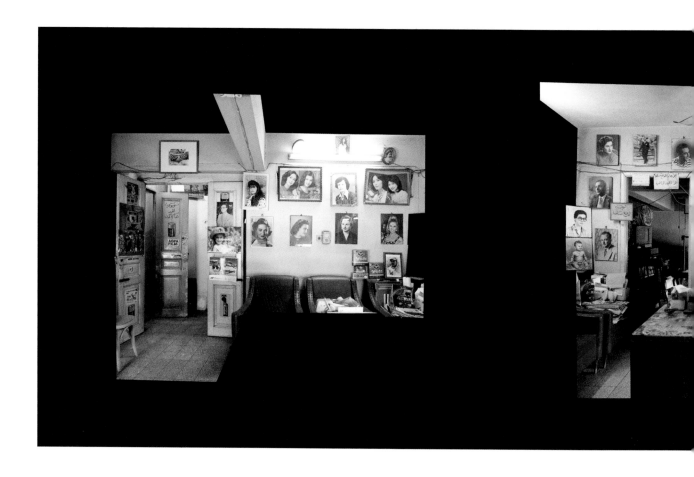

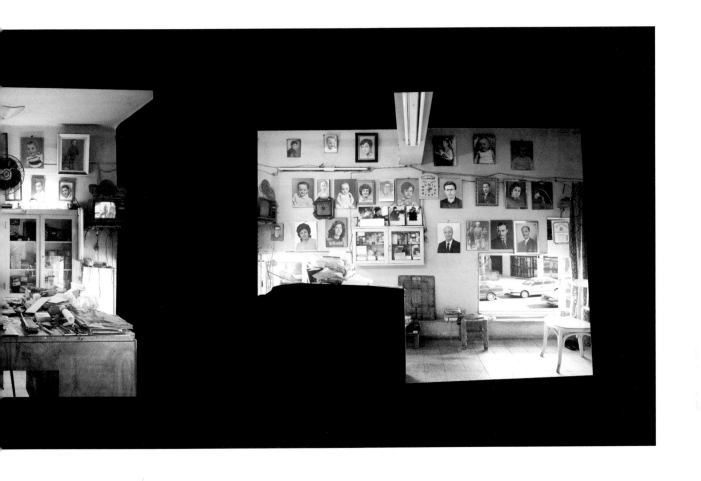

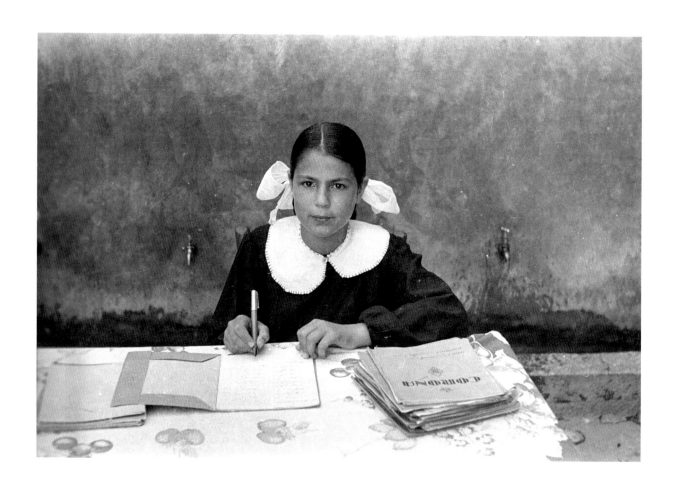

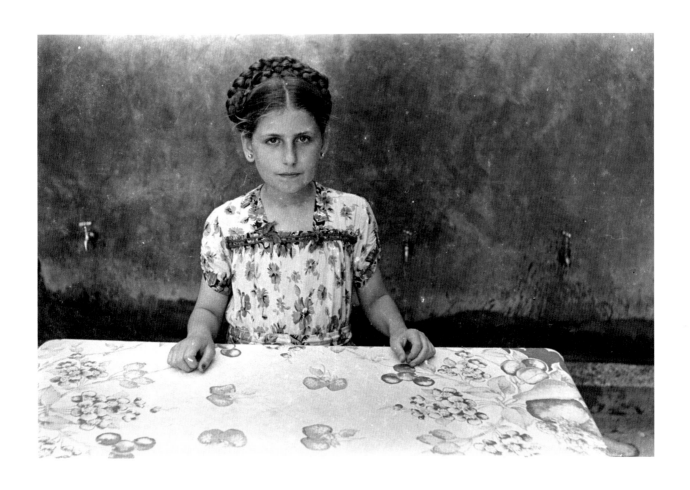

PREVIOUS SPREAD

Objects of Study/Studio Shehrazade–Reception Space, 2006. Chromogenic prints in three parts, 43 $\frac{1}{4}$ × 78 $\frac{3}{4}$ in (109.8 × 200 cm)

OPPOSITE & ABOVE

Hashem El Madani–Student of Aisha Om el Mo'minin School for girls. School courtyard, Saïda, Lebanon, 1948-49. From "Objects of study/The archive of Shehrazade/Hashem el Madani/Studio practices," 2006. Gelatin silver prints, 5 $\frac{7}{8}$ × 8 $\frac{5}{8}$ in (15 × 22 cm)

BIDOUN FOLIO
AN ANTHOLOGY OF CRITICAL TEXTS

INTRODUCTION

In contributing to this catalogue, we found ourselves in an unexpected place, revisiting a handful of questions that have been vexing us since 2004, when *Bidoun* launched as a well-meaning repository for "arts and culture from the Middle East." Many of those questions were posed in concrete form by our ongoing Bidoun Library project, which was first staged at the New Museum in 2010. The Library, a gathering of literally thousands of books and periodicals, represents an attempt to trace the various ways the Middle East—as an imagined territory and an object of discourse—has been depicted and defined (not to mention slandered, celebrated, obfuscated, hyperbolized, photographed, surveyed, and/or exhumed) in printed matter over the past five decades.

Our collaboration with the New Museum continues today in the form of an intervention in the catalogue in your hands—a motley collection of texts drawn primarily from the pages of *Bidoun* along with a handful of others published elsewhere by longtime contributors. Here, we hoped to present a folio of references that lay out some of the debates that have shaped and queried both the category of contemporary Arab art and the framework of group shows like the one before us. The pieces at hand are not only diverse in genre, tone, and argument but also occasionally contradictory, manifesting just some of the ways our own project has struggled with and against geography and cultural identity as organizing rubrics.

The fifteen texts to follow include a catalogue essay outlining the infrastructure for contemporary art in the Arab world alongside a tentative argument against allowing context to over-determine close readings of a given work; a curatorial introduction to a touring exhibition's postmortem publication; two exasperated editorials on cosmopolitanism and the global condition; three tough-minded reviews of British, French, and Qatari initiatives, respectively, which each in their own way attempted to materialize an aesthetic and define a narrative for the

history of modern and contemporary Arab art for an international milieu; two personal reflections on how identity in the Middle East has seeped into discussions about authenticity in cities as far afield as London, New York, and Mumbai; and a wild piece of fiction theorizing a state of cross-cultural curatorial affairs in the fable of a girl named Orient and a boy named One.

Our folio of texts also includes the introduction to an artist's long-term project on Gulf Futurism and a lively roundtable debate that delves into some of the anxieties surrounding foreign funding, particularly in Egypt at a time of pervasive suspicion and unrest. Three later texts, written as unabashedly speculative opinion pieces, attempt to take on the image regimes and other implications of the so-called Arab Spring, especially for artists who are living and working in a part of the world where every-thing—power, politics, and the institutions of art and governance alike—is up for grabs. Not all of these texts are subtle. Some are deliberatively irreverent; others unintentionally bombastic. But we hope they introduce a number of thoughtful if also argumentative threads about what it means to produce artworks as well as ideas in and around a series of geographies, both real and imagined, that are caught in a dialogue with so many others.

—*Bidoun*

OFF THE MAP: CONTEMPORARY ART IN THE MIDDLE EAST

KAELEN WILSON-GOLDIE
2010

The map of the modern Middle East has proven a remarkably popular and resilient model for the making of contemporary artworks over the last few years. For her first solo exhibition, in 2007, at the Jordanian arts foundation Darat al-Funun, the artist Oraib Toukan created an interactive wall piece called *The New(er) Middle East*, from 2007, which presents a stylized map of the region as an oversized jigsaw puzzle made of foam, magnets, neon, and iron. Only the most problematic piece, Israel/Palestine, appears as it would on any other map, its shape fixed as fact. The rest of the puzzle pieces are rendered in curvy, biomorphic forms that are totally fictional, bearing only the faintest of resemblances to existing national demarcations. What one would recognize as Iraq is split in two, Saudi Arabia in three, Iran in several fragments of its current self.

Toukan's piece was produced in response to the proposition of Ralph Peters, a retired United States Army Lieutenant Colonel, who penned an article for the *Armed Forces Journal*, entitled "Blood Borders: How a Better Middle East Would Look," in 2006. Toukan superimposed Peters's recommendations for redrawing the map of the Middle East over the equally artificial borders established by the Sykes-Picot Agreement in 1916, which divided the territories of the faltering Ottoman Empire into spheres of French and British influence (see Muller et al. 2007, 47). The discrepancies between these two proposals generated the forms of Toukan's puzzle. When installed, *The New(er) Middle East* invites viewers to play with the region as policymakers and powerbrokers have done for decades. You can move the pieces around, experiment with new configurations, and consider along the way the consequences of geopolitical positions and proximities.

Similarly, the artist Moataz Nasr's *Ice Cream Map*, from 2008, is a jigsaw puzzle of the Middle East with pieces missing from areas associated with political conflict or sectarian strife (most of Iraq and Palestine, southern Sudan, the Western Sahara), which tend to go unacknowledged by Arab leaders committed to ideologies of territorial sovereignty and/or Arab nationalism. Drawing on his memories of the maps that used to hang in his classrooms at school in the wake of the Arab-Israeli War in 1967, the artist makes an associative link to his contemporaneous experiences as a boy, ducking out for ice cream with his friends at recess, when competition was fierce for the best color and flavor of the frozen treat (see Amirsadeghi et al. 2009, 232). By equating the authority of the map with childhood high jinks, Nasr brings the region's politics down a notch or two, imagining its leaders playing trivial games with little concern for the dire consequences of their actions.

Marwan Rechmaoui's *Untitled 22 (The League)*, from 2005, is another wall piece toying with two-dimensional representations of the region. In Rechmaoui's work, the twenty-two states of the Arab League are carved out of tough black rubber and affixed to the wall, with the shape of each country slightly pulled apart from that of its neighbors. The piece, produced in several previous versions (in crepe paper and milled rubber) under several different names (*Untitled 22 (The Arab World)* and *Missing Links*), fundamentally challenges the specious notion of Arab unity and questions the efficacy of a political grouping that has become fractious to the point of utter irrelevance.

Other map works that either zoom in on particular cities or pull back to encompass the world include Rechmaoui's magisterial *Beirut Caoutchouc*, from 2004-06, a map of Beirut made from interlocking pieces of tough black rubber splayed out on the floor in an open invitation for viewers to tromp across; Yto Barrada's playfully oversized wall puzzle *Tectonic*, from 2010, which renders the seven continents in smooth wooden pieces that slide along diagonal grooves that have been cut into a blue background; and scores of works produced

REMAINDER 1

THE FOLLOWING IS NOT AN ORIGINAL TEXT. IT IS A COMPOSITE OF MISSION STATEMENTS FROM ARTS ORGANIZATIONS AND THEIR BENEFACTORS, PRESS RELEASES FROM EXHIBITIONS AND ART FAIRS, AND ALL BOOKS WITHIN THE BIDOUN LIBRARY ON THE SUBJECT OF CONTEMPORARY ART IN THE MIDDLE EAST PUBLISHED AFTER SEPTEMBER 11, 2001.

THE ARTISTS

This was a large independent art show organized by a group of young Egyptian artists for two weeks in one of the old hotels downtown.

Collectively, the artists in this exhibition show us alternative ways of interacting with a location, encouraging us to think of that location more than just as a physical place, but as a point of encounter which has its own character, heartbeat and rhythm.

Many artists from different regions are embarking on historical adventures, exploring how the narrative—recent and remote—is constructed, and

over the past decade by Mona Hatoum, such as the series "Routes II," from 2002, in which maps illustrating the routes and flight patterns of international airlines have been altered and embellished by the artist's hand; *3-D Cities*, from 2008, which cuts delicate patterns into maps of Beirut, Baghdad, and Kabul; and another *Tectonic*, from 2010, which depicts the world on glass plates that rest uneasily on the floor.

Why so many cartographic adventures among contemporary artists in the Arab world? These works, and so many others like them, allude to the generally artificial nature of national boundaries in the Middle East, and to the particularly crass pronouncements of political pundits always bent on drawing the region's contours anew. Toukan, Nasr, and Rechmaoui address their works, pointedly, to both Arab and Western audiences as they seize on the act of defining the region for themselves. But they also go one step further. All of their works are interactive. Viewers are meant to mess around with them, and in doing so, to not only grasp present political realities, but also to imagine future scenarios in which their relation-künstlership to the region might be different, and of their own making. They call for agency in the face of representations that have been imposed upon them. But they also signify a subtle act of deflection: You want art from the Middle East? Here it is, find it on the map, with nothing more than

a superficial surface of shapes and colors to help you find your way.

When discussing contemporary art in Europe and the United States, scholars have reached a degree of consensus that retrospectively dates the beginning of the category either to 1945, the end of World War II, or to 1970. This is the benefit of a relatively robust academic industry for the writing of art historical textbooks, and the side effect of a lucrative art market, in which auction houses, commercial galleries, and art fairs are complicit in laying down definitions for sales categories.

When discussing contemporary art in the Middle East, however, no such rules apply, in part because the geographical region at stake is too vast, its histories too varied, its politics too complicated and entangled for tidy definitions to work. There is no such thing as a contemporary art scene in the Middle East, nor is there an agreed upon sequence of touchstones for how contemporary art practices in the Arab world came into being. While a smattering of solid scholarly volumes and surveys exist, most of them address or lay claim to national histories of modernisms in the visual arts (see, for example, Howling 2005, Khal 1985, and Lahoud 1974; Boullata 2009 and Ankori 2006; Karnouk 2005). Very few of them propose an overarching art historical narrative that may be draped over the region as a whole.

Rather than a singular scene, there is a constellation of

many such scenes, pockets of critical activity and artistic vitality, scattered across and beyond the territories marked on maps. The histories of those scenes, moreover, must be pieced together from primary rather than secondary sources, from occasional catalogue essays, themed issues of magazines, and special editions of journals, artists' books, independent publishing efforts, and the ephemeral printed matter and critical material generated, for the most part, by artist-driven initiatives in cities such as Beirut, Cairo, Ramallah, Amman, Alexandria, Damascus, Tangier, Casablanca, and more.

As the critic and curator Rasha Salti noted during a recent discussion on arts writing that was staged for the Global Art Forum, a series of talks and panels that runs annually in parallel to the art fair Art Dubai: "The market has been totally ruthless toward the production of knowledge in universities, and it has been totally thrilled by the production of art. ... Art criticism lives in that gray area, in that horrific gap between the production of knowledge and the production of art" (see Hagey 2010). Institutions of higher learning in the region, in terms of producing art historical thought, have not kept pace with the market or with the production of art, which, for better or worse, feeds into and off of the market. As such, the category of contemporary art in the Middle East runs the serious risk of being solely

projecting their own time and concerns. Each carries unique scents that may trigger personal memories in the audience, transporting them from tangible reality to a different, very personal, time and place. They transcend geographical boundaries to bring us into direct contact with another world.

The works of these Afghan, Chinese or Cuban artists, to name just a few, create new spaces that call for a new viewer/reader, one who is acutely aware of the oscillation between the global and particular (between an inherited identity and an acquired one through domicile) that artists have to negotiate in order to

create heterogeneous works.

Inevitably, Asia is re-depicting itself and the world, as the West re-defines Asia and itself in the light of geopolitical evolution. They all gather as though preparing for a group photo. Their poses are absurd, with proportions handled in an expressionist fashion enhanced

by the theatrical composition of a tragedy. Faces, hands and empty pots, including a water ewer, are carefully scattered and exquisite forms suggest abject poverty mixed with lethargy and foolishness.

These images of bodies crowded together and arranged alternately right side up and

determined and defined by the buying and selling of art—as product—without the crucial counterbalance and consideration provided by academic knowledge, critical analysis, and historical reflection. That said, for the sake of argument and as an exercise in thinking about how such sweeping narratives have been or could be constructed, the contemporary art practices under discussion in this essay may be traced back more or less consistently to developments occurring in several cities since the 1990s. In cities such as Beirut, Cairo, and Amman, the 1990s were marked by the taking shape of independent, alternative infrastructures for the production and presentation of contemporary artworks that were critical and largely nonprofit and non-commercial in form, content, context, and intent.

In Beirut, the arts association Ashkal Alwan was established in 1994, the Arab Image Foundation in 1997, and the film and video collective Beirut DC in 1999. The Ayloul Festival, which ran from 1997 through 2001, served as a crucial precursor and prototype for Ashkal Alwan's Home Works Forum on Cultural Practices, which debuted in 2002, and grew out of a series of art projects in public spaces organized by Ashkal Alwan in 1995 (the Sanayeh Garden Project), 1997 (the Sioufi Garden Project), 1999 (the Corniche Project), and 2000 (the Hamra Street Project). In Cairo, the Townhouse Gallery for Contemporary Art opened in 1998, the influential and

foundational Nitaq Festival was held in 2000 and 2001, and the Contemporary Image Collective was established by a group of artists and photographers in 2004. In Amman, the arts foundation Darat al-Funun was formed in 1993, and began not only exhibiting, but also collecting contemporary art from the region just ten years later. Makan, an independent art space that hosts residencies, studios, and experimentation, opened its doors down the street from Darat al-Funun in 2003. To the list of like-minded initiatives, one could add the Anadiel Gallery and Al-Mamal Foundation in Jerusalem, Cinémathèque de Tanger, L'Appartement 22 in Rabat, the Alexandria Contemporary Arts Forum, the Beirut Art Center, the 98 Weeks Research Project in Beirut, the Doc Box film festival in Damascus, Meeting Points, the Young Arab Theatre Fund, the Sharjah Biennial, the Riwaq Biennial, the Jerusalem Show, and many, many more.

Together, these initiatives provided early platforms, catalysts, and incubators for artists who have become well established in the decade and a half since, including Walid Raad, Akram Zaatari, Rabih Mroué, Lina Saneh, Walid Sadek, Hassan Khan, Sherif El Azma, Amal Kenawy, Mahmoud Khaled, Doa Aly, Maha Maamoun, Wael Shawky, Lara Baladi, Oraib Toukan, Samah Hijawi, and more. They also linked up with one another to create a network of structural support, facilitated distribution, and shared experience.

The members of the Arab Image Foundation, for example, include the artists Raad, Zaatari, Baladi, and Yto Barrada, the Founder and Director of Cinémathèque de Tanger. Ashkal Alwan has organized exhibitions for the Townhouse Gallery in Cairo, and William Wells, the Founder and Director of Townhouse, has curated a show of contemporary works from Cairo for Sfeir-Semler Gallery in Beirut. Townhouse, Ashkal Alwan, and the Platform Garanti Center for Contemporary Art in Istanbul are all sutured into a joint residency program with three other institutions. These connections and collaborations have made it possible for artists and artworks to move more easily in a region where the crossing of borders has become more difficult, taxing, and bureaucratically burdensome now, paradoxically, than in much of the twentieth century.

Of course, the development of these scenes and networks, linking different cities in the region to each other and to points outside of the Middle East entirely, has not happened in a vacuum. This particular story intersects and overlaps with several others, and to consider the narrative mesh created by them all is perhaps useful and potentially productive in the context to the current exhibition. One such narrative is the overall internationalization of the art world, which broke the long-standing hegemony of the New York-London-Berlin axis and pushed curators, critics, collectors, and institutions

upside down create a virtual boat that brings to mind the risks of servitude and of past and present migrations.

In the age of migrants, curfews, identity cards, refugees, exiles, massacres, camps, and fleeing civilians, however, they are uncooptable mundane instruments of a defiant memory facing

itself and its pursuing or oppressing others implacably, marked forever by changes in everyday materials and objects that permit no return or real repatriation, yet unwilling to let go of the past that they carry along with them like some silent catastrophe that goes on and on without fuss or rhetorical bluster.

These artists are the wandering souls of the world who move from one place to another making art that witnesses, that challenges and that asks other questions.

They are celebrated, ignored, persecuted and sometimes even killed for refusing to take sides in the game of "us" against

"them"; they are always the innocents abroad who are often exiles in their own countries of birth. They spill forth from the opacified holes of culture and are beyond recuperation. Wrenched from the void, they pour scorn on beauty to the end of time.

The marionettes are moved by clearly visible strings and don

from the West to consider contemporary art practices much farther afield, often with an emphasis on trouble spots and conflict zones that dovetailed nicely with the so-called documentary turn and the return to art and politics as inseparable and intractable.

Another relevant narrative is the rising interest in contemporary art from the Middle East, which, whether the relationship is causal or not, followed on the aftermath of the events of September 11, 2001. This gave rise to a spate of geographically themed group exhibitions, such as the curator Catherine David's ongoing "Contemporary Arab Representations" project; Jack Persekian's "DisORIENTation" at the House of World Cultures in Berlin in 2003, revisited in 2009 as "Disorientation II" on Saadiyat Island in Abu Dhabi; "Fantaisies au Harem et nouvelles Schéhérazade," which toured several European museums in 2003 and 2004; "Regards des photographes arabes contemporains" at the Institut du Monde Arabe in Paris in 2005; Venetia Porter's "Word Into Art: Artists of the Modern Middle East" at the British Museum in 2006, and later reprised during Art Dubai at the Dubai International Financial Centre; "Without Boundary: Seventeen Ways of Looking" at the Museum of Modern Art in New York in 2006; and, not to be outdone, "Unveiled: New Art from the Middle East" at the Saatchi Gallery in London in 2009. These exhibitions, accompanied by complementary conferences and symposia, were often celebrated, but also came in for sharp criticism. Some were reductive; others were simply confused. Whatever their merits, they gave artists from the region greater opportunities to meet and collaborate, which strengthened the networks linking their scenes, cities, and circumstances back home.

One final narrative of interest, which reflects back on the previous two, concerns the sudden and ambitious rise of the Gulf as an arts and cultural hub to be realized in the not-too-distant future. The museums and cultural districts planned for Abu Dhabi, Doha, and, on a now humbled scale, Dubai, seem strategically positioned to knock old cities like Beirut, Cairo, and Damascus from the old, deeply entrenched cultural perches (Baghdad, of course, has already fallen; cities such as Jerusalem, Ramallah, and Bethlehem struggle for audiences and with the fact of being turned into the disjointed elements of an earthbound archipelago; and who knows what sorrows will continue to befall besieged Gaza). Is this a political calculation, the crude purchase and importation of culture, the triumph of the neoliberal agenda over how cities are made and marketed, the start of a second Arab renaissance, or an earnest embrace of contemporary art in all its challenging, disruptive, searching, and solacing capacities? Nobody knows for sure or sounds convincing enough to be believed. But in a process that combines the skeptical (a wariness of the intentions behind the Gulf's interest in contemporary art), the genuine (an intention to seek out meaningful engagement with projects that are going to happen with or without regional participation and involvement), and the mercantile (follow the money), this story too has served to fortify the networks of contemporary art practice and exchange in the region, whether out of curiosity, solidarity, or defiance.

Together, these competing narratives may one day bring into being the singular category of contemporary art from the Middle East that has so far proven artificial, elusive, and in a way, wonderfully uncooperative. In the meantime, however, interest in cultural production from the region has also put great pressure on the artists and artworks being used to fuel what can probably, with some accuracy, be described as a boom. On the one hand, contemporary artists from the Middle East have benefitted handsomely from the international exposure they have received. On the other hand, they have rarely been engaged on the merits of their work alone. More often than not, they are enlisted to provide information, assuage a lurking sense of guilt, and give evidence for a thesis or worse, a showcase. This is what the Middle East looks like. And so, the causal result may be the frequency with which artists resort to maps.

To meet interest in the region with a representation of the region that is, in effect,

the costumes of the characters who were present in the Christian armies of Europe and in the Muslim armies during the conflicts. Their individual voices are barely heard, and their accomplishments rarely acknowledged. Spoken words have a strong effect as it was accompanied by the emergence of human appearance on Earth in primitive times as the basis for communication between members of the group.

These nomadic artists give voice to the silence amongst us through their works. They savage the underbelly of our politeness and claw off our surface veneer.

Sometimes, we hate the day we don't hear the word "NO." It is commonly used to express denial and refusal, which is natural, therefore, there is an agreement on the meaning of this word.

They started complaining about their job in terms of harassment, lack of obtaining their financial rights, and other issues. They seem to spring from the massive cocoon of some female monster squatting to give birth in the slough of life, when animality is at last free to impregnate raw humanity. They will continue struggling over their identities as they develop their work and their ties to institutions that function like a life-support system.

satire or parody, is a clever act of flipping the inquiry back on the inquirer, a means of asking, What are you really looking for and why? This is precisely the process, and the subject, under formal and theoretical investigation in Walid Raad's current project, entitled "A History of Modern and Contemporary Arab Art." Included within this project is a model of the project that came before. Raad's long-term project known as "The Atlas Group" is represented in a miniaturized model entitled "Part I_Chapter 1_Section 139: The Atlas Group (1989-2004)" and dated, counterfactually, 1989-2004. The piece looks like an elaborate mock-up of an exhibition design, with images the size of postage stamps and absurdly small yet fully functional videos running on tiny LCD screens. The piece plays Alice in Wonderland-style with scale, but it also comments on the commodification of critical art practices that were not necessarily intended to enter the art market at the time of their initial articulation.

Raad's piece points to two emergent tendencies. One is the model as an elaboration on the map. Yto Barrada's *Gran Royal Turismo*, from 2003, takes this further with a modified, automated model of a racetrack—suitable for vehicles the size of matchbox cars—that winds through the landscape of a threadbare village. From a tunnel gouged into a hillside, a tiny convoy of seemingly presidential cars emerges. As the convoy travels along the track, resplendent green palm trees rise from a series of holes in the ground. A drab façade swivels to reveal a whitewashed wall. Moroccan flags flutter in an artificial breeze. The piece probes the mechanisms of power, short-term beautification schemes, and the phenomenon of the Third World motorcade. Like much of Barrada's work, it touches on history, colonial legacies, modernist notions of progress, neoliberal economic agendas, rapacious real estate development, and environmental degradation, without ever coming across as didactic.

The other, slightly more enduring, but still exponentially expanding tendency is the nearly performative presentation of the archive as exhibition material. One of the most ambitious and illuminating examples of this is Zaatari's ongoing project entitled "Objects of Study/Studio Shehrazade." A substantial chunk of Zaatari's individual artwork draws on the collective archive housed by the Arab Image Foundation, including the collection of Studio Shehrazade, which consists of some five hundred thousand negatives by Hashem El Madani. Known as the hardest working commercial photographer in Saïda, Madani is rare in that he has nurtured an archive over half a century that is entirely intact (many of the mid-twentieth-century commercial photographers in Beirut based their studios in the downtown district, and most were destroyed during the civil war; other studio archives have been lost, discarded, or dispersed by heirs and business partners).

Madani is the subject of a long-term project that Zaatari began ten years ago, for which he considers all of the archive as artistic material, occasionally representing or recreating the entire thing as an elaborate installation. To date, Zaatari has published two books of Madani's photographs—*Hashem El Madani: Studio Practices* and *Hashem El Madani: Promenades*—and he plans to do six more. He has made one video, titled *Video in Five Movements*, from 2006, based on a collection of Super-8 footage that Madani shot in the 1950s and 1960s, and another, luminous work, titled *L'enlèvement*, from 2008, based on material found among the contents of Madani's storage closet.

While studio photographers like Malick Sidibé and Seydou Keïta have earned considerable, and largely posthumous, art world acclaim, Zaatari is careful to preserve the conditions that informed both the production and consumption of Madani's work. He doesn't simply turn a commercial product into art. The art in question is the more complex manner in which Zaatari moulds Madani's material, collecting images, texts, films, documents, and objects around the photographer for the purpose of exploring photographic phenomena alongside conceptualizations of photography itself. His archival practice seems, on the surface, to be quite different from Raad's. Hashem El Madani is real. The Arab Image Foundation is real. The Atlas Group is not, and neither are the donors, informants, and

The intrinsic painterly life-logic of these simulacra characters pushes them to acts of unknown violence, unleashing a sometimes unrestrained aggression beyond all reason. They are metamorphic demonstrations of cruel, grimacing alterity, the fascinating proximity of horror within eyeshot and its complacent seductions. They find it hard to exist, and cause great hardship for existence. They dilate and dilute uncomplainingly and give rise to living excrescences—semblances of being with an implacable presence.

Some saw exaggeration in these representations; others saw themselves inside the tent or the birdcages. Others stopped nearby just for few seconds and left when they knew that the stuff was not for sale, not even wanting to know why such a large crowd gathered around the tables.

Their paintings, mainly created in a nontraditional style, are expressive, creative, and an honest translation of their personal experiences which adds to the originality of their artwork. Each character appearing as part of her open-ended narratives acts as herself.

The influences of various modern schools of Western Art such as impressionism, abstract

interlocutors, such as Fadl Fakhouri and Operator #17, who have supplied Raad with material; all figures he has invented are like character sketches for a not yet full-bodied fiction. But as different as "Objects of Study" and "The Atlas Group" may be, both projects raise questions of history, memory, identity, and representation that lead to a familiar place. If the map is a deflection, a means of exposing ideas about the region as artificial and shifting, then the archive does the opposite, drawing viewers in and drowning them in details, such that the experience of a small city like Saïda may come across in all its complexity, without being reduced into digestible bits.

In her essay "Against Interpretation," Susan Sontag calls for an approach to art that emphasizes transparency, "experiencing the luminousness of the thing in itself, of things as they are" (Sontag 2001, 13). Against the tendency to divide a work into its form on one side and its content on the other, and to overplay the latter at the expense of the former, Sontag argues for an engagement with art that restores the sensory experience of the work. In her analysis, acts of interpretation have dulled the senses, and moreover, perpetuated the view that all art is deficient, dissatisfying, until it has been made to mean something more than it offers. In light of the current interest in contemporary art from the Middle East, one could make a similar argument. But

it is not the over-interpretation of content that is most problematic, but rather the over-reliance on context.

For example, the artist Basma Alsharif is one among many contemporary artists in the region grappling with the Palestinian condition and deconstructing the means by which it has been represented. She is also one among many artists mining archival material for artworks engaging notions of memory and history. But at the same time, she belongs to a small and select group of artists currently making work in and around a region called the Middle East who are comfortable casting aside the most obvious markers of identity politics that have made contemporary Middle Eastern art such a hot commodity in the international art market.

Like the artists Iman Issa, Hassan Khan, Sherif El Azma, and Haris Epaminonda, Alsharif has created a distinctive visual language with its own internal system for generating meaning. Her videos, such as *We Began By Measuring Distance*, from 2009, and *Everywhere Was the Same*, from 2007, do not ply viewers with information about the region's conflicts and troubles, nor do they make direct reference to newsworthy issues or events, nor do they peddle in or pander to the exotic. Instead, they hinge on codes, forms, and gestures that only begin to make sense in relation to one other. After the so-called documentary turn in contemporary art, Alsharif's work points in a direction

that leads past the cold and the clinical, where notions as démodé as formal beauty and a distinctly literary imagination can reclaim their critical potential.

Haris Epaminonda's work consists primarily of found material. Her early videos are excerpts from Egyptian soap operas and fragments from Greek films. Her objects are relics from antique dealers and curiosities from flea market stalls. Her images are pages from antiquarian books that have been carefully cut, cropped, photographed, or used as the base layer of lacelike collage. Because so much of her material is old, her work hums with a nostalgia that is consistent, but impossible to place. For example, a series from 2009, entitled "Vol. I," consists of mysterious Polaroids depicting plants, animals, landscapes, ruins, tribes, riverboats, rock formations, and more. All of the photographs are of pages from books, and clearly the books tend toward anthropological, ethnographic, or art historical tomes. But Epaminonda strips away the context to create chains of association and patterns of meaning that operate outside of any specific references to time, place, history, or culture.

Iman Issa's highly enigmatic series of triptychs, from 2009, feature minimalist photographs, a metronome, a flashing light bulb, a notebook scribbled with indecipherable lists, a portable CD player with headphones, a monitor looping a video of a flashlight rolling

geometric and abstract expressionism and touches of surrealism are evident in the work of the young students of the center, however, their freedom of choice in terms of deploying and mixing different styles in order to express their own original ideas, inspired by the socioeconomic condition that they live

in, makes their work unique, valuable, and authentic. For them, Russian-Soviet art and, in particular, the legacy of the Russian avant-garde remained a major source of creativity that did not exclude an appeal of both key themes of historical art of the region and problems of international art. Concentrating

on ephemeral, interactive, improvised, and critical practice, the experiences provided by the project were very different from the previous artistic experiences of most participants.

Special emphasis was put on encouraging cooperation, discussions, and dialogue in order to create a state of awareness and

interaction among them to be able to adopt individual stances toward numerous issues and to express them in artistic practice. A strategy of inclusivity became the aesthetic roots of their choice, as the principal means of artistic expression—patchwork, superimposing, overlapping, cohesion, a combination

back and forth across the floor, among other things. This is a highly personalized vocabulary of forms, objects, images, and sounds that leaves you to wonder what the relationship might be between two plates of breakfast and a chessboard, between a typewriter and a rack of blood samples. Issa's work offers riddles, games, possible meanings, and narrative connections that credit her viewers with having the presence of mind, and the genuine curiosity, to wrestle them toward making sense.

Equally evocative and open-ended is Sherif El Azma's *Psychogeography of Loose Associations*, a performance piece from 2007, for which the artist situates himself behind an audience in a cinema and narrates a text while images, photographs, statistics, and videos are projected onto a screen. Maurice Luca, one third of the electronic music group Bikya, contributes live sounds while Nermine al-Ansari, using an electronic pen, contributes live drawings. The performance unfolds like a lecture or presentation, running through the research findings that might have followed a period of study into the casual formation of informal psychogeographical societies in Cairo. Azma finds, or imagines, these societies as leisurely, recreational affairs. Their activities have much to do with practice and little to do with theory. Guy Debord is never mentioned.

Hassan Khan's meticulous video installation *The Hidden Location*, from 2004, is a fifty-two-minute work housed in a seven-by-seven-meter room. With four screens, sixteen parts, and a synchronizer, it is the rare video installation that justifies its command of both space and time. Each of the sixteen parts presents a character or a situation—an insurance salesman, a corporate coach, a scorned lover, the apartment of an upwardly mobile young professional, an overstuffed supermarket, and so on. Each part establishes its own logic, but the relationships that reach and form between the different stories snap the viewers' gaze from one screen to another, such that you end up carving out your own space, your own hidden location, in the center of the room as you try to take it all in.

In addition to being an artist, Khan is also a writer, editor, and musician who has, over the past few years, taken a strong position against curatorial tendencies to group artists according to geography. For example, in a review of a recent book on contemporary art in the Arab world, he argues: "The book presents its readers with a seductive blend of capitalist-driven modernism and the exotic erotic. [It] presents its artists only in relation to their assumed ethnic affiliation; it becomes difficult to see them any other way. Although this is a technique that has made many a fortune - the Chinese example being the most striking yet - it has failed to acknowledge artists as producers within the very centre of contemporary discursive practice." Khan draws a distinct line between this kind of writing and that which is part of his artistic practice, but one could nonetheless read his remarks as an attempt to carve out a space that returns artists to the center of the conversation, a space for himself and his work and that of his peers, whoever and wherever they may be, and regardless of where they come from.

"*The Hidden Location*," says Khan, "is a space where certain things exist that limit human possibility, an imagined space, and I attempt to engage, work with, and work against this space as if it were an object. I'm not trying to interpret it. I am just trying to deal with it. It's about encountering versus interpreting" (see Hamza/Molnár 2009, 38). Khan's work emboldens a sense of interiority, be it the life of the mind, the imagination, or a protected place in which artists can live and work and develop their practices on their own, apart from the contemporary art scenes in the region that have perhaps, at this point, become overexposed. His work, like that of Alsharif, Issa, Epaminonda, and Azma, deserves the defense that Sontag calls for in "Against Interpretation," deserves to be taken for what it is, not for what it says about a particular geographical region. It deserves our curiosity and our engagement with its forms, languages, expressions, and ideas. We, in turn, must find the time to experience the work in a more productive way, and to develop the means to articulate and

of heterogeneous and randomly combined elements.

As you meet these talented men and women expressing themselves through paint, collage, and sculpture, remember that because the majority of the artists produce art considered un-Islamic by the Taliban, they still fear for their lives if they are caught.

One would like to see them hung in proximity.

THE EXHIBITION

The works included in this exhibition are marked by an insistence of the artist to highlight the make-ability of memory and forgetfulness, and how the latter are inscribed within a socio-political consciousness.

Over the past ten years, the Arab world has witnessed the emergence of a number of contemporary art festivals, art funds, cultural institutions, art galleries, art fairs, and collectors of contemporary art. Moreover, the planned construction of several large art museums and art schools in the Arab Gulf raises

express the effect of its lumi-
nousness. And, for the sake of
the work, we must do so without
those maps to guide our way.

Ebtisam Abdul-Aziz, *(Re-Mapping)* (Dubai, 2010).
Bidoun Projects flyer published on the occasion of Art
Dubai, March 17–20, 2010.

Brahim Alaoui, *Regards des photographes arabes
contemporains,* exh. cat. (Paris: Institut du Monde Arabe,
November 22, 2005–January 22, 2006).

Hossein Amirsadeghi, Salwa Mikdadi, and Nada Shabout,
New Vision: Arab Contemporary Art in the 21st Century
(London: Thames & Hudson, 2009).

Gannit Ankori, *Palestinian Art* (London: Reaktion
Books, 2006).

Bidoun Projects, *A New Formalism,* exh. cat. (published
on the occasion of Art Dubai, March 17–20, 2010).

Kamal Boullata, *Palestinian Art: From 1850
to the Present* (London: Saqi, 2009).

Fereshteh Daftari, *Without Boundary: Seventeen
Ways of Looking,* exh. cat. (New York: Museum of Modern
Art, February 26–May 22, 2006).

Haris Epaminonda, *Vol. I,* exh. cat. (Malmö: Malmö
Konsthall, April 2–May 10, 2009).

Keach Hagey, "The Paradox of Middle Eastern Art
Criticism," National, Abu Dhabi, March 17, 2010.

Aleya Hamza and Edit Molnár, *PhotoCairo 4:
The Long Shortcut,* exh. cat. (Cairo: PhotoCairo 4,
December 17, 2008–January 14, 2009).

Frieda Howling, *Art in Lebanon 1930 – 1975:
The Development of Contemporary Art in Lebanon*
(Beirut: Lebanese American University Press, 2005).
Liliane Karnouk, *Modern Egyptian Art 1910 – 2003*
(Cairo & New York: American University in Cairo Press,
2005).

Edouard Lahoud, ed., *L'Art contemporain au Liban*
(Beirut: Dar el-Machreq Éditeurs, 1974).

Venetia Porter, *Word Into Art: Artists of the Modern
Middle East,* exh. cat. (London: British Museum,
May 18–September 3, 2006).

Susan Sontag, "Against Interpretation," *Against
Interpretation and Other Essays* (New York: Picador,
2001), 3–14.

Nat Muller and Sama Alshaibi, *Counting Memories:
Oraib Toukan,* exh. cat. (Amman: Darat al-Funun,
May–July 2007).

REGIMES OF THE IMAGE

NEGAR AZIMI

2011

On August 3 of this year, Hosni
Mubarak, the recently deposed
and disgraced president of
Egypt, was rolled out on a hos-
pital gurney into an overcrowded
courtroom and placed into the
steel-mesh cage that is *de
rigueur* for defendants awaiting
criminal trial in Egypt. Dressed
in a white tracksuit and with
conspicuously newly dyed hair,
he lay covered by a white sheet
like a mummy while a prosecu-
tor read the charges against
him: corruption along with the
premeditated murder of peaceful
protesters during the January
revolution that would eventually
topple him. For several hours
(with his sons in their matching
tracksuits hovering defiantly
over him, probably trying to
shield him from the cameras),
he continued to lie there,
ashen-faced, looking drugged or
distracted, occasionally pick-
ing his nose—all of which was
broadcast live on the very

state television network that
was once his mouthpiece. At
one climactic point amid hours
of procedural tedium, a prose-
cuting lawyer announced that
the real Mubarak had been
dead since 2004, and that the
man before us was a body double
(he called for a DNA test).
Soon after, presiding judge
Ahmed Refaat warned that the
trial should not be mistaken
for theater. But of course, it
was difficult not to think of
it as just that.

The revolution that shook
Egypt this past winter was an
uncommonly mediatized event—
inspiring near-constant live
coverage on Al Jazeera and other
satellite channels, not to
mention via videos taken by cit-
izens themselves and uploaded to
YouTube. (Indeed, this mediati-
zation has itself been the topic
of countless hours of media
coverage.) While Egyptian state
television offered up facile,
fearmongering agitprop accusing
foreigners, Islamists, and
even Kentucky Fried Chicken
of sowing unrest in the country,
Al Jazeera's live stream
revealed an entirely other nar-
rative arc, one whose more per-
sistent theme was the powerful
pitted against the powerless.
The sight, for example, of dem-
onstrators praying on the Qasr
al-Nil Bridge in spite of the
tanks and water cannons threat-
ening to knock them over was
as unforgettable as any image
from Tiananmen Square. And
as Al Jazeera beamed images of
protesters both heroic and
helpless in the face of state
security (and its American-made
tear gas, batons, guns, and

a number of questions about
how culture, and in particular
contemporary visual art will
be conceived, made, distributed,
and consumed in the future,
not only in the Gulf, but in
the Arab world in general, and
beyond.

A new identity is being
developed here, people are
evolving with the change; some
are holding on to who they are,
and others are trying to fit in
with this change, the person
in this frame is simply a represen-
tation of that thought. This
means that it is not about con-
necting two "disparate" sources,
but about combining the already
mixed and remixed. Tastes
converge and, like the modern
movement, are international.

We are confronted with
a gamut of mixed genres and
diverse circumstances, with their
different forms, audiences and
different, sometimes conflicting,
demand.

Excitingly, this invites new
audiences into the space, revives
debate on what defines cultural
memory, nationalism in art,
the influences of colonization,
modernization, and globaliza-
tion, and puts a contemporary
face on the past.

Here, for the first time, Arab
positions on literature, music,
theater and art will be the subject
of in-depth discussion. Authors

distinctive Darth Vader-esque headgear), state television cut to bafflingly static shots of dark, empty streets.

It is no accident that one of the primary events galvanizing Egyptian protesters was the circulation of an *image*—that of twenty-eight-year-old Alexandrian businessman Khaled Said, who had been beaten to death outside an internet café by two policemen the previous summer. The garish image of Said, head and teeth bashed in, circulated swiftly on the internet, on commemorative posters, and even as stenciled graffiti. A "We are all Khaled Said" Facebook page eventually became a focal point for organizing the demonstrations of January 25. Equally pivotal was the intensely telegenic footage of a boyish marketing executive at Google weeping on television at the height of the protests. Having been held for twelve days, in part for his role as administrator of the Said Facebook page, Wael Ghonim emerged as the Western-friendly face of the protesters. "I am not a hero," he opined to popular talk-show host Mona el-Shazly; "This is the revolution of the youth of the Internet," he said, then burst into tears. Ghonim's melodramatic yet extremely affecting public mourning pushed many middle-class Egyptians, previously on the fence, into Tahrir Square to join the demonstrations. Later, he would be hailed by Barack Obama as "the Google Guy." A $2.5 million book deal would follow, and there was even talk of a Nobel Prize.

In short, the screens of the world circumscribed Egyptians—the US-Backed Dictator, the Young Martyr, the Google Guy—into a passion play starring the aging Pharaoh and his defiant subjects. Media treatment of the events reduced the complexities of Egypt—Islamist, secular, Christian, rich, poor—into a neat storybook narrative. And Tahrir Square itself became a kind of utopian fable, a ground zero that was portrayed as miraculously clean, orderly, syncretic, and devoid of the violence, sexual harassment, or sectarianism one could vividly imagine taking place. The fact that the Egyptian revolution had been rendered an easily consumable one-liner was confirmed in the weeks following Mubarak's fall, as chief protagonists of global brand culture, from Pepsi and Coca-Cola to Egypt's two big telephone companies, cashed in on the radical chic of the demonstrations. Mobinil, for its part, festooned the city with billboards featuring quotes from the likes of Barack Obama praising the Egyptian people. Its competitor Vodafone produced a cinematic if not histrionic ad about "ordinary people" that implied Vodafone had played a role in the protests (even if phone companies had complied with state orders to shut off telecommunication in the early days of the revolution). Coca-Cola encouraged people to "Make Tomorrow Better" in an ad that featured purposeful twenty-somethings throwing hooks into the sky to pull back ominous clouds, allowing sunlight

to radiate over the gray city. And Pepsi boasted a similar spot that involved colorful paint being inexplicably splashed across the urban expanse, with the slogan "express yourself." This is to say nothing of the lo-fi revolutionary knickknackery that continues to dot the country's streets.

Egypt has long had a vexed relationship with the camera. In a country where images of donkeys wading in the Nile or of rubbish on the street have consistently inspired the ire of the censors, the state has fiercely controlled its public image throughout its modern history. (The warning MAMNOUA AL TASWIR [forbidden to photograph] is ubiquitous.) Public walls, museums, and monuments are characterized by anodyne postcard images of the Pyramids, of the October War victory over Israel, of broad-shouldered and steroidal nationalist hero Gamal Abdel Nasser. So the image of millions in the streets where previous demonstrations had been marginal, sullying the name of the president and calling for an end to his regime, destabilized any happy liberal, pro-Western consensus ("Egypt is not Afghanistan"). What was easily co-opted into media narrative or commercial cliché, then, was also undeniably *effective*—a logic of the image that had a direct and perhaps even causal relationship to the manner in which this revolution unfolded. Thomas Keenan has written at length about the problem of images as they relate to the discourses of conflict and human rights—the trouble with claims

reflect on the necessity of writing in a society which is either torn between tradition and modernity or devastated by civil war.

There is always the fear that the work of a dissident artist, or one too close to an unfolding "politics," compromises its aesthetic intentions; the fear that

form might become subordinate to content.

Instinctively, the artist sidesteps the problem of documentation, in which tragedy and atrocity struggle to take their place within the real too soon after their own occurrence and in which human memory is necessary to grasping the depth

and universality of emotion rather than the specificity of a particular event. Calm and collected reflections on these matters might help us meditate on past errors, which crop up again and again in a never-ending cycle.

After September 11th 2001, ideological traps constructed in

regards to Arab and Islamic countries have been an increasing focus of deconstruction for many contemporary visual artists coming from this part of the world. The lines of conflict between local traditions and globalization, liberalism and social conservatism, religious and ethnic groups are not as

about the ability of images to induce empathy or to demonize, to reveal or to mislead, to condemn or to exonerate; the trouble with our Enlightenment-rooted assumptions concerning visual knowledge and individual agency. In other words, as Keenan wrote in 2004, "What would it mean to come to terms with the fact that there are things which happen in front of cameras that are not simply true or false, not simply representations and references, but rather opportunities, events, performances, things that are done and done for the camera, which come into being in a space beyond truth and falsity that is created in view of mediation and transmission?" He continues, "It is now an unstated but I think pervasive axiom of the human rights movement that those agents whose behavior it wishes to affect—governments, armies, businesses, and militias—are exposed in some significant way to the force of public opinion, and that they are (psychically or emotionally) structured like individuals in a strong social or cultural context that renders them vulnerable to feelings of dishonor, embarrassment, disgrace, or ignominy." In contrast to this paradigm, Keenan has demonstrated that, as in the case of Bosnia, media exposure and accompanying attempts to "shame" do not necessarily lead to behavior change by rights-abusing regimes (for here was genocide in the heart of Europe that, as Susan Sontag famously put it, took place on television). But with Egypt so vigilant and even paranoid about

its public image, it is difficult not to wonder how many more protesters would have been sacrificed without the cameras faithfully tracking them. Had the eyes of Al Jazeera not lingered on Tahrir Square as they did, how much longer would it have taken Mubarak, in his catatonic state, to step down? Indeed, media narrative may have played the powerful role it did in Egypt in part because the country has long been the center of the Arabic film industry—an old hand at intertwining the production of information and the manufacture of myth. From the cinematic heyday of the 1950s and '60s up until today, most feature films, documentaries, and, later, music videos in the Arab world have been made in Egypt. And so, on January 31, when the characteristically diffident screen icon Omar Sharif called for Mubarak to step down, it seemed that cinema (or at least *Lawrence of Arabia*) had merged with real life more than ever. Days later, Sherihan, the Egyptian equivalent of Michael Jackson (for she is also a cosmetically enhanced, tragically fallen child star), famously visited the protesters. Before long, the production of dozens of revolutionary music videos began—shot in the same lovingly hagiographic manner with which the international news media had captured the protesters weeks before.

Cinema merged with real life once again on August 3, in the opening moments of what was hailed by many as the "trial of the century." In offering up their own form of justice, the

interim ruling military council that took over for Mubarak once again borrowed from Hollywood—a strategy that had served them well in the days leading up to the revolution. The image logic that had galvanized protesters via Facebook, signs, and television was here marshaled as obfuscating stagecraft. Close-ups of evidence placed in manila envelopes and cardboard boxes, along with an almost comically wry judge, recalled at once the strange moral weather of *Twelve Angry Men* and the wooden glamour of *Perry Mason*.

Outside the police academy in Cairo where the trial was taking place, the military council had installed a giant screen to satisfy those who had traveled to this barren patch of desert to get as close to the proceedings as they could. Al Jazeera, for its part, often split the screen in its live coverage, with the trial on one half and the image of Egyptians watching the trial—and, by extension, themselves watching themselves being watched—on the other. Television viewers around the world searched their faces for signs of anger, joy, satiation.

And many were satiated. The military council had managed, for the moment, to quell the anger of protesters through a gross form of judicial voyeurism. Never mind that, by the second day, the presiding judge announced that filming would cease. Never mind that Mubarak's defense attorney, the wily Farid El-Deeb, called for 1,631 defense witnesses—indicating that this trial was

clear-cut as the media often present them.

In this atmosphere, the few art projects that are worthy of note had been undertaken by a small number of dynamic and inquisitive individuals. They tackle the role of aesthetics when mediating larger political questions.

Contemporary artists from Mexico, China, Iran, Israel and Palestine, to name just a few, are not only creating complex spaces and temporalities that seek a newer audience; they are also working as anthropologists, cultural critics, ethical philosophers and photojournalists who are creating a textured world that

is rarely found in the popular media.

It would be just another instance where hasty judgments based on superficial observations, favour "imitation", "borrowing" and "influence" over the due formal, historical and philosophical analysis of the work, its conditions of

formation and its genuine stakes. These characteristics of the gaze preserve the condition, conserve, and archaeologize in advance.

At stake are issues of control, as people negotiate their place in society and as society attempts to regulate the individual. Here, on the other hand, it is hard to

just beginning and that any form of "justice" would be situated in some distant, opaque future. Never mind that at the end of that first day, cameras captured Gamal Mubarak walking out of the courtroom sanguine and smiling, shaking the hands of the police officers as if he knew very well that things would not end up so badly. Never mind. Egyptians have their pyramids, they have their film industry, and now they had their telegenic revolution along with this hackneyed parody of storybook justice.

If the Egyptian protesters were paradoxically aided both by the ubiquity of images and by the facile narratives attached to them, what of the other Arab intifadas that have sputtered on without such cinematic results? It is useful to look at Syria, where, at the time of writing, more than three thousand people have lost their lives in President Bashar al-Assad's brutal crackdown on dissent. Syria, without pyramids, the Nile, or a booming film industry, is not as iconic as Egypt. Nor does the revolt in Syria fit the outlines of the Egyptian revolt. Scattered between multiple cities, this revolution has no Tahrir Square where millions have collected. There are no Al Jazeera cameras documenting the revolution twenty-four hours a day. Intrepid Syrian activists have revealed that cameras provoke as much, if not more, distrust than arms, and precious few journalists have managed to last long. Little comes out of Syria beyond the occasional grainy cell-phone image. There

is no Google Guy, no Coca-Cola or Pepsi ad, and we don't know the names of the Syrian martyrs.

Of course, in Egypt, images alone did not topple the Pharaoh, nor did the social media fetishized by State Department staffers and Silicon Valley digerati alike. (This truth is perhaps best evinced by the fact that the most organizing activity occurred around January 28, when both internet and phone service were cut.) Yet, if Egypt's political relationships to the rest of the world (not to mention Syria's) will inform to what extent and how images animate that country's struggles, those images, however partial, can still be uncommonly potent—and are rendered even more effective when they are familiar, cinematic, easily consumed. The Syrians may very well shed the yoke of dictatorship, but it will certainly take more time than it did in Egypt.

The iconic depiction of suffering and crisis is an image regime as old as My Lai, or Walker Evans, or the Ottoman conquest. And yet what confronts us now is the possibility that the image—or, more precisely, its "mediation and transmission"—is all we have to register, diagram, and help us attempt to understand the realities erupting from afar. In late October, the dual spectacularization and efficacy of the image once again became evident as news broke that fugitive Libyan President Muammar al-Qaddafi had been captured. Within hours, images of his blood-soaked, geisha-

faced form, dragged out of a drainpipe and held up like a spoil of war, were revealed in a harrowing video taken by rebel fighters. With cues worthy of an action movie, the video depicts al-Qaddafi's ebullient captors pumping him full of bullets, all the while chanting, "Allāhu Akbar," or "God is great." It is remarkable how many news outlets defended their decision to show this gruesomeness on the basis of the news cycle in the digital age. "These images are the very definition of *news*," Jeffrey Schneider, an ABC News spokesman, remarked blankly. The American-led NATO mission that unseated al-Qaddafi, in the meantime, declared "Mission accomplished" against the backdrop of this disturbing, news-manufactured western starring the heroic rebels. Beyond the old postmodernist update of the empiricist question— Does a dictator die if no one is there to see it?—the al-Qaddafi episode indicated that the image was not only mythic but also performative, an enactment in every sense of the word. A silent pact emerged between those wielding the cameras and the viewing public. In the terrifying and confusing video of al-Qaddafi's last seconds on earth, the only other spoken words that reveal themselves as clearly as "Allāhu Akbar" are "Soora, soora." "Photograph, photograph" is the only thing left to say.

identify who, or what, is being exploited.

The exhibition seeks to emphasize diversity by questioning the use of artists' origins as the sole determining factor in the consideration of their art.

In their works, they emancipate themselves from local social and political restrictions, while at the same time taking a position on their "orientalization" by the West. In a plastic vocabulary that oscillates between minimalism and the aesthetics of density and dangling, it is a system of hypotheses constructed within an often volatile creation.

Modern aesthetics secularize and essentialize the border, in which, once set as absolute, confronts the forces of negativity, and translates this confrontation into the aesthetics of the sublime. It is one thing to dominate by exercising authority, quite another to enact the power of life and creativity.

However provisional these boundaries might prove, they assume the countenance of certitude at a given moment, and need to in order to be readable as such (their moments of transformation are often understood as crises, as described above). In its original conception of a synaesthetic totality, it was conceived as an answer to an irrevocable stigma, which characterised art:

THE GAZE OF SCI-FI WAHABI: INTRODUCTION

SOPHIA AL-MARIA

2008

"Is this science fiction? Yes. But up until now all environmental mutations derived from an irreversible tendency towards a formal abstraction of elements and functions, their homogenization into a single process, as well as to the displacement of gestural behaviors: of bodies, of efforts, in electric or electronic commands, to the miniaturization in time and space. These are processes where the stage becomes that of the infinitesimal memory and the screen."
—Jean Baudrillard

So is this science fiction? Yes.

But this is also a romance in miniature and a catastrophe at large. The things you'll see and read are both strange and beautiful: a cavalcade of technology, theory, and history presented in approach to a poetic and ironic analysis (as prescribed by J. B.) of the contemporary Arabian Gulf: a region acting as uncanny preview of long-imagined futures/nows where love is mediated by mobile and death conquered by camera.

Built on the retreating sands of reality and increasingly submerged in the unreal, the Gulf has become a place where individuals are forced to fracture their lives into multidimensional zones of illusion and reality. Squeezed by the intense hyper-pressurized conditions of life in the Gulf, by puberty, young girls have stepped into their black *abayas* already diamond-cut: multifaceted and many-faced. Worn veterans of poly-existence, they effortlessly navigate the complicated culturally specific binary code of public and private, truth and lies, me and you.

Of course, this has always/already been told in abstract prophecies by the champions of inner space (J.G. Ballard, P.K. Dick, H.I. Sabbah, F.M. 2030). But now it is a multi-staged/thousand-plateaued plot being constantly related via invisible webs of communication in simple images by real beings with "effective motivations" and endless resources. Optimistic futurism has faded into an apocalyptic narrative informed in equal parts by Islam and postmodernity. We can read this narrative in the vast and undulating mass of media that blankets the Gulf, painted in broad strokes by the thin brushes of personal media recorded on mobile phones and laptop computers.

As of November 2007, 3.3 billion people had mobile-phone technology. That's over half the world's population. It is by far the most widespread and common communication technology in the world. Most of those mobile-phone owners/sharers in the case of many in Third World countries have Bluetooth capability. What this means is that half the world has access to anyone's handset and files within a one- to one-hundred-meter range from their person. These are called Wireless Personal Area Networks or PAN. This web of Personal Area Networks is used to wirelessly and seamlessly connect individuals. It is a "haptic" space in the same way that Deleuze and Guattari termed cyberspace. It is a network only apparent from a distance, like a mirage in a hot and shifting desert. "One never sees from a distance in space of this kind, nor does one see it from a distance. No panoramic view is possible, for the space is always folding, dividing, expanding, and contracting."

Needless to say, this has created an influx and boom in file sharing, particularly in places where users are less likely to have a computer than a mobile to watch or listen or create media with. But on top of the technical and economic ramifications of this rather sudden blast of connectivity is the massive personal production of media for these PANs. In a region like the Arabian Gulf, we can see a fascinating (and utterly weird) crop of video files that are being shared across national borders, across sexual boundaries, and across age groups.

And despite the cultural signifiers inevitably present in these videos such as dress or music or facial features, they somehow manage to be culturally universal. To watch them is to understand.

The big shift that has happened is less to do with content the stigma of art's own fictionality, by means of which it is separated from reality.

Today technology has made possible a plurality of artistic practices that continue to challenge the notion of the work of art itself. History in the making is an interesting concept in this regard. This is a place where people understand that time is of consequence, and they witness that in "real" time. The present tense seems to be contributing towards futurity or time continuum. Reality and timelessness collide in a clash of times and spaces. Concrete but also invisible blockages are currently being broken.

The groundbreaking exhibition features thiry-five artists living and working in Iran alongside twenty-one others living in the Diaspora. A dramatic pageant which, as a painterly feat, is tantamount to a certain Babylonian process of stacking and towering: a sundry of everyday objects, of disparate things including suitcases, cartons and mysterious strongboxes; shoes, coat stands, jackets, veils and mounds of coal; trumpets or old radios, are thrown together onto the barren desert of his rashly applied painting grounds. These works question Lebanon today, which is more disconcerting and intriguing than ever.

of the media than with the collapse of two platforms of visual consumption: the socially shared/mandated/public broadcast of television and the secret/pirated/specialized/private world of black-market, dubiously sourced video. These new artifacts in .AVI and .MPEG present a movable feast, flickering on the tiny handheld screens of absolutely everyone. It is a thoroughly cross-generational, non-gender-specific obsession.

This emergent mobile media is becoming increasingly intrusive. It probes the most private and illicit (orgies, cross dressing, drugs) along with the mind-numbingly dull (computer tutorials, baby pictures, blurry street shots) aspects of Gulfi life. This trajectory towards inner space via culturally modified technology runs directly in line with J.G. Ballard's prediction of narrative fiction dying at the hands of everyday vignettes related to audiences on cassette and videotape. Of course, at the time of Ballard's essay "Which Way to Inner Space?," Centel had yet to put their early mobile prototype on the market, let alone add a camera or Bluetooth capability. However, Ballard, great lyricist of the mundane, manages to envisage a science-fictive subject matter far ahead of its existence. Ballard's imagined inner-space science fiction could as easily be captured on a grainy .MOV file as it is expressed here in his words, "The gleam on refrigerator cabinets, the contours of a wife's or husband's thighs passing the newsreel images on a colour

tv set, the conjunction of musculature and chromium artifact within an automobile interior, the unique postures of passengers on an airport escalator." Such is the stuff of new and interesting science fiction for Ballard and it exists in abundance around the Arabian Gulf where image and video proliferate indefinitely via the boundless viral web of mobile-phone culture or as the handsets are called in Arabic: *jawal*. These files know neither sex nor death though they often provide the subject matter along with the more humdrum. "It is for this reason that they obsess us in this period of recession of sexuality and death: through images we dream of the immortality of protozoa, infinitely multiplying through contiguity in an asexual chain of progression." This spontaneously unfolding progression of images Baudrillard speaks of has, in fact, taken up the service of plot in the Grand Guignol and apocalyptic farce that the Gulf is enacting now. Each file is a mini act, chapter, and verse unto itself. A small notch in a greater story being acted on countless LCD theaters in the palms of an enthralled and participating audience.

Since the pre-Islamic *Jahilliya*, the Gulf has been home to prolific chroniclers and great poets: "The mediator-storytellers, through whom truth is summoned to unwind itself to the audience." But unlike many of the great narrative traditions, our bards skipped the formality of the written word

and jumped directly from relating aural tradition in poetry to living AV possibilities through their top-of-the-line and standard issue *jawal*. In Dammam, Doha, and Dubai, the phone-cameras are always capturing and the Bluetooth always on. The collectively sung and recorded epic is told unsentimentally by a million faces on a million screens, each outfitted with the tool to tell (the *jawal*), but stripped of the ability manipulate fate or change the conclusion.

The last event that went unrecorded by the *jawal* was the moment of collapse. The cameras weren't rolling when the colossal gravitational force of the Gulf's ancient cultural/spiritual/technological platforms bored a hole in reality. The volatile forces of a regressive Islam, foolhardy futurism, and sudden wealth jettisoned the oil states through this fresh temporal portal into a prophetic unreality at the edge of our end.

Although cyber-levels rise around the globe as our understood reality melts away, the Gulf, being a flat desert plateau at the edge of a vast simulacra-sea will be the first to be completely immersed. But the boundaries between the real and unreal already exist seamlessly there, ungraspable, but mediated through various types of screen (tinted window, *niqab*, LCD) and hidden by the shadows of privacy, propriety and law. Outside of the abstracting hothouse of the Gulf, these same boundaries are cast under bright analytical lights and

We didn't know if we would find enough artists to fill the space, but it was far easier than we thought. The result is a multifarious portrait of fifty-six contemporary Iranian artists challenging the conventional perceptions of Iran and Iranian art. Located at the intersection of Chinese, Indian, Turkic, Iranian

and Russian worlds, as well as in the zone of interaction of four world religions, Central Asia has always been an arena of métissage. The final result, whether installations or simple two-dimensional photos, offer the visitor the chance to reflect on the profound global transformations which are currently taking place.

It includes pieces by about eighty different artists, some of whom are represented here. It is truly a mass of sordid debris piled up amidst a pictorial desert that looms wavering before the beholder. It does not matter whether this is an act of profanation of ancient sacredness or sacralization of today's

profanities. The historical picture that emerges is at once powerful and level-headed, political and unbiased.

The exhibition's point of departure is the space itself. But these are not simple boxes open or closed. Each unique and complex shape plays with an ambiguity of interior and

resultantly cannot attain such unchecked fluidity.

Secret subversion of rigid public rules and stilted conversation has resulted in the very separate flourishing of private worlds and the blossoming of rich interior lives, which would not be nurtured in any other situation. Freed from the regulatory bounds that prevent real-life sex and death from occurring, the images born from these infinitely creative intimate inner spaces circulate as privately public. Without the proliferation of a device (the *jawal*), which made clandestine communication possible, these secret worlds would remain largely unexplored despite their rich theoretical resources for the mapping of our trajectory out of reality.

This is why the Arabian Gulf is unique in the world as a floodlit, pressurized stage of the imaginary, and birthplace of the very hole that caused its still recent conception. It is an infuriating abiogenesis that haunts all discussion around the Gulf, fueling what Baudrillard called an "obscene rage" to unveil truth. "The more one nears truth, the more it retreats towards the omega point, and the greater becomes the rage to get at it. But this rage, this fury, only bears witness to the eternity of seduction and to the impossibility of mastering it." Just as Orientalists were seduced and subsequently obsessed by what lay beyond the veil/garden-wall/ Mecca, now, we court speculation over what lies beyond reality: an imaginary visualized easily

on the brittle science-fictive pulp of today's 'Ole Araby.

The pulpy stock on which the story of the Gulf is printed is a mottled mesh of disappearing boundaries between the human and inhuman and the limits of life and death, which has "turned our world into a world beyond." And as Baudrillard terms it, the pages become "the site of total superstition." Perfect for a the maudlin end-times farce of the Arabian dream: "A resplendent bazaar of repacked times and spaces (history and geography) to be encountered and consumed with an Edenic simultaneity... the infusion and diffusion of hyper reality into everyday life." The exploration of inner space and the conception of a Gulf third space à la Edward W. Soja's Los Angeles.

J.G. Ballard once said, "The cataclysmic tale is the most powerful and mysterious of all categories of science fiction," and as "there has clearly been no limit to our need to devise new means of destroying the world we inhabit." The Gaze of Sci-fi Wahabi will also be a sensationalized telling of the Arabian Gulf at dusk on its thousand-and-first night, the eve of Armageddon, the end of time.

Our latter-day Scheherazade, Sci-fi Wahabi, is suffering from amnesia, exhausted by her quantum leap through time, terrified of the dawn, and readying for That Which Is Coming. But, being a fearless myth-correspondent, she relays images and video to us from the edge of time: right now.

The nocturnal poetics hidden in these grainy videos hate to be exposed and shrink from examination, but for the sake of our story, they will be probed into opening up. I'll invoke Ballard once more to elucidate Sci-fi Wahabi's intentions in transmitting the seven videos attached with this project from the inner reaches of inner space:

"Each one of these fantasies represents an arraignment of the finite, an attempt to dismantle the formal structure of time and space which the universe wraps around us at the moment we first achieve consciousness. It is the inflexibility of this huge reductive machine we call reality that provokes infant and madman alike, using his imagination to describe the infinite alternatives to reality which nature itself has proved incapable of inventing."

Everything Sci-fi Wahabi relates to us in these videos is part of a larger global satire and all of a local farce. It is a musical, a tragedy, a family saga told in .AVI and .MPEG. It is a project culled from amateur Bluetooth biometrics, a leap of faith and stupidity over the vast gorge of cultural theory and speculative fictions.

It has a cast of millions and a budget of billions and is the serialized tales (in words and video) of what brought the Gulf to the cusp of history, through a shimmering warp in time and why the region IS the perfect stage and ideal host to the topsy-turvy variety show before Baudrillard's high-kicking grand finale: exodus from reality.

exterior. Like the chance circumstances of life, corners turn in surprising ways.

The names literally disappear and appear in the room, thus marking the white cube gallery space as the condition of both the visibility and invisibility of the artist as a figure with a name, a history, and a biography.

The room stands as an object lesson in which the brief and illusory unity of curation is collapsed by the business of running a commercial gallery. This way the objects lose their common use, de-functionalised in the construction process— perforated, cut up, twisted, tied up by wire, etc—for acquiring a

sometimes awkward and pure aesthetic and decorative effect, as the colours and the materials coalesce.

What remains is the freighty warehoused and packed-up quiet of the things themselves, which elocute their own exposed private lives, but in no way recklessly disclose them. A sublime gap is given

a concrete content: the faceless sublime suddenly acquires a face, and the grand gesture of metaphysical presence is revealed as a technique in which the particular is sublimated, and indeed ideologically "masked" to provide an image of a border-condition that is to be experienced as universal and transcendent.

ETHNIC MARKETING: INTRODUCTION

TIRDAD ZOLGHADR

2007

THE STAKES

How to assess the emergent vicissitudes of the gradually "globalizing" art circuit without repeating the curatorial clichés of recent years. Having watched one example of critical internationalism after another reduce itself to postcolonial platitude or self-congratulating adventurism, I framed this project as an inquiry into Euro-American xenophilia in and of itself. Rather than try and build the proverbial Third World "platform," or "forum," or "bridge," I'd like to know what makes the bridging so attractive in the first place. Who stands to gain from searing critiques of the North and Northwest, and upholding the aims of the East and South.

One main problem here is the dearth of terminology. If art and artifacts are traveling at higher and higher speeds, the terms and methods we use to think through these movements are still indebted to the protonationalist roots of the Western humanities. In any discussion of artists or issues framed as "non-Western," myths of Authorship, Authenticity, Culture, and other superstitions declared dead and gone since the advent of poststructuralism, resurface in a manner that is surprisingly naïve, almost endearing.

A particularly interesting and unresolved tension here is the contradiction between formal analysis positing a degree of artistic autonomy, and the premise that art always testifies to a sociocultural context. If art is a Euro-American tradition per se, how can it be globalized without a reasonable amount of epistemic violence? And if it is irretrievably enmeshed with context, like milk and espresso in a Starbucks latte, how to explain the miracle of art being immaculately conceived all over the planet in a comparable way? Though we cannot jump over our own intellectual shadows to answer questions of such pretentious magnitude, we can, however, take a good look at the xenophiliac fervor that fuels and complexifies them.

TURNING BARRIERS INTO SALES OPPORTUNITIES

Tellingly, the context for this growing mobility on the art market—a mobility that is halting yet, with only ca. 4 percent on the international market stemming from non-Northwestern artists—is accompanied by an unprecedented degree of global economic inequality, coupled with ever louder accusations of multifaceted Euro-American expansionism. Which renders the overall shift of critical attention towards ethnic, culturalist, and "civilizational" obsessions rather ironic, and might imply a necessity to revisit questions of economic hierarchy instead.

It is becoming ever more plain to see that the West is not a mere observer of globalized cultural flows, but, just as any other demanding client, actively defines the supply. Which aesthetic and intellectual strategies might be used to deal with hegemonic structures of the kind? To state the obvious, a number of artists and intellectuals worldwide are quite comfortable with the idea of using mainstream Euro-American expectations to their own advantage, but only a few are in a position to do so.

Western critics and curators, now expected to come to terms with vast quantities of work from geographically removed contexts, are becoming dependent on a small handful of willing players with a foothold in global centers. As some have put it, these exclusive networks are leading to a practice no less arbitrary than the art-historical autocracy of the Eurocentric Trained Eye.

XENOPHILIA

As Michaela Kehrer describes in her essay, Ethnic Marketing in the most common sense of the term refers to the practice of pinning down the taste and buying power of a given non-White minority. In this context, it is relevant not only as an example of commercialized representations of various Others, but also in that it picks up on collective patterns of intercultural consumption in the West. For all its hair-raising stereotyping, the benefit of Ethnic Marketing is that it addresses the importation of goods, emblems, and contents

It grants the artist, paradoxically, a parallel reality where nothing is necessarily as it seems and where they find a refuge for their exquisitely coded expressions. Here, each element acts as a metaphor. And the artist has no intention of hiding her purpose since everything is contained in the title;

we are entering an artificial world.

Nothing, therefore, in this unbearably violent moment is true. The images running before our eyes are not what they claim to be, and we must look elsewhere, in ourselves, to grasp if not the truth—a very controversial notion—then at

least the echo that is awakened in us.

In a suspended, void space, somewhere between absence and presence, nostalgia and déjà vu, the installation explores an anxious and obsessive state of being, a scattered condition obscured by repetition, forgetfulness, and the subsequent feelings

of impotence and frustration. There is no separation between what is called heaven and what is called earth, between reason and instinct, between what is high and what is low.

We have seen that this work has its own reality and is independent of any point of view or privileged space. The entire

strictly in the light of economic premises, as a question of supply and demand, far from misleading stipulations of authenticity and integrity.

As Kehrer puts it, marketing is experiencing "a shift in meaning, away from product towards the consumer." During discussions with Ethnic Marketeers, particularly with Turco-German agencies in Berlin, I was struck by the eagerness of corporations to fine-tune into "specific cultures," and the tendency among their marketing agencies to frame "ethnic" advertising and collective consumption as a collective step toward emancipation. But I was equally fascinated by the familiarity of the debates regarding strategic essentialism and self-othering, debates and issues that are all too similar in many parts of the international art world.

In sum, the crux of the project at hand is to critically assess Ethnic Marketing practices—to then flip the objective on its head. The target ethnicity, or, if you will, the strategically ordained essentialism, is not an Eastern or Southern minority, but the West, the Center of the Real itself. How does Western xenophilia work? What does the Euro-American art circuit wish to buy, and why does it wish to do so? And what advantages might one derive from such consumer cravings, such intellectual hopes and aesthetic desires?

IDENTITY BAZAAR

NAV HAQ
2010

It's easy to imagine that art revolves around parties. There's always so much to celebrate—exhibitions, refurbishments, acquisitions, patronage, and lifetime achievements, among other things. Institutions most often play host, organizing receptions, galas, and previews for all these various occasions. And indeed, it's always a privilege to be invited. Vernissage parties (and after-parties), which celebrate the opening of a new exhibition, are the most common variety. There is the finissage, to celebrate the end of an exhibition, and apparently even a midissage. There are occasions to acknowledge the good work that museums are doing, housewarming-style parties to mark the opening or reopening of an institution, award ceremonies, fêtes for anniversaries, and crucial fundraising galas. They're all part of the social economy of art. But when does celebration itself become problematic? When does it go too far?

I find it fascinating how certain words appear in particular contexts time and again. In the not-too-distant past, I lived in South London, where it wasn't uncommon to come across the word "vibrant" in newspapers, local council literature, and elsewhere, to describe a district of the city such as Brixton. What "vibrant" really meant, of course, was that a lot of black people lived there. Such areas might be a bit "edgy" for some, but the locals are surely content, making plenty of "noise," selling colorful fabrics and exotic fruits. It follows from those details that they're always ready for festivity.

Art institutions have their own special lexicon for when they work with artists (and, occasionally, audiences) who sit awkwardly within their traditional curatorial frameworks of practice and reference. The word "local," for example, represents another somewhat discourteous term, invoked when an institution wants to communicate to the world that it does, on occasion, work with less-established artists. "Voices" is yet another common term, applied to so-called Third World artists, evoking frail, human, emotional stories from the battle-scarred, crisis-ridden outback.

But the word "celebration" is something else altogether. Normally found in either the snappy opening paragraph or the pensive last paragraph of press releases and exhibition guide texts, it's a word often used with regard to foreign, predominantly non-Western artists, especially as gathered together in the ubiquitous "regional representation" exhibition. The type of celebration here, more akin to the surprise party, is sprung on groups of artists hailing from the same country or region, who have succumbed to exhibiting together

world is revealed to you as an almost-foreign land; even the topography of your own hand is at once mysterious and familiar.

The visitors in the installation are enveloped by an absolute darkness that is disorienting and deprives them of the usual certainty of the everyday. The darkness of the space is enlarged

into an imagined infinity by the sound, as the distance overcome by the voices we hear at the moment appear immeasurable. The ground and the walls are bedecked with primitive drawings. The show is performed without an audience.

As you enter the exhibition space and examine the images

of ware and commodities and sexed-up cartoons on the walls, you circle around a shiny black box in the center. It stays in the background, emphasizing the place in which it is situated and the person who is looking at it. Any view into the impenetrable empty depths is misaligned as though belonging to Kafka's

attics; no option is left but to linger among an imposing heap of motival clutter. Scenes form and reform around you, yet at your center, you feel an intense calm.

The unusual metaphysical silence of this work has the effect of making the images explode, giving them epic scope.

in this anachronistic yet tenacious format.

For artists, having your exhibition billed as a celebration must be a bit like encountering one of those flash mobs, where everyone seems to be in on the same joke, except for you. The general tone is radically different from the norm, creating situations in which the pecking order between institutions and exhibiting artists becomes excruciatingly transparent. The message translates, roughly, as "Congratulations for making it this far!" To the public, artists are portrayed as happy-clappy ethnics—expressive beings, always grateful, always ready and waiting for a carnival to break out in the self-conscious bourgeois museum.

More prolific artists are surely bemused to find themselves generating so much fun around the world. *Why is it that when I'm with this particular grouping of artists someone always throws a party?* (The fact that artists exhibit alongside the same peers again and again is a different, though not unrelated, issue, one we'll set aside for now.) As with any surprise party, a lot rides on the reaction of the honoree(s). When the lights come on, some artists recoil, while others revel in delight, lapping up the attention, perfectly happy to perform for their patrons. Both responses are unfortunate in their own ways.

I'm no killjoy; celebrations are often important occasions. They're markers for reflecting on how far something has come, and for projecting ambitions into the future. Internationalism in contemporary art is often about celebrating difference, unlike market globalization, which is about striving to harmonize the machineries of communication, economy, and mobility. For globalization, this harmonizing offers, at the very least, a kind of technological lingua franca. In the art sphere, the acculturation occasionally yields the sense that we haven't quite discovered our own common language yet (other than the prerequisite ability to speak English, that is). It's when celebration dissipates any attempt at criticality and intellectual relations that it becomes a problem.

Having been present at the openings of many of these sizeable group exhibitions and festivals—including, for example, "Africa Remix" at the Hayward Gallery, London, and the "Images of the Middle East" festival in Copenhagen—I've witnessed, if I'm to be particularly severe with my analogies, a present-day form of bear dancing, with foreign artists performing before appreciative crowds. Often, these openings have a Putumayo vibe, as was the case at the opening of MoMA's "Without Boundary," where exotic canapés were served and live bands evoked the sounds of acoustic Arabia. For an artist of conscience, it's a serious dilemma: either turn down such exhibition possibilities and risk losing high-profile opportunities for supporting one's artistic life, or agree to such exhibitions and subscribe to an unsolicited identity. When embracing the latter, there's no better time to assume the ethnic mantle than during a good party.

IDENTITY BAZAAR

NIDA GHOUSE
2010

I spent a stretch of 2008 landlocked in Cairo, not too far from an art scene in which news about international contemporary art shows, especially those of the survey-seeking-to-be-seminal sort, would trickle in and turn into discussions about the claustrophobia of catchall categories such as "Arab" and "Islamic" art. These rants would be directed at the contemporary art condition that caters to a vaguely defined concern for "the region" (curatorial attempts to understand or engage with the Middle East seemed, for one thing, to falter by reducing all matters of culture to political crises). In this context, artists often felt straitjacketed into identities they didn't always care for, much less ask for.

At a symposium on the occasion of PhotoCairo 4, artist Raed Yassin declared that he had been turned into a "war-artist product." Sometime after the summer of 2006 in Lebanon, when he realized that he was only being asked for works about postwar Beirut, he opted to assume the "war artist" tag and

This silence is not a mere lack of sound, as in silent films, but a plastic, expressive, poetic silence. It is the means of making the leap into an absolute, timeless space, far from logical reasoning.

As you continue to watch, those other sounds start to feel oddly familiar, almost anticipatory. Everything is still and yet you seem to see the molecules rushing like pixels to compose that stillness.

As soon as the visitors enter the hall, they are able to control the amount of illumination of the light bulbs by means of the volume of their voice. If they speak at a high volume, the lamps illuminate brightly, thus overshadowing their image projected onto the same bulbs, fuelling a power struggle between the viewer and the system.

The project included many levels of multimedia, starting from projections within an installation that were fuelled by an interactive live performance between the visitors and the artists throughout the duration of the exhibition.

The work consists of a tempestuous, erotic belly dance performed for the camera by a male dancer. The viewers are invited to interact in an audible dialogue with the artists. The dialogue is captured by microphones and processed digitally

see what would come of it. He made a work in this vein while in Switzerland. Describing a true incident in which a missile destroyed his Beirut apartment, he extended the anecdote into an outrageously dramatic fiction-alized narrative involving a pop singer and a party.

What Yassin was most sur-prised to discover was the built-in-plausibility of his tale as he performed his war credentials; the work was well received, and just about everybody believed it to be true. Of course, his mode was mostly mocking, but where the compulsion originated was far from comic. He was deeply dis-turbed, for he felt that the avenues available to him for artistic expression were dras-tically shrinking. He found it difficult to show some of his favorite pieces—ones that were important to his practice, like the one he had playing in the background during his talk, titled *Tonight*—simply because they didn't conform to prevail-ing preoccupations.

I moved back to Mumbai in 2009, and the context in that city was a bit different from the Cairo scene. India and its bold economic attitude had been in vogue for about a decade, and the art market was dealing with the aftermath of having gone manic. Through those boom years, many artists had played to the demand for their ethnic-ity and catered their production as such.

In an art scene wracked with identity opportunism and the lure of the lucrative, the more morally inclined might raise

the charge of complicity, insisting that the only way for artists to salvage something of themselves would be for them to stay home, resisting the imposition of those terrible terms, which relegate them to the role of cultural contrac-tors. But the futility of such a position lies in the failure to recognize the pervasiveness of a structure that—all the pretty prospects of cultural policies considered—seems to be firmly in place. The first thing to face, then, is that if the bazaar is found to be ubiquitous, withdrawal ceases to be an actual opinion.

Those who would seek to pack entire subcontinents into the confines of a couple of white cubes are invariably undone by their ambitions. International curators come to a region to carry out combing operations, and even though they scan the scene quite stringently at times, they often settle for a cast of usual suspects to provide the iconography for their museumization of that region. Even the most benevolent of biennials suffers from an insularity whose preoccupations can't seem to move past the postcolonial.

Thinking about these things, I recalled a conversation that I had with Sherif El Azma about the day he opened his cupboard at his studio in downtown Cairo to find his 2004 *Kenya Tapes* still lying there. The videos had been left there for a while, ongoing, overlooked, excluded. At that time, Cairo was still considered to be part of the Middle East—North

Africa hadn't entered the dia-logue just yet.

Well, it has now.

Works that land outside the circuits of consumption are ultimately powerless; if they don't find an audience for themselves, they can have no impact, they don't matter. Given that the market is everywhere—this is my take, anyway—their failure to get commodified, to attach themselves to an ethnic or national agenda and offer themselves up as art objects in that way, keeps them from entering the public view. This forecloses any claims of the works' actual autonomy. Brave as they might have been at birth for not conceding to market control, they still don't seem to stand on their own, and require the consent and courtesy of exhibitions to walk them out as "emerging" into the world and put them into circulation.

But despite the absence of these works in the global art scene, their ontological exis-tence as contents of a cupboard is crucial, given the current condition of ethnic market exhaustion. Even as they lack visibility, they possess a strange tension that is, at the most basic level, a covert confrontation with a flawed cause. Their infidelity to the notion of a fixed or fitting identity gives them the elastic-ity to move across and outside the constraints of categories. It is precisely for having fallen in the fissures that these works act out an aching and even arrogant ambivalence toward the market that couldn't

by the artists. The data was then transferred wirelessly to the computer that projected it onto a large screen with a graphic grid and geometrical coloured shapes that changed in accordance with the physiological changes in his body as he moved, creating an interactive relation between the living body and the digital system

in an aesthetic manifestation of colour and shape. A particular strength of the work lies in the way it superimposes the social and geographical divide over the image/voice divide, creating an overlap in the formal unity of the artwork. This transposition, however, is not a synthesis. The object that is intended to carry

the voice is instead placed on the ground, visualizing a response to the danger of speech act as a seizure of power over the masses.

The viewer could then choose to push the letter assigned to him and project it onto the other screen by swinging his head to the side in a process that could include several viewers who had

to synchronize their movements to compose coherent words or sentences onto the opposite screen.

Most viewers, accustomed as we are to cinematic sound mixes that create an impossi-bly perfect point of audition by piecing together separately recorded sounds, do not notice

capture or contain them. In this state of suspension, the extent of their power is not limited, but latent, ambiguous, and unknown. The question, then, is how these works are found, how they slip into view, what structures they stand on, and what mechanisms they employ to enter and trouble the dominant world.

WORD INTO ART: ARTISTS OF THE MODERN MIDDLE EAST (REVIEW)

HASSAN KHAN
2006

"This exhibition brings together the works of over 80 contemporary artists from the Middle East, North Africa and beyond. Whether living in or away from their homeland, the art they produce shows strong links with their artistic heritage." So we are informed by the wall text at the entrance of the "Word into Art" exhibition (subtitled "Artists of the Modern Middle East") recently on show at the British Museum. Underneath the text, photographs of the participating artists were placed in rows, with their printed names neatly identifying them.

The (if one is to be kind) misguided curatorial decision to introduce the exhibition in this format underlines

the problematic nature of the endeavor. Grand and general statements are made about both art and artists (culprits pinned to the wall, members of some tribe deciphered for us through the lens of anthropology), a specific unified and fixed artistic heritage is presumed, and maybe most problematic is the absolute assurance that what they produce (not as individuals, but as representatives of the Modern Middle East of the title) is strongly linked to that heritage. For the Middle East, the argument goes, will always remain in thrall of an imagined tradition, hypnotized by a past that gloriously recedes, static and fixed, while the cultures of other regions become the harbingers of modernity and development.

We are informed that most of the works are from the collection of the museum, whose policy since the mid-'80s has been to collect modern art from the region—as long as it possesses a textual element, and therefore may be tied into their collection of (admittedly fine) Islamic calligraphy. Other than the obvious lack of sophistication of such a curatorial approach, its passive acceptance of a Victorian model of linear history, of cause and effect, of essential identities, and the apparent confusion between art as a self-conscious conceptual and intellectual practice and art as an essentially decorative skill, it is also a model that denies its subject—in this case, modern art from the Middle East—the possibility

of functioning within different (more generous, less restrictive) genealogies. It thus places severe restrictions and limitations on itself as a collection, while laying totalizing claims to the corpus of work that it possesses. This is obviously an approach that excludes a tremendous amount of the most interesting and dynamic work being produced at the moment. Such fallacies are typical of an arrogance whose sole redeeming factor might be that it is blind.

This is a highly condescending exhibition, where artists' works (regardless of formal quality or conceptual underpinnings) are used to demonstrate a specific thesis about the region. The dominant metaphor at work here is that of "possession"—a collection of glamorized artifacts whose function (symbolic value) is to normalize and validate specific ideological (dare we say racial?) agendas; the "Middle East" is an essentially unmodern place, its relation to modernity derivative of Western influence and only accessible through some kind of reaffirmation of a basic predetermined identity. The exhibition's linear progression through four numbered sections—Sacred Script; Literature and Art; Deconstructing the Word; and History, Politics, and Identity—clearly resonates with the essentialist implications that seem to prefigure the exhibition itself.

Other than the inane nature of such generalities, these are headings that give us, the viewers, easy access to what

breakdowns in the vision-audition sync relationship unless they involve dialogue spoken by a body whose mouth is visible on screen. The viewers have to choose either to remain silent and let their personal image appear or to produce any sound, making their image disappear in the great brightness of the

lamps. Speech, in fact, is always historical, while silence is outside history, in the absolute realm of images.

The room was enclosed in transparent plastic sheets. But the world beyond the glass looks a little different. The scene is both inexplicable—where is this place, what will happen to that

bulging bag, and what does it actually contain?—and painfully clear.

This situation shows the strategic importance of philosophy as a sphere for thought situated behind and under all activity. Video cassettes, antenna cables, protective helmets: these technical materials, simple and

common, are transformed and re-created into plastic vocabulary. This myriad of heterogeneous objects and materials interact with the painted surfaces and painted figures: heads, faces, the human body and body parts.

Kaleidoscopic images create an unbearable tension between

must seem to be traits of a specific cultural landscape. This approach leans heavily on a classical anthropological model, where the works become examples of a cultural landscape, alienated from the viewing experience, a foreign Other to the art object, trophies from faraway cultures. The progression from the sacred to history and identity inextricably links these concepts to a chain of causality that frames our viewing experience. The works on display are supposed to reflect some essentialized truth about that culture. Last but not least, it is important to point out that the title of the exhibition makes one more totalizing reduction: that this is an essentially and historically artless place (that old cliché: Middle Eastern cultures have to discover art by transforming their mainly literary heritage through an interaction with Western culture). All aforementioned points are underlined and enhanced by the plethora of Qur'anic verses, Arabic sayings, and lines of poetry (translated into English and calligraphically rendered on the walls) that punctuate the exhibition.

It thus comes as no surprise that this is an exhibition that succeeds in bringing together all the worst traits of the state-sanctioned, mainstream decorative art produced in the region. Ironically enough, it is the region's nationalist, state-sponsored productions that most neatly fit within the British Museum's perspective. Abstract calligraphic doodles and (the ever present) Sufi references are surrounded by megalomaniac colorful sculptures that would fit quite nicely in the gardens of the Creativity Center in Cairo. Faux naïve village scenes and Bedouin happenings are framed by the more tasteful pop-orientale of Chant Avedissian's glamorized nostalgic wallpaper, as well as the decorative melancholic, which seems to be dominated by Iranians like Shadi Ghadirian, Bahman Jalali, and Malekeh Nayiny. Although the stalwarts of the modernist scene (of different trends and countries) in the region are present—such as Rachid Koraïchi, Mohamed Abla, Youssef Abdelke, Shafic Abboud— the exhibition also attempts to cross ethnic and regional boundaries by a few representatives of non-Muslim culture: the Japanese Kouichi Fouad Honda and the (unproblematized) Israeli Michal Rovner. These additions, however, are not enough to render inclusiveness more than illusory, or token. Including works on the basis that they include text brings together a number of anomalies that remain unexplained. Youssef Nabil's trendy narcissistic photograph, for example, was more fitting for a glossy lifestyle magazine. The museum here (much like a neocon think tank relying on local consultants) makes arguments of cultural superiority, which are implicit and unspoken, all the more salient. Most disturbing was to watch this act of validation at work in relation to Muslim and Arab visitors, who, on both my visits, seemed to passively consume the museum's position. The works on show became ciphers of their own identity, and a positive sense of ownership (easily translatable to a sense of a specific essential identity) was communicated in some of the conversations I had with different visitors. It seems that the shadow of the institution strikes deep, and I was left with the unsettling thought that what is being subtly confirmed, affirmed, and maintained is one specific image.

CALL ME SOFT

SARAH RIFKY
2012

On a warm August night in Brussels, a curator, Orient, of feminist inclination, dressed up in an Egyptian belly dance costume, swaying her hips and breasts to Umm Kulthum's epic song of a thousand and one nights. This act of seduction was intended for an audience of One. One was a man, a curator. This highly staged act, of Orient sexualizing herself for One's gaze, transcended all codes of proper politically correct behavior. As both overcame mediocre intercourse, Orient gently asked One how, despite her intentionally seductive act, he had achieved at best an indefinite arousal. One told her repeatedly that sex didn't matter so much to him. He enjoyed it, but he was not ruled by it; that in fact, he preferred to have what he curiously

the horrors they represent and the ornamental beauty of the compositions. People and objects are classified as in a list in which life is systematically reconstructed. Other items include metalwork, glass, tiles and glazed pottery, woodwork, textiles, coins, jewellery and carpets. At first sight, it seemed as though it was a usual display of sundry goods, and at first people could not recognize the objective of our show.

This piece, which was also a performance, was intended to explore people's sensations as they entered this space. In general, the artwork is an experience that must be perceived through all the senses and reconstructed by the subjective experiences of the viewer. The senses play a crucial role in understanding and helping recognize and categorize things in order to comprehend their meaning.

The works displayed, videos, paintings, and drawings, are all driven by the same momentum, the same creative inspiration. The drawings and paintings are directly related to the films for which they are the matrixes. As you look at it you feel that room around you; if you reach your hand just so far to the left you'll find that spoon left on the counter after breakfast. On every piece of cutlery, porcelain

dubbed a soft erection than succumb to her desire. It was purposeful; One would not allow his desire to fully blossom around Orient. In fact, he said: in private, call me Soft. To her this felt of dysfunction. But was it something else? Perhaps he did not really like her? Perhaps he secretly liked men? As the summer receded, Orient lingered in Europe, embracing the cold, and set out to make a full investigation. She began talking to friends in the field of art, both men and women: intellectuals, writers, artists, philosophers. It wasn't just him. More and more, she realized, the greater the intellectual and imaginative capacity of the man, the more susceptible they were to what One suffered from. They all wanted, privately, to be called Soft.

It was both daunting and upsetting to Orient that she could not rule over One—or other men she encountered in love—through her projected desire to be desired. In fact, the more desire and urgency she brought to love, the more she found herself swathed in his cold softness. It was only in Europe that this ambivalence toward sex seemed to be accompanied by an imaginary freedom. Perhaps Gala was right, half a lifetime ago, when she sang, "Freed from Desire." Was it that? Or was the world of art becoming rather transcendental? Returning, perplexed, to a place that was no longer Cairo, she shared her concerns with her mother. "Oh, Orient, Orient. This doesn't sound new at all.

It sounds quite Christian, in fact!" Orient lost sleep over this peculiar condition. Might this withholding of a full expression of sexuality, this subversion of orgasm, somehow be a side effect of consumer culture? Less Christian than capitalist? Did softness correlate to new economic realities? Was it a response to market trends? Was the rarifying of the sex act meant to convey a specific kind of culturedness?

Orient thought again about what her mother had said. Sexual pleasure, in Christianity, was planted by the Devil to drive a wedge between man and God. In the art world, it seemed, sexual pleasure had wedged itself between man and his intellectual power. Maybe the curse went all the way back to Adam's expulsion from the garden for frolicking with Eve. Back to the apple. Apples grew in Eden, but now they were imported from America.... Her thoughts drifted to the greengrocer. Orient liked hard red apples. Was it that One and his ilk imagined that an undelayed gratification, some coming insurrection of hormonal fluids, would leave them marooned among the masses of men?

Orient felt perplexed. She was content with Soft's affectionate caresses, his half-formed form. What did bother her, though, in the afterfeeling of it all, was that One seemed to imagine himself a more evolved species, beyond the sphere of mass consumption. Something similar seemed to be at play in their different

responses to the market. Orient gravitated to all manner of products, whereas One patronized only a few exquisitely specific boutiques, invisible to the naked eye. Orient was not used to that. Visibility and desire were very much connected. No matter how much she disliked that murky gilded print on brown leather, Louis Vuitton still ruled the imagination of the fashion-minded where she came from.

Diligently investigating the etiology of softness over dinner with an Austrian pseudo-scientist in Beirut, Orient was told that perhaps what she was trying to understand was something quite simple. Biological. "I know a man in Los Angeles," he said, "whose manhood reaches his knees. When he gets hard, all the blood in his brain rushes downward, and the man faints." Orient saw another parallel: the more intellectually conscious and plugged in One was, the more guarded they were in intimate settings. They were simply afraid not to think around her. Perhaps for ones such as One, hardness was a luxury they could afford. There is only so much blood in one's body. She made a mental note to raise this question in the medical sphere. It was an Armenian friend, a former queer activist and art historian, who inspired a new theory on the topic. Men like One had grown up with postmodern critical theory, she suggested, including the second-wave feminist theory of the '60s and '70s. It was women like Luce Irigaray and Hélène Cixous who had set the phallus on fire,

and tableware are printed images and definitions from the found book on etiquette. Full of Persian script and design motifs, like votives displayed among piles of rubble, these objects suggested the way violence atomizes identity and self-history.

You are directed towards a room in an office. You open the

door and find a phone ringing. You pick up the phone and a person strikes up a conversation with you.

In the centre of the room sits a live performer sewing bits and pieces of the city map, creating a new city. On the dais where she seats herself is a white wedding dress on an iron dummy, some

unstuck parts fluttering in the wind. A cobweb is wrapped around a woman, creating a chrysalis from which, in a strange process of evolution, a butterfly evolves.

The "decorations" become stifling, the thread wraps around the barely pounding heart that becomes the body of the bride

lying on a huge white bed. She is covered by a shroud—never really having had the wedding party—and gradually, around huge pins with lit heads, threads are woven in the manner of a huge spider gone erratic, zigzagging, coming and going, smothering the woman, like the heart before her, till... nothingness. Darkness.

a devilish effigy, as part of the struggle for a symbolism less antagonistic to female pleasure; indeed, to orgasm, so long ignored, derided, or even pathologized, as in the psychoanalytic diagnosis of hysteria. Had One completely imbibed such theory? Was his softness a form of excessive politeness, a desire not to offend?

She was dissatisfied with this idea. Could it be true that raising a boy on a healthy diet of feminist theory could only produce a kind of intellectually self-conscious man? That the unintended consequence of that fine pedagogy should be to make it impossible for One to enter Orient without seeing it as privately if not politically invasive, a violent intrusion?

Orient worried that she was on the wrong side of the world perhaps, or the wrong side of history. Her own quest for power was not easy to master in this new world, populated by sexually ambivalent men who insisted on being called Soft. Orient vowed that if Soft was, intentionally or not, slipping the rug out from under her, she would not take it lying down.

Soft asks Orient to accompany him to Barcelona. She agrees. And it is there where she finally starts to see the ways of men. "What would you do if you were a woman?" she asks. "I would use my sex appeal to manipulate others, secure power," he says. Perhaps it is not yet time to stowaway her costume after all. There may yet be a place for the trappings of theatrical femininity, rummaged out of the historical wardrobe.

Perhaps this is why she retains her stage name. Though these days, upon making one's intimate acquaintance, she asks him, too, to call her Soft.

GLOBAL EPIDEMIC ART IN THE AGE OF GLOBALIZATION

MAI ABU ELDAHAB
2005

Let's recap. Globalization— this obscure word remains consistently used and misused. Today, anything that includes non-Western nationalities/ cultures/ethnic or political groupings is defined as being the face of this globalization. On the art front, this globalization is rampant; inIVA (London) produces the hit show "The Veil"; the Fridericianum (Kassel) opts for "In the Gorges of the Balkans," prepping the art market for the art of the new European states; in the aftermath of September 11, Witte de With (Rotterdam), the Bildmuseet (Umeå), and Fundació Antoni Tàpies (Barcelona) cohost "Contemporary Arab Representations"; and MoMA P.S.1 (New York) introduces us to poverty and violence in "Mexico City: An Exhibition about the Exchange Rates of Bodies and Values." In this so-called new age of multiculti/fusion/ hybrid everything, globalization rhetoric is not only modish but

economically viable as well—a catchphrase for a product line.

In the coming paragraphs, I don't want to redundantly propose yet another definition of globalization (in 1998 alone, 2822 academic papers on globalization were written and 589 books on the subject were published), but rather, I will try to put forward a suggestion of the three most commonly utilized understandings of this term and how they manifest themselves in the culture trade.

Definition One: For the economically minded, the World Bank explains, "Globalization is the growing integration of economies and societies around the world." From this definition comes a plethora of theoretical texts and sociopolitical analysis ranging from the hyper-objective writings of Saskia Sassen to the highly reductive statistics of Naomi Klein. Massive amounts of social science and economic research are continuously produced, of which most responsible cultural practitioners are somewhat informed. Art critics, culture theorists, and curators make use of this research and incorporate it in their analysis of exhibitions, artworks and practices, biennials, and so on and so forth. (See "Authentic/ Ex-centric" [Venice], "Unpacking Europe" [Rotterdam/Berlin], "Unrealized Democracy: Documenta 11" [Kassel], "When Latitudes Become Forms: Art in a Global Age" [Minneapolis], and the like.)

Definition Two: Globalization is a process that is gnawing away at authenticity, destroying

In the same room, a dummy wearing a man's clothing had hands coming out of its neck and barbed wire instead of feet. The future becomes the present, and if you pass back through the room you will be hearing the past. A rat gnaws at her entrails, drawing purple blood, a transmogrified woman standing over

her. The scene is repeated in a set of drawings on the walls of the hall, culminating in the video (based on the drawings) of the same woman, first real, then becoming a drawing too. In graffiti-style, she repeatedly writes the Arab word for "daddy" in white on a black wall, and similarly, the

word for "mummy" in black on a white wall.

The notations are articulated with descriptions, as tools for decoding and interpreting with images. In addition, the dazzling quality of the annotation lies in the amalgam of two given names and a nickname not so much to designate historical figures as

energize signifiers inherent in the powers of humankind: religion, philosophy, revolution, tyranny, barbarism.

This powerful play explores the complex emotional realities of two immigrants with very different histories and aspirations who are forced together in a shared state of exile. The poetic

cultures that must be pre-
served. Here, we have the good-
will factor, wherein promoters
of cultural exchange discuss
preservation in a spirit fueled
by a contrived romanticism. In
accordance with their position,
an affirmative action culture
is advocated. Workshops, net-
works, and collaborations are
the way to get to know each
other, to learn, and develop—
more often than not the result
is condescension in the guise of
generosity; cultural-specificity
and the local are stagnant
prescriptions—difference is
celebrated as long as it is
maintained. Cultural parasites
are the most active under
this banner; certainly coming
soon, we'll have "Baghdad
Blues: Art in a post-Saddam
Iraq," curated by whoever
got there first.

Definition Three: Any inter-
action across cultures/bor-
ders/ethnic groups constitutes
globalization, from elephants
parked outside McDonalds in
Bangkok and German businessmen
drinking Corona, to the mys-
terious all-powerful internet.
This view is the outcome of
the infectious "other" rhetoric
systemically dominating today's
political arena. In this case,
McDonald's is perceived as the
original global messenger—
ignoring that, McD's revenues
aside, many historical trans-
national cultural sources like
the Bible are still more popular
than a Big Mac. Fortunately,
most exhibitions and projects
produced in this language are
easily forgotten, although
the impact of their underlying
assumptions is alarming.

Various combinations of these
definitions are constantly at
play, and when the word pops
up, everyone gives a politi-
cally correct nod to indicate
that "Yes, we are all on board
here"—we know that exploit-
ing Malaysian workers is bad,
but the spread of wonderful
Ethiopian restaurants is great,
and of course, finding a bal-
ance is so very complicated. And
once again, complex issues are
reduced to generic mis/under-
standings to minimize damage and
keep latent conflicts at bay.
We are not in the politics
industry after all; this is just
about art.

"Art cannot change the world"
are words spoken nonchalantly
day in and day out, and the
agency of the arts and culture
production industry is com-
fortably reduced to the mere
fetishism of a few privileged
practitioners. Discussions of
the seminal role of funding
agendas, curatorial policies
both of private and public
institutions, production values,
etc., are simply engulfed by
the standardization of machin-
ery. And for those not so easy
to appease, well they can chat,
complain, and theorize about
"representation," and there
is funding for that too. And
of course, the machinery of
standardization also provides
the margins for this debate:
postcolonialism, exoticism,
Orientalism, regionalism, and
so on.

But how does this global-
ization hype impact profes-
sional practice on an individual
level? I am a Muslim, Arab
female. Whatever implies tragic

inflictions in the real world
puts me at great advantage on
a politically correct cultural
stage eager to flaunt its open-
ness. Professional integrity
can only be maintained some-
where in the equilibrium between
exploitation and self-serving,
reckless opportunism; and
to find the balance, one must
suffer the curse of acute
self-consciousness, a condition
that can incite bouts of
paralysis—or conversely—might
inspire the occasional original
thought. How can one situate/
frame one's self either locally
or internationally on one's
own terms? Isn't participation
in the representation debate
a legitimization thereof? And
under what conditions can new
paradigms emerge?

On the local level, the
dynamics are different. In Egypt
and perhaps the Middle East at
large, this luxurious separation
of art and politics does not
exist. Official instruments and
propaganda are the original pur-
veyors of the Bush-esque dictum:
"If you are not with us, you are
against us!" In this atmosphere,
independent curatorship is
involuntarily a form of cultural
activism mixed with a zeal for
art, some administrative skills,
and a hint of academic *savoir-
faire* that allows for making
small talk with the history of
twentieth-century Western art.
Contextualization remains the
name of the game; but with-
out locally generated artistic
references and sources, where is
the backbone of a more inclusive
and shared discourse? On what
grounds do you build local art
critical debates? No wonder

tension embodied in the dance
itself is gradually intensified
due to the relation formed
between the dancer and his
shadow, which flickers on the
wall throughout the dance.
On the other hand, there was a
tension in the relation with the
female performer, who moved
slowly like a puppet around him,

trying carefully to invade his
space. The work alluded
to the nature of the contra-
dictory relations between two
different realms that might want
to secretly unite to discover a
common language through the
virtual body. Every performed
act, every gesture, has an open
beginning (open onto that which

has preceded it) and an open
ending (open onto that which
ensues).

A woman with a ghostlike
figure who is trying to take care
of her children in a dark setting
with a faded beam of light com-
ing from a far away horizon, a
shadowy profile of a young
girl looking through a dark room

that almost looks like a bird
nest towards a dull sky, the bare
feet of a young girl standing next
to the stagnant water, but her
reflection in the water looks
like an upside down leafless tree,
an empty uniform of a soldier
in a dark background, broken
into even squares that indicate
lack of security in the country,

the artworks easily fall prey to superimposed categorization on the international scene—they keep traveling without any luggage!

The question on everybody's mind remains: What curatorial strategies work amidst these conditions? What are the criteria for evaluating whether or not a curatorial strategy works anyway?

MODEL UNESCO

BIDOUN WITH NADIA AYARI, ANNABEL DAOU, RANYA HUSAMI, MAHMOUD KHALED, AND SARAH RIFKY

2012

For the past two decades, the US State Department has sponsored an American pavilion at the International Cairo Biennial. The American participation has been variously wrongheadedly PC, expensive, beautiful, boring, or, in the case of one California-based artist named Lita Albuquerque, outright controversial. (She planned to build a hexagonal honeycomb structure at the pyramids; some detractors claimed it was the Star of David.) In making each selection, the State Department would announce an open call for American curators to propose artists and projects. For the most part, the American selections have included a

smattering of fine and pointedly principled artists—from conceptual artist Fred Wilson in the event's inaugural year, to feminist Nancy Spero in 1998 (it is said that traces of her installation of Pharaonic stamps remain on the walls of Cairo's Palace of Arts), to the quietly powerful Daniel Joseph Martinez in 2005, who built a human-size android that would periodically erupt into epileptic fits.

For the 2010 iteration of the Biennial, the State Department took the unusual step of awarding the curatorial platform not to an individual curator, but to an American museum. Founded in 2005, the Arab American National Museum in Dearborn, Michigan, is the first and only museum in the United States devoted to Arab American history and culture. Its website reads, "By bringing the voices and faces of Arab Americans to mainstream audiences, we continue our commitment to dispel misconceptions about Arab Americans and other minorities. The Museum brings to light the shared experiences of immigrants and ethnic groups, paying tribute to the diversity of our nation."

The museum, in turn, commissioned independent curator Ranya Husami to tend to the selection, which she did, working with four Arab American artists—Rheim Alkadhi, Nadia Ayari, Annabel Daou, and Dahlia Elsayed—and a highly articulated (in the catalogue, anyway) rubric of "Orienteering." The State Department's press release declared, vaguely, that the four artists would "exhibit work that

examines issues of time, place, and identity." In the exhibition catalogue, Arab American National Museum Director Anan Ameri declares that the arts are "a powerful tool that empowers people, instills community pride, and bridges some of the racial, ethnic, and global divisions that have separated communities and nations for too long." In this cheerily formulated gesture, the Arab Americans would be going "home."

On December 11, the day after the Biennial opened, the American embassy and the State Department organized a talk at the Townhouse Gallery in Cairo to address that year's American representation. Daou and Husami were joined by curator Sarah Rifky and Alexandria-based artist Mahmoud Khaled. Ayari, in the meantime, was in the audience, along with Ameri and a representative from the State Department. What was initially conceived of as a one-hour discussion ended up extending into two or more, as the very basis of the selection—the Arab American meme—inspired impassioned debate, if not outright vitriol, on the part of some of the local artists present in the room.

As it happens, Daou took the Biennial's top prize. And some weeks later, revolution would come.

DISCUSSION

NADIA AYARI The discussion at Townhouse has become mythic in our experience, a myth of an experience.

a young girl walking through an old door to a richer home but her eyes are covered by a golden bracelet, a woman rising from a dark cemetery holding an empty blank canvas, a woman lost in an impressionistic style green forest, where the green background color is juxtaposed with drops of red paint symbolizing the

bloodshed in her surroundings, a green canvas divided by black horizontal lines, decorated with some Islamic designs and a smile of a woman seen through a narrow small square window, and an upside down television set with a portrait of a politician, symbolizing the emptiness of the media. A dream, a nightmare in which the

screen seems to be drowning in a symphony of lavish blood. A purple that stages an open and ever-bleeding wound.

At the same time, the dancer's muscular body and extraverted masculinity endow the belly dance, which is considered a quintessential form of extraverted femininity, with

subversive power. By opening up his process, he also implicates us, as viewers, in his mischief, which is a subtle, wonderful way of prodding an audience to act, to question, to challenge and to think. Crushing a mike with his bare feet. A crude, radical, unanswerable act: telling the power of speech.

MAHMOUD KHALED Frankly, we were surprised when we saw the selection. We had a pretty established idea about the American pavilion at the Cairo Biennial. They used to send over big names, people like Daniel Martinez or Paul Pfeiffer. So this was a surprise. I mean, the Biennial is a professional international event that hopefully brings with it a new language. We expected a certain quality, especially coming from the American pavilion.

RANYA HUSAMI When I got the invitation to curate the pavilion, I thought about whether I should walk away. It was a difficult position to be in. I sought the advice of a lot of people. A lot of them said forget it, it's too political, don't do it. I do have an allergic reaction to the Arab American category. Maybe that's what eventually made it more interesting to me—to have the chance to throw myself into this thing I felt totally uncomfortable with and find out why. I wasn't fond of the museum, but I did think the Biennial could be an important platform.

NA I consider myself an Arab and an American. I grew up in Tunisia and moved to the US when I was eighteen. I know the experience of being an Arab in America is very different from being an Arab living in the Arab world. And as identity politics-based as it is, there is validity to the category. But sure, the pigeonholing is a problem.

ANNABEL DAOU What is an Arab American anyway? I mean, it's complicated. I lived in Lebanon for the first nineteen years of my life. I consider myself Lebanese, probably, before I consider myself American. Given the war, you're living in an intense place and inevitably your childhood is marked by that. At the same time, I've lived in America and Europe for fourteen or fifteen years now, so I don't really know where that leaves me. I've always been hesitant about the category. And in terms of my work, I don't consider myself an Arab American artist or a Lebanese artist at all.

RH So they asked me to suggest an Arab American artist, and that's when I approached Annabel. A lot of people had suggested [the artist] Diana Al-Hadid, but I guess I was hoping for someone who was a little more under the radar. We went ahead with Annabel's proposal, thinking it was a long shot.

AD I put together a proposal for a project that was meant to explore the ambiguities of social and geographic, but also personal or emotional, location. The plan was to travel from New York to Beirut and ask people, "Where are you going?" and "Where are you coming from?" en route. The answers were sometimes complex, sometimes enigmatic, sometimes straightforward. It became a sound piece accompanying a visual work in which I charted my own locations. It seemed

to resonate with the premise of the invitation, the fact that we're all in between places...

RH The museum kept reminding me they wanted something that would resonate with their mission.

MK When I Googled the museum, I noticed that it was more like a cultural center. I totally understand that it's important to have such a place in a city like Dearborn to promote and represent the Arab culture, but when it comes to international contemporary art shows, it's really problematic for a cultural center to commission work to put in the context of an art museum.

RH It turned out that having Annabel wasn't enough. The museum wanted several artists that would address Arab Americanness—like four! It was ludicrous. I had something like four days to get three new artists. They said okay, we'll send you a catalogue from an exhibition that [curator] Salwa Mikdadi had curated to look at, as if it would be quick and easy to add a few more people into the mix. I approached others. Some artists said no, understandably.

AD I don't really know what happened behind the scenes. We went through different phases in this process. At one point, the museum wanted to make a bigger show, so they asked Ranya to add artists, but they claimed it was the State Department that wanted that. They made all sorts of demands. I withdrew at one

The symbolism is such that you cannot keep pace with it. Life-giving and life-taking, women, babies, blood, light and darkness, juxtapositions that talk about trans-formation—of life gone into nonexistence, of one form of life into another, of one species becoming another, of the power of the human being

to effect such transformation, of its impotence in succumbing to it.

We asked her if this could mean that a breakaway from the traditional female role is problematic and maybe not so easy to realize. She replied: "I don't know... sometimes yes, but we still try to smile! These

flashbacks expose the pain that I felt and just talking about it makes me feel like I still have the piece of broken glass stuck in my forehead."

Western art critics may be taken aback by this declaration, for in recent decades speaking about meaning has ceased to have any... meaning.

It is precisely insofar as it resembles nothing save for itself that art should in turn be resembled. What is unlike anything else, inimitable in its singularity: this is what calls for imitation. Cherries have tender skin, meat and a kind of bone inside them. Their juice is red like blood. When you treat them like humans

point... I had a lot of hesitations. You felt you were always making a concession to some sort of position or agenda.

RH When I had originally called each of the artists about the project, I was honest about the situation and the difficulties involved. It was more like, are you game? And most were and found it an interesting paradigm. We said, collectively, what could we do with this situation? The problem became part of the work itself.

NA Sure, we all had qualms about being grouped together in this Arab American woman thing. In the end you had one Iraqi, one North African, one Lebanese... That was heavy. It had always been a one-person pavilion and suddenly you needed four women? Why? It didn't make any sense.

AD A pragmatic way to think about it for me, maybe, was that you're surrounded by cages no matter what you do. Being in New York is a sort of cage, being an artist from the Arab world is another cage... It's something you just have to learn how to negotiate.

RH It was discussions like that one that left us with the title of the exhibition, this Orienteering concept. We liked that it played on the words "Orient" and "disorientation" and also had nothing to do with them. It's a reference to this Swedish land navigation sport from the nineteenth century in which you negotiate unfamiliar

terrain in trying to locate defined checkpoints before going back to where you came from. These artists were "orienteers" in their own way—and the checkpoints of the game are a metaphor for all sorts of institutional pressure. Rather than having a structured counter-narrative, it was about destructuring things. It allowed us to be very free and very loose.

AD I guess the conversation between us leading up to the Biennial was, like, why should we pussyfoot around this? We're four Arab American women who come from very different places. It's complicated to put all these people together and we thought the Orienteering framework would allow us to play around with it ... take the piss out of the circumstances of being grouped together under this very limiting label.

RH We weren't prepared for the talk at all. I don't know if you spoke to William Wells and Sarah Rifky about it, but I think it's safe to say they had zero expectations. Or they expected we would be horrible Americans. They were ready to roll their eyes and I knew it.

NA We realized immediately that people at Townhouse hadn't actually seen the show. I felt they didn't want to deal with it, but just wanted to focus on the Orienteering bit.

RH I don't even remember what the official topic of the discussion was to be, because we moved away from it so

quickly. It started off with us explaining what Orienteering was, and then Sarah spoke. If I recall correctly, she had a major allergic reaction to the title and also had a big sensitivity to us working with the Arab American Museum in the first place.

AD It's funny; we thought it would be this quiet thing—the discussion. They really had it in for us. They had it in for Ranya especially, even though, in the end, it was me and Nadia who pulled that title together. We thought that the Egyptian art scene—and this is where we got it wrong—would recognize that this was a strategic response to a set of circumstances, an attempt to create something productive out of the reality of the situation. But then this would have required them to have looked at the work first or at least to have read the catalogue essay. Little did we expect that they would come at us with "How dare you use that word?"

SARAH RIFKY It worried me vis-à-vis art in general. The preceding question should have been: What is this museum of Arab American art? What is this particular tradition that isn't coming from a tradition of art? Is it an ethnographic museum? What does it mean when this museum commissions contemporary art? The discourses and the questions being raised weren't finding any resonance from the commissioner. They found this Arab Americanism something to be celebrated rather than

sometimes treat other humans, they become them.

Stitch after painful stitch pricks the heart. On occasion, a given mass, such as the body of an animal—often a donkey or the body of a bird, a hoopoe—comes to pass through yet another mass that looks like a human body. The most definable

character is a rooster-like form that begins this motion, one which is hard not to read as a symbol of America and the arrogant manner in which it undertook the invasion and "correction" of Iraq.

The anomaly has nothing to do with a normative and moral judgement of an individual,

society, or ideology. It simply displays a hallucination of a monster of power—except that this monster of power is not alien to language or to representation. Scissors incise openings where beads on wires are inserted by the almost cruel hands that start sewing a white paper rose on the "breathing" organ. Like a

modern-day Penelope, she starts sewing part of it, graceful like a bird in flight, with measured movements full of purpose.

A small fire flickers at the bottom of the vessel, growing stronger with each lapping flame, paradoxically "creating" the ever-present wedding dress instead of consuming it, leaving

critically conceived. There was no consideration of the artist's work beyond birthright or origin.

MK The fact that it was organized by an Arab American museum raises important questions about the difference between art and culture.

AD I don't think we were trying to do anything subversive as such, but something authentic to us. There was a certain amount of realism about our work and what it represented rather than us trying to come up with some clever idea. The title came after a lot of thought about what could possibly hold us all together. Nadia and I had been joking about how the idea of mapping always seems to come up in relation to work by Arab artists. In the end you could say our work was pulled together in a map-like way. We were finding our way, finding spots that were sometimes disparate, sometimes cohesive.

MK We talked about this—the fact that they kept saying they were "playing." Like they were being in the game and playing with it, too. But you can't be in it and be critical, too. It doesn't work: You're already instrumentalized.

SR In Egypt, these issues hit a sore spot. It was all framed as an opportunity to "play." This kind of thing makes us crazy. And it makes Edward Said turn in his grave.

MK Yeah, we're very sensitive about this kind of stuff. We

always face this dilemma of identity and how it relates to our practices. I personally was surprised that art institutions and cultural-funding bodies in the States are still waiting to hear the same old identity-based narratives and not looking for a new language. Also the fact that they were all women: it felt like art as a form of helping minorities or something.

SR It goes back to 2002 and 2003 and the very first topographic shows, like "Contemporary Arab Representations" by Catherine David or "Fault Lines" by Gilane Tawadros. It's an issue that's been tackled extensively since then by people like Tirdad Zolghadr with his "Ethnic Marketing" project. The curator seemed unaware of a long history of problematizing these platforms.

RH I tried to explain, if you read the essay, that we're actually critiquing these ideas, that we're aware of the problems related to this kind of representation. They said, "Don't even address them at all," "You're playing into it by even naming it as such," and "You're reinforcing these identities." Which is true in some ways. Sure, sometimes by talking about the "Arab American" in the first place, you might be reinforcing a myth you're trying to dispel.

MK For me, this identity stuff has been one of the biggest challenges of my career. It even informs my work. It's always a question in the Egyptian

scene. How do you deal with it? National representations are already problematic in a place like the Cairo Biennial.

NA It got so heated—this question of representing a place or a culture. At one point during the discussion, Annabel turned to one of the local artists, I think it was Mahmoud, and said, "Would you represent Egypt in Venice?," and he said something like, "Venice is different." What? How is it different? And what would it have meant to accept a commission from Farouk Hosny? To each their own at that point.

RH No one really turned it around. Every one of these artists occasionally takes part in a loosely Arab show. No matter who you are, whether you're Hassan Khan or you're placed in a Christie's Dubai show. You can't say you're above and beyond these issues... You can't possibly be immune to these cultural categories as an artist.

AD Townhouse is also a very Western place. It's where every visitor goes when they come to Egypt. It's as much an extension of the international art community as it is a local institution. So there were all sorts of ironies with respect to their own positions.

RH You can't push these things away and say these issues are so '90s, or so ten years ago, which is what I kept hearing. Everyone is involved in a multicultural experience, whether

it floating in the water. Artists, students from all Tunis, as well as residents of Carthage Byrsa and its surroundings, young and old, came to transform these charred cars into a blooming of objects in bright colors, adorned with revolutionary graffiti.

The underlying political complex is constantly subcutaneously

present. A phone rings, a child cries out.

You move to answer and the window changes again. Your plane is taking off.

One moment you are looking at a window that could be your own kitchen window, and hearing familiar, half-identifiable sounds that could be the sounds

of your own life in that kitchen.

Look again and the captain is addressing the passengers, doors slam, forks are dropped, water runs and runs and finally stops. A train passes by the window and you're back in the kitchen but something different is happening, the call of the muezzin faint through the glass.

It offered a glimpse of eternity close-up, as a mystical and succinct visceral experience. The affect was reminiscent of Goya's The Third of May 1808 (1814).

Between these pieces there were hands scattered around the floor and coming out from the walls as if they were trying to find an exit from what restrained

you're an Egyptian or an Arab American. All these issues are real. I mean there's some truth to the Arab American stuff. You know, when I was a kid, I had a hummus sandwich and everyone else had a peanut butter and jelly sandwich. It's a silly example, but I mean to say there's something there that needs to be addressed.

MK Culture is specific to a place, a land, a minority, an ethnicity, etc., while art's job is to go beyond all these things.

NA It's true—we were stand-ins for what America does best, which is the melting pot. And sure, that is a powerful part of the US's identity...but it's complicated. I felt as if there was a need for me to present a very lovely face of my experience as an Arab American. I wish the encounter were more complex and nuanced. I wish it had been reflected on a little more on their part.

SR To be apologetic about the framing is not enough. There are many constituents involved in such an invitation. It starts with the State Department and the commissioning museum. These discomforts are best addressed through the framework that hosts these artists and with the curator, who is the arbiter between these different constituents. It's one thing to use this opportunity for a real critical encounter in some prolific way that speaks truth to power from the position of the

artists, but that didn't really happen here. The agency of the artists was completely lost.

NA I think it was the fact that we were funded by the State Department in December of 2010 in Cairo—that was the real problem. I don't think I really understood that until later.

AD There are times when I'm uncomfortable representing the US, but it also comes down to individuals and relationships with them. It turns out the person from the State Department—her name was Maura Pally—was great.

RH At some point someone said, "Why would the State Department give the commission to the Arab American Museum?," implying that it was because of political interests and it would serve to make them look good. Maura from the State Department was in the audience and got up and said, "I would like to introduce myself as Deputy Secretary of the Cultural Department, and I could say with 100 percent honesty that we gave it to the museum because they had the best proposal." She kind of shut everyone up with that. In the end, I think the problem was the Arab American Museum.

AD It *was* the museum.

NA I mean, there were so many cooks involved. At one point the museum told us that my work was "jarring." I think it was a combination of the psychosexual quality of large pink flowers that look like tongues

as well as the political undertones of the piece, which is about two politicians.

RH Basically, I think the museum was doing anything it could to get this grant from the State Department. I think for them it was a big deal. It was a quarter-million dollars or something, so they wanted to give the State Department what they thought it wanted to see. A lot of it was mental laziness. They weren't willing to dig deeper. They just wanted to get a grant and put their logo on it.

SR You can't really expect much from the State Department or even the museum, but you could expect more from their critical counterparts—the curator, the artist, and so on.

RH My problem was, throughout this whole discussion, I was thinking, Has anyone read the catalogue? Will anyone talk about the work? They got so caught up about the labels attached to the exhibition that no one bothered to look at the work. Rheim stood up at one point, frustrated, and said, "No one has seen the work! Why don't you go see the work and then we have this talk again?"

SR Regardless of what I think about the artwork, these issues irk me because they represent a much broader condition for art. When art becomes a stand-in for cultural performance, it completely co-opts the artwork and overrides the agency of the artist. Not to be aware of these

them. Finally, there was a black tent where people could come in to find themselves accompanied by a person covered in black, moving in the darkness. Even if nothing informed viewers about the sex of the person moving in the darkness of the tent, visitors actually interpreted that it was a woman.

Far from being veiled from view, she meets our gaze with alarming directness, overcoming Western stereotypes of the female condition in the Middle East even while challenging her own society's conceptions.

One raises a finger to lips in a gesture of surprise, another throws up her arms in confusion

and dismay: "Chi shod?" They ask. "What happened? What happened to my past? To my dreams for life? To the dream my life was?"

Ever vigilant, a single eyeball rolls to the center of the foreground, still impossibly seeing, it would seem; but who is watching, who is witnessing, who is

mourning this moment? Through this inner confusion, the physical experience forces the viewer to reconsider its relationship with its surroundings. Where is he coming from, where is he going to—this lonesome figure traversing the barren deserts of his own agitated imagination? The edge is never settled, be it of

HERE AND ELSEWHERE

things raises questions for me about the role of the curator in this context.

NA I'm not sure how much we interacted with the Biennial. That's why we talk about the talk at the Townhouse as mythic. Everyone was screaming! It was meant to be one hour, but it became a two-hour back-and-forth questioning why the US State Department would fund a pavilion of four "Arab American" artists in Cairo. Outside of that and the awards ceremony, there wasn't that much engaging with what we were doing as a group.

AD You know, a lot of us don't like the contexts in which we may work, and the fact is, this is the world we live in. We thought we were doing the best thing we could do given the context. And if we said no to the platform, they would have just done it with a different set of artists.

NA I don't know if we were changed by seeing the work there. I think that everyone saw—how can I put this?—everyone was satisfied with what they accomplished given all the constraints. I don't want to misspeak or offend anyone, so I'll be careful, but I think everyone saw what they wanted to see. There was no real epiphany, but the entire experience was profound.

AD In the end, it was a very precious experience on all kinds of levels. On the level of language, for example, a lot has happened to my work since.

The important thing is what these encounters do in the long run, whether good or bad.

NA I would do it again, in retrospect. Even with all the drama. Simply because the work really carried the pavilion. It created this relationship between Annabel and I and Rheim and I and Ranya that's more important than being seen as perhaps placating these agendas or these institutional identity politics. Whenever you take on these projects, the risks are big. You know how that is.

MK All in all, it was problematic for the [Egyptian] scene. It raised a lot of issues that we struggle with as is. And the American pavilion? It once had a reputation and it was destroyed.

SR If art is the last zone of autonomous expression, it should also be a place where one could respond critically to these platforms.

RH I thought, Let's see if we could play with the platform and get away with it. I understand we may have failed. In the end, it may have just have been our fault. It turns out that the Arab American Museum wanted a happy Arab American show. And I thought we could manage to work with an institution and do whatever we wanted. In retrospect, that may have been a bit overambitious...

IN THE ARAB WORLD ... NOW / JEROME SANS, ED. / PARIS: GALERIE ENRICO NAVARRA (REVIEW)

HASSAN KHAN
2008

With three volumes that come to 1001 glossy pages (an intentional detail proudly printed at the beginning of each volume), *In the Arab World ... Now* is a pretty heavy object. I should know, because I dragged it home from Dubai and it added a few kilos to my luggage. Disclosure is in order here—I was returning to Cairo from Art Dubai, and the books were in my bag because I am, along with other artists, writers, cultural producers, and almost everyone else I know, featured in the volumes.

A few months earlier, after making initial contact, a "creative team" with thick French accents came to my house and pranced around taking pictures of everything they saw, letting out a "Supercool!" every few minutes while interviewing me. An earlier effort by the same team, *Made in India*, was left on my table, and before I knew it, the entourage of designers, photographers, musicians, and curators was gone, and I was left alone to suffer Coffee-Table Book paranoia. The process did eventually develop into a

a pictured figure or figuration itself.

A middle-aged woman is seen wearing a transparent veil lightly covering her head. It sits there, always raw, enigmatic and disconcerting in its form and the ways it opens up meanings. These ghostly, dangling shrouds were fiber

art in the service of anti-war frustration.

The work was produced as a reaction to post-9/11 Islamophobia, especially that targeting women during a period in which anti-immigrant groups in Europe used "the covered thus disempowered" Muslim figure to justify their racist politics. But

perhaps this is the plaintive element in the project that activates feelings of the viewer, regardless of their origin and cultural background. A person's clothing and appearance send messages asserting his or her identity or thinking, assertions addressed to a circle of relationships. Well-mastered, appearance expresses

less and less a state of fact and becomes pure communication.

By consequence the niqab is not the center of a critique, but a means to portray women's eyes playing and doing funny faces, a means of expression and not of rendering women victims of their clothes. Only on closer inspection do we see that the veils and

pretty extensive online interview with Audrey Mascina that I'm happy with—but I can't say the same for the project as a whole. This is not a naïve rant against commercialism or even the (unavoidable) processes of selection. A case for the type of eye candy that coffee-table books strive for can always be made. Mundane generalizations and the literal gloss-over—grave mistakes like confusing the Cairo-based Contemporary Image Collective with the Alexandria Contemporary Art Forum—are systemic, one suspects, to the genre. They are not the source of contention here.

A few questions to start: Why Arab art? Why now? And, who exactly was behind this? The man behind the project is Enrico Navarra, a well-known dealer and major player in both the Indian and Chinese art markets. Navarra's endeavors in promoting "new markets" seem to have served him well, as did his earlier dealings with lucrative safe bets like Warhol, Basquiat, and Picasso. My aim is not to criticize Navarra but rather to learn from him which way the wind blows—for the appearance of such a book is the sign of a specific moment in the art world, or in the culture business at large, and its failures are ultimately indicative of deeper issues.

We are, after all, living through seismic changes, when undeserving retro-modernists sell for 200K-plus on the Sotheby's and Christie's circuit and Dubai continues to beat its chest with a hysterical splurge

of dollars. Is it possible to explain it all away with financial analysis of the potential of "emerging markets"? Or is there a more insidious process in which power operates? One wonders, for example, why in the 1960s, when a strong and active cultural movement in the Arab world was at its apogee, it was largely ignored by the more traditional centers of cultural power. Were they rejecting the idea of a postcolonial state's emergence? Was their disinterest related to the movement's strong sense of localism? Were wider transformations and shifts in power reflected in cultural value and its assignation?

The gesture of an encyclopedic endeavor such as *In the Arab World* is essential in maintaining the illusion of a healthy environment that is ripe for investments of all sorts. The elephant in the room is the transparent attempt at raising the cultural capital of all involved—from city to dealer, from artist to public art space, and ultimately the value of the specific ethnicity in question through the evocation of a general ambience (travelers' notes, maps, etc.). Implicit is a denial of the work's validity as an independent, formal proposition—it is only through their association with a series of cities, presented as hip and hyper-modern yet foreign (like Dubai, Beirut, and Cairo) that the artist is validated. The book presents its readers with a seductive blend of capitalist-driven modernism and the erotic exotic.

In the Arab World ... Now (the three-dot pause is meaningful) presents its artists only in relation to their assumed ethnic affiliation; it becomes difficult to see them any other way. Although this is a technique that has made many a fortune—the Chinese example being the most striking yet—it has failed to acknowledge artists as producers within the very center of contemporary discursive practice.

On a more positive note, the generous space given to in-depth artist interviews and hi-res images of their work allows us, for once, to get close to actual content. Here at last, one manages to get some sense of what the artists included are involved with on both conceptual and formal levels. *In the Arab world ... Now* teaches us more about the idiosyncrasy of the art market than about the "Arab world" of the title. It is a market (especially in its emerging sector) that lacks the confidence to allow creative forces to operate outside its control. Its failure is epistemic more than anything else. Thus, all is well—the great drama of the emerging contemporary Arab market (accompanied by a background of occupations, military interventions, and tottering stifling dictatorships) unfolds.

djelabbah worn by his subjects are covered in fashion logos, thus forcing the viewer to question the very nature of stereotyping.

The hijab and the niqab also appear covering a young woman in contrast to the same woman "covered" by make-up. The symbolic link between turbans, veils, masks and the act of masking:

the effect of being engulfed by an encroaching hypothetical (illusory) reality is the truth of our reality.

One of the interesting reactions in the opening days of the exhibition came from a middle-aged male passerby, who anxiously asked how far she would uncover herself. Paradoxically,

it appears that the "seen" is ever more obscure and the "unseen" is increasingly open to discovery.

Such a stance is not surprising in the art world where the concept of artistic autonomy—or the artwork at best being part of a universal art historical canon—is often juxtaposed with the notion of context in which artists

are perceived as representing local realities.

Traditionally, "orientalizing" Western artists appropriated aspects of the Islamic world—above all, the erotic imagery of the harem—for the viewer's sensual gratification.

"Part of this romanticism," she elaborates, "is the way

SAJJIL: A CENTURY OF MODERN ART, INTERVENTIONS, & TOLD/UNTOLD/RETOLD (REVIEW)

KAELEN WILSON-GOLDIE
2011

The new museum of modern art in Doha, known as Mathaf, opened in late December with a list of promises to fulfill. In the months leading up to the inauguration, Mathaf's principal players embarked on a five-city tour to introduce and drum up support for the museum, in what was billed as a series of conversations. While those conversations were too often quite short, particularly in Beirut and Cairo, they held out a number of interesting prospects, positioning the museum as the mother of all projects, finally addressing the gaps in knowledge, access, and exposure that have blunted the study of modern art in the Arab world.

Mathaf would be the first of its kind, a major hub for research and a center for education of great relevance to the region and to the world. With a collection of more than six thousand artworks, it would give an encyclopedic view of the different phases through which Arab modernism has passed. With the development of its programming, it would challenge the notion that modernism can only be understood as a Western phenomenon. With its first major exhibition, entitled "Sajjil: A Century of Modern Art," it would explicitly avoid constructing an Arab canon running parallel to or in the shadow of a Western canon. Instead of one narrative, it would offer many in a bid to show that Arab modernism wasn't an alternative to Western modernism, but that modernism everywhere was part of the same tangled knot, which unraveled differently, and provoked different forms of engagement, in different parts of the world all at once.

Given the prelude, by the time Mathaf actually opened in a refurbished school on the edge of Education City, the air of anticipation was thick. In a way, the museum couldn't lose. Opportunities to see works by the region's major nineteenth- and twentieth-century artists are frustratingly rare. The international auction houses that have become active in the Middle East over the last five years have given the market a good shake, but some of the best and most ravishing works remain firmly in private hands. The events staged around Mathaf's inauguration included a conference organized by AMCA (the Association for Modern and Contemporary Art of the Modern World, Iran and Turkey), and many of the art historians, who lined up to speak were thrilled to wander around "Sajjil" for the first time. Imagine spending years of your life writing a dissertation on an artist whose paintings you had only seen reproduced in books, and then finding yourself in front of those paintings in all their physical, tactile presence.

At the same time, the museum couldn't win, either. Even if the curators of "Sajjil"—Mathaf's Acting Director and Chief Curator Wassan Al Khudhairi, Guest Curator Nada Shabout, and the museum's Head of Strategy Deena Chalabi—organized the exhibition according to a narrative that was fragmented, multiple, and occasionally contradictory, they were bound to be criticized by dint of being the first to do so. That isn't to say that the narrative proposed by "Sajjil" is weak, just that any narrative would have been challenged, and that is precisely Mathaf's point. During the museum's pre-opening presentation in Beirut, Chalabi characterized "Sajjil" nicely as "an invitation to research." As Khudhairi explained further: "There's still so much to be done on the collection, and a lot of these works have not been made accessible before. I just think once we get some things out there, there's going to be a lot of feedback, and a lot of information coming our way."

The only problem is that "Sajjil" isn't couched in any narrative at all. The show consists of more than 250 works by some 120 artists spanning roughly 150 years (the earliest piece is an oil painting dated 1847, the latest a fiberglass sculpture from 2008—a century, give or take). The works have been grouped into galleries according to themes such

Middle Eastern women have been portrayed artistically as exotic, mysterious creatures."

Originally these printed shrouds came in symbolic, plain colours—black and white, red and green—but over the last twenty years there has been a drastic shift in style. Each of three acts exhibits different aesthetics combined through their color and fabric qualities.

Here the mythological fantasy-world of A Thousand and One Nights is shattered and has turned into its opposite.

The dream has become a desperate nightmare of a dysfunctional society.

Here all ends are also new beginnings and the opposing forces—of individuality and the body politic, desire and death, sacred and profane—are short-circuited and made to arc across thwarted narrative trajectories.

Here the steadfast identity politics of national tradition are mashed and garbled in the mouth of relentlessly dissident individualism to create a complex memento and contemporary vanities.

Here, we pause and ask if this word has a real impact on the present daily life or in the long run, and if this impact is positive or negative.

Here, there are intense images that address notions of

as city, nature, society, and family. Those themes correspond to what is literally in the picture. The nature gallery features paintings of mountains and trees and still lifes with flowers or fruit. The city gallery features paintings of buildings, markets, indications of industry. The gallery tagged "individualism" is all portraits. The gallery tagged "struggle" dips into politics. And yes, there are nudes.

But as the first glimpse into a collection Sheikh Hassan bin Mohammed bin Ali Al Thani has been building for twenty-five years, "Sajjil" plays it extremely safe. Single galleries jumble decades, movements, and styles. Works are crammed together in random fashion. Pity the small but striking sculpture by Saloua Raouda Choucair from the 1960s, with six stacked aluminum pieces that lock together to form one of her wonderfully tactile "poems." Jammed into a glass box with an artist's book by Kamal Boullata, it has no room to breathe.

Artists are identified by where they were born, where they lived and worked, and, for about half of them, where they died. While it is refreshing to see a curatorial approach that casts aside chronology and nationality, the story being told here about modernity is really just a sampler. It hints at what the museum could (maybe) do in the future, but it doesn't, as yet, make good on Mathaf's promises.

Although it is uneven, the show offers flashes of brilliance. Truly stunning works are placed sporadically throughout the museum, such as an untitled 1962 landscape by Fateh al-Moudarres, so different from his usual compositions of crowded faces, so thick with paint that you want to run your hand across its surface to feel the tiny drips of red scattered across a deep green forest. Equally impressive is the texture of an undated oil, pastel, ink, and gouache work on paper by Jawad Selim, a portrait of a woman holding a chicken while balancing a sewing machine on her head. And Jassim al-Zainy's oil on board from 1973, titled *Features from Qatar*, is a revelation. A woman pulls back the *thob* of a reclining young man, whose face is averted in an expression of shyness or fear. She has a threaded needle in her hand, poised above the man's abdomen. Is she about to repair his dress or suture an unseen wound? The scene is ambiguous, deeply intimate, and tinged with strange sorrow.

But overall, the links that could have been made between works are buried far beneath the surface. Over the course of his career, the Lebanese painter Saliba Douaihy made a radical transformation from hazy realism to hard-edged abstraction. His late work consists of Brutalist, geometrical compositions, which remain landscapes to the letter, albeit dramatically distilled down to form, color, and flatness. "Sajjil" includes three completely different paintings by Douaihy. One of them captures a pivotal moment between his early and late styles: an untitled oil on canvas from 1968 shows a swirling, expressionist landscape in tempestuous strokes of deep purple mountains and heavy, redolent pink skies. But there's no thread to tie this piece in the "nature" gallery to an earlier, figurative portrait in the "individualism" gallery, or to a later, totally abstract painting—tough and austere—in one of the two "form and abstraction" galleries. By so fiercely resisting the urge to canonize, "Sajjil" dodges the duty to make meaningful connections.

It is not quite the case that no museum of this kind has ever existed in the region before. Algeria, Tunisia, and Egypt all have their own museums of modern art. Morocco has the Villa des Arts in Casablanca; Jordan has the National Gallery of Fine Arts in Amman. The Musée Nicolas Sursock in Beirut has been closed for renovations for years, but it does hold a large if uneven collection of paintings, sculptures, ceramics, and more. Same goes for Lebanon's Ministry of Culture, with a collection of paintings that has been added to (and deleted from) since the 1950s. True, there are only 1,610 pieces; they've been assembled to achieve a sectarian balance; many have been damaged by war, dust, and water; and what passes for public airing is being hung in the presidential palace. The problem is that all of these museums are old-fashioned. None of them are so explicit in treating the Arab world as a whole, or modernity as a territory so fraught. This is where

personal yearning and loss; the display of hiding the body and its sensuality; the interior and the domestic world and its relationship to the outside or social sphere; vanishing or enforced ritual and tradition; meditations on the landscape as a theater for conflict or as an emblem of the spirit; and concerns expressed over moral and social rule.

Here we see triangles appearing. But it is still possible to break the sphere up into pieces that individually can be described by lattices of squares. It is this feature which leads to our impression of the world being flat. At a human level we experience the local patching. We map out our cities and our countries using two-dimensional grids.

Here, it shifts from a problem of ontology to one of viability on the level of, say, curriculum and canon.

Here the laws of street and jungle, of nature and culture are in constant flux.

Here the unwitnessed theaters, theaters of the street—with their premonitions of community and isolation, kindness and violence—are written in drab palimpsest, their aspirations to immortality washed over by memory and rain.

Blood and words are spilled. Loves are born and lost. Private

Mathaf could make a crucial contribution.

In addition to "Sajjil," the museum opened with two secondary exhibitions installed off-site, in a *kunsthalle* of sorts erected on the grounds of the Museum of Islamic Art. This new space, Al-Riwaq, was reportedly built to exact specifications requested by Takashi Murakami, who is scheduled to do a show there in 2012. For now, it is hosting "Told/Untold/Retold," organized by the guest curators and consultants Sam Bardaouil and Till Fellrath, and "Interventions," curated by the multitasking Shabbout. Both shows consist of new commissions, emphasizing Mathaf's potential to make Doha a site of production. And both shows exemplify the good that can come from curators putting the theoretical frameworks aside and lending support to their artists, providing them with the time and material resources to make ambitious work.

"Interventions" pulls off a subtle twist by glancing in on the long-standing relationships between artists and patrons (the five featured artists are all represented in Mathaf's permanent collections, and their new works have been commissioned for the museum to own). "Told/Untold/Retold" says it's about one thing—the vague convergence of time, storytelling, and transmodernity—but delves into another, concerning men and masculinity. A number of visiting curators and critics walked out of the show asking: "And where are the women?"

"Told/Untold/Retold" offers a tiny percentage of terrific work—such as Hassan Khan's mesmerizing video installation *Jewel* and Akram Zaatari's tender and thoughtful inquiry into photography, collecting, and memory, "On Photography, People and Modern Times." But overall, the show feels padded and excessive, a biennial without the buzz.

It also suffers unnecessarily. After a brief, preliminary paragraph that bashes together quotations by Orhan Pamuk and Yve-Alain Bois, the catalogue essay introducing the show begins like this: "'Told/Untold/Retold' is a response to an exigent disparity in critical discourse evident in the putative designation of form as subaltern to content and the posturing of the referent and iconological as the cardinal gateway for all understanding." Then it continues for forty more pages of gibberish. If this is representative of the quality of texts Mathaf intends to produce, then the museum is definitely going to need a dictionary, an editor, and a copy of Strunk and White's *The Elements of Style*.

BONUS MILES: THE CASE FOR COSMOPOLITANISM

TIRDAD ZOLGHADR
2005

"So now the Americans are coming over here to teach us how to be critical." I was standing outside the US pavilion, featuring Fred Wilson, at the Venice Biennale 2003, talking to an art theorist from Graz. Wilson had chosen to reveal the unacknowledged history of African slaves and migrants in Venice, and there was something sublime about my perspiring Austrian friend in his drenched Missy Elliott T-shirt and Diesel khakis, reprimanding Fred Wilson, of all people, for American expansionism—declaring him the flagship of the very US elite that would routinely mistake him for the porter at his openings.

I tried to defend the artist with some unadventurous and predictable postcolonial wisdom, saying art was always instrumentalized in some way or other, that there was no harm in rubbing Venice's nose in its racist past, and so on, sounding like a Routledge textbook. I don't think I was doing justice to the ironic subtlety of the situation. What exactly was it about Wilson's pavilion that made him look like he was an uninvited guest "coming over here"? His race? Hardly. Geopolitics? Was

lives take on public dimensions. Haemorrhaged from the domestic setting, personal contestations of desire, ethics and will take on the visceral urgency of negotiations that affect not just individual expression, but also the definition of the very spaces in which such contests can be held.

On first seeing the whole setup, you mainly notice its improvised nature; there is little of the high-tech military about the wooden frame that two long mirrors are propped on, beneath this trapped and hanging missile.

They lead straight to the question: Is power capable of being represented? What is the

power to act in the construction of discourses and the production of images?

Approach and look down into the mirrors, and the thing reveals its secret: that trace of symmetry you might have noticed multiplies, propagates itself in the mirrors, into the fully-rounded rotational variety.

The mirror is an extremely desirable object in one's life, be it a woman or man's. That which resembles itself is not, on account of this resemblance, rendered identical to itself (that the artwork is self-resembling does not simply state a tautology). On the contrary, what is like itself is not present to itself

the enlightened European reacting strongly to the imperial superpower? But then, surely it would make a difference that Wilson was the outstandingly critical type, rather than your average US warmonger. So it may have been sheer populism, a reaction against established mouthpieces endorsing (supposedly) antiestablishment positions. Whether or not this is really what made my critical companion shudder in his clammy khakis, seeing as it is now increasingly common for all sorts of social hierarchies to be played down by transnational gestures of critical awareness, it is, I would argue, the one most pertinent side of the situation.

Back in the mid-1980s, Gayatri Spivak wrote her seminal essay "Can the Subaltern Speak," hoping to tease open fissures in the walls of Western academia for the subaltern voice to twitter through into the undergrad seminars and PhD programs. Over the twenty-odd years since her essay's publication, Afro-Venetians and other subalterns have become more present in both academic research and contemporary arts production. Subalterns aside, scores of intellectuals with surnames as racy as a *Bidoun* editorial board started "coming over here," straight into the epicenters of Western "high culture" and "learning." 9/11 hysteria notwithstanding, it is now significantly harder to argue that racist bias is still a career stumbling block, or that it is what makes Austrian art critics raise their voices in anger.

A magazine like *Bidoun* is relatively vulnerable as an obvious example of "coming over here," and I'd like to take a brief look at the particular, latter-day brand of cosmopolitanism with which it will be associated. Although cosmopolitanism smacks of privilege and repose, it is easy to relate it to open-minded progressives who all agree on voting for Kerry as the lesser evil, and on deconstructing the Western gaze, and on the fact that Third World filmmakers are important political voices even though "Third World" is, like, a really problematic concept if you think about it. The outright opponents of cosmopolitanism, however, go a step further, and consider it the common denominator between the proponents and the adversaries of US expansionism, as a symptom of deep-seated complicity with Western economic interests, across party lines.

The usage of the term "Third World" plays an important part in Timothy Brennan's monumental critique of cosmopolitanism (*At Home in the World: Cosmopolitanism Now*, Harvard University Press, 1997). Seeing as, according to Brennan, most critical intellectuals of today have a distinctive tendency towards self-irony, subtlety, complexity, and shades of gray, a term such as "Third World," in all its glaring Manichaeism, is inappropriate. To name a second example, it's not surprising that, during the 1990s, Homi Bhabha's concept of "hybridity," which plays down polarity, confrontation, and conflict to the benefit of wit,

negotiation, and re-inscription, became something of an international hallmark throughout Euro-American academia. Cosmopolitans—a "network of academic and governmental media" who uphold the ideal of "globalizing experience and outlook" (Brennan)—are of course critical of the West, but only as those "whose sympathies finally belong here." The hand that feeds is not so much bitten as flirtatiously nibbled at.

Brennan's *At Home in the World* traces a genealogy of cosmopolitan "murmurings of a world community of peace," running from the pre-Socratics to early biblical sources, and on to early colonial travel writing, Immanuel Kant, the Jacobins, and various strands of the European Left of the nineteenth century, when it was reconceptualized to fit the collective demands of the politically marginalized. In the twentieth century, the term came to signify a dystopian urban culture bereft of authenticity, and was beset with anti-Semitic connotations playing on the "wandering Jew" cliché (the uprooted highbrow, not clearly discernable in terms of national affiliation), at one point becoming a vague synonym of "intellectual." The latest chapter in the history of cosmopolitanism was ushered in with the discourses of globalization, when it gained a post-national, heroic touch, a herald of the impending "global village." Those who refused to partake in the cosmopolitan celebration of rhizomatic flow and hybridity came to be seen as difficult individuals who had

as something indivisibly one. Self-resemblance holds the work of art in incommensurability with itself, leaves it 'broken'. Also, many used the mirror to arrange their appearance and were grateful for the tissue paper to dry their sweat on such a hot day.

The exhibition consists of fourteen photographs that deal

with these themes, where mirror objects encroach upon the body and the landscape and act as an agent of alienation, cutting through elements that should otherwise be in harmony.

Within individual photographs, and all the more so when they are lined up together, we can suddenly leap, as it were,

from the 1960s into the 1990s and beyond. The photographs are inspired by the intricate layers of visual code that are unconsciously collected in one blink of the eye. Each of these works could be perceived as a momentary snapshot trying to contain history; a history which has burdened itself with the

Sisyphean task to remember itself ad infinitum until it can make sense of itself.

The photographs spotlight the key issue of 'modernist architectures' as the spaces in-between architectural development. The three projects all confront the urban landscape as a problem of "in-betweenness,"

yet to theorize their own role in a common global heritage.

Peer pressure aside, it is always tempting to cast oneself as a harbinger of a new age, and biennial catalogues, Routledge readers, and conference introductions are now rife with announcements of epochal upheavals and historical thresholds. With globalization, we are, among many other things, a) leaving the Neolithic age behind, and b) realizing that the Western intellectual heritage is so colonialist, we must, in fact, redefine art, theory, culture, and criticism as we know it.

The rhetoric of rupture begs the question of how globalized things are really. Depressing statistics on the number of phone lines in Ghana and Bolivia notwithstanding, even if we reduced globalization to its most banal characteristic— that of unmistakable traces of Western culture in metropoles worldwide, whether in art exhibitions, restaurants, fashion collections, government policies, medical facilities, transport technologies, or university curricula—such traces have been noticed in most parts of the world for a century or more. In some places, Muslims listening to Mambo, or concept art in Calcutta, simply isn't the same scintillating globalization fetish that it is in others. In other words, at one point, globalization itself needed to be globalized, and the breathless enthusiasm for a new era had to be disseminated somehow. This is where, in Brennan's view, the cosmopolitans come in.

Today, provided you equip your project with the fitting theoretical armature, your standard, voyeuristic game of show and tell—DAKAR DESIGNERS! RANGOON REVOLUTIONARIES!—can become a daring approach to bridging intercultural gaps in the global infoscape; the bridging of which, by the way, remains unquestioned and unquestionable as a moral imperative. The sheer romance of exploration aside, Body Shop hermeneutics and the cushy sense of ideological superiority through critical consumption, is now an integral part of our everyday culture, both high and lowbrow. As Brennan points out, the difference between painful political struggles in faraway places, and the consumption of representations thereof—research, journalism, art installations, video clips, consumer goods, and fundraising festivals—is increasingly blurred. This, he argues, is a further, decisive danger inherent to the spread of cosmopolitanism as we know it.

And yet, I'm sure even Brennan would admit that the cosmopolitan tenor, in our present context of hardnosed imperialism, is the most potent key to penetrating the "center of the real," to working it from within, and that it would be risky to abandon such tools in the name of lofty ideological credentials. If Brennan is arguing for the aggressive use of concepts that are as embarrassing and alienating as "Third World," then he should embrace the term "cosmopolitan" wholeheartedly. Let's face it: Who would call themselves

"cosmopolitans" at, say, the Venice Biennale opening dinner, and keep a straight face while they're at it? As an agenda, the blue-eyed buoyancy of cosmopolitanism is widely shunned, which is precisely what shows its potential as an analytical utensil. The alternative, that of simply jumping over our own ideological shadow and returning to anti-spectacular, localized grassroots parameters, is as boring as it is strategically ineffective—and impractical.

Precisely like my own, Brennan's take on cosmopolitanism as a global phenomenon already partakes in that pipe dream of epochal, planetary rifts. Can cosmopolitanism be the same in Venice and DC? In Dakar and Rangoon? The fact that it obviously cannot is one of the challenges not only for Brennan, but also for a magazine like *Bidoun*. If a quarterly is distributed in Europe, the US, North Africa, and the Gulf, the definition of its clientele implies awkward and repeated leaps of faith. It assumes that there really is a transcontinental mainstream of some form, a horizon of expectation that all metropolitan areas share in—like, for example, the notion that Kerry may have been the lesser evil, that "Third World" is, like, a problematic concept.

At first glance, Brennan would define this awkward "reaching out" as a pernicious form of "taking in," the sort of thing that ultimately buttresses America's interventions beyond its borders. But other

depicting locations trapped in a state of geographic and temporal limbo, neither fully abandoned, nor actively integrated into the urban context.

These large and ever-present images, self-portraits, grew to mythical/symbolic proportions. These are not portraits but faces of imaginary features that seem

to embody the melancholy of displacement. Faces, like landscapes, marred by tragic histories. They either look straight ahead or avert their gaze away from the camera.

The process is emphasized by the presence of light bulbs and electric pylons, objects that bring light, another life-giving element,

into our lives. The structures that form this thick horizon are found, rather than built specifically for the photographs.

The incongruity of the props also makes plain the artifice and theatricality of the studio portrait more generally.

Around the table are thirty-six vividly coloured, iron

beams that run from floor to ceiling. The sculpture itself is reminiscent of both twisted Baroque pillars and modern skyscrapers, while the voices from within the column suggest the Tower of Babel.

There are several references to monuments in this exhibition and each one is saturated in its

passages in his book are decidedly less paranoid, implying that the two may be symptoms of some common problem, rather than related in terms of cause and effect: "Trends in book markets are not equitable with decisions made in corporate boardrooms or with speeches by a US president on world order. But it is important, I think, to sketch out the atmosphere in which all three are simultaneously happening."

Indeed, latter-day cosmopolitanism can be set up as an "effect" of the globalization of globalization, a new self-image of a global community of middle class, bourgeois-bohemian culture workers. But it could just as well be staged as the very motor of these mechanisms, a prescriptive, middle class, bourgeois-bohemian ideal that has no clear existing referent *a priori*. As even Brennan appears to be suggesting—despite himself—instead of indulging in chicken-and-the-egg speculations regarding cause and effect, we could, rather, be considering common roots in matters such as colonialism and class privilege.

As far as the former is concerned, since the appearance of Spivak on the academic stage, colonialism has been established as a critical *cause célèbre* in many university departments, while the class issue, by contrast (despite Spivak's own efforts in this regard), has not. Considering the Frequent Flyer biennial crowd, the Third Text aficionados with G4 PowerBooks and Paul Smith jackets who speak fluent English, and hold double

or triple nationalities, and diplomas composed not in Arabic or Farsi or Hindi, but in French or German or English, analyses like Brennan's could prompt a useful and rigorous discussion of the economic parameters of cosmopolitanism. It would also entail a more incisive definition of what one stands to gain from a cosmopolitan agenda. Why exactly must any gap be bridged in the first place? Hasn't the enthusiasm for bridging been part of the problem in recent years? Who stands to gain from all this bridging?

Arguably, the best we stand to gain from cosmopolitanism itself is a forceful reminder that expectations shouldn't be raised to a point where they're hopelessly overheated, or channeled toward objectives that the middle class, social democratic, bourgeois-bohemian romanticism can never fulfill. If consumer ideologies and other sympathies and self-interests could be presented as such, and not as selfless tributes to momentous ruptures in the history of humankind, then that would make the likes of us, and of Fred Wilson, a lot more *simpatico* already.

RADICAL BLEAK

NEGAR AZIMI
2012

"Is there any need before we go to bed to recite the history of the changes and will we in that bed be murdered?"
—John Cage, *Silence: Lectures and Writings* (1961)

Like many of my colleagues who live or spend time in the Middle East, I've received emails from around the world—from curators, writers, charitable foundations, and miscellaneous others—curious as to the sort of art being produced and imbibed in these revolutionary times. These emails inevitably open with a bland honorific and, only occasionally, include a half-hearted caveat along the lines of, "Of course, I realize how foolhardy my question is." Throughout the past year, these queries have climaxed in a bounty of topical articles, books, panel discussions, and exhibitions. Whatever you think of these platforms and initiatives—and it may very well not be much—they can't help but leave you lingering over the sort of questions they raise and, indeed, wondering whether *too much* is being asked of art in times of revolution.

Many before me have narrated the sudden and surreal rise in interest in contemporary art from the Middle East over the past ten years. For the most part, this has been a phenomenon of the post-9/11 dispensation,

own way with the prevalent sense of disdain, conflict and division. It is not the aesthetic and structural phenomena alone that fascinate the photographer, but the absurdity of human activity and its potentialities expressed by the empty, punctuated facades. Architecture is a framework into which the work can worm its way

without any modification, can circulate, be a fleeting apparition or can be fixed so that it can be part of the environment. The attempt to change people through architecture has failed. Coming to a halt in a modern building does not suddenly make you modern. The suggestion of luxury stands for prosperity and progress.

Another work, an installation, deals with notions of tension and fragility. If your curiosity leads you to walk to the other side, you will discover that you have passed right through the window; now you are hearing the sounds of the next window before you see it. You are suddenly at the centre of a hexagonal

arrangement of red tubes, perfectly poised equilibrium that keeps them just millimetres away from the fragility of the glass. So, those who are far away must be cautious of getting nearer and those who are close must be weary of getting closer. Those of us who are away must be careful of being far off.

a period during which the Middle East—then, as today—entered the public consciousness in a powerful way. Married to a surge in capital in cities in the Gulf in particular, the evolution of Middle Eastern contemporary art represents a case of the cart preceding the horse: many cities in the region did not have the luxury of art schools, museums, or critics, much less bustling contemporary art scenes, even at a time when bulky hagiographic coffee-table books were being devoted to their artists. Ten years on, that post-9/11 interest in the arts has only been amplified by the recent (and telegenic) uprisings in the Arab world. It is not an unfamiliar instinct, and certainly not an ignoble one, to want to know how artists are responding to these heady times. But sometimes good intentions are the companion of misplaced efforts, which begs the question: what if contemporary art is not the zeitgeist of the current moment? What if there are more pressing forms of culture to think about, explore, and nurture—both from within and without?

For years, culture in the Middle East has been tightly entwined with affairs of the state. In Egypt, officially sanctioned arts events—from the Cairo Biennial to the city's annual Youth Salon—have historically been festooned with bloated political themes, from Palestinian intifada to world poverty to American imperialism. For the most part, this embrace of political content has been conveniently outwardly orientated (officially, there is no poverty in Egypt) and served up a safe, neutered version of principled engagement with the world. Works were emotionally charged, shallowly existential, neatly cropped one-liners that had more to do with paying lip service than engaging our senses.

In the aftermath of the uprisings, which began on January 25, 2011, and that climaxed with the fall of president-for-life Hosni Mubarak, that relationship to politics has remained largely intact—though the dominant narrative is now concentrated squarely on a singular dramatic mode: the heroism of the revolution. A state that was scrambling to hold on to power has now, predictably, co-opted the very narrative that threatened to dismantle it.

Commercial galleries, too, have appropriated this logic, offering up their own steady stream of shows—some as early as a month after the event—monumentalizing the revolution. Their names—such as "Our Revolution, Our Pictures," "The Art of Revolution," etc.—reveal their simultaneously expansive and limited vision. Witness images of purposeful children holding the Egyptian flag, heroic soldiers beaming patriotically, and of course, the famously witty protest signage of Tahrir Square (my favorite remains "La Vache Qui Rit: Muuuh Barak"). The revolution, in a sense, has offered itself up as a readymade; it has become an engine for producing artistic flotsam that, for the most part, looks like lobby art for the United Nations and mines the language of consensus (for how can one argue against art that represents such a historic moment?). A survey of titles of works from recent exhibitions in Cairo reveals the following: "Freedom," "Drink Freedom," "Shadow of Freedom," "People Demand," "Man Crying," and so on. This, it turns out, is the sort of revolution-kitsch the market seeks. Mona Said, the owner of the Safar Khan Gallery in Cairo, told Reuters that she had held a show of revolutionary art in March that was so successful that she sold four times the amount she expected and ended up shipping works to clients all around the world. To be blandly political is in vogue and to be apolitical risks flirting with philistinism. This is, of course, not entirely surprising in a country in which the faces of revolutionary martyrs have been mass-produced on car air-fresheners.

The market for Revolution Art exists internationally, too. A number of exhibition projects have emerged that have the Arab revolutions as a reference or organizing zeitgeist. Though not always explicitly, these shows seem to ask of artists what we barely even expect of journalists anymore. Many of their mission statements are marked by an intoxication with the notion that artists are experiencing unprecedented freedoms. A piece in Reuters in August, says this: "People whose ideas had been suppressed during the Mubarak regime,

Suddenly the makeshift nature of the frame has significance: it renders the glass so very vulnerable, conspicuously so: the unsupported mirror-ends ready to shatter catastrophically at the slightest touch, were the metal to swing.

Meanwhile, in the installation's other two sections, a bar and a heavily armed airfield represent the opposing culture that lies beyond the fearsome wall and border crossing. The copy machine, located at the main entrance, captured more than three-hundred images, where faces, expressions, hands, arms, show the combination of hope, naivety and daring of the Tunisian youth. Visitors are invited to open the lid, like Pandora, and look inside.

When you lift the sugar bowl's lid, you see that the ends of the material are burnt and there are pieces of a broken mirror and bangles. There is a certain automatism about them as I am sure there must be to all true witnessing. It is precisely insofar as it resembles nothing save for itself that art should in turn be resembled. What is unlike anything else, inimitable in its singularity: this is what calls for imitation.

The works displayed, videos, paintings, and drawings, are all driven by the same momentum,

such as the deaf-mute artist Hanan el-Narhrawy, are allowed to spread their work without fear of retribution." Deafmute! Hardly radical chic; most of this work mines in radical bleak. Witness multiple hastily put-together shows scrambling to capture the current moment artistically, among them, an Arab Spring platform at the recent Bamako Biennial of African Photography (and lo, an Egyptian, Khaled Hafez, won the video prize). There was, too, an Arab Summer in London named "Shubbak," which, though organized by the Mayor of London's office before intimations of revolt, certainly referenced it. Multiple panel discussions have canonized the current artistic moment and, as my colleague Kaelen Wilson-Goldie argued in the October 2011 issue of *frieze*, abundant money to nurture this expression has flowed, too.

There are risks attached to the sudden interest in and market for Revolution Art. Artists are asked to swiftly respond to the changes in their midst, but this demand is out of touch with the tenor, spirit, and temporality of art production. Now might be the time to look at other forms of culture that are more pliant, and that may respond to the current moment in more organic ways. Theater, for example, has been a prime space for improvisation and experimentation, as has music. Graffiti, too—though it has admittedly been written about to death— reflects a form that is more faithful to the texture of

daily life in a city such as Cairo today.

There is another risk. By insisting on the finished artwork, catalogue, or film, one risks communicating that the revolution has come and gone and is a static, undynamic, finite topic suited for reflection. Instead, these revolutions—as ongoing military trials, abuses, and mass protests in Egypt testify—are anything but over. How can one possibly reflect on, much less make a sculpture or film about, a moment that remains in progress and, ultimately, in flux? As an editor of an arts and culture magazine that tried to do this very thing, I can testify how difficult it is.

And, finally, a point that is close to my heart. What if the proliferation of articles, books, and exhibitions depicting a happy emerging art market in a happy emerging democratic state serves to mask more trenchant realities? The use of culture as a facile façade for more grim truths and, equally, as a marker of freedoms (of expression, for starters) is a tactic as old as the Cold War (witness Louis Armstrong paraded around Europe, care of the State Department, to belie the realities of Jim Crow racial segregation laws in the US). Today, however, with international interest at its peak, such shows may serve to mask the infrastructural problems and violence embedded in systems that will take generations to undo.

One year after the fall of the House of Mubarak, it may be time to stop zealously memorializing the Arab Spring through artistic platforms. The revolutions in the region, at best having toppled a handful of dictators, will have wrought many things—not least among them, a lot of timely mediocrities and, well, a lot of bad art.

ON RUPTURE
KAELEN WILSON-GOLDIE
2013

By almost any measure, last summer was terrible in Alexandria. For much of its modern history, Egypt's second-largest city had been a breezy seaside refuge and an escape for those who could afford the train or bus fare from the chaos and density of Cairo. But eighteen months after the ousting of Hosni Mubarak, Egypt's entrenched and autocratic president, the city was a wreck. The streets and public beaches were clogged with rubbish, unemployment anxiety, idle youth, and festering anger. Many Cairenes who had vacationed in Alexandria as children, or who had retreated to the city in their adult lives for moments of rest and reprieve, were stunned to find it so agitated and on edge. In the sweltering heat and turbid humidity, amid cloying theories of conspiracy and counterrevolution, it felt

the same creative inspiration. The drawings and paintings are directly related to the films for which they are the matrixes.

The video is projected onto a transparent scrim suspended in the center of a dark room. The video can be watched from either side of the room; but if you are standing on the side of the room

where you enter, you can faintly hear that from the other side of the screen other sounds are emanating.

To the sound of dramatic music, the skilled animation rapidly transforms scene after scene, faithfully rendering by now familiar images: rooms (dimensions given) that become

of confining sizes and forbidding bars that become grids; rats that are metamorphosed into bats, all blood-drawing animals with lugubrious connotations; trees that become hearts, abstract shapes and well-defined images, a familiar world and one of fantasy drawn by the imagination of an evil mind.

With the form of short stories, these short movies establish systems of notations, as visual phrases, involving writing and language, meant to decipher signs found in urban spaces or in landscapes. We see the girl again and again, in color, in profile, in black and white, always different,

like the place was about to explode. With the so-called Arab Spring lurching from euphoria to despair, it seemed pertinent to ask questions related to the writing of a very recent history. What had gone wrong? When had the movement for change in the most populous and politically pivotal country in the Arab world unraveled? What had caused the revolution to crack? And where was the break, the rupture, the tear in the narrative that had been so beautifully woven together on Tahrir Square?

To pose these questions to artists and curators may have seemed eccentric to members of the mainstream Arab media, where cultural production remains niche and a novelty—something wholly sidelined in times of crisis. Yet the answers were almost exactly the same as those of press-friendly pundits, political analysts, and popular academics: The moment that darkened the mood of the revolution was surely the massacre in Port Said, when more than seventy football fans were killed, and over one thousand injured, in a stadium riot that followed a match between the teams Al-Masry and Al-Ahly. The mayhem was allegedly provoked for political reasons—hardcore fans of Al-Ahly had been instrumental in the demonstrations on Tahrir and vocal in their disdain for the military—and the police were said to have stood by and done nothing. A year later, Port Said erupted in violence all over again when a local court handed down death sentences to the twenty-one fans of Al-Masry (the local team), holding them responsible for the loss of life. The police opened fire on a crowd of protestors, killing thirty people, and then opened fire again on their funeral procession, shooting at the families of those they had just gunned down. This threw Port Said into full revolt. The government declared a curfew, which was emphatically defied. Residents have now stated their audacious desire to secede from the country and declare themselves an independent state. As such, the massacre may soon be regarded not only as the rupture that mattered in the revolution, but also as the first critical fracture, if Egypt now well and truly falls apart. But, what do such ruptures or fractures really mean? And how do they play out in and for the field of art, not as historical events or documentary subjects, but rather as theoretical concepts influencing both curatorial thought and artistic practice?

I have Alix Rule and David Levine to thank for the knowledge that "rupture," as a word, has become passé, having hit its peak usage in "International Art English"—as defined in their astute essay of the same name for the online journal Triple Canopy—back in 2011. As an operative idea and an organizing principle, however, rupture still has a stubborn and enduring sense of currency in the Arab world, where the history of so many nation states runs through much of the twentieth century in coughs and stutters, from colonial mandates and partition plans to independence eras followed by rounds of coups and civil wars. In the world at large—or more precisely in the United States and Europe—art-historical narratives tend to pivot on terms such as "postwar" and dates such as 1945, 1968, or 1989. In the Arab world, the mother of all ruptures is 1967: the year Israel devastated the armies of Egypt, Jordan, and Syria and all, but annexed the Sinai Peninsula, the West Bank, and the Golan Heights. "That defeat wrecked the hopes of one generation, and branded a younger one raised in its shadow," wrote the Lebanese-born, American writer Fouad Ajami, in 1997, in a brutally honest essay titled "The Arab Inheritance" for the journal *Foreign Affairs*. "The universal truth of Arab nationalism—that large idea of a common political inheritance and destiny, that belief that the national boundaries of the Arab world were contrived - had cracked." What's more, he added, "That truth had only itself to blame."

In the same season when Egypt's once-glamorous port city was rank and smoldering, the American University of Beirut (AUB) was hosting a conference of art historians titled "The Longevity of Rupture: 1967 in Art and Its Histories." Organized by the Association for Modern and Contemporary Art in the Arab World, Iran, and Turkey (AMCA), the conference sought to challenge the notion that the Six-Day War changed everything, not only the status, standing, and

always the same, an enigma in progress.

This virtual image, provided by the computer screen and reworked into a fractal image, is like a window, recalling that the perception of others is not so easily understood. There is an air of ultrarealism, which only enhances the nightmarish quality of the series.

Through a reverse animation process, a leafless tree, like a living object, gradually regresses to a small speck in a bare, clinical room, becoming a stone, a moving amorphous body that assumes the image of a beating heart. These images are shocking in a world where so little now shocks us—that is, until something similar happens to us or penetrates the space we ourselves occupy.

The film explores the idea of displaced identities, typical of societies that have undergone political turmoil, and their diaspora. Exploring the overlap between personal trajectories and historical narratives, the chosen sequences convey a sense of the ephemeral, appearing as fragments of lived or imagined memories.

Firstly, it is the language of the newly-created ritual itself, which retains characters of Islamic memorial ceremonies, as

institution of art, but also the social, aesthetic, and political sensibilities of artists in the Arab world. A line-up of by now locally well-known doctoral candidates—including Saleem al-Bahloly, Clare Davies, Holiday Powers, and Anneka Lenssen—presented their research on episodes in Iraq, Egypt, Morocco, and Syria. Then Angela Harutyunyan, AUB's first dedicated professor of contemporary art history and theory and a specialist in the post-Soviet period (whose formative research focuses on 1989 rather than on 1967), raised an obvious point: "In historiography in general and art historiography in particular, the desire to revisit, re-conceptualize and re-historicize certain periods as epochal shifts and ruptures, and to find ideological, formal and stylistic continuities, often arises from the needs of the present."

What was most depressing about the events of the past year in Port Said was the realization that Egypt was still ruled by fear, rumors, plots, and intrigues. This kept security panic high and the need for a strong state firm—the logic being that authoritarianism was bearable while total chaos was not. Painfully, this also made the revolution effectively false, not a rupture, but its opposite: the continuity of the Mubarak regime's tactics and strategies, minus the man. Likewise, the speakers for AMCA's conference emphasized the things that did not change; the intellectual debates, trade

union disputes, and repressive regimes that were present in the region before and after 1967. They also disputed the notion that the war and its staggering defeat had shattered solidarity among Arab artists, because artists' syndicates and a series of pan-Arab biennials came later.

And yet, it might not be enough to merely disprove a thesis, to assert that 1967 was not a rupture, but a continuity, or to argue that a rupture within a revolution in 2011 also exposed it as a situation unchanged. To quote Harutyunyan again: "Must art-historical moments always be traumatic or can they also be affirmative?" If the writing of history is neither innocent nor objective, then perhaps we should not just disassemble the old histories that have already been written, but figure out what we are trying to do, and what we want from the new histories that we can't help but posit, formulate, and test out all over again. Harutyunyan's point should not be missed. A conference on 1967 in 2012 was surely a means of raising questions about 2011, the year when "rupture" was most popular in art speak and also, given the rolling tumult of Arab uprisings, the most present on the ground. At least one panel considered artistic practices that began in the 1990s rather than the 1960s, but it would be interesting to think at greater length about how the rupture of 1967, and the idea of historical breaks more generally, is playing out now in specific artworks made in and of the region.

Perhaps the most far-reaching example of this is Joana Hadjithomas and Khalil Joreige's project "The Lebanese Rocket Society" (2011-12), which takes 1967 as nothing less than the death of the Arab world's political imagination and capacity for dreaming. Through videos, installations, archival photographs and films, a documentary feature, two carpets, and two sculptures playing with the ambiguities between missiles for war and rockets for study, the project delves into the story of a group of students in a science club at an Armenian university in Beirut who inadvertently started a national space program and entered Lebanon into the space race, only to have the program militarized and quietly shut down. To return to this moment now is to try and revive a time when the advancements of science, technology, and education had not yet been thrown under the bus of bad politics and debilitating ideologies. It is an act of great urgency and like Maha Maamoun's film *Domestic Tourism II* (2008-09), which wonders what became of an entire genre of Arab science-fiction films, it orchestrates the slimmest of suggestions that all of those versions of progress might again be possible.

Without the obligations of an academic discipline, artists and curators have a greater tendency to be irreverent, playful, and productively irresponsible in their revisiting of past ruptures. They are also freed from the orthodoxies of how history is understood within a field.

well as possibly some of pre-Islamic origin. Each series works with a strong desire to de-territorialize and re-code the spaces and locations they took place in; the artist believes that unexpected performances of the body may alter its surroundings. At first this involves a certain fictionalization, appropriation and disassociation

in which the audio and visual recordings of the event are allowed to be dissociated from their context and become autonomously experienced aesthetic expressions—they are sublimated and become sublime.

This project examined the relationship between body-language and verbal communication.

Each of these, in its own way, perceives the possibility of a mixed language in the matter of trans-cultural communication. Hence a new set of vocabulary is created for the interpretation of our modernity, one that is especially characterized by a forceful relationship with our time.

The collection began as part of a journey. There is a necessity, therefore, to elucidate the contours and challenge of this original aesthetic and cultural project, by cruising through a characteristically heterogeneous body of work—at times perplexingly so—and revisiting the artist's very personal journey. In each of

When curator Rasha Salti was organizing the three-part film program "Mapping Subjectivity: Experimentation in Arab Cinema from the 1960s to Now" (2010-12) with Jytte Jensen of the Museum of Modern Art in New York, she said, "I was operating with this notion that there was a rupture in the 1990s. I thought people started experimenting in film and video only in the 1990s. We all operated under this idea. But it's not true. Nobody in the region is supposed to have watched Maya Deren's films when they came out, but they did. The first post-independent films in Algeria? So radical. The first post-independent films in Morocco? Crazy. There was obviously a tremendous amount of cultural transmission moving through the cine-clubs of the Arab world in the 1980s. There's a whole world that's waiting to be discovered. I think the way we write art history has to change [...] Curators can make wild speculations, so why not use curatorial practice to explore the theses of art history?"[1]

Why not use artistic practice, too, given that wild speculations have fuelled fine exhibitions but better artworks? Céline Condorelli's mesmerizing series of installations and performances bundled under the title "Il n'y a plus rien (There Is Nothing Left)" (2010-11) complicate our understanding of what happened to the polyglot, multinational milieu of Alexandria after the Free Officer's Coup of 1952 and the rise of Gamal Abdel Nasser,

the Egyptian president who promulgated the quasi-socialist ideology of Arab nationalism. Hewing close to the history of Alexandria's cotton industry, unrivaled in the world for a time, Condorelli then jumps from one fascinating anecdote and figure to another— for example, from the Marxist historian Mahmoud Hussein, a pen name for the writing partnership of Bahgat El Nadi and Adel Raf'at (the great-grandson of a Sephardic rabbi from Aleppo), to the renegade publisher François Maspero and his grandfather, Gaston Maspero, a leading Egyptologist. In the 2008 installation *Nefertiti*, the artist Ala Younis ruffles a similar history by studying the manufacture of a domestic Egyptian sewing machine.

Another curious artwork concerning rupture—which was exhibited alongside Condorelli's project at the now sadly closed Alexandria Contemporary Arts Forum—is Uriel Orlow's *The Short and the Long of It* (2010-11). Based on a forgotten scrap of history, Orlow's material tells the story of how fourteen international cargo ships had been passing through the Suez Canal when the Six-Day War erupted. Staggeringly, they were stranded there for eight years until the canal reopened in 1975. The crew members, caught in an absurd situation and bored out of their collective skulls, invented an island nation, issued their own stamps, and played out an alternate version of the Olympics while Mexico City hosted the real games

in 1968. The Swiss-born Orlow's installations play with the codes of high-minded documentary and resolutely formalist geometric abstraction to invest a forgotten interlude with meaning.

It's worth noting that, among the artists who did start experimenting with film and video in 1990s, Jalal Toufic has probably done more than any other thinker in the Middle East in terms of theorizing rupture as two key principles, radical closure, and the withdrawal of tradition following a surpassing disaster, which necessitates the resurrection of art and culture, but warns of being fooled by doubles and fakes. Was 1967 a surpassing disaster? Has the Arab world after the Arab Spring found itself in a state of radical closure? Works such as Hrair Sarkissian's "Execution Squares" (2008) and "Istory" (2010) suggest—through a series of evocative images depicting public execution sites in Syria (presaging the civil war there) and library archives on Armenian history in Istanbul—that the latter has been the long-standing condition of the region. The space of ruptures, disasters, and radical closures appears in certain artworks like an interlude that is dangerously still yet eerily productive. (Witness the short lifespan of the Egyptian Surrealism movement, explored at length in "Tea With Nefertiti" (2012), curated by Sam Bardaouil and Till Fellrath at Mathaf, Doha, which started to crack in the 1940s and then broke apart completely with the expulsion of foreigners and minorities after 1952.) This

these instances, the artwork is inextricable from the incidental circumstances of its making (be it time, travel, or light). The video does not only reconstitute a journey, but also constitutes a new body: the body of the subject whose point of view/audition it re-members.

In addition, the "body" of work here—all produced between 2006 and 2007—brings memory back into the realm of the corporeal and the material, where it is breathed, ingested, printed or even written on the body of what appears to be at times a failed attempt to find meaning "proper".

This body of work is an experiment in displacement, productions devised and completed against the backdrop of personal detachment and self-awareness only achievable when away from home.

The first five projects were realized intermittently on Friday mornings between February and

June 2009 at different localities in Bahrain. Most of the ideas were a result of direct brainstorming evolving through group interaction into a sound piece that tickles the mind and senses when heard in a live performance studio. The perception of the film's subject, meanwhile, is multiple and simultaneous, and

raises the unsettling question of what it means for horrific moments in history to instigate great works of art.

However, for all the alternative histories and latent continuities, the philosophy scholar Elizabeth Kassab argued at the end of the AUB conference that 1967 was and must be viewed as a critical turn. "It was the regimes that came in reaction to 1967 more than the war itself that devastated our lives," she said. But it was also an event that provoked "a radicalization of critique, of inward examination, of self-examination. And by critique I mean becoming more busy with raising questions than readymade answers." In the aftermath of 1967, the dominant question among Arab intellectuals, Kassab explained, had been this: Why, in the face of twentieth-century modernity, had attempts to revive the *nahda*, the Arab renaissance of the nineteenth century, failed? Before the advent of the Arab Spring, the question had become: "Why have we failed, period, without hope? In the early 2000s, there was a sense of total incapacity and total despair." Protestors on the streets in 2011 may have restored hope to the region's vocabulary. Artists in their studios in 2013 might have to take up the hard work of reinvigorating that notion of radical critique to keep it going.

1 Author's interview with Rasha Salti in Beirut, October 24, 2012.

this flexibility allows the subject's body to re-form itself in relation to each new body of spectators that it encounters. Moreover, the subject's body is transparent: it is not looked at but looked through.

Every cut in the video seems to displace this body from one geopolitical location to another, yet despite its high degree of mobility it is radically fixed to a center point by the immutability of the window frame—to such an extent that we must question whether it is the subject or the landscape that is truly moving. The works in this exhibition focus on the influence of a place on our creativity.

The deeper structure of these pieces is driven by an impulse to encapsulate, not just to represent memory but to capture and contain its ephemeral nature. The fragmentary images within these boxes are birds that are longing for cages to call home. Pieces of netting wrap up many of the scenes, creating distance and a softening of edges like memory's own process, a curtain that renders the past still visible, if dimly, but essentially untouchable.

This work is about exile—families forced to leave their homes in the middle of the night and wander towards nowhere.

But because the cinematic subject's point of view is

FOLIO BIBLIOGRAPHY

AZIMI, NEGAR. "Radical Bleak." *Frieze* 144 (January/February 2012): 106-107.

AZIMI, NEGAR. "Regimes of the Image." *Artforum* 50, No. 4 (December 2011): 236-239.

ABU ELDAHAB, MAI. "Global Epidemic Art in the Age of Globalization." *Bidoun* 5 (Fall 2005): 19-20.

BIDOUN WITH NADIA AYARI, ANNABEL DAOU, RANYA HUSAMI, MAHMOUD KHALED, AND SARAH RIFKY. "Model UNESCO." *Bidoun* 27 (Summer 2012): 92-97.

GHOUSE, NIDA. "I spent a stretch of 2008 landlocked in Cairo..." in "Identity Bazaar." *Bidoun* 20 (Spring 2010): 76-77.

HAQ, NAV. "It's easy to imagine that art revolves around parties..." in "Identity Bazaar." *Bidoun* 20 (Spring 2010): 73-75.

KHAN, HASSAN. Review of "Word into Art: Artists of the Modern Middle East" at the British Museum. *Bidoun* 8 (Fall 2006): 114-115.

KHAN, HASSAN. Review of "In the Arab World... Now," ed. Jerome Sans. *Bidoun* 15 (Fall 2008): 193.

AL-MARIA, SOPHIA. "The Gaze of Sci-Fi Wahabi: Introduction." *The Gaze of Sci-Fi Wahabi* (excerpt). http://scifiwahabi.blogspot.com/.

RIFKY, SARAH. "Call Me Soft." *Bidoun* 26 (Spring 2012): 86-88.

WILSON-GOLDIE, KAELEN. "Off the Map: Contemporary Art in the Middle East." *The Future of Tradition - The Tradition of Future.* Ed. Chris Dercon, León Krempel, and Avinoam Shalem. Munich: Prestel Publishing, 2010: 60-67.

WILSON-GOLDIE, KAELEN. "On Rupture." *Frieze* 154 (April 2013): 120-123.

WILSON-GOLDIE, KAELEN. Review of "Sajjil: A Century of Modern Art," "Interventions," and "Told/Untold/Retold," at Mathaf: Arab Museum of Modern Art. *Bidoun* 24 (Spring 2011): 164-165.

ZOLGHADR, TIRDAD. "Bonus Miles: A Case for Cosmopolitanism." *Bidoun* 3 (Winter 2005): 138-139.

ZOLGHADR, TIRDAD. Introduction to *Ethnic Marketing.* Ed. Tirdad Zolghadr, Charlotte Bydler, and Michaela Kehrer (excerpt). Zurich: JRP/Ringier, 2007.

directed away from the space she inhabits (toward the future visible through the window), this visual rigidity frees the editor to create a "mutative commixture" of sounds. In this video they are juxtaposed with a tableau enacted on the Yerevan Steps, which would have stretched from the central plaza of the city to the World War II monument on the hill above it if the fall of the Soviet Union had not halted the construction and left both steps up and steps down suspended over a void of air.

Indeed, although the video's elements are mostly documentary, the experience of watching and especially of hearing it is unlike the passive reception of information sometimes characteristic of documentaries because so much of the video's information is delivered offscreen, thereby engaging the viewer/listener in an active and individualized synthesis of those elements. The story told in the video, however, is a remembering of the original at a distance of twenty years.

ALL CONTENTS ON LOAN FROM THE BIDOUN LIBRARY. EDITED BY BIDOUN PROJECTS: BABAK RADBOY, NELSON BART HARST, ANNA DELLA SUBIN, NEGAR AZIMI, MICHAEL C. VAZQUEZ, GRAHAM HAMILTON, AVENA GALLAGHER.

ARTIST ENTRIES

ABOUNADDARA
f. 2011 Damascus, Syria

The project of the anonymous filmmaking collective known publically as Abounaddara began with a Facebook post in April 2011, one month after the start of large-scale demonstrations throughout Syria. The collective's first post included a short video titled *Que faire?* [What to do?], which suggested the need to produce images of the developing events. What was initially a close group of self-taught filmmakers in Damascus grew into a larger production company that incorporates many voices and perspectives, telling the stories of Syrians living amid the social turmoil that has since become an ongoing civil war. Collectively sharing files online or smuggling flash drives with traveling friends, Abounaddara posts one video each week, working in what they call "emergency cinema" to high-light the urgency of the moment, the need to bear witness, and the importance of producing images that counter state television broadcasts.

For many years, under the dictatorship of Assad, Syrians and filmmakers especially faced strict censorship. Since 2011, however, many turned to social media and amateur documentary practices to share their experiences with a local and international audience. Within this emergency situation, Abounaddara encountered an unexpected freedom—the ability to "portray the way in which our reference points have been turned upside down by the revolution." Abounaddara's videos are eclectic, but most are short one- to two-minute videos that offer a glimpse of everyday life by inviting ordinary people to tell their stories,

recall a particular event, or register fragments of what they have lost. Many utilize static shots of subjects in dark spaces, sometimes with their faces or voices obscured. Yet, whether interviewing Free Syrian Army fighters or the *shabihah* (pro-regime militia), Christians, Shiites, Sunnis, or Alawites, Abounaddara, above all, aims to show the dignity of all Syrians—sharing the heartfelt testimonies of not only victims, but also those who have killed. Dissociating their efforts from activism, Abounaddara does not align with any political faction, but instead uses its anonymity to shed critical light on all sides of the conflict.
—N.B.

ETEL ADNAN
b. 1925 Beirut, Lebanon; lives in Paris, France, and Sausalito, CA

Growing up surrounded by Greek, Arabic, Turkish, and later, French and English speakers, Etel Adnan was drawn toward poetry and abstract expression at an early age, taking pleasure in forms that resist simple translations. Until recently, Adnan has been best known as a poet, novelist, translator, and professor of philosophy. Her novel *Sitt Marie Rose*, a gripping account of a Lebanese woman abducted by militia, along with her book of poetry *The Arab Apocalypse* are regarded as two of the most important literary responses to the Lebanese Civil War. In tandem with these pursuits, Adnan has maintained a practice of painting and weaving, and has authored multiple watercolor artist books that serve as calligraphic experiments with gestural text and abstraction.

Adnan began drafting *The Arab Apocalypse* in 1975, the first year of a conflict that would engulf Lebanon for the following

fifteen years. At the time, Adnan had recently resettled in Beirut following university studies in Paris and the United States. Raw, dark, violent, and prophetic, the seventy-two-page poem channels the energy of both Symbolist and Concrete poets to evoke the absurd brutality of the civil war massacres, occasionally invoking a higher power as a "celestial comrade." Adnan also intermittently interrupts the prose with the word "STOP," at times mimicking the choppy elliptical tempo of a telegram, at others, appearing as an injunction, an involuntary tic, or a reminder of death. Words also fail her: Adnan eventually exchanges adjectives for hiero-glyph-like symbols whose identical iterations take on varying significance (an inked-in circle is a black sun, a meteorite, or a bullet). The omnipresent sun—perhaps a metaphor for colonial forces—is alternately technological, savage, human-like, and ultimately fleeting. It will extinguish itself, Adnan proposes, but only after extinguishing everything else. In its absence, in total darkness, she finds potential for redemption: "In the night in the night we shall find knowledge love and peace."
—N.B.

RHEIMS ALKADHI
b. 1973 Buffalo, New York; lives in Beirut, Lebanon

Rheims Alkadhi's artistic practice encompasses photography, sculpture, video, and performance, and her works often take on conceptual strategies of documentation. Whether as long-term social immersions or collected traces of ephemeral interactions, Alkadhi's practice is, as she describes it, "Necessarily a public activity, which may or may not be acknowledged." Other works result in photo series

narrated by ardent and enigmatic prose, or found objects playfully anthropomorphized. In *House of the Matchmaker* (2008), for example, she collected over three hundred individual shoes from a rural village in northern Jordan and installed them in an abandoned home, figuratively mimicking the role of matchmakers in engagement traditions by pairing each lost sole. In *Destroyed in Baghdad/Repaired in Cairo* (2009), Alkadhi set up a temporary practice in Cairo's auto mechanics district, juxtaposing the human body with the auto body, and contrasting the shells of cars in Baghdad with those in Cairo being restored and refitted.

In creating the works exhibited, Alkadhi drew from her interactions in urban marketplaces, where many peddle or trade their personal belongings. Laid upon blankets on the street or affixed to sellers' clothing, these items are often versatile in their reuse—and, for Alkadhi, in their significance. In her peculiar alterations, Alkadhi re-envisions these items' utility or failed utility. In *Costume for a fly (teapot)* (2013), for example, a taxidermied housefly rests upon the spout of a battered aluminum tea kettle. The wooly sheepskin dickies that compose *Chorus of chest-beards looking leftward (fashion for women)* (2013) recall the beards that for many Muslim Brotherhood adherents symbolize their identity and belonging. Alkadhi's piece, however, proposes a new women's fashion, the attire of an imagined "Sisterhood." *Hairs from the hairbrushes of Palestinians* (2013), a collection of hair, combs, twigs, and spools, resulted from her project "Collective Knotting Together of Hairs" (2012), in which she spent several months living with four Palestinian women in a village south of Nablus. During this time, she solicited the hair of nearby residents, and worked with members of the local Women's Association to knot together what she had gathered. Through this collaboration, in which each woman was paid hourly, Alkadhi's project also introduced a new, if temporary, source of income to the village. Working collectively, they knotted thousands of strands of hair to create a single strand that could reach Jerusalem, forty kilometers south, poetically imagining a link to a place that, for many Palestinians, remains inaccessible.
—N.B.

BASMA ALSHARIF
b. 1983 Kuwait;
lives internationally

Basma Alsharif's video and photographic works are fragmented narrative odysseys that double as poignant exercises in perspective. Occasionally alluding to her experience of being uprooted and in exile, Alsharif's pieces weave together an ever-expanding archive of audiovisual recordings both culled and created. Her works often present the accounts of anonymous groups or individuals, and invite viewers to experience how memory can induce feelings of intimacy and desire, as well as those of loss and alienation.

We Began By Measuring Distance (2009) opens with images of vacant skies and the cries of a young girl who witnessed an attack that killed her family on a Gaza beach in 2006. Then, through the film's narrator, we learn of an anonymous group that devises a game of measuring distances. Initially, they measure shapes and degrees, or the metric equivalents of imperial lengths. But these arbitrary and innocent dimensions soon begin to take on political significance as geography is considered. The distance from Jerusalem to Gaza is measured repeatedly, but the results vary and conclude in several numbers that index key border-shifting dates in the Palestinian-Israeli conflict, further reinforcing a sense of disenchantment with the usefulness of measurements and measures. Ending with underwater aquarium scenes, footage of Gaza airstrikes in 2008, and a moody waltz by legendary Egyptian singer Abdel Halim Hafez caught in a loop, the narrator concludes, "We began to have the distinct feeling that we had been lied to...and that our measurements had left us empty-handed."
—N.B.

ZIAD ANTAR
b. 1978 Saïda, Lebanon;
lives in Saïda, Lebanon, and Paris, France

Ziad Antar's photographs probe the production of images, their role as documentation, and their symbolic relationship to time passing within the urban environment. Rather than embrace the technological advances of digital photography, Antar's work is centered on photography's relationship to history and archives. For "Beirut Bereft" (2009), he documented Beirut's abandoned and functionless buildings, scarred by the traces of war, commenting on the temporal and unstable nature of these exposed edifices. "Portrait of a Territory" (2012), made while in residency at the Sharjah Art Foundation in 2009 and 2011, recorded the burgeoning real estate developments across the coastline of the United Arab Emirates, dwarfed as they are by surrounding expanses of sand and sea with an eerie absence of human presence.

Antar's "Expired" series (2010) began in 2000 with the artist's visit to Studio

Shehrazade in Saïda, the workshop of renowned Lebanese studio photographer Hashem El Madani (b. 1928), whose archives are now part of the Arab Image Foundation. From El Madani, Antar purchased a 1948 Kodak Reflex II camera and ten rolls of medium format, black-and-white film that had expired in 1976. For nearly a decade, Antar experimented with this film in different vintage cameras during his travels to Cairo, Dubai, and Sharjah, producing grainy, painterly reflections of light and shadow. Many of the subjects of these photographs are futuristic constructions, such as the Burj Khalifa in Dubai, the tallest building in the world. Others are Brutalist structures in Alexandria or vestiges of war, such as the Saint Georges Hotel in Beirut, which was once synonymous with Beirut's glitz and glamour before the Lebanese Civil War. The series of hazy images that result from shooting with expired film meld past with present, while also recall the blurry substance of memories and the many events that these locations have witnessed over time. —M.N.

MARWA ARSANIOS
b. 1978 Washington, DC;
lives in Beirut, Lebanon

Marwa Arsanios's research-led practice often draws from a combination of history, politics, and literature. Among her early projects are investigations into modernist architecture in Beirut. In these works, Arsanios mines buildings' histories through personal photos, video, and newspaper articles. In particular, the Sheraton hotel and a private residence on Beirut's Acapulco Beach serve as both subject and setting in her related video animations (*I've Heard Stories* [2008] and *I've Heard 3 Stories* [2009]) that narrate the various rumors and stories of these places.

In recent works and through 98 Weeks, the Beirut-based artist organization she cofounded in 2009, Arsanios has incorporated her interests in rituals of collective reading, role-playing, and the history of leftist and socialist movements in the Arab world. Several works have stemmed from archived issues of the Cairo cultural magazine *Al-Hilal* [the Crescent], which in the 1950s and '60s was the ideological mouthpiece of Arab nationalism.

Have You Ever Killed a Bear? Or Becoming Jamila (2013-14) developed from a lecture, book, and installation of the same title, which similarly drew from 1950s- and 1960s-era issues of *Al-Hilal*. As part of its promotion of secularism and women's liberation at that time, the magazine often featured women on its cover. Among these was Jamila Bouhired, a celebrated freedom fighter in the Algerian Revolution against French colonial rule, who, for Arsanios, was emblematic of this brief period in which women were publicly celebrated. In Arsanios's video, an actor who has been asked to play Bouhired studies for her role by looking at old *Al-Hilal* issues, as well as various cinematic representations (*Jamila the Algerian* [1958] and *The Battle of Algiers* [1966]). Exploring Bouhired's life story through different voices, the film alludes to both a feminist history lost to ideological shifts and revolutionary icons transformed into what the film deems "guardians of dictatorships"—accessories to the same oppression they had rebelled against in the first place. —N.B.

KADER ATTIA
b. 1970 Dugny (Seine-Saint-Denis), France; lives in Berlin, Germany

Kader Attia's sculptures, installations, and videos investigate the intersections of history, personal memory, and various cultural traditions. Attia was raised in the suburbs of Paris and in Algeria, and has since lived in the Democratic Republic of Congo, Venezuela, and Berlin. In his work, Attia draws on the physical and emotional experience of living in and between these disparate locations and the specific histories of making objects and structures that each place sustains. In the past, he has created haunting portraits of women in prayer rendered from tinfoil and sprawling installations that re-create the landscape of corrugated metal rooftops found in poor neighborhoods around the world. Attia's works are both poetic evocations of places and communities, and rigorously researched explorations into historical memory and cultural exchange.

Over the last several years, Attia has focused on the concept of repair as a way of understanding history and generating sculptural forms. His installation at Documenta 13 took the form of a vast archive juxtaposing images of wounded World War I soldiers with a large collection of African masks, suggesting cultural and political interdependence between Africa and Europe in the early twentieth century. His installation for this exhibition pairs two objects that are further linked through processes of restoration: a wooden board and a Carrara marble bust. Similar to one owned by his father, the board is a found object common in North Africa used to teach writing to children as well as Arabic to Berbers, and was repaired numerous times over the course of its life. The bust depicts a wounded French soldier from World War I whose face was surgically repaired by Hippolyte Morestin (1869-1919), a French surgeon and pioneer in modern cosmetic surgery. These two objects

reveal the differences as well as the overlaps between technological innovation and craft, modernity and tradition, and between ideal forms and improvised reconstructions. Attia's larger project on repair exposes the mechanisms of assimilation, syncretism, and colonialism that reverberate into the present.
—G.C.M.

YTO BARRADA

b. 1971 Paris, France;
lives in Tangier, Morocco, and New York, NY

Yto Barrada grew up between Tangier and Paris, where she studied history and political science at the Sorbonne. When her university research led her to studying Israeli checkpoints in the West Bank, she found she was using her camera more than her notepad, and began to take an interest in how art could describe a political situation. Upon returning to her hometown of Tangier, Barrada cofounded Cinémathèque de Tanger, a movie theater, film archive, and essential cultural resource in the region. She also trained her eye on contemporary geopolitics in Morocco, using photography, film, and sculpture to chronicle the various changes to the physical and emotional landscape of Tangier that have materialized since the mid-1990s. In particular, many of her photo series have recorded the tensions that result from the city's "frustrated proximity" to Europe—the Strait of Gibraltar separates Tangier from the Spanish coast by less than eight miles—and the impossibility of legal passage for most Africans.

The photographs in the series "Riffs," dating from 1999-2011, draw on a reference to both the Rif mountain range in northern Morocco, and the improvisational, repeated phrases of musicians. Though drenched in

color, Barrada's photos contradict typical representations of Mediterranean cities as buoyant and folkloric. Instead, she identifies what she calls "a closed system of fantasies" through collective and individual aspirations and failures, often indexed in unrealized construction projects or colonial-era ruins. Some of Barrada's photos take a more illustrative approach to Tangier's contemporary social politics—depicting a pile of bricks in an empty lot or the peeling image of a new condominium on a rusted building site wall. Others quietly recall neglected sites loaded with history, such as the dilapidated house of Abdelkrim el Khattabi, a Riffian revolutionary leader, or a monument commemorating the highway built to unite Morocco when it gained independence from colonial France and Spain. In this subjective space between photomontage and reportage, Barrada's photos are a kind of testimony to both the present and the past, and her careful juxtapositions lay bare the complicated postcolonial dynamics that are still manifest in everyday life in and around the northern Moroccan city.
—N.B.

ANNA BOGHIGUIAN

b. 1946 Cairo, Egypt;
lives internationally

Anna Boghiguian's gnarled drawings and dense watercolor paintings chronicle her ongoing engagement with both ancient civilization and contemporary cities. Boghiguian was born in Cairo, but has lived most of her life nomadically, seeking inspiration from new places as well as from poets and literary figures, ranging from Rabindranath Tagore to Constantine Cavafy to Adonis, whose writings she has often illustrated. Her sketchbook compositions—exuberant and

spontaneous observations—present a kind of subjective visual research annotated with a more meditative stream of thoughts, questions, or associations, which compose layered self-portraits of an artist consumed and riveted by her daily surroundings.

The two series of drawings exhibited, rich with intensity and energy, examine Egyptian culture in the past and present-day. In one series of works exhibited, Boghiguian ponders the venerated bust of the ancient Egyptian queen Nefertiti, ensconced in Berlin, and in another, she probes Cairo's collective unconscious while training her eye on the violent confrontations and existential anguish that she witnessed throughout Egyptian society in early 2011. In these teeming and unsettling images, many intentionally divested of color, countless hands, mouths, and eyes allude to the desperate and frustrated multitude that instigated and fueled the revolution, while barbed wire, chains, and flames reinscribe the menacing and pervasive emblems of power.
—N.B.

FOUAD ELKOURY

b. 1952 Paris, France;
lives in Paris, France

Fouad Elkoury grew up with a passion for photography, and after finishing an architecture degree in London, he returned to photography and to Beirut in 1979. At that time, the city was four years into its civil war, a sectarian conflict that lasted until 1990 and left over a hundred thousand dead as well as an estimated seventeen thousand missing. For the following five years, and throughout the Israeli siege on Beirut in 1982, Elkoury reported daily for international agencies, documenting, sometimes inadvertently, the

city's disintegration into an ever-worsening conflict. Although Elkoury published numerous photos from this time, many of his images frustrated the agencies' desires for conspicuous trauma, combat, and carnage. Elkoury began calling these his "VAT (value-added time) pictures," knowing that their significance would increase after an extended period. In them, he captured aspects of daily life that were otherwise unknown outside of the city—civilians sunbathing at a beach club, days before the Israeli invasion; a family posing for a photographer peddling snapshots in a pockmarked Martyrs' Square; masked children celebrating Eid al-Burbara, a Halloween-like tradition that marks the feast of St. Barbara; or Lebanese soldiers standing guard over an empty hotel pool while protecting a failed amnesty meeting of Lebanese and Israeli delegates.

In 1991, after the end of the Lebanese Civil War, Elkoury was invited to return to Beirut on a documentary mission that aimed to record the city's remains after the fifteen-year conflict. With a group of six renowned photographers, including Robert Frank and Gabriele Basilico, Elkoury spent two weeks roaming the traces of the old city center, which had served as ground zero of the conflict. It had become an utterly devastated ghost town of dirt roads littered with landmines and ruins inhabited by a few lone, war-shattered squatters. The resulting publication of the project, *Beyrouth centre-ville* [Beirut city center], captures the little that remained of the city's architectural heritage just weeks before demolition would purge the city's center of these besieged relics and the painful history they evoked. In the face of these skeletal structures, themselves witness to fifteen years of violence,

Elkoury's photos take a lyrical and subjective approach to a somewhat forensic task. A façade eroded by countless shells slips into an abstract symmetry, windows pitted from blasts appear as if holes were torn in the printed image, and the celestial pretense of metal shop shutters perforated by bullet holes sets up a wrenching contrast to the catastrophic scene below.
—N.B.

SIMONE FATTAL

b. 1942 Damascus, Syria; lives in Paris, France, and Sausalito, CA

Simone Fattal began her career as a painter, but stopped when she left Lebanon five years into the Lebanese Civil War to settle in California. Not long after arriving, Fattal founded the avant-garde Post-Apollo press, and in the late 1980s, she returned to art-making, in particular, creating stone, bronze, and ceramic sculptures. Many of Fattal's sculptural works present an interesting conundrum: Radically primitive in their aesthetic, her raw, rough-hewn masses appear to predate their creator. Inspired by her fascination with the history and artifacts of prehistoric cultures, her creations seem comfortably suspended between the past and present, inviting viewers to move through both real and mythical time.

In their archaic appearance, Fattal's lumbering, finger-pressed forms recall universal myths of origin in which humans and creatures alike are fashioned from the earth by the gods of creation. While some works allude to this lore (*Déesse Préhistorique* [2008], for example, is a goddess mother), others simply hark back to characters from an ancient past (a columnar mass illustrates a high-ranking official from antiquity in *Haut*

Fonctionnaire Antique [2008]). Fattal also takes warriors as a subject, drawing viewers into a quasi-fictional past with figures from the Mesopotamian epic poem *Gilgamesh*, and shifting abruptly to the present with maimed soldiers returning from battle in Iraq. Though a tension manifests between these references to warfare and violence that straddle thousands of years, her medium of choice (terracotta) sets these works up as equivalents— from a hypothetical future point, these rugged effigies might appear as equally ancient artifacts. In this sense, Fattal's sculptures prompt us to scrutinize the events that we find historical, and to remember that in the scope of human existence, our beliefs, political sagas, strife, and conflicts are perhaps not so exceptional after all.
—N.B.

MEKHITAR GARABEDIAN

b. 1977 Aleppo, Syria; lives in Ghent, Belgium

Many of Mekhitar Garabedian's works draw from his experience as an immigrant and play on the humor and poetic qualities he finds between languages, cultures, and histories. Born in Syria and raised in Belgium, Garabedian's upbringing established a consciousness of his family's continued struggle to preserve their Armenian heritage. Memory is central to many of his works, articulated not only through recollection or looking to the past, but also through repetition as a mnemonic exercise. Often his works build on aspects of Armenian culture, but others take their inspiration from works in music, literature, or film. His *Library*, for instance, is an ongoing installation of artifacts that are charged with a personal significance. For Garabedian, "Each one of us

constitutes a mini-culture"—
a unique synthesis of influences
that can often be described
through the things we collect.

In *Learning Piece: Be
Patient, My Soul* (2006),
Garabedian draws from his own
knowledge of art history as
he appropriates Vito Acconci's
1970 performance *Learning Piece*,
in which Acconci sat with a
tape recorder and memorized a
Leadbelly song two phrases at
a time. In Garabedian's video,
the artist learns an old
Armenian revolutionary song one
stanza at a time from a pro-
fessional Armenian singer who
regularly urges him to emphasize
his pride, his grief, and his
yearning for his motherland.
MG (2006) presents Garabedian
as the protagonist of a short
video that references a scene
from François Truffaut's 1968
romantic comedy *Stolen Kisses*.
In his film, Garabedian repeats
his own name while gesturing
in front of a bathroom mirror,
alternating Dutch and Armenian
pronunciation as he drifts in
and out of his own conviction.
Though Garabedian acknowledges
that language affects our sense
of being in the world, seen
on its own, *MG* seems to illus-
trate his conviction that
"the foreigner's accent is
his strength; it is precisely
this that distinguishes him,
not just his appearance but
his melody."
—N.B.

GCC

f. 2013 Dubai, United Arab
Emirates; live in New York,
London, Kuwait City, Beirut,
and Dubai

A nine-person delegation of
artists with common roots in
the Gulf region, GCC borrows
its name from the abbreviation
of Gulf Cooperation Council,
an alliance of six oil-exporting
nations bordering the Persian
Gulf (Kuwait, Saudi Arabia,
Bahrain, Qatar, the United Arab
Emirates, and Oman). Since its
founding, GCC has ironically
examined aspects of contemporary
Gulf society, often parodying
the decorum and objects that
accompany rituals of celebra-
tion, or tapping into the lexi-
con of images, environments,
and aesthetic sensibilities
that they find emblematic of
the region. Assuming the stately
posture of Arab monarchs,
GCC members employ diplomatic
language and a ministerial
approach. Many works appear as
tokens or symbolic mise-en-scène
made to commemorate the del-
egates' meetings and achieve-
ments. GCC's videos *Protocols
for Achievement* and *Ceremonial
Achievements* (both 2013), for
example, recreate ribbon-cutting
ceremonies, while the photos
that compose *Inaugural Summit,
Morschach 2013* illustrate
handshakes and gift exchanges
overlooking a scenic Swiss coun-
tryside. "Congratulants" (2013-
14), a series of crystal and
marble trophies, laser-engraved
with circular self-congratula-
tory filler text, emphasize the
triviality of the object viewed
as a marker of success.

At the New Museum, GCC has
transformed the Museum's Lobby
into one characteristic of
a luxury Gulf hotel, wallpa-
pering images onto the Lobby's
core elevator wall and façade
windows. The palatial interior
depicted was photographed on
location at a multi-billion-
dollar hotel in Abu Dhabi,
renowned for opulence that sur-
passes its crystal chandeliers,
marble paneling, and gold-leaf
ceilings: At this particular
hotel, a vending machine in
the hotel lobby dispenses gold
ingots. Also incorporated in the
wallpaper are images of eight
original oil paintings commis-
sioned by the delegation members
and painted by a Kuwaiti artist
who typically creates portraits
for sheikhs. Wearing Emirati-
style *ghutrah* and *agal*, the
traditional headscarf and cord
worn by men in the Gulf, the
GCC members are perched sheikh-
style above the Museum's Visitor
Services desk, playfully
mimicking the commonplace
presentation of local monarchs
in such a setting.
—N.B.

FAKHRI EL GHEZAL

b. 1981 Akouda, Tunisia;
lives in Akouda and Tunis,
Tunisia

Fakhri El Ghezal began teach-
ing himself photography over
a decade ago when his father
bought him an old Nikon camera
at a flea market. At the time,
he was enrolled at the Institute
of Fine Arts in Tunis, but
photography was unrecognized
as a discipline in the academy,
and prior to the 2011 revo-
lution, photographers were
required to have a license.
Under the twenty-three-year
dictatorship of Zine el-Abidine
Ben Ali, artists also faced
considerable censorship: reli-
gion, sexuality, as well as
any subject implying a power
imbalance were off limits—
as were depictions of Ben Ali's
predecessor, Habib Bourguiba.
Challenging these boundaries
in his works, El Ghezal uses
metaphor, satire, and humor
to consider how images create
narratives and identities in
both private and public spaces.

El Ghezal's series "Weld Mén"
translates loosely to "son
of whom," a Tunisian Arabic
phrase commonly used by elders
when asking a younger person
who they are. As an approach
to self-portraiture through
existing pictures, El Ghezal
traces his own identity through
images and details of his
family members' houses—in a
bare niche, his great-grandpar-
ents' portraits sit among an
array of medications; on sparse
walls, calligraphic dedications
laud the prophet Muhammad;
on an attic floor, framed
photos of the artist as a boy
lay shattered.

For the series "Chokran ya siédété al raiis" [Thank You Mr. President] (2011), which documents the absence of Ben Ali's image, El Ghezal's title ironically borrows the text that was typically displayed alongside the former dictator's portraits. Before the revolution, his portrait had loomed over not only thousands of public spaces, but also many interiors—shops, restaurants, hotels, and households. In the aftermath of the revolution, El Ghezal recorded the empty walls, shattered glass, and gaping frames throughout the city. Countering the spectacle of revolutionary images that dominated the media at the time of Ben Ali's coup, these photos instead appraise and contemplate what is left in its wake.

—N.B.

TANYA HABJOUQA

b. 1975 Amman, Jordan;
lives in East Jerusalem

Tanya Habjouqa was born in Jordan but grew up mostly in Texas, where she started her career as a documentary photographer and freelance journalist chronicling the lives of Mexican migrant workers. She went on to receive her MA in Global Media and Middle East Politics at the University of London, and proceeded to travel and cover crises along with everyday life in Lebanon, Iraq, Sudan, Egypt, and Palestine. Her photos often attest to entangled social and political dynamics, the various effects of the Israeli occupation in the West Bank, or simply bear witness to less-visible subcultures. Among the eclipsed subjects she has taken up are women in Gaza under the Islamist leadership of Hamas, Bedouin communities facing displacement in the West Bank, and outcast heroin addicts in East Jerusalem's old city. In other series, she trains a playful but keen eye on under-exposed subcultures like competitive Arab bodybuilders, female street car racers in the West Bank, or transsexuals and drag queens in West Jerusalem. Her series "Occupied Pleasures" (2009-13) documents Palestinians in the West Bank and Gaza enjoying a day at the beach, practicing sports or yoga, visiting zoos or amusement parks, or preparing for weddings or parties—images that strikingly counter typical media depictions of violence, victimhood, or extremism.

The photos exhibited are drawn from "Tomorrow there will be apricots [بكرة في المشمش]," an ongoing series that looks at the hardships endured by Syrian women—many now refugees in Jordan—whose husbands and loved ones are fighters or activists among the forces attempting to overthrow the dictatorship of Bashar al-Assad. Through her photos, Habjouqa looks, in particular, at the keepsakes, images, and messages that sustain these women or function as tokens of their spouses, brothers, fathers, or sons. Often their photos are digital and stored on cellular phones, which serve as not only pocket-sized mementos, but also provide the main link for communication and news from home—much of which includes cell phone videos that depict the civil war's appalling violence and atrocities. Though much of the video footage is gruesome, it supports their faith in the importance of their struggle and sacrifices, which so often include losing those they love.

—N.B.

ROKNI HAERIZADEH

b. 1978 Tehran, Iran;
lives in Dubai, United Arab Emirates

In his drawings and videos, Rokni Haerizadeh isolates still and moving images from news media and transforms them with expressive painterly gestures into scenes of grotesque fantasy and ribald humor. Haerizadeh initially produced skillful, large-scale paintings before shifting to more intimate works on paper and delicate handmade animations. Working from his adopted home city of Dubai, the artist often focuses on scenes of revolution and violent protest from the Middle East and around the world, capturing images of social repression and institutionally sanctioned brutality. Reminding us that the scenes of protest like those that took place in the various Arab Springs were not isolated incidents, Haerizadeh also confronts the Western expectation that this type of public retaliation only occurs in the Middle East rather than in Moscow, Kiev, London, or the United States.

"Fictionville" (2009-ongoing), Haerizadeh's recent series of videos and works on paper, borrows its title from the influential 1968 play *City of Tales* by the Iranian writer Bijan Mofid, which used the structure of folk tales to offer strident political and social commentary. Haerizadeh couches his own critique of power in the form of nightmarish fairy tales. To create each of his works, the artist prints thousands of sequential stills from YouTube videos of media broadcasts. He then proceeds to paint on each printout, animating the landscapes and morphing the soldiers and policemen, protestors and bystanders, politicians and celebrities, and even the news broadcasters narrating the horrific events into half-human, half-animal hybrids. The variation between stills in these deliberately imperfect sequences causes the images to shift and vibrate with tension and anxiety. What had been presented as documentary footage becomes an allegorical expression of the universality

of violent oppression, some-
thing that has become familiar
to the point of being ignored.
Haerizadeh's work implicates
the viewer, who may not only
be numb to these tragedies, but
perhaps even takes voyeuristic
pleasure in the spectacle of
death, destruction, and scandal.
—G.C.M.

RANA HAMADEH

b. 1983 Beirut, Lebanon;
lives in Rotterdam, Netherlands

Rana Hamadeh's installations,
publications, and performance
lectures propose alternative
narratives of history and
current events through a web of
illustrated events and concepts.
She considers her role as that
of a "theater-maker"—often per-
forming a monologue that engages
the objects on display—and
many of her works start from
a single idea or phenomenon and
expand into different fields
or historical periods. In the
scenography of The Tired Land
(2012-ongoing), she connects
her conversations with four
illegal immigrants to the colo-
nial and corporate history
of the town in Mauritania where
they had been detained. In
Al Karantina (2013), a cabinet-
like installation of documents,
photos, and maps, she compares
the medical and legal use
of "immunity," linking radical
politics and epidemiology
through concepts of resistance
and hygiene.

The Big Board or 'And
Before It Falls It Is Only
Reasonable To Enjoy Life A
Little' (2013) is part of
her long-term research project
"Alien Encounters," which
considers foreignness and
strangeness by looking at the
figure of the social outcast,
the immigrant, and the extrater-
restrial. The Big Board recalls
a war room map unfurled on
a large table, charting con-
nections between concepts and
places, people and power. Four

audio tracks function as gates
to the table's cartography,
introducing the work with an
excerpt from Hamadeh's related
lecture, the "big board" scene
from Dr. Strangelove, an A-Z
index of the work's subjects
and key words, and an autotuned
speech by Gaddafi, inspired by
the popular Egyptian music style
Mahragan. Like Al Karantina,
the board connects the domains
of law, crime, and disease by
looking at the techniques and
terms they have in common. The
work is inspired by Sun Ra's
1974 film Space is the Place,
in which Ra and fellow Arkestra
crew "fall off the planet" in
order to escape its unjust con-
ditions. Drawing from this,
The Big Board calls attention to
modes of falling exemplified
by a chunk of the Berlin Wall or
a glass figurine of Yuri Gagarin
on a sloping block. It also
depicts what Hamadeh calls a
"theatrics of power," alluded
to through colonial-era tokens
and scrip coins as well as
illustrated scenes of plagues
and quarantines, all placed
within a network of court-
rooms, refugee camps, hospitals,
islands, and spaceships.
—N.B.

SHURUQ HARB

b. 1980 Ramallah, Palestine;
lives in Ramallah, Palestine

As a writer, curator, and art-
ist, Shuruq Harb often focuses
on public space, visual cul-
ture, and contested histories.
Many of her projects originate
from everyday encounters or
experiences and expand toward
the production of an archive,
index, or collective portrait.
In All the Names (2011), she
revealed how cultural histories
are publicly narrated by creat-
ing a large street sign listing
210 Ramallah streets that were
recently renamed for individuals
deemed important—from Averroes
and Newton, to Spartacus and St.
George, to Picasso and Guevara.

In Searching for Rahab (2013),
she led a walking tour around
ancient Jewish archaeological
sites in the Palestinian city of
Jericho, visiting little-known
ruins on private properties
as well as tourist destinations,
and using the biblical story
of Rahab to question the exclu-
sion of Jewish history in
Palestinian historical narra-
tives. In an installation at
Birzeit University, Harb sug-
gested a provocatively progres-
sive approach to religious and
historical studies by install-
ing signage for two nonexistent
departments, the Palestinian
Institute of Archaeology, which
used to exist, and the Center
for Jewish Studies, a hypotheti-
cal structure.

Harb's The Keeper (2011-13)
is a multifaceted project
that began with her encounter
with Mustafa, a young street
vendor in Ramallah who sold
prints of photos, mostly mined
from the internet. For over
a decade, Mustafa's family
business was to supply pictures
to Palestinians—his elder
brothers had started in the late
1990s and Mustafa took over
around 2004. The related video
sluggishly pans Ramallah street
scenes as Mustafa describes
the changes he witnessed in
consumer demand through the
course of different political
events, and the moral pressure
he felt to get out of the
business when his images had
become predominantly singers,
sports figures, and soap opera
stars. The prints displayed
are from the several thousand
that Mustafa gave Harb when
he closed the business, yielding
an accidental archive of
unwanted visual culture. Many
of the prints are fragile,
dirty, or very low-resolution,
but for Harb, they are precari-
ous links to both an individual
story and a larger, fragmented
cultural history.
—N.B.

SUSAN HEFUNA

b. 1962 Cairo, Egypt; lives
in Cairo, Egypt, Düsseldorf,
Germany, and New York, NY

Susan Hefuna was born in Cairo
and grew up in Egypt, Austria,
and Germany. Her extensive trav-
els—back to Cairo as well as
to New York, India, Japan, and
the United Arab Emirates, among
other distant locales—have
resulted in a body of work that
attempts to map the physical
and psychological contours of
urban space. Hefuna has produced
drawings, videos, sculptures,
and performances in which she
explores the way the social,
political, and architectural
context of a place shapes the
actions of individuals. Although
Hefuna often embraces a loose
aesthetic based on an intuitive
approach to rendering forms,
her work also serves to analyze
structures and systems of power,
especially as they are felt
as one moves between different
cultures.

Hefuna first received atten-
tion for a series of photographs
in which she posed in front
of *mashrabiyas*, a traditional
element within Arabic architec-
ture consisting of intricately
carved wooden latticework
that offers privacy from the
street. Hefuna's photographs
mimicked the stereotypical
images of Arabs shot by Swiss-
German photographers in the
early twentieth century. She
has extended the gridlike pat-
terns of the *mashrabiya* into
multiple series of delicate
drawings. These exquisite works
are rendered in ink, graphite,
and watercolor, often on over-
lapping sheets of tracing paper.
While some of the artist's
drawings are purely abstract
compositions, others are
inspired by specific cities
such as New York, Sharjah,
or Istanbul. In these works,
her arrangements of dots
and lines suggest impressions
of architectural details, floor
plans of imaginary buildings,
or psycho-geographical maps
outlining the emotional topogra-
phy of spaces passed through
and deeply felt. At the same
time, Hefuna's works vibrate
with life, suggesting multitudes
moving through streets, alleys,
and squares, and capturing both
the isolation and latent tension
contained within public space.
—G.C.M.

WAFA HOURANI

b. 1979 Hebron, Palestine;
lives in Ramallah, Palestine

Wafa Hourani studied filmmak-
ing in Tunis before turning his
focus to visual art, although
he continues to incorporate pho-
tography and video into his
sculptures and architectural
spaces. The installation exhib-
ited here, *Qalandia 2087* (2009),
is part of Hourani's "Future
Cities" series, which envi-
sions different futures of the
Qalandia refugee camp. Qalandia
was established in 1949 on
land leased from Jordan, and
takes its name from the for-
mer Jerusalem airport (now an
Israeli military base) to which
it is still adjacent. Though
it was originally built to
accommodate about three thousand
people—Palestinian refugees who
had fled nearby villages—its
population has nearly quadrupled
in the fifty years since. The
camp is also near the military
checkpoint that bears the same
name, and which, since the
start of the Second Intifada in
2000, has separated the northern
West Bank from Jerusalem with
a large-scale industrial termi-
nal of metal passages and turn-
stiles. Tens of thousands
of Palestinians pass through it
as part of their daily commute.
Each of Hourani's works from
this series envisions Qalandia
one hundred years after a major
political event, such as the
UN Partition Plan in 1947, which
proposed separate Jewish and
Arab states, or the Arab-Israeli
War of 1967, in which Israel
won control of the Gaza Strip
and Sinai Peninsula from Egypt,
the Golan Heights from Syria,
and the West Bank and East
Jerusalem from Jordan. *Qalandia
2087* presents the camp one
hundred years after the First
Palestinian Intifada, the
six-year organized resistance
that resulted in the estab-
lishment of the Palestinian
Authority. In the details of
this installation, Hourani
imagines this future in archi-
tectural changes that take on
literal and figurative signifi-
cance: in 2019, the Palestinian
Mirror Party (PMP) covers the
separation wall with mirrors;
in 2085, the Qalandia check-
point is removed and becomes a
free-speech point; and in 2087,
the concrete from the wall is
removed and replaced with mir-
rors on the other side.
—N.B.

ALI JABRI

b. 1942 Jerusalem, Palestine;
d. 2002 Amman, Jordan

Born into an affluent political
family from Aleppo, Syria, at
the age of seven, Ali Jabri
was sent to boarding school
in Alexandria until the 1952
coup of King Farouk forced him
to move to Switzerland and
then England, where he later
left for university in the
United States. Jabri had a
fondness for art and literature
from a young age, and his years
at Stanford in the early 1960s
nourished his artistic ambi-
tions and fostered his bohemian
inclinations. Throughout the
following decades in London,
Cairo, Aqaba (Jordan), and
Amman, Jabri's artistic practice
was rooted in his sketchbooks
and scrapbooks filled with notes
and musings, impressions from
everyday life, excerpts from
his readings, and discussions
on history, archaeology, and
architecture, which channel the
ardor of both T.E. Lawrence and
Jean Genet.

In notebook entries and letters to friends, Jabri occasionally confessed his struggle with his own conflicted identity—"home" and "exile" were synonymous when he finally settled in Amman in 1978. Despite his many years abroad, Jabri was passionate about Arab history and civilization, and closely followed current events in Egypt and the Middle East. As many of his collages and notes reveal, he saw how swiftly victims and perpetrators traded places within a given conflict, and his reflections on politics were prescient and incisive. The series of collages exhibited date from the late 1970s and early 1980s and echo the quick-witted sensibility of his commentaries ("Gamal Abdel Nasser got up in his own machine, surrounded by yes men & stooges in zoot soots & loud ties. Propaganda blitzkrieg on the air-waves, socialist rule and rigidity behind the bars..."). From the dining, tuxedoed men flanked by soldiers and grenades in *By Agreement*, to the salacious torsos summoning our gaze in *Prayer Call*, to the bombed-out car underpinning a cinematic embrace in *Red Sea*, Jabri's montages cannily dissect and expose the dissonant dynamics he observed in his time.
—N.B.

KHALED JARRAR
b. 1976 Jenin, Palestine;
lives in Ramallah, Palestine

Many of Khaled Jarrar's works documents the physical, political, and social barriers erected to restrict the daily movements of Palestinians. Jarrar served as a soldier in the Palestinian Presidential Guard while studying interior design at the Palestinian Polytechnic University. He then went on to study photography and the visual arts, gradually adopting an interdisciplinary approach in order to address the problems of his homeland. Jarrar moves between documentary film, photography, and sculpture, evoking the physical and psychological impacts of regulations, security checkpoints, walls, and fences in an effort to imagine a world in which they may be overcome.

Much of Jarrar's work has attempted to survey the brutal materiality of security structures and the attempts by Palestinians to negotiate acts of constricted transit and communication. One of Jarrar's first major projects was his series "Journey 110" (2009), which used photography and video to map a network of underground sewage tunnels used by Palestinians to illegally enter Jerusalem. The series eventually led to the feature-length documentary film *Infiltrators* in 2012, in which Jarrar captures further attempts to breach the over four-hundred-mile-long wall separating Israel from the occupied Palestinian territories. Jarrar follows groups of men and women as they wait to be smuggled across for exorbitant fees, in the hopes of visiting separated loved ones, seeing doctors, or attending school. The harrowing film captures the frustration of these arduous and often futile journeys, comprising moments of anxious waiting and careful movements along the perimeter to avoid Israeli security patrols, punctuated by frantic sprints to reach the gaps that the smugglers have identified. Jarrar himself never joins the groups traversing the concrete, barbed wire, and electric fences, instead remaining behind to serve as witness to the desperation and determination of those willing to risk their lives for social amenities most would take for granted.
—G.C.M.

LAMIA JOREIGE
b. 1972 Beirut, Lebanon;
lives in Beirut, Lebanon

Lamia Joreige's videos and installations often navigate the tension between highly subjective recollections and a common narrative of a shared past. Culling archival documents and excavating material traces, Joreige calls attention to how memories, objects, and documents are all subject to interpretation—and how fact and fiction can, at times, be hard to distinguish. In her documentary film *Houna wa Roubbama Hounak* [Here and Perhaps Elsewhere] (2003), Joreige explores the haunting legacy of Beirut's former "green line"—a barricade separating the predominantly Christian east and Muslim west during Lebanon's civil war. The city grew ideologically and physically more divided as the war progressed and the green line became controlled by militia checkpoints where civilians were forced to reveal their religion, listed on their government ID cards. As sectarian violence flared, these checkpoints became sites of abductions, torture, and assassination, and an estimated seventeen thousand people "disappeared" between 1975 and 1990. In her film, Joreige roves the area asking passersby whether they knew someone who had been kidnapped. Incorporating archival images of former checkpoints into her footage, she juxtaposes the past and present to jog the memory of her subjects.

For her long-term video and installation project *Objects of War* (1999-ongoing), Joreige conducts interviews in which she asks her subjects to speak about particular personal items that bring back memories of wars in Lebanon (the Lebanese Civil War in *Objects of War Nos 1-3* and the war in 2006 between Israel and the militant wing of Hezbollah in *Objects of War No 4*). Seen alongside the filmed interviews, the objects that compose Joreige's installations—a wallet, a Sony Walkman,

a teddy bear, a curtain, and a suitcase, for instance—evoke intimate and, at times, traumatic anecdotes. Through collecting these firsthand accounts and related objects, Joreige provides an alternative history of these conflicts, reflecting on the capacity of common, everyday objects to serve as mementos or to become embedded with parts of a larger history that, for many, remains unresolved. As Joreige has acknowledged, "These testimonials, while helping to create a collective memory, also show the impossibility of telling a single history of this war."
—M.N.

HIWA K

b. 1975 Sulaymaniya, Iraq; lives in Berlin, Germany

In gestural videos, performances, and sculptural installations, Hiwa K illustrates personal and political histories, drawing attention to routine activities that reveal modes of adaptation and feelings of nostalgia. Many of his works draw inspiration from his hometown of Sulaymaniya in Northern Iraq, a predominantly Kurdish area that was home to Saddam Hussein's Amna Suraka, or Red Security Building, a site of torture and detainment for thousands of Kurdish political prisoners in the late 1980s. The remains of the building serve as the setting for Hiwa K's video works *Diagonal* (2009) and *Moon Calendar, Iraq* (2007), in which he uses his own body to animate the tension that remains latent in architecture that is as Brutalist in form as its function was under the ruling dictator.

In his practice, Hiwa K draws on moments of rupture in public life and several works have stemmed from interventions in political demonstrations. As a political refugee, he has grappled with doubt about the effectiveness of civil protest and has considered how the qualities of protest compare to routine communal rituals. In the video presented here, Hiwa K and guitarist Daroon Othman improvise a street procession amid a crowd of protesters in the chaos that followed an antigovernment demonstration in Sulaymaniya in 2011. With megaphone amplification, they interpret a melody from the 1960s western *Once Upon a Time in the West*, a haunting harmonica motif that builds a sense of urgency and anxiety as much it suggests a mood of mourning. The work's title, *This Lemon Tastes of Apple*, refers both to the lemon juice used to alleviate the effects of tear gas deployed against demonstrators in the video, and to the devastating chemical attacks Saddam Hussein led against the Kurdish town of Halabja in 1988, which survivors recall as having the scent of apples. With its atmosphere of urgency and struggle, the video emphasizes the visceral quality of the moment—and the memories induced—even if the protesters' specific grievances remain undefined.
—N.B.

AMAL KENAWY

b. 1974 Cairo, Egypt;
d. 2012 Cairo, Egypt

Amal Kenawy's early works in video, photography, performance, and animation tend toward intimate, meditative, or wistful themes and often use the body to explore desire, doubt, or the nature of memory. Many of her later works, however, seem to pivot away from these existential concerns. In considering social issues alongside local and international politics, Kenawy often used her work as a stage on which to assert the presence of forgotten spaces or people. In *Non Stop Conversation* (2007), Kenawy took the Emirates's rapid development as a subject, finding an old, neglected building in Sharjah and swaddling it with pink quilts that boldly announced its existence. In *Silence of the Lambs* (2009), she herded a procession of crawling men through the streets of downtown Cairo, alluding to simmering frustrations around poverty, labor issues, and an oppressive regime, and inciting the fury of passersby who felt her performance caused further indignity. Enigmatic and arresting, Kenawy's labor-intensive video animation *The Purple Artificial Forest* (2005) borrows its title from a dream in which she heard the phrase repeated. The work takes on an unsettling surrealistic character as limbs and organs sprout and bleed into new shapes, from cobwebs, to spiders, to pupae, embryos, and butterflies. Emerging bed frames, mirrors, and oil derricks are obscured by white ink before resurfacing in a provisional chamber whose boundaries are continually redrawn. For Kenawy, this purple-infused theater was not a strictly fictional space, but a reflection of the physical world around her. Through lush gestural brushstrokes and ambient music that builds to a dense electric guitar climax, Kenawy draws us into the "metaphorical world that lies hidden beneath the physical," illustrating the precarious and often incongruous space of imagination.
—N.B.

MAZEN KERBAJ

b. 1975 Beirut, Lebanon;
lives in Beirut, Lebanon

As a drawing and graphic arts student at the Lebanese Academy of Fine Art, Mazen Kerbaj had always been attracted to modes of experimentation and improvisation in art. As a visual

artist, he produces comic books, drawings, paintings, and videos, and as a musician, he is known as a trumpet and woodwind player, as well as the founder of several record labels devoted to improvised, experimental, and electronic music. His often spontaneous and unpredictable approach to drawing follows his compositional instincts with music, whereby the subjects of his "real time drawings" are revealed in the course of creation. His first major comic book, "Journal 1999," was styled as a diary and he has since published nearly a dozen graphic novels along with many short stories and drawings.

The series of drawings exhibited, "Beyrouth, juillet-août 2006" [Beirut, July-August 2006], chronicle the thirty-four days in summer 2006 when the Israeli military, provoked by an attack from the militant branch of the Islamic political party Hezbollah, coordinated airstrikes on Beirut. At the time, Lebanon had enjoyed fifteen years of relative stability and peace following its civil war (1975-90), but for many Lebanese, the attacks restored feelings of fear and anxiety. As his friends and family fled the country, Kerbaj turned to drawing and music as a way to respond and cope. Kerbaj started his illustrated diary as a blog, writing in Arabic, French, and English so that an expanding international audience could also bear witness to his experience. In energetic lines, splatters, blots, and a scrambled, expressive style, many drawings depict the artist as he contemplates what to do, speaking to his uncertainty of what is to come, or as he laments the rising death toll. Kerbaj lays bare the impact of the attack on his daily life: As a recurring figure, he often depicts himself as sleepless, eyes sunken, up until dawn drinking whiskey and debating among friends, or alone, drawing by candlelight,

counting each airstrike with a star on the page.
—N.B.

BOUCHRA KHALILI
b. 1975 Casablanca, Morocco; lives in Berlin, Germany

Bouchra Khalili produces artworks in which the mechanics of migration and the politics of voice are brought to the forefront. Khalili studied film at the Sorbonne Nouvelle and visual art at the École Nationale Supérieure d'Arts de Paris-Cergy, and has gone on to produce a diverse body of work in video, installation, and drawing. Regularly following the movement of people across geographic and social boundaries, her pieces articulate the way in which structures of power contain and silence disenfranchised individuals across the world—in particular, the millions of illegal immigrants who enter Europe each year, many of whom are imprisoned or lose their lives in attempts to improve them. Her work attempts to visualize the often clandestine movements of her subjects and treats their stories as radical expressions of resistance.

For "The Mapping Journey Project" (2008-11), Khalili met the subject of each video through chance encounters in European cities considered transitory points for the movement of people and goods. In each work, Khalili asked the individuals to narrate their journey from their original home to their current location tracing their path in marker on a two-dimensional map. Individuals' faces are never revealed; instead, the camera follows their stops and starts, detours and diversions across the surface of the page. The series follows journeys from Somalia to Bari, Bangladesh to Rome, Ramallah to Jerusalem, and other destinations even

further afield. The narrators of Khalili's videos each embark upon their journeys for a variety of reasons—to escape war or discrimination, to earn a better living, or for simpler tasks, like visiting loved ones—but all of them have been restricted due to political conflict. Describing the piece as an attempt at "knocking down the vocation of mapping as a tool of power," Khalili highlights the emotional lives of these individuals and exposes the visible and invisible boundaries that control freedom.
—G.C.M.

MAHA MAAMOUN
b. 1972 California; lives in Cairo, Egypt

In mining a range of images from everyday life and popular culture, Maha Maamoun's works in photography and video underscore the many ways in which visual representations can carry a political charge or influence social dynamics. Her video *Domestic Tourism II* (2008-09), for example, chronicles decades of cinematic depictions of Egypt's iconic pyramids, allowing viewers to consider what these varying portrayals reveal about Cairo's shifting relationship to these majestic monuments of the ancient past.

Maamoun's video *2026* (2010) grew out of her research into the limits of language and imagination, and draws from Mahmoud Uthman's 2007 novel *The Revolution of 2053*, a story set amid current events in Cairo featuring a photographer as the main protagonist who can see the future of what he shoots. For Maamoun, this character recalled the science-fiction time traveler in Chris Marker's *La Jetée* (1962), an experimental film composed almost entirely of black-and-white stills. Pairing the formal qualities and iconic time traveler scene of *La Jetée* with excerpts from Uthman's

novel, Maamoun's video centers around a time traveler who, suspended in a hammock, describes a view of the Giza pyramids in 2026. While his vision is definitively futuristic—spherical crystalline buildings are linked by glass bridges, and with the sweep of a hand, food is summoned from a hologram patch on a dinner table—the dystopic aspects of the future he visits seem to echo the economic inequalities and social unrest of contemporary Egypt. The protagonist of *2026* recounts being at an opulent private banquet and looking out on the pyramids' plateau. He notices, however, that a faint line encircles this lavish setting: a massive video screen masks the crumbling old city and informal settlements, making the pyramids the only landscape that is not digitally rendered. He continues to relate his observation of a scene beyond the wall in which skeletal, hysterical children chase an armored car, clamoring to enter it, until part of the wall opens up to release bags of food. As they wrestle over the provisions, the car escapes to the other side of the wall, from which side it appears as a glass window simply looking out onto the pyramids.
—N.B.

HASHEM EL MADANI
b. 1928 Saïda, Lebanon;
lives in Saïda, Lebanon

Hashem El Madani's photographs document the residents of the southern Lebanese city of Saïda, where he has lived and worked for over sixty years. El Madani's collection of over one million images charts the function of the studio portrait as an item of intrinsic value as well as a telling record of social identity and status. His career began in 1947, when he went to Palestine looking for work, like many other teens his age, and landed a position

working in Haifa as an assistant to a Jewish immigrant photographer. He returned to Saïda a year later, where he bought his first camera and set up a studio in his parents' living room. He began to work itinerantly, wandering the city and offering his photographic services to passersby. With the growth of his business, in 1953, he opened Studio Shehrazade on the first floor of the building where the renowned Cinema Shehrazade was located, and much later, in 2005, launched a second studio in a storefront on the ground floor of his home.

In El Madani's studio, individuals could portray themselves the way they wished to be seen, assuming various identities, showing off, posing with accessories and props, or acting out characters. Visits to his studio averaged thirty a day, peaking at one hundred a day in the 1960s and '70s, before a gradual decline after the Israeli invasion of southern Lebanon in 1982. His clients came from a wide variety of social backgrounds and included schoolchildren, teenagers, families, Syrian and Palestinian residents of Saïda, and members of the resistance in Lebanon. In a particularly poignant series, couples of the same sex mimic kiss scenes from movies. Images of heterosexual couples kissing are absent from El Madani's archive in keeping with the conservative climate. El Madani's collection was recently unearthed by the Arab Image Foundation, which was founded in 1997 by contemporary artists Fouad Elkoury, Samer Mohdad, and Akram Zaatari with the goal of preserving and researching photographic collections in the Arab world. Zaatari went on to create the Madani Project, a series of exhibitions, publications, and videos focusing on El Madani's career. The project examines the ways in which his archive creates a shifting collective portrait of his community, illuminating

social, political, and economic aspects of Lebanese society in the flux of time.
—M.N.

MARWAN
b. 1934 Damascus, Syria;
lives in Berlin, Germany

For over fifty years, the painter Marwan Kassab-Bachi (known to many simply as "Marwan"), has been preoccupied with representing human beings and their expressions of inner emotion and desire. Marwan was born in Damascus and in 1957, left Syria for West Berlin, where he still lives today. In Berlin, Marwan studied painting with artist Hann Trier, and became close friends with fellow students Georg Baselitz and Eugen Schönebeck. His early works from this period share the expressive figurative style of his fellow West German contemporaries, but for Marwan, his works also illustrate his own interest in the traditions of Sufism, a branch of Islam known for its mystical approach to faith. Marwan conceives of these paintings as ruminations on the inner self, reflecting Sufism's focus on attaining "wisdom of the heart," a fundamental tenet of the practice.

After his first few years in Germany, Marwan found that his family's lands and wealth had been confiscated by Syrian authorities, following a change in the country's political situation. Discontent with Egyptian dominance over the United Arab Republic, Syria had seceded from its union with Egypt in 1961. The '60s in Syria were characterized by military revolts, coups, and violent riots, which eventually resulted in Hafez al-Assad's military coup in 1970 and subsequent thirty-year rule. Cut off from his native homeland both physically and emotionally, Marwan turned to painting to express the intensity of emotion he

experienced, in particular, the loneliness, isolation, and longing. In paintings of individuals, such as *Das Knie* [The Knee] (1967), *Kaddouch II* (1966), and *Mann am Tisch I* [Man at the Table I] (1966), body parts are contorted, forms are transfigured, and limbs seem to be pushing outward to escape the body. His works of this period also include depictions of couples, as in Untitled (1969-71), where the two figures engage with the gaze of the viewer rather than communicating with each other. Describing his paintings from this period, Marwan explains, "I started using my features as a symbol, as a mirror. My face as a window on my world." Rather than aiming to create a self-portrait through these works, he depicts the human condition and the joys, fears, and yearnings of the soul. —M.N.

AHMED MATER

b. 1979 Tabouk, Saudi Arabia; lives in Abha, Saudi Arabia

Having grown up in Asir, a mountainous region in Saudi Arabia's rural southwest, the disparity between village life and urbanized Saudi cities became one of the main themes of Ahmed Mater's work. As a young student in Saudi Arabia, Mater lacked both precedence and context for a career in visual art, so he pursued his artistic practice alongside a professional one—medicine— and many of his works also synthesize his medical observations with knowledge of Islamic art traditions. His series of X-ray paintings, for example, couple scientific imaging with traditional techniques for Qur'an illustrations—calligraphy and gold leaf on paper colored with tea, pomegranate, and coffee.

Mater has also worked to document less visible aspects

of Saudi history and culture—examining, in particular, the places where traditional Islamic values cohabit alongside favorable attitudes toward consumerism, development, and modernization. In 2010, Mater began a series of visits to Mecca, the historic and sacred center of the Islamic world, which for thousands of years, has attracted pilgrims for the ritual known as *hajj*, a religious duty that all physically and financially able Muslims are required to do at least once in their lifetime. In recent years, Mecca has seen tremendous development in an effort to encourage a year-round religious tourism industry that could accommodate an estimated twelve million pilgrims annually. In addition to photographing a city center full of cranes and half-erected towers, Mater visited these building sites and befriended Mecca's construction workers, curious to know how these men experienced the city's recent customs of demolition and reconstruction. He was also interested in exploring the contrast between the video and images that they record (typically for themselves or for their families) and the more stereotypical, touristic images of Mecca that circulate among other visitors. The footage that composes *Leaves Fall in All Seasons*, dating from 2008 to 2013, consists of cell-phone recordings that Mater gathered via YouTube as well as directly from the workers he met—many of whom are migrant laborers from South Asia. Editing this material into a series of vignettes that bear witness to the city's transition, Mater offers a range of perspectives—from playful profiles of coworkers, to labor strikes, to the placement of the iconic golden crescent atop the 1,900-foot-tall Mecca Royal Clock Tower. —N.B.

ABDUL HAY MOSALLAM

b. 1933 Al-Dawayima, Palestine; lives in Amman, Jordan

For nearly four decades, Abdul Hay Mosallam has created detailed sculptures and paintings that document and archive Palestinian folk traditions as well as important figures and events in the modern history of Palestine. Not long after being forced from his hometown of Al-Dawayima in 1948, Mosallam enlisted in the Jordanian Air Force and soon after joined the Palestinian Liberation Organization (PLO). While stationed in Libya in the late 1970s, an experiment with sawdust and glue proved decisive for his burgeoning art practice, and these modest materials continue to form the basis of his painted reliefs and sculptures. While he has always viewed it as a direct extension of his political activism, art-making began as an alternative to military engagement for Mosallam, and his boldly painted reliefs have since functioned as depositories of memory and sites of documentation.

Mosallam has lived in Beirut, Damascus, and Amman, but regardless of his context, his subject matter has remained as consistent as the materials he uses. Many of his tableaux depict themes of Palestinian community and tradition in vibrant scenes of ritual events and ceremonies—wedding festivities, harvest traditions, Ramadan observances—while others confront viewers with dark massacre scenes, loaded with symbols that ascribe imperialist world powers to bombastic hybrid beasts. The works exhibited here date to a period between 1977 and 1978 when his artistic vocabulary was dominated by pan-Arab colors and focused on chronicling the efforts of the PLO's guerilla fighters (*fedayeen*). In each of these works, militant figures bear weapons and wear *keffiyehs*—the Arab cloth that has

symbolized Palestinian nation-
alism and solidarity since
the late 1960s. In *A Military
Statement/Martyr Dalal Mughrabi*
(1978), a silhouette embellished
with a psychedelic scriptlike
motif represents the Fatah mili-
tant who led the PLO's Operation
Martyr Kamal Adwan, an infa-
mous bus hijacking that became
known in Israel as the Coastal
Road Massacre, and for which
Dalal Mughrabi was denounced as
a terrorist by Israeli offi-
cials and revered as a martyr by
many Palestinians. In another,
*Tyre, "Sour," The Castle of
Steadfastness and Defiance*
(1978)—whose title refers to the
defense of the then-PLO strong-
hold Tyre, in southern Lebanon,
against the invasion of Israeli
forces following the Coastal
Road attack—a Janus-faced
fighter signals victory and
seems to personify a watchtower
or fortress. Sedimented in these
gritty and uninhibited depic-
tions is not only Mosallam's
solidarity with the *fedayeen*,
but perhaps also his conviction
that these images, like weapons,
could advocate a political cause.
—N.B.

SELMA AND SOFIANE OUISSI

b. 1975 / 1972 Tunis, Tunisia;
live in Paris, France / Tunis,
Tunisia

Working with dance, chore-
ography, and film, Selma and
Sofiane Ouissi have also ini-
tiated a number of ambitious
projects together. These include
"Dream City," a biennial for
art in public spaces in Tunis,
"Z.A.T.," a free review on art
in public spaces, and the
"Popular Spaces Art Factories,"
through which they attempt to
revitalize communities in rural
areas of Tunisia. Combining
their dance and choreography
practice with artistic, polit-
ical, and social work, the duo
works between Tunis and Paris.
Developing their work via Skype,
they have recently made *Here(s)*,

a live performance of the two
dancing simultaneously in each
of their apartments, carrying
out a choreography that addresses
their collaborative paradox of
being close and yet distant as
they fall in and out synchro-
nized movements and actions.

Since 2011, the Ouissis have
led a collective project in
Tunisia's northwestern region,
Sejnane. Comprising a group of
Berber women, Laaroussa is an
organized co-operative of sixty
women potters and ten art-
ists who collaborate and carry
on the ancestral practice of
pottery-making. Producing clay
from the land's mineral-rich
earth, the project revitalizes
a dying handcraft specific to
this region, as passed down
from mother to daughter. It
also provides the women with a
platform for organizing and sus-
taining themselves through the
production of figurative sculp-
tures—Laaroussa means "doll" or
"bride" in the Berber language.
Spending time with the community
as the project developed, the
Ouissis created a new choreog-
raphy inspired by the women's
movements while working. The
duo made a performance and film
work focusing specifically on
the women's hands, their most
important tool. Isolating their
gestures and transforming them
into a sensual hand dance, they
created a sign alphabet specific
to this community as a poetic
reflection on the relationship
between movement and work,
culture and history.
—H.C.

JAMAL PENJWENY

b. 1981 Penjwen, Iraq;
lives in Baghdad, Iraq

Jamal Penjweny started making
sculptures when he was still
a shepherd living in a remote
village in the Kurdistan region
spanning between Iran and Iraq,
the site of Saddam Hussein's
attempted genocide of the
Kurdish people in the 1980s.

When Penjweny was a teenager,
the wife of Jalal Talabani, cur-
rent Iraqi president and fellow
Kurd, discovered the young
artist's work on a trip to the
territory. He went on to study
art in the nearby city of
Sulaymaniya and then photography
in London. At the beginning of
the second United States inva-
sion of Iraq in 2003, Penjweny
relocated from his home in
Kurdistan to Baghdad and has
since become one of Iraq's most
prominent photographers, docu-
menting the lives of Iraqi citi-
zens across the country, as well
as the war and its aftermath.
His images depict more than
simply the physical destruction
of war, they also bear witness
to the psychological impact that
the conflict and a decade of
convulsive and radical change
has left on Iraqis.

Penjweny's series "Saddam Is
Here," (2009-10) depicts life in
Iraq since Saddam Hussein was
overthrown after almost twenty-
five years in power, and the
complicated emotional response
that this shift has had on indi-
viduals from various walks of
life. Each image depicts a dif-
ferent Iraqi holding an image
of Saddam in front of their
face. The works, capturing men,
women, children, doctors, butch-
ers, and housewives, are shot
in the street, in offices, and
in people's homes. Penjweny's
series was inspired by the idea
that, as he explains, "When
you kill the dictator, it
doesn't mean you can erase him
from the minds of people." The
subjects of the photographs
relayed a range of emotions to
Penjweny about Hussein, from
mourning the loss of a powerful
and long-ruling leader to fear
bordering on terror at the
memory of the brutality he
inflicted. These particular
emotions are subsumed into an
overall ambiguity in the pho-
tographs, as each subject is
masked. The series captures the
psychological scars of history
and the ghosts haunting a nation

that has dealt with conflict, pain, and suffering.
—G.C.M.

MOHAMED LARBI RAHALI

b. 1956 Tétouan, Morocco;
lives in Tétouan, Morocco

Mohamed Larbi Rahali spent two years studying painting at the Art Academy in Tétouan, but his foremost passion has always been the sea. After leaving school, he worked in a range of occupations: as a carpenter, a boat mechanic, and, most frequently, as a fisherman. For Rahali, the return to his artistic practice in 1984 started with a tiny doodle on a discarded matchbox, but marked a major turning point in his life. He began to view matchboxes as miniature sketchbooks that could be salvaged from the sidewalk or collected from café patrons throughout the Tétouan medina.

Thirty years later, Rahali's matchbox works number in the thousands, and new blank boxes continue to provide miniature settings for his ever-expanding cast of characters. Rahali populates his pocket-sized stages with humans and animal figures, landscapes and seascapes, geometric designs and collages, and found objects like seashells, beads, or buttons. Rahali's matchbox drawings register where his observations meet with his own imagination, drawing from a range of sources—overheard conversations, television programs, stories in newspapers and magazines, or works of poetry and literature. In the past decade, when inexpensive lighters made his favored medium increasingly obsolete, Rahali began to make his own boxes by cutting and folding carton paper from product packaging. With a stack of these cut and bound in one of his pockets at all times, Rahali continues to illustrate the small and everyday moments that compose this larger and longterm autobiographical project, which

Rahali calls *Omri*, or "my life."
—N.B.

MARWAN RECHMAOUI

b. 1964 Beirut, Lebanon;
lives in Beirut, Lebanon

Marwan Rechmaoui creates large-scale sculptures from raw, tactile materials that often refer to urban development and its effect on society. Drawing from the rich and complex cultural history of Beirut, he uses industrial staples like rubber, tar, and concrete to chart how the city's past has influenced its landscape, geography, and inhabitants. *Monument for the Living* (2002-08) is a human-sized model of Beirut's iconic Burj Al-Murr—an unfinished office tower that served as a prison and sniper nest for leftist Muslim militias battling against conservative Christian forces during the 1975-76 Battle of the Hotels, the first large-scale, sustained conflict of the Lebanese Civil War. Rechmaoui's *Beirut Caoutchouc* (2004-06), a gigantic, rubber floor map, invited local audiences to consider Beirut's enduring resilience as well as the debates over the city's boundaries, illustrated by the public electrical utility map, whose service had been an index of stability for decades.

Spectre (The Yacoubian Building) (2006-08) is a replica of the apartment complex where Rechmaoui lived in the late 1990s—formerly Beirut's biggest, most expensive building and home to an oil-rich elite who brought their assets to Beirut as socialist sentiments swept the Arab world in the 1960s and '70s. In attending to every detail of the well-worn building's façade, Rechmaoui's sculpture reflects the waves of change that have made their mark on the edifice since it was built in the early 1970s. After the onset of the Lebanese Civil War in 1975, the complex became

increasingly inhabited by rural migrants and squatters. These new residents brought their own traditions, including vividly colored curtains and gates that mimic the entrances to their village homes, creating an unusual contrast to the building's restrained modernist façade. Rechmaoui portrays the structure following its evacuation during the 2006 military conflict with Israel, known in Lebanon as the July War. Deserted and exposed, it is a grim but irrefutable portrait of the city's history and its many ghosts, architectural and otherwise.
—M.N.

ABDULLAH AL SAADI

b. 1967 Khor Fakkan, United Arab Emirates; lives in Khor Fakkan, United Arab Emirates

Abdullah Al Saadi's relationship to the natural world is essential to his practice, and he conceives of his own vocation as the cultivation of objects, alphabets, and narratives. Al Saadi studied literature in the Emirates and in Japan, where he came into contact with calligraphic painting and story scrolls, and his acquaintance with these diverse languages and traditions is reflected in his works. Al Saadi's paintings often depict landscapes of the mountainous farming area in the Emirates where he has spent most of his life, and his drawings, extensive notebooks, and alphabets aim to catalog surrounding living things and found objects through various systems. These range from taxonomic sketches of corpulent sweet potatoes, to alphabets based on the contours of a donkey, to coded diagrams of litter and twig configurations that his illiterate mother would leave at his door as a kind of visible voicemail message.

The 151 watercolor paintings and video that compose *Camar*

Cande's Journey chronicle an expedition that Al Saadi embarked upon through northern UAE in 2010. For over twenty days, Al Saadi trekked across the region with a friend (who video-recorded), a dog, and a donkey named Camar Cande. The title also alludes to Samarkand, an ancient city in present-day Uzbekistan famously celebrated in Western accounts of Silk Road adventures. In the spirit of these bygone expeditions, Al Saadi set out on foot, documenting the striated and undulating desert terrain in photos, videos, diaries, and sketches that he later painted in warm gold and deep brown tones. Creating an intentionally naïve personal cartography, he captured details like local landmarks or mottled fields of stones as he meandered along with a cart and his companions. Al Saadi embraces a near-obsolete mode of travel in the region, and through a playful, imagined narrative recorded in his notebooks and watercolors, he immerses himself in the natural world in order to document its contours, both real and imagined.
—N.B.

HRAIR SARKISSIAN
b. 1973 Damascus, Syria; lives in London, UK

Growing up in Damascus, Hrair Sarkissian spent nearly all his time in his father's photo studio and laboratory, where he gleaned his technical training and began to develop his artistic practice. At an early age, Sarkissian was also introduced to his Armenian roots, and like others in the diaspora was raised with stories of a semi-fabled homeland and the ghosts of the Armenian genocide, which had forced his grandparents from Eastern Anatolia in 1915. Fittingly, many of his works negotiate the unevenness of memories shaped by both collective narratives and personal

experience. Sarkissian also addresses historical omissions by capturing spaces that are void of their subject but loaded in significance—the task, for him, is to depict "the invisible in the visible." In *Istory* (2011), for example, he trains his camera on private and semi-public Ottoman-era archives in Istanbul, discretely registering the inconsistency between his personal history and the "official" Turkish narrative that has ostensibly omitted his ancestors.

Sarkissian produced "Execution Squares" (2008) while still living in Damascus. The series of photographs documents sites in the Syrian cities of Damascus, Aleppo, and Latakia where, until the current uprising against the Assad regime began, public hangings of criminals regularly took place in the early morning hours. As a teenager, Sarkissian witnessed one of these scenes, and the sight of the hanging figures has haunted him since. Partly in an effort to clear his memory of the traumatic image, he developed this series in which the subject is conspicuously absent. In these oddly deserted scenes, we see a vignette of everyday urban life paused in a moment of quiet, but nothing testifies to what the series' title describes. In staging this paradox, Sarkissian sets up a tension between what is visible and what is known, inviting us to question both the nature of photography and the act of witnessing itself.
—N.B.

HASSAN SHARIF
b. 1951 Dubai, United Arab Emirates; lives in Dubai, United Arab Emirates

Hassan Sharif started his career in the 1970s drawing witty and provocative political caricatures for local newspapers in the United Arab Emirates, which, recently independent and

amid an oil boom, was undergoing rapid social and economic transformations. With a portfolio of drawings and paintings, Sharif received a scholarship to study art in London in 1979, and the experimental environment he experienced in the UK—the British Systems group and the Fluxus movement were major influences—radically altered his approach to art-making. Embracing found objects, readymades, and performance, Sharif returned to Dubai in the mid-1980s with a methodical but distinctly experimental framework that has since defined his practice.

Many of Sharif's early performances and "Semi-System" works from the '80s began with a simple object or the artist's body and developed through his application of a formula or rubric. *Movement of a Square's Side* (1985), for example, is a hand-drawn permutation of congruent lines that deviate from defining a closed square. In his performance *Body and Squares* (1983), Sharif laid out in various positions on a twenty-five-square grid, spreading his limbs over as many of its quadrants as possible in each pose. His ongoing series "Objects" began in the early 1980s when Sharif started looking for an alternative to contemporary painting and sculpture. Finding similarities in the deconstruction of everyday scrap materials and the construction of art objects, Sharif coined the idea of "redundant repetition," and embraced a Zen-like approach to boring serial tasks that, for him, mirror natural and industrial systems of production. In early "Objects," Sharif stapled scraps of cardboard or knotted natural fibers in twisted clusters, creating mounds of near-identical shapes. In more recent years, Sharif has incorporated cheaper, synthetic, and manufactured components: metal teaspoons are bound with black cables or copper piping; strips

of acrylic blankets are rolled and cinched with cord; plastic funnels, perforated aluminum baking sheets, or cheap foam sandals are coerced into clumps with metal wire. Like his early satirical caricatures, Sharif's "Objects" reveal his critical eye toward globalized industries and the wasteful consumerism that drives it. For Sharif, every artistic act has political and economic significance, and through his "Objects," he continues to catalog how these materials easily become artifacts of consumption in an increasingly interconnected world.

—N.B.

WAEL SHAWKY

b. 1971 Alexandria, Egypt; lives in Alexandria, Egypt

Wael Shawky's installations, videos, drawings, and performances transpose cultural traditions into new, unlikely contexts to reflect his interest in the intersection of history, myth, and faith, and the overlap of storytelling and entertainment. In his video trilogy "Cabaret Crusades" (2010-13), handmade marionettes illustrate episodes of the Crusades through an Arab perspective, following historian Amin Maalouf's *The Crusades Through Arab Eyes* (1984). Shawky's "Telematch" films (2007-09) borrow their titles and formats from a 1970s German game show that Shawky watched growing up in Saudi Arabia. As a child, Shawky also followed the TV coverage of the death of Egyptian president Anwar Sadat in 1981. In *Telematch Sadat* (2007), he invited Bedouin children—too young to know the significance of what they were staging—to re-enact the assassination and funeral of Sadat. Shawky filmed the piece using the same camera angles as the original documentation, revisiting the footage that had become ingrained in the visual memory of people throughout Egypt and the Arab world.

Shawky's *The Cave* has been filmed in Istanbul (2004), Amsterdam (2005), and Hamburg (2006). In each video, the artist roams the aisles of a supermarket reciting from memory the *Surah al-Kahf*, a well-known Qur'anic *surah* [chapter] read by many Muslims each Friday. The *surah* opens with a parable in which religious youths seek refuge in a cave where Allah protects them from persecution, and the subsequent stories assert the virtue of humility with regard to wealth, knowledge, and the wisdom and omnipotence of Allah. While Shawky's saunter and delivery along with tickertape-style subtitles appear oddly reminiscent of a news report, the content of his recitation underscores the consumerist oblivion of the shoppers weaving in and out of the supermarket aisles, who are almost certainly unaware that the artist's words relate to a revelation of the Prophet Mohammad. The incongruity of Shawky's articulation of a religious text within a banal location highlights the gap between different cultures and contexts. With this work, Shawky plays on the expectations and stereotypes that supermarket-goers and viewers alike may bring to the scene, while also offering a meditation on the complex relationships between consumerism, religion, and spectacle.

—M.N.

MOUNIRA AL SOLH

b. 1978 Beirut, Lebanon; lives in Beirut, Lebanon, and Amsterdam, Netherlands

Through role-playing, ventriloquism, and mischievous takes on autobiography, Mounira Al Solh's works often question concepts of identity, subjectivity, and gender. Al Solh is also sensitive to the politics that are embedded in the everyday. As she has explained, growing up in Beirut—a city deeply divided by religion and politics, and host to a civil war from 1975-90—propelled her to "explore critical tactics of inhabiting or surviving unstable times." Despite the devastating impact of the civil war, it remains largely absent from Lebanese history textbooks, in part out of fear of inciting old sectarian hostilities. In the early 1990s, many Lebanese artists began delving into this contested past, but in her 2006 video *Rawane's Song*, Al Solh announced her refusal to fetishize war in her art. The video, however, plays on an inherent irony—even in refusing this alleged trope, she realizes she cannot address the expectations that are held of her as a Lebanese artist without also speaking of this history.

In Al Solh's most recent video work, *Now Eat My Script* (2014), the narrator introduces a writer who has failed to write a script for a new video—perhaps, as the setting suggests, the video we are watching. Instead, the writer has been observing the waves of Syrian refugees (of which there are roughly one million now living in Lebanon) arriving in the streets outside of her Beirut apartment. Midway through the video, the narrator recalls her own family's experience fleeing Beirut for Damascus during the Lebanese Civil War. Her memories focus on the exchange of food items during this period, and the camera pans slowly, first over an overstuffed, old car parked in the street, and later over a slaughtered lamb carcass neatly laid out on butcher's white paper. In remembering past exchanges as well as more recent ones among family in Syria and Lebanon, the narrator wonders whether trauma can be consciously lived, or even recorded in a non-voyeuristic way. "Of course you can report on events," she notes, concluding

266

that perhaps this is "the most difficult and most useful thing you can do."
—M.N.

SUHA TRABOULSI

b. 1923 Birzeit, Palestine;
lives in Chbanieh, Lebanon

A pioneering conceptual and performance artist, Suha Traboulsi draws from diverse encounters with language and philosophy, often surveying the boundaries of disciplines as much as the limits of her own body. In the early 1940s, Traboulsi studied art at the Beirut College for Women, but upon finishing her degree, her interests turned from painting toward performance- and language-based conceptual inquiries. Traboulsi was also drawn to philosophy and, discontent with lay approaches to the discipline, enrolled in studies at Harvard and at the University of Heidelberg, where she completed her PhD in 1954.

Not long after finishing her graduate studies, Traboulsi began to gain attention as an influential and, at times, controversial figure in the Amman, Cairo, and Beirut art scenes. During this period, much of her work centered on performances and was largely regarded as both sensationalist and scandalous, earning her the epithet "the witch of contemporary art." In many pieces from this time, she explored the psychological experience of personal danger. While her performances were often defined by her treatment of the objects and architecture around her, she also looked for ways to investigate space and time in text and numerical-based works on paper, which led to her "Antithesis" series (1968-70) and her mail art project "Two Untitled Projects" (1969). The works exhibited are from the 1940s, marking Traboulsi's first departure from conventional methods of painting to more

conceptual portraits illustrated using ink or even ballpoint pen on paper. In these works, brightly colored and oddly offset fragmented shapes appear as if stenciled and digitally manipulated—in line with the minimalist aesthetic soon to prevail internationally, yet uncannily ahead of their time.
—N.B.

VAN LEO

b. 1921 Jehane, Turkey;
d. 2002 Cairo, Egypt

Van Leo, born Levon Boyadjian, was an Armenian-Egyptian photographer originally from southern Anatolia. At the age of four, Van Leo immigrated to Egypt with his family, escaping the Armenian genocide only because his father worked for the German-owned Baghdad Railway Company, whose workers were spared through a German-Ottoman alliance. In Cairo, Van Leo was exposed to the studio practices of a number of renowned Armenian photographers, and in his late teens, he took up an apprenticeship at Venus Studio (owned by another Armenian who went by the name Artinian), which was located in the city's lively opera district. He soon found himself immersed in the cultural and artistic milieu of the time and developed a distinct style of black-and-white or hand-colored portrait photography inspired by theater, fashion photography, and Hollywood movies.

After establishing his own studio in 1941, first with his brother and later alone, he adopted the name Van Leo and became known for his glamorous yet natural as well as more psychological stagings of the women who were often the subjects of his portraits. Van Leo's studio attracted not only numerous aspiring and established actresses and cabaret singers, but also British soldiers stationed in Egypt during this

period as well as musicians, writers, politicians, and many influential figures in Egypt's cultural circles.

These early years when Van Leo established himself as a photographer are also when he produced his most distinctive body of work—over four hundred staged self-portraits, of which a selection is included in this exhibition. Using a variety of costumes and lighting settings, he anticipated later postmodern photography, and the pieces are recognized today as a singular body of work made during this era. Drawing freely on references from film and theater, re-enacting real or inventing fictional characters, Van Leo's self-portraits are a strong testament to his inventiveness and deep desire to create and express his own identity. Their range and impressions testify to a great artistic sensitivity, from the very staged and in costume, to the classic portrait, to a play between the masculine and feminine. The 1952 revolution and the gradual cultural and radicalized political transformation of Egypt ended his self-portrait period and resulted in him burning many nude portraits that he deemed too risky to keep. He remained living and working in Cairo for the rest of his life, and in 1998, donated the entirety of his prints and negatives to the American University in Cairo. First shown by artist Akram Zaatari, Van Leo's works have gained the attention of a larger audience in recent years and are currently the subject of a book and exhibition in development by curator and writer Negar Azimi and the Arab Image Foundation.
—H.C.

ALA YOUNIS

b. 1974 Kuwait City, Kuwait;
lives in Amman, Jordan

Ala Younis is an artist, writer, and curator whose works address

the ways in which historical events shape not only the lives of individuals, but also entire generations. Many of her videos and installations combine found objects and archival footage, reflecting her long-term research into political leaders, cultural figures, utopian architecture or art projects, and the manifold legacies of conflicts in the Arab world. With over twelve thousand painted metal figurines, her installation *Tin Soldiers* (2010–11) illustrates the relative scale of militaries in Middle Eastern countries and how the concept of war is ingrained from childhood. Her film *Six Days* (2009) focuses on Arab volunteers in the 1967 war between Israel and allied Egypt, Jordan, and Syria, and the rhetoric of victory among the Arab countries that attempted to conceal a major political defeat. The film is part of a body of work that engages the history of Arab Nationalism, and also includes *Nefertiti* (2008), an installation of vintage Egyptian sewing machines presented alongside a video narrated by the women who used them.

Younis's research has also led her to produce several publications and curate exhibitions for arts institutions around the world. For "Here and Elsewhere," she organized an exhibition on the Fifth Floor centered on a number of political and aesthetic ideas relating to Godard's film *Ici et ailleurs* as well as resonant, concurrent themes in the Arab world of the 1970s. Among the works that introduce her project are a series of 1950s- and '60s-era photos from the collection of the Arab Image Foundation depicting urban crowds performing exercises in nationalist parades, welcoming charismatic politicians, marching in public demonstrations, and mourning major cultural figures like Egyptian president Gamal Abdel Nasser or legendary singer Umm

Kulthum. Younis's exhibition also revisits the revolutionary cinema produced in the 1970s by filmmakers Tawfiq Saleh and Masao Adachi, and recalls the promise of space exploration in the Arab world through Muhammed Faris, a Syrian research cosmonaut who joined the Soviet mission to the Mir Space Station in 1987. The presentation also features works by artists that inspire a further reflection on depictions of landscapes, workers, and crowds from this period and, more broadly, on the role of images in defining personal and collective histories during an era marked by pan-Arab nationalism, industrialization, and revolutionary political promise.
—G.C.M. & N.B.

AKRAM ZAATARI
b. 1966 Saïda, Lebanon;
lives in Beirut, Lebanon

Akram Zaatari addresses photographic practices relating to the history of his native Lebanon and the ways in which historical memory is either preserved or interrupted during times of war and crisis. Zaatari's work as an artist, curator, and writer has often drawn on archival practices to unearth forgotten moments within the photographic record and to create new images that speculate on the gaps between social and political history. He has assembled found photographs and moving images from a number of historical events and created complex film and video installations. These works tell the stories of photographers, soldiers, and citizens whose personal narratives complicate and contrast with media representations of Lebanese life. In 1997, Zaatari, fellow artist Walid Raad, and photographers Fouad Elkoury and Samer Mohdad founded the Arab Image Foundation, an organization whose stated mission is "to collect, preserve and study photographs from the Middle

East, North Africa and the Arab diaspora."

In recent years, Zaatari has created several artworks that address specific lost histories of image making. His focus has often been the social role of vernacular photography across the Arab World, focusing on legendary studio photographers like Van Leo and lesser known or anonymous individuals who created snapshots, wedding portraits, and other images of daily life. His series "On Photography, People, and Modern Times" (2010) captures an archivist from the Arab Image Foundation presenting images from the collection while the individual photographers who took the photos tell stories related to their respective practices. Revealing the depth of the archive still to be explored, these works enliven the images with personal histories. Furthermore, they offer fascinating insights into the nature of photographic activity, highlighting its ability to not only document, but also impact social life across cultures. For "Here and Elsewhere," Zaatari presents three works relating to photographer Hashem El Madani and his portrait studio, Studio Shehrazade, which he operated in Saïda, Lebanon, starting in the 1950s. The pieces include a photographic triptych depicting Studio Shehrazade, a 16mm film shot outside El Madani's window in the 1960s showing the streets of Saïda, and a video that captures Zaatari and El Madani watching unidentified images on a computer screen. Zaatari's work does more than simply bring attention to an underappreciated photographer. He uses El Madani's activities and images to reconstruct the history of Lebanon over the past fifty years, challenging accepted notions of social life in the Arab world, and preserving the memory of individual lives and communities.
—G.C.M.

WORKS IN THE EXHIBITION

ABOUNADDARA
Selection of video works, 2011–14
Courtesy Abounaddara

ETEL ADNAN
Untitled, 1985
Oil on canvas
30 × 29 in (76.2 × 73.7 cm)
Courtesy the artist and Callicoon
Fine Arts, NY

The Arab Apocalypse (Manuscript), 1989
Typewritten notes, red and black fine liner
pen, and pencil on paper
Seventy-two pages and one cover sheet
10 $\frac{7}{8}$ × 8 $\frac{3}{8}$ in (27.9 × 21.5 cm) each
Courtesy the artist and Sfeir-Semler Gallery,
Beirut/Hamburg

Untitled, 2012
Oil on canvas
9 $\frac{1}{2}$ × 11 $\frac{3}{4}$ in (24.1 × 29.8 cm)
Courtesy the artist and Callicoon
Fine Arts, NY

Untitled, 2012
Oil on canvas
8 × 10 in (20.3 × 25.4 cm)
Courtesy the artist and Callicoon
Fine Arts, NY

RHEIMS ALKADHI
Hairs from the hairbrushes of Palestinians,
2013, from the project "Collective Knotting
Together of Hairs," September–November 2012
Groupings of hair from twenty-one
individuals, hairpins, comb, hairbrush,
plastic pen, twig, and plastic spool
Dimensions variable
Courtesy the artist

*Back brace from an injured laborer,
valves from pressure cookers*, 2013
Leather and steel "bone" lace-up back brace
and twenty-two valves from pressure cookers
13 $\frac{3}{4}$ × 17 × 7 $\frac{7}{8}$ in (35 × 43 × 20 cm)
(approx.)
The Khalid Shoman Collection, Amman

*Chorus of chest-beards looking leftward
(fashion for women)*, 2013
Five sheepskin cuttings with clasps
and five wooden stands
15 $\frac{3}{4}$ × 11 $\frac{3}{4}$ × 11 $\frac{3}{4}$ in (40 × 30 × 30 cm)
(approx.) each
The Khalid Shoman Collection, Amman

Costume for a fly (teapot), 2013
Aluminum kettle, housefly
10 × 9 $\frac{7}{8}$ × 5 $\frac{7}{8}$ in (25.5 × 25 × 15 cm)
Courtesy the artist

*Costume for hands (gloves from the Friday
market, on a Thursday)*, 2013
Reconfigured leather gloves and thread
$\frac{3}{8}$ × 5 $\frac{1}{2}$ × 2 $\frac{3}{4}$ in (1 × 14 × 7 cm)
Courtesy the artist

Costume for water (hose, dress pins), 2012
Hose, dress pins
Dimensions variable
Courtesy the artist

*Refugee comb-seller with empty pockets, she
was dressed as a man (combs among those
collected for new Syrian refugees in Abu
Alanda)*, 2013
Synthetic shirt (*jalabiyya*) and plastic and
metal combs
48 × 19 $\frac{5}{8}$ in (122 × 50 cm) (approx.)
Courtesy the artist

*Rubber tube, once inflated carries the weight
of a vehicle (from a Palestinian man late on
a Friday, along Saaf il Sayl)*, 2013
Tire inner tube (collapsed)
13 × 13 × 7 $\frac{7}{8}$ in (33 × 33 × 20 cm)
Courtesy the artist

*System experiments (sewing needles, plastic
thread)*, 2013
Three-inch sewing needles (177 count) and
blue plastic thread
Dimensions variable
Courtesy the artist

*Tambourine from an Iraqi song (silenced by
mastic gum)*, 2013
Tambourine, mastic gum
11 $\frac{3}{4}$ × 11 $\frac{3}{4}$ × 2 $\frac{1}{2}$ in (30 × 30 × 6.5 cm)
Courtesy the artist

*The smell of an urban people in the lining of
a jacket*, 2013
Polyester jacket
$\frac{3}{4}$ × 7 $\frac{1}{8}$ × 4 $\frac{3}{4}$ in (2 × 18 × 12 cm)
Courtesy the artist

BASMA ALSHARIF
We Began By Measuring Distance, 2009
Video, color, sound
19 min
Courtesy Galerie Imane Fares, Paris

ZIAD ANTAR
Pine Trees, Jessine, from the "Expired"
series, 2003
Gelatin silver print
19 $\frac{3}{4}$ × 19 $\frac{3}{4}$ in (50 × 50 cm)
Courtesy the artist and Selma Feriani
Gallery, London

Alexandria I, from the "Expired" series, 2005
Gelatin silver print
19 $\frac{3}{4}$ × 19 $\frac{3}{4}$ in (50 × 50 cm)
Courtesy the artist and Selma Feriani
Gallery, London

Hajj Tents, from the "Expired" series, 2005
Gelatin silver print
19 $\frac{3}{4}$ × 19 $\frac{3}{4}$ in (50 × 50 cm)
Courtesy the artist and Selma Feriani
Gallery, London

Mecca I, from the "Expired" series, 2005
Gelatin silver print
19 $\frac{3}{4}$ × 19 $\frac{3}{4}$ in (50 × 50 cm)
Courtesy the artist and Selma Feriani
Gallery, London

Mecca Alah Tower II, from the "Expired"
series, 2005
Gelatin silver print

19 $\frac{3}{4}$ × 19 $\frac{3}{4}$ in (50 × 50 cm)
Courtesy the artist and Selma Feriani
Gallery, London

Saïda, from the "Expired" series, 2005
Gelatin silver print
19 $\frac{3}{4}$ × 19 $\frac{3}{4}$ in (50 × 50 cm)
Courtesy the artist and Selma Feriani
Gallery, London

TV and Radio Station, Cairo,
from the "Expired" series, 2005
Gelatin silver print
19 $\frac{3}{4}$ × 19 $\frac{3}{4}$ in (50 × 50 cm)
Courtesy the artist and Selma Feriani
Gallery, London

Murr Tower, Wadi Abu Jmil, Built In 1973,
from the "Expired" series, 2009
Gelatin silver print
19 $\frac{3}{4}$ × 19 $\frac{3}{4}$ in (50 × 50 cm)
Courtesy the artist and Selma Feriani
Gallery, London

*The Saint Georges Hotel, Ain el-Mreisseh,
Built In 1950*, from the "Expired" series,
2009
Gelatin silver print
19 $\frac{3}{4}$ × 19 $\frac{3}{4}$ in (50 × 50 cm)
Courtesy the artist and Selma Feriani
Gallery, London

Burj Khalifa III, from the "Expired" series,
2011
Gelatin silver print
19 $\frac{3}{4}$ × 19 $\frac{3}{4}$ in (50 × 50 cm)
Courtesy the artist and Selma Feriani
Gallery, London

MARWA ARSANIOS
*Have You Ever Killed a Bear?
Or Becoming Jamila*, 2013–4
Video, color, sound
28 min
Courtesy the artist

KADER ATTIA
Repair, Culture's Agency, 2014
Marble sculpture, repaired antique wooden
board with Arabic inscriptions, two wooden
bases
Installation dimensions variable
Courtesy the artist and Galleria Continua,
San Gimignano/Beijing/Le Moulin

YTO BARRADA
Cinéma Flandria (Flandria Cinema), 1999/2011
Chromogenic print
39 $\frac{3}{8}$ × 39 $\frac{3}{8}$ in (100 × 100 cm)
Courtesy the artist and Sfeir-Semler Gallery,
Beirut/Hamburg

Rue de la Liberté, 2000
Pigmented inkjet print
49 $\frac{1}{4}$ × 49 $\frac{1}{4}$ in (125 × 125 cm)
Courtesy the artist and Sfeir-Semler Gallery,
Beirut/Hamburg

Landslip, 2001
Chromogenic print
23 $\frac{5}{8}$ × 23 $\frac{5}{8}$ in (60 × 60 cm)
Courtesy the artist and Sfeir-Semler Gallery,
Beirut/Hamburg

Casa Barata, 2001/2010
Chromogenic print
39 ¾ × 39 ¾ in (100 × 100 cm)
Courtesy the artist and Sfeir-Semler Gallery,
Beirut/Hamburg

Dauphin (Dolphin), 2002
Chromogenic print
31 ½ × 31 ½ in (80 × 80 cm)
Courtesy the artist and Sfeir-Semler Gallery,
Beirut/Hamburg

Briques (Bricks), 2003/2011
Chromogenic print
59 × 59 in (150 × 150 cm)
Courtesy the artist and Sfeir-Semler Gallery,
Beirut/Hamburg

*N du mot Nation en arabe, Tanger
(N of the Nation in Arabic, Tangier)*, 2003
Chromogenic print
31 ½ × 31 ½ in (80 × 80 cm)
Courtesy the artist and Sfeir-Semler Gallery,
Beirut/Hamburg

Arbre généalogique (Family Tree), 2005/2011
Chromogenic print
59 × 59 in (150 × 150 cm)
Courtesy the artist and Sfeir-Semler Gallery,
Beirut/Hamburg

Couronne d'Oxalis (Oxalis Crown), 2006
Chromogenic print
49 ¼ × 49 ¼ in (125 × 125 cm)
Courtesy the artist and Sfeir-Semler Gallery,
Beirut/Hamburg

La Cage aux singes (Monkey Cage), 2007/2011
Chromogenic print
49 ¼ × 49 ¼ in (125 × 125 cm)
Courtesy the artist and Sfeir-Semler Gallery,
Beirut/Hamburg

Nuancier de roses (Pink Color Chart),
2008/2011
Chromogenic print
49 ¼ × 49 ¼ in (125 × 125 cm)
Courtesy the artist and Sfeir-Semler Gallery,
Beirut/Hamburg

Classe de menuiserie (Carpentry Class),
2009/2011
Chromogenic print
31 ½ × 31 ½ in (80 × 80 cm)
Courtesy the artist and Sfeir-Semler Gallery,
Beirut/Hamburg

Libellule bleue (Blue Dragonfly), 2009/2011
Chromogenic print
49 ¼ × 49 ¼ in (125 × 125 cm)
Courtesy the artist and Sfeir-Semler Gallery,
Beirut/Hamburg

Palissade de chantier (Building Site Wall),
2009/2011
Chromogenic print
31 ½ × 31 ½ in (80 × 80 cm)
Courtesy the artist and Sfeir-Semler Gallery,
Beirut/Hamburg

Sidi Hssein, Beni Said, Rif, 2009/2011
Chromogenic print
59 × 59 in (150 × 150 cm)
Courtesy the artist and Sfeir-Semler Gallery,
Beirut/Hamburg

Patrons (Patterns), 2009/2011
Chromogenic print
31 ½ × 31 ½ in (80 × 80 cm)
Courtesy the artist and Sfeir-Semler Gallery,
Beirut/Hamburg

Provinces du Nord (Northern Provinces),
2009/2011
Chromogenic print
31 ½ × 31 ½ in (80 × 80 cm)
Courtesy the artist and Sfeir-Semler Gallery,
Beirut/Hamburg

*Abdelkrim el Khattabi's House (Maison de
Abdelkrim el Khattabi)*, 2011
Chromogenic print
39 ¾ × 39 ¾ in (100 × 100 cm)
Courtesy the artist and Sfeir-Semler Gallery,
Beirut/Hamburg

ANNA BOGHIGUIAN

Untitled, 2011
Paint on paper
15 ½ × 11 ¾ in (39.5 × 30 cm)
Courtesy the artist and Sfeir-Semler Gallery,
Beirut/Hamburg

Untitled, 2011
Pencil and wax crayon on paper
15 ⅔ × 11 ¾ in (39.8 × 30 cm)
Courtesy the artist and Sfeir-Semler Gallery,
Beirut/Hamburg

Untitled, 2011-13
Paint, pencil on paper
16 ½ × 11 ⅔ in (41.8 × 29.5 cm)
Courtesy the artist and Sfeir-Semler Gallery,
Beirut/Hamburg

Untitled, 2011
Paint, crayon and pencil on paper
15 ½ × 11 ¾ in (39.5 × 30 cm)
Courtesy the artist and Sfeir-Semler Gallery,
Beirut/Hamburg

Untitled, 2011-13
Paint, pencil on paper
11 ⅔ × 16 ½ in (29.5 × 42 cm)
Courtesy the artist and Sfeir-Semler Gallery,
Beirut/Hamburg

Untitled, 2011
Paint, pencil on paper
15 ¾ × 11 ¾ in (40 × 30 cm)
Courtesy the artist and Sfeir-Semler Gallery,
Beirut/Hamburg

Untitled, 2011
Paint, pencil on paper
16 ½ × 11 ⅔ in (42 × 29.8 cm)
Courtesy the artist and Sfeir-Semler Gallery,
Beirut/Hamburg

Untitled, 2013
Paint, sand, and collage on paper
16 ½ × 11 ⅔ in (42 × 29.8 cm)
Courtesy the artist and Sfeir-Semler Gallery,
Beirut/Hamburg

Untitled (Nefertiti), 2012
Paint, pencil on paper
16 ½ × 11 ⅔ in (42 × 29.8 cm)
Courtesy the artist and Sfeir-Semler Gallery,
Beirut/Hamburg

Untitled (Nefertiti), 2013
Paint, pencil, sand, and collage on paper
16 ½ × 11 ⅔ in (42 × 29.8 cm)
Courtesy the artist and Sfeir-Semler Gallery,
Beirut/Hamburg

Untitled (Nefertiti), 2011
Paint, charcoal, sand, and lacquer,
and collage on paper
16 ½ × 11 ⅔ in (42 × 29.8 cm)
Courtesy the artist and Sfeir-Semler Gallery,
Beirut/Hamburg

Untitled, 2013
Paint, pencil, and wax crayon on paper
15 ½ × 11 ¾ in (39.5 × 30 cm)
Courtesy the artist and Sfeir-Semler Gallery,
Beirut/Hamburg

Untitled, 2013
Paint, pencil, and pastel crayon on paper
16 ½ × 11 ⅔ in (42 × 29.8 cm)
Courtesy the artist and Sfeir-Semler Gallery,
Beirut/Hamburg

Untitled, 2011
Paint and white pencil on paper
15 ¾ × 11 ¾ in (40 × 30 cm)
Courtesy the artist and Sfeir-Semler Gallery,
Beirut/Hamburg

*Untitled (When will they hang the herd,
Albanian)*, 2011
Paint on paper
15 ¾ × 11 ¾ in (40 × 30 cm)
Courtesy the artist and Sfeir-Semler Gallery,
Beirut/Hamburg

Untitled, 2011
Paint on paper
15 ½ × 11 ¾ in (42 × 30 cm)
Courtesy the artist and Sfeir-Semler Gallery,
Beirut/Hamburg

Untitled (Cairo), 2010
Crayon and pencil on paper
11 ⅔ × 16 ½ in (29.8 × 42 cm)
Courtesy the artist and Sfeir-Semler Gallery,
Beirut/Hamburg

Untitled, 2011
Paint, crayon, and pencil on paper
15 ½ × 11 ¾ in (39.5 × 30 cm)
Courtesy the artist and Sfeir-Semler Gallery,
Beirut/Hamburg

Untitled, 2011
Paint on paper
15 × 13 in (38.5 × 33 cm)
Courtesy the artist and Sfeir-Semler Gallery,
Beirut/Hamburg

Untitled, 2011
Paint, pencil on paper
15 ¾ × 11 ¾ in (40 × 30 cm)
Courtesy the artist and Sfeir-Semler Gallery,
Beirut/Hamburg

Untitled, 2011
Paint on paper
15 ¾ × 11 ¾ in (40 × 30 cm)
Courtesy the artist and Sfeir-Semler Gallery,
Beirut/Hamburg

Untitled, 2011-13
Paint on paper
15 ½ × 11 ¾ in (39.5 × 30 cm)

Courtesy the artist and Sfeir-Semler Gallery, Beirut/Hamburg

Untitled, 2011
Paint, pencil on paper
15 ¾ × 11 ¾ in (40 × 30 cm)
Courtesy the artist and Sfeir-Semler Gallery, Beirut/Hamburg

Untitled, 2011-13
Paint on paper
15 ¾ × 11 ¾ in (40 × 30 cm)
Courtesy the artist and Sfeir-Semler Gallery, Beirut/Hamburg

Untitled, 2011
Wax crayon on paper
15 ¾ × 11 ¾ in (40 × 30 cm)
Courtesy the artist and Sfeir-Semler Gallery, Beirut/Hamburg

Untitled, 2011-13
Paint and ink on paper
15 ½ × 11 ¾ in (39.5 × 30 cm)
Courtesy the artist and Sfeir-Semler Gallery, Beirut/Hamburg

Untitled, 2011-13
Paint, pencil on paper
16 ½ × 12 ½ in (42 × 31.8 cm)
Courtesy the artist and Sfeir-Semler Gallery, Beirut/Hamburg

Untitled, 2011-13
Paint on paper
15 ½ × 11 ¾ in (39.5 × 30 cm)
Courtesy the artist and Sfeir-Semler Gallery, Beirut/Hamburg

Untitled, 2011
Diptych, paint and charcoal on paper
16 ½ × 11 ¾ in (42 × 30 cm) each
Courtesy the artist and Sfeir-Semler Gallery, Beirut/Hamburg

Untitled, 2011-13
Paint, pencil on paper
15 ½ × 11 ¾ in (39.5 × 30 cm)
Courtesy the artist and Sfeir-Semler Gallery, Beirut/Hamburg

Untitled (Berlin), 2011
Paint, pencil on paper
15 ¾ × 11 ¾ in (40 × 30 cm)
Courtesy the artist and Sfeir-Semler Gallery, Beirut/Hamburg

Untitled, 2011
Paint, pencil on paper
15 ½ × 11 ¾ in (39.5 × 30 cm)
Courtesy the artist and Sfeir-Semler Gallery, Beirut/Hamburg

Untitled, 2011
Paint, pencil on paper
16 ½ × 11 ⅔ in (42 × 29.8 cm)
Courtesy the artist and Sfeir-Semler Gallery, Beirut/Hamburg

Untitled, 2011-13
Paint, pencil on paper
15 ¾ × 11 ¾ in (40 × 30 cm)
Courtesy the artist and Sfeir-Semler Gallery, Beirut/Hamburg

Untitled, 2011-13
Paint and wax crayon on paper

15 ¾ × 11 ¾ in (40 × 30 cm)
Courtesy the artist and Sfeir-Semler Gallery, Beirut/Hamburg

Untitled, 2011
Paint, pencil on paper
15 ¾ × 11 ¾ in (40 × 30 cm)
Courtesy the artist and Sfeir-Semler Gallery, Beirut/Hamburg

Untitled, 2011-13
Paint and crayon on paper
15 ¾ × 11 ¾ in (40 × 30 cm)
Courtesy the artist and Sfeir-Semler Gallery, Beirut/Hamburg

Untitled, 2010
Collage, crayon, pencil, and ink on paper
11 ⅔ × 16 ½ in (29.8 × 42 cm)
Courtesy the artist and Sfeir-Semler Gallery, Beirut/Hamburg

Untitled, 2011-13
Pencil, felt tip pen, collage, and fire on paper
11 ⅔ × 8 ¼ in (29.8 × 21 cm)
Courtesy the artist and Sfeir-Semler Gallery, Beirut/Hamburg

Untitled, 2011
Paint, pencil on paper
15 ¾ × 11 ¾ in (40 × 30 cm)
Courtesy the artist and Sfeir-Semler Gallery, Beirut/Hamburg

Untitled, 2011-13
Paint, pencil on paper
15 ¾ × 11 ¾ in (40 × 30 cm)
Courtesy the artist and Sfeir-Semler Gallery, Beirut/Hamburg

Untitled, 2011-13
Paint on paper
15 ¾ × 11 ¾ in (40 × 30 cm)
Courtesy the artist and Sfeir-Semler Gallery, Beirut/Hamburg

Untitled, 2011-13
Paint, pencil on paper
15 ¾ × 11 ¾ in (40 × 30 cm)
Courtesy the artist and Sfeir-Semler Gallery, Beirut/Hamburg

Untitled, 2011-13
Paint on paper
15 ¾ × 11 ¾ in (40 × 30 cm)
Courtesy the artist and Sfeir-Semler Gallery, Beirut/Hamburg

FOUAD ELKOURY

Tijara Street (Beirut 1977), 2014
Digital inkjet print
23 ⅝ × 15 in (60 × 40 cm)
Courtesy the artist, The Third Line, Dubai, and Galerie Tanit, Munich/Beirut

Sporting Club a few days before the Israeli invasion (Beirut 1982), 2014
Digital inkjet print
15 × 23 ⅝ in (40 × 60 cm)
Courtesy the artist, The Third Line, Dubai, and Galerie Tanit, Munich/Beirut

Masks, Place des Canons (Beirut 1982), 2014
Digital inkjet print
15 × 23 ⅝ in (40 × 60 cm)

Courtesy the artist, The Third Line, Dubai, and Galerie Tanit, Munich/Beirut

Color snapshot, Place des Canons (Beirut 1982), 2014
Digital inkjet print
15 × 23 ⅝ in (40 × 60 cm)
Courtesy the artist, The Third Line, Dubai, and Galerie Tanit, Munich/Beirut

Lebanon Beach Hotel (Khalde 1982), 2014
Digital inkjet print
15 × 23 ⅝ in (40 × 60 cm)
Courtesy the artist, The Third Line, Dubai, and Galerie Tanit, Munich/Beirut

Portemilio, A Perfectly Boring Day (Lebanon 1984), 2014
Digital inkjet print
15 × 23 ⅝ in (40 × 60 cm)
Courtesy the artist, The Third Line, Dubai, and Galerie Tanit, Munich/Beirut

Eaten Up Façade (Beirut 1991), 2014
Digital inkjet print
22 ⅛ × 17 ¾ in (56.3 × 45 cm)
Courtesy the artist, The Third Line, Dubai, and Galerie Tanit, Munich/Beirut

The Pier (Beirut 1991), 2014
Digital inkjet print
22 ⅛ × 17 ¾ in (56.3 × 45 cm)
Courtesy the artist, The Third Line, Dubai, and Galerie Tanit, Munich/Beirut

Place de l'Etoile (Beirut 1991), 2014
Digital inkjet print
22 ⅛ × 17 ¾ in (56.3 × 45 cm)
Courtesy the artist, The Third Line, Dubai, and Galerie Tanit, Munich/Beirut

The Rape (Beirut 1991), 2014
Digital inkjet print
17 ¾ × 22 ⅛ in (45 × 56.3 cm)
Courtesy the artist, The Third Line, Dubai, and Galerie Tanit, Munich/Beirut

The Sniper, Allenby Street (Beirut 1991), 2014
Digital inkjet print
22 ⅛ × 17 ¾ in (56.3 × 45 cm)
Courtesy the artist, The Third Line, Dubai, and Galerie Tanit, Munich/Beirut

Rivoli Cinema (Beirut 1991), 2014
Digital inkjet print
17 ¾ × 22 ⅛ in (45 × 56.3 cm)
Courtesy the artist, The Third Line, Dubai, and Galerie Tanit, Munich/Beirut

Place des Canons (Beirut 1991), 2014
Digital inkjet print
17 ¾ × 22 ⅛ in (45 × 56.3 cm)
Courtesy the artist, The Third Line, Dubai, and Galerie Tanit, Munich/Beirut

Kitkat, Zeitouneh (Beirut 1991), 2014
Digital inkjet print
17 ¾ × 22 ⅛ in (45 × 56.3 cm)
Courtesy the artist, The Third Line, Dubai, and Galerie Tanit, Munich/Beirut

Bechara Elkoury Avenue (Beirut 1991), 2014
Digital inkjet print
22 ⅛ × 17 ¾ in (56.3 × 45 cm)
Courtesy the artist, The Third Line, Dubai, and Galerie Tanit, Munich/Beirut

The Pool, Hotel Phonecia (Beirut 1991), 2014
Digital inkjet print
17 ¾ × 22 ⅛ in (45 × 56.3 cm)
Courtesy the artist, The Third Line, Dubai,
and Galerie Tanit, Munich/Beirut

Ajram, Ain el Mreisseh (Beirut 1991), 2014
Digital inkjet print
22 ⅛ × 17 ¾ in (56.3 × 45 cm)
Courtesy the artist, The Third Line, Dubai,
and Galerie Tanit, Munich/Beirut

The Hand, Place des Martyrs (Beirut 1991),
2014
Digital inkjet print
17 ¾ × 22 ⅛ in (45 × 56.3 cm)
Courtesy the artist, The Third Line, Dubai,
and Galerie Tanit, Munich/Beirut

Assaf Mosque (Beirut 1991), 2014
Digital inkjet print
17 ¾ × 22 ⅛ in (45 × 56.3 cm)
Courtesy the artist, The Third Line, Dubai,
and Galerie Tanit, Munich/Beirut

SIMONE FATTAL

Untitled, 2006
Terracotta
11 ¾ × 6 ⅝ × 21 ½ in (30 × 17 × 54.5 cm)
Courtesy the artist and Galerie Tanit,
Munich/Beirut

Untitled, 2006
Terracotta
ii ¾ × 6 ⅝ × 20 in (30 × 17 × 51 cm)
Courtesy the artist and Galerie Tanit,
Munich/Beirut

La Reine de Tyr, 2008
Terracotta
11 ⅜ × 5 ⅛ × 2 ⅜ in (29 × 13 × 6 cm)
Courtesy the artist and Galerie Tanit,
Munich/Beirut

Déesse Préhistorique, 2008
Terracotta
24 ¾ × 13 ¾ × 4 in (63 × 35 × 10 cm)
Courtesy the artist and Galerie Tanit,
Munich/Beirut

Gilgamesh, 2008
Terracotta
18 ⅛ × 4 × 3 ⅛ in (46 × 10 × 8 cm)
Courtesy the artist and Galerie Tanit,
Munich/Beirut

Soldat Irakien Retour de Guerre, 2008
Terracotta
9 × 10 ¼ × 9 ½ in (23 × 26 × 24 cm)
Collection Nayla Bustros

Haut Fonctionnaire Antique, 2008
Terracotta
20 ½ × 7 ½ × 3 ⅛ in (52 × 19 × 8 cm)
Collection Ghassan Khatib

Cavalier, 2011
Terracotta
15 × 7 ⅞ × 19 ¼ in (38 × 20 × 49 cm)
Courtesy the artist and Galerie Tanit,
Munich/Beirut

MEKHITAR GARABEDIAN

MG, 2006
Video, color, sound

2:05 min
Courtesy the artist and Albert Baronian
Gallery, Brussels

Learning Piece: Be Patient, My Soul, 2006
Video, color, sound
14:39 min
Courtesy the artist and Albert Baronian
Gallery, Brussels

GCC

*The One and Only Madinat New Museum
Royal Mirage,* 2014
Wallpaper and sound installation
Dimensions variable
Courtesy the artists

FAKHRI EL GHEZAL

Chokran ya siédété al raiis [Thank You
Mr. President], from the "Chokran ya siédété
al raiis" series, 2011
Gelatin silver print
8 ¼ × 5 ½ in (21 × 14 cm)
Courtesy the artist

Café Paris, from the "Chokran ya siédété al
raiis" series, 2011
Gelatin silver print
8 ¼ × 5 ½ in (21 × 14 cm)
Courtesy the artist

Retour chez Abdelbasset l'encadreur 1,
from the "Chokran ya siédété al raiis"
series, 2011
Gelatin silver print
8 ¼ × 5 ½ in (21 × 14 cm)
Courtesy the artist

Retour chez Abdelbasset l'encadreur 2,
from the "Chokran ya siédété al raiis"
series, 2011
Gelatin silver print
8 ¼ × 5 ½ in (21 × 14 cm)
Courtesy the artist

Retour chez Abdelbasset l'encadreur 3,
from the "Chokran ya siédété al raiis"
series, 2011
Gelatin silver print
8 ¼ × 5 ½ in (21 × 14 cm)
Courtesy the artist

Retour chez Abdelbasset l'encadreur 4,
from the "Chokran ya siédété al raiis"
series, 2011
Gelatin silver print
8 ¼ × 5 ½ in (21 × 14 cm)
Courtesy the artist

Books for Hiding My Mother's Hair,
from the "Weld Mén" series, 2011
Gelatin silver print
8 ¼ × 5 ½ in (21 × 14 cm)
Courtesy the artist

Hamma's Room 1, from the "Weld Mén" series,
2011
Gelatin silver print
8 ¼ × 5 ½ in (21 × 14 cm)
Courtesy the artist

Hamma's Room 2, from the "Weld Mén" series,
2011
Gelatin silver print

8 ¼ × 5 ½ in (21 × 14 cm)
Courtesy the artist

Hamma's Room 3, from the "Weld Mén" series,
2011
Gelatin silver print
8 ¼ × 5 ½ in (21 × 14 cm)
Courtesy the artist

Hamma's Room 4, from the "Weld Mén" series,
2011
Gelatin silver print
8 ¼ × 5 ½ in (21 × 14 cm)
Courtesy the artist

In My Studio, from the "Weld Mén" series,
2011
Gelatin silver print
8 ¼ × 5 ½ in (21 × 14 cm)
Courtesy the artist

Najet 's Room 1, from the "Weld Mén" series,
2011
Gelatin silver print
8 ¼ × 5 ½ in (21 × 14 cm)
Courtesy the artist

Najet 's Room 2, from the "Weld Mén" series,
2011
Gelatin silver print
8 ¼ × 5 ½ in (21 × 14 cm)
Courtesy the artist

Najet 's Room 3, from the "Weld Mén" series,
2011
Gelatin silver print
8 ¼ × 5 ½ in (21 × 14 cm)
Courtesy the artist

Oumma Hlima's Room, from the "Weld Mén"
series, 2011
Gelatin silver print
8 ¼ × 5 ½ in (21 × 14 cm)
Courtesy the artist

Oumma Hlima's Room 2, from the "Weld Mén"
series, 2011
Gelatin silver print
8 ¼ × 5 ½ in (21 × 14 cm)
Courtesy the artist

Oumma Hlima's Room 3, from the "Weld Mén"
series, 2011
Gelatin silver print
8 ¼ × 5 ½ in (21 × 14 cm)
Courtesy the artist

Oumma Hlima's Room 4, from the "Weld Mén"
series, 2011
Gelatin silver print
8 ¼ × 5 ½ in (21 × 14 cm)
Courtesy the artist

*The Attic or The Remains of my Circumcision
Party,* from the "Weld Mén" series, 2011
Gelatin silver print
8 ¼ × 5 ½ in (21 × 14 cm)
Courtesy the artist

TANYA HABJOUQA

"Tomorrow there will be apricots
[بكرة في المشمش]," 2013
Selection of six works
Chromogenic prints
13 ⅛ × 19 ¾ in (33.3 × 50 cm) each
Courtesy the artist

ROKNI HAERIZADEH

Just What Is It that Makes Today's Homes So Different, So Appealing?, 2010-11
Video, color, silent
4:23 min
Courtesy the artist and Gallery Isabelle van den Eynde, Dubai

Fictionville, Go Find A New Bed, 2011
Gesso, watercolor, and ink on printed paper
Portfolio of nine works
8 ¼ in × 11 ¾ in (21 × 30 cm) each
Courtesy the artist and Gallery Isabelle van den Eynde, Dubai

Fictionville, Adrenaline Runs in Armpits, 2011
Gesso, watercolor, and ink on printed paper
Portfolio of nine works
8 ¼ in × 11 ¾ in (21 × 30 cm) each
Courtesy the artist and Gallery Isabelle van den Eynde, Dubai

Fictionville, Some Breath Breathes Out of Bombs and Dog Barks, 2011
Gesso, watercolor, and ink on printed paper
Portfolio of nine works
8 ¼ in × 11 ¾ in (21 × 30 cm) each
Courtesy the artist and Gallery Isabelle van den Eynde, Dubai

Cyrus Cylinder Coming Back Home, 2011
Gesso, watercolor, and ink on printed paper
Portfolio of nine works
8 ¼ in × 11 ¾ in (21 × 30 cm) each
Courtesy the artist and Gallery Isabelle van den Eynde, Dubai

Subversive Salami in a Ragged Briefcase, 2014
Gesso, watercolor, and ink on printed paper
Selection of thirty works
11 ¾ × 15 ¾ in (30 × 40 cm) each
Courtesy the artist and Gallery Isabelle van den Eynde, Dubai

Letter!, 2014
Video, color, silent
Courtesy the artist and Gallery Isabelle van den Eynde, Dubai

RANA HAMADEH

The Big Board or *'And Before It Falls It Is Only Reasonable To Enjoy Life A Little,'* 2013
Performance and stage set with objects
118 × 59 × 27 ½ in (300 × 150 × 70 cm)
Courtesy the artist

SHURUQ HARB

The Keeper, 2011-13
Installation with video, includes photographs, wires, clips, and street sign
Overall dimensions variable; black and white, sound, 5:45 min
Originally commissioned by 9th Gwangju Biennial and supported by the Arab Fund for Art and Culture (AFAC)
Courtesy the artist
Video editor: Rama Mari
Special thanks to Mustafa for sharing his story

SUSAN HEFUNA

Cityscape Istanbul, 2011
Ink on paper, sixteen works

7 ¼ × 5 ¼ in (18.5 × 13.5 cm) each
Courtesy the artist and Pi Artworks, Istanbul/London

WAFA HOURANI

Qalandia 2087, 2009
Mixed media installation in six parts, sound
216 × 354 in (550 × 900 cm)
Nadour Collection, Düsseldorf

ALI JABRI

Director of Antiquities, from the "Nasser" series, ca. 1977-83
Collage
7 ⅞ × 5 ¾ in (20 × 14.8 cm)
Courtesy Diala al Jabiri

Private Crimes, from the "Nasser" series, ca. 1977-83
Collage
7 ⅞ × 5 ¾ in (20 × 14.8 cm)
Courtesy Diala al Jabiri

With Compliments, from the "Nasser" series, ca. 1977-83
Collage
7 ⅞ × 5 ¾ in (20 × 14.8 cm)
Courtesy Diala al Jabiri

Corps Diplomatique, from the "Nasser" series, ca. 1977-83
Collage
7 ⅞ × 5 ¾ in (20 × 14.8 cm)
Courtesy Diala al Jabiri

Prayer Call, from the "Nasser" series, ca. 1977-83
Collage
7 ⅞ × 5 ¾ in (20 × 14.8 cm)
Courtesy Diala al Jabiri

Sleep Cycle, from the "Nasser" series, ca. 1977-83
Collage
7 ⅞ × 5 ¾ in (20 × 14.8 cm)
Courtesy Diala al Jabiri

Midnight Call, from the "Nasser" series, ca. 1977-83
Collage
7 ⅞ × 5 ¾ in (20 × 14.8 cm)
Courtesy Diala al Jabiri

Golden Age, from the "Nasser" series, ca. 1977-83
Collage
7 ⅞ × 5 ¾ in (20 × 14.8 cm)
Courtesy Diala al Jabiri

Dead on Arrival, from the "Nasser" series, ca. 1977-83
Collage
7 ⅞ × 5 ¾ in (20 × 14.8 cm)
Courtesy Diala al Jabiri

Red Sea, from the "Nasser" series, ca. 1977-83
Collage
7 ⅞ × 5 ¾ in (20 × 14.8 cm)
Courtesy Diala al Jabiri

By Agreement, from the "Nasser" series, ca. 1977-83
Collage

7 ⅞ × 5 ¾ in (20 × 14.8 cm)
Courtesy Diala al Jabiri

And Now..., from the "Nasser" series, ca. 1977-83
Collage
7 ⅞ × 5 ¾ in (20 × 14.8 cm)
Courtesy Diala al Jabiri

KHALED JARRAR

Infiltrators, 2012
Video, color, sound
70 min
Courtesy the artist and Galerie Polaris, Paris

LAMIA JOREIGE

Objects of War Nº 1, 2000
Video, color, sound; 68 min
UHF Radio, suitcase, Miss Piggy Bag (and contents), beer can, tissue, torchlight, batteries, pouch, playing cards, curtain, jerry can, photograph, guitar audiotape, and VHS cassette case
Display dimensions variable
Tate, Purchased 2011

Objects of War Nº 2, 2003
Video, color, sound; 85 min
Identity card, Walkman, worry beads, photograph, VHS tape, mini DV cam tape, Heart to Heart, Teddy Bear, and book
Display dimensions variable
Tate, Purchased 2011

Objects of War Nº 3, 2006
Video, color, sound; 53 min
Candle, perfume flask with pouch, radio, cigarette sheets, and photograph on paper and ink
Display dimensions variable
Tate, Purchased 2011

Objects of War Nº 4, 2006
Video, color, sound; 72 min
Key, plastic watch with photograph, photograph on paper, plastic watering can (spray bottle), ballpoint pen and paper from notebook, passport, and mini DV case
Display dimensions variable
Tate, Purchased 2011

Objects of War Nº 5, 2014
Video, color, sound
Courtesy the artist

Objects of War Nº 6, 2014
Video, color, sound
Courtesy the artist

HIWA K

This Lemon Tastes of Apple, 2011
Video, color, sound
13:26 min
Courtesy the artist

AMAL KENAWY

The Purple Artificial Forest, 2005
Video, color, sound
8:50 min
The Khalid Shoman Collection, Amman

MAZEN KERBAJ

"Beyrouth, juillet-août 2006" [Beirut, July-August 2006], 2006
Selection of forty works
Ink on paper
5 ½ × 3 ½ and 8 ¼ × 5 ⅛ in
(14 × 9 and 21 × 13 cm) each
Courtesy the artist

BOUCHRA KHALILI

"The Mapping Journey Project," 2008-11
Eight videos, color, sound
Courtesy the artist and Galerie Polaris, Paris

MAHA MAAMOUN

2026, 2010
Video, black and white, sound
9 min
Courtesy the artist and Gypsum Gallery, Cairo

HASHEM EL MADANI

Syrian resistant, Studio Shehrazade, Saïda, Lebanon, early 1970s. From Akram Zaatari, "Objects of study/The archive of Shehrazade/Hashem el Madani/Studio practices," 2006
Gelatin silver print
11 ½ × 11 ½ in (29 × 29 cm)
Courtesy the artist and Sfeir-Semler Gallery, Beirut/Hamburg

Syrian resistant, Studio Shehrazade, Saïda, Lebanon, early 1970s. From Akram Zaatari, "Objects of study/The archive of Shehrazade/Hashem el Madani/Studio practices," 2006
Gelatin silver print
11 ½ × 11 ½ in (29 × 29 cm)
Courtesy the artist and Sfeir-Semler Gallery, Beirut/Hamburg

Syrian resistant, Studio Shehrazade, Saïda, Lebanon, early 1970s. From Akram Zaatari, "Objects of study/The archive of Shehrazade/Hashem el Madani/Studio practices," 2006
Gelatin silver print
11 ½ × 11 ½ in (29 × 29 cm)
Courtesy the artist and Sfeir-Semler Gallery, Beirut/Hamburg

Syrian resistant, Studio Shehrazade, Saïda, Lebanon, early 1970s. From Akram Zaatari, "Objects of study/The archive of Shehrazade/Hashem el Madani/Studio practices," 2006
Gelatin silver print
11 ½ × 11 ½ in (29 × 29 cm)
Courtesy the artist and Sfeir-Semler Gallery, Beirut/Hamburg

Syrian resistants, Studio Shehrazade, Saïda, Lebanon, early 1970s. From Akram Zaatari, "Objects of study/The archive of Shehrazade/Hashem el Madani/Studio practices," 2006
Gelatin silver print
11 ½ × 11 ½ in (29 × 29 cm)
Courtesy the artist and Sfeir-Semler Gallery, Beirut/Hamburg

Student of the UNRWA school, South Lebanon, 1960s. From Akram Zaatari, "Objects of study/The archive of Shehrazade/Hashem el Madani/Studio practices," 2006
Gelatin silver print
7 ½ × 11 ⅜ in (19 × 29 cm)

Courtesy the artist and Sfeir-Semler Gallery, Beirut/Hamburg

Student of the UNRWA school, South Lebanon, 1960s. From Akram Zaatari, "Objects of study/The archive of Shehrazade/Hashem el Madani/Studio practices," 2006
Gelatin silver print
7 ½ × 11 ⅜ in (19 × 29 cm)
Courtesy the artist and Sfeir-Semler Gallery, Beirut/Hamburg

Student of the UNRWA school, South Lebanon, 1960s. From Akram Zaatari, "Objects of study/The archive of Shehrazade/Hashem el Madani/Studio practices," 2006
Gelatin silver print
7 ½ × 11 ⅜ in (19 × 29 cm)
Courtesy the artist and Sfeir-Semler Gallery, Beirut/Hamburg

Student of the UNRWA school, South Lebanon, 1960s. From Akram Zaatari, "Objects of study/The archive of Shehrazade/Hashem el Madani/Studio practices," 2006
Gelatin silver print
7 ½ × 11 ⅜ in (19 × 29 cm)
Courtesy the artist and Sfeir-Semler Gallery, Beirut/Hamburg

Student of the UNRWA school, South Lebanon, 1960s. From Akram Zaatari, "Objects of study/The archive of Shehrazade/Hashem el Madani/Studio practices," 2006
Gelatin silver print
7 ½ × 11 ⅜ in (19 × 29 cm)
Courtesy the artist and Sfeir-Semler Gallery, Beirut/Hamburg

Student of Aisha Om el Mo'minin School for Girls. School courtyard, Saïda, Lebanon, 1948-49. From Akram Zaatari, "Objects of study/The archive of Shehrazade/Hashem el Madani/Studio practices," 2006
Gelatin silver print
5 ⅞ × 8 ⅝ in (15 × 22 cm)
Courtesy the artist and Sfeir-Semler Gallery, Beirut/Hamburg

Student of Aisha Om el Mo'minin School for Girls. School courtyard, Saïda, Lebanon, 1948-49. From Akram Zaatari, "Objects of study/The archive of Shehrazade/Hashem el Madani/Studio practices," 2006.
Gelatin silver print
8 ⅝ × 5 ⅞ in (22 × 15 cm)
Courtesy the artist and Sfeir-Semler Gallery, Beirut/Hamburg

Ibtissam Hashisho (right) and a school friend. Students of Aisha Om el Mo'minin School for Girls. School courtyard, Saïda, Lebanon, 1948-49. From Akram Zaatari, "Objects of study/The archive of Shehrazade/Hashem el Madani/Studio practices," 2006
Gelatin silver print
5 ⅞ × 8 ⅝ in (15 × 22 cm)
Courtesy the artist and Sfeir-Semler Gallery, Beirut/Hamburg

Sakakini (right) and Hadiyeh Bsat. Students of Aisha Om el Mo'minin School for Girls. School courtyard, Saïda, Lebanon, 1948-49. From Akram Zaatari, "Objects of study/The archive of Shehrazade/Hashem el Madani/Studio practices," 2006
Gelatin silver print

5 ⅞ × 8 ⅝ in (15 × 22 cm)
Courtesy the artist and Sfeir-Semler Gallery, Beirut/Hamburg

Student of Aisha Om el Mo'minin School for Girls. School courtyard, Saïda, Lebanon, 1948-49. From Akram Zaatari, "Objects of study/The archive of Shehrazade/Hashem el Madani/Studio practices," 2006
Gelatin silver print
5 ⅞ × 8 ⅝ in (15 × 22 cm)
Courtesy the artist and Sfeir-Semler Gallery, Beirut/Hamburg

Wadiah Lotfy (right) and a schoolteacher colleague. Aisha Om el Mo'minin School for Girls. School courtyard, Saïda, Lebanon, 1948-49. From Akram Zaatari, "Objects of study/The archive of Shehrazade/Hashem el Madani/Studio practices," 2006
Gelatin silver print
8 ⅝ × 5 ⅞ in (22 × 15 cm)
Courtesy the artist and Sfeir-Semler Gallery, Beirut/Hamburg

Palestinian resistant, Studio Shehrazade, Saïda, Lebanon, 1970-72. From Akram Zaatari, "Objects of study/The archive of Shehrazade/Hashem el Madani/Studio practices," 2006
Gelatin silver print
11 ½ × 11 ½ in (29 × 29 cm)
Courtesy the artist and Sfeir-Semler Gallery, Beirut/Hamburg

Ringo, Zarif's cousin, Studio Shehrazade, Saïda, Lebanon, 1970-72. From Akram Zaatari, "Objects of study/The archive of Shehrazade/Hashem el Madani/Studio practices," 2006
Gelatin silver print
11 ½ × 11 ½ in (29 × 29 cm)
Courtesy the artist and Sfeir-Semler Gallery, Beirut/Hamburg

Zarif, Palestinian resistant, Studio Shehrazade, Saïda, Lebanon, 1970-72. From Akram Zaatari, "Objects of study/The archive of Shehrazade/Hashem el Madani/Studio practices," 2006
Gelatin silver print
11 ½ × 11 ½ in (29 × 29 cm)
Courtesy the artist and Sfeir-Semler Gallery, Beirut/Hamburg

Ringo, Zarif's cousin, Studio Shehrazade, Saïda, Lebanon, 1970-72. From Akram Zaatari, "Objects of study/The archive of Shehrazade/Hashem el Madani/Studio practices," 2006
Gelatin silver print
11 ½ × 11 ½ in (29 × 29 cm)
Courtesy the artist and Sfeir-Semler Gallery, Beirut/Hamburg

Hassan Jawhar, Studio Shehrazade, Saïda, Lebanon, 1970-72. From Akram Zaatari, "Objects of study/The archive of Shehrazade/Hashem el Madani/Studio practices," 2006
Gelatin silver print
11 ½ × 11 ½ in (29 × 29 cm)
Courtesy the artist and Sfeir-Semler Gallery, Beirut/Hamburg

Palestinian resistant, Studio Shehrazade, Saïda, Lebanon, 1970-72. From Akram Zaatari, "Objects of study/The archive of Shehrazade/Hashem el Madani/Studio practices," 2006
Gelatin silver print
11 ½ × 11 ½ in (29 × 29 cm)

Courtesy the artist and Sfeir-Semler Gallery,
Beirut/Hamburg

Palestinian resistants, Studio Shehrazade,
Saïda, Lebanon, 1970-72. From Akram Zaatari,
"Objects of study/The archive of Shehrazade/
Hashem el Madani/Studio practices," 2006
Gelatin silver print
11 $\frac{1}{2}$ × 11 $\frac{1}{2}$ in (29 × 29 cm)
Courtesy the artist and Sfeir-Semler Gallery,
Beirut/Hamburg

Anonymous, Studio Shehrazade, Saïda, Lebanon,
early 1970s. From Akram Zaatari, "Objects
of study/The archive of Shehrazade/Hashem el
Madani/Studio practices," 2006
Gelatin silver print
11 $\frac{1}{2}$ × 11 $\frac{1}{2}$ in (29 × 29 cm)
Courtesy the artist and Sfeir-Semler Gallery,
Beirut/Hamburg

Anonymous, Studio Shehrazade, Saïda, Lebanon,
early 1970s. From Akram Zaatari, "Objects
of study/The archive of Shehrazade/Hashem el
Madani/Studio practices," 2006
Gelatin silver print
11 $\frac{1}{2}$ × 11 $\frac{1}{2}$ in (29 × 29 cm)
Courtesy the artist and Sfeir-Semler Gallery,
Beirut/Hamburg

Tarho and el Marsi, Studio Shehrazade, Saïda,
Lebanon, early 1958. From Akram Zaatari,
"Objects of study/The archive of Shehrazade/
Hashem el Madani/Studio practices," 2006
Gelatin silver print
7 $\frac{1}{2}$ × 11 $\frac{1}{2}$ in (19 × 29 cm)
Courtesy the artist and Sfeir-Semler Gallery,
Beirut/Hamburg

Bashasha (left) and a friend, Studio
Shehrazade, Saïda, Lebanon, late 1950s.
From Akram Zaatari, "Objects of study/The
archive of Shehrazade/Hashem el Madani/Studio
practices," 2006
Gelatin silver print
7 $\frac{1}{2}$ × 11 $\frac{1}{2}$ in (19 × 29 cm)
Courtesy the artist and Sfeir-Semler Gallery,
Beirut/Hamburg

MARWAN

Khaddouch II, 1966
Oil on canvas
51 $\frac{1}{4}$ × 35 in (130 × 89 cm)
Private collection, New York

Mann am Tisch I [Man at the Table I], 1966
Oil on canvas
51 $\frac{1}{4}$ × 38 $\frac{1}{4}$ in (130 × 97 cm)
Courtesy the artist and Sfeir-Semler,
Beirut/Hamburg

Stehender [Standing], 1966
Oil on canvas
51 $\frac{1}{4}$ × 35 in (130 × 89 cm)
Courtesy the artist and Sfeir-Semler,
Beirut/Hamburg

Das Knie [The Knee], 1967
Oil on canvas
63 $\frac{3}{4}$ × 44 $\frac{3}{4}$ in (162 × 114 cm)
Courtesy the artist and Sfeir-Semler,
Beirut/Hamburg

Untitled, 1969-71
Oil on canvas
37 $\frac{3}{4}$ × 51 $\frac{1}{4}$ in (96 × 130 cm)

Courtesy the artist and Sfeir-Semler,
Beirut/Hamburg

AHMED MATER

Leaves Fall in All Seasons, 2013
Video, color, sound
35:20 min
Courtesy the artist and Athr Gallery, Jeddah

ABDUL HAY MOSALLAM

Loyalty to the Martyrs: Bajes Abuatoan,
Ali Abu Al Maliha, Khalil Abdullah, Ibrahim
Khalil, 1977
Acrylic on sawdust and glue
44 × 33 in (112 × 84 cm)
Courtesy the artist

Tyre, "Sour," The Castle of Steadfastness
and Defiance, 1978
Acrylic on sawdust and glue
47 $\frac{5}{8}$ × 28 $\frac{7}{8}$ in (121 × 73.4 cm)
Courtesy the artist

A Military Statement/The Martyr Dalal
Mughrabi, 1978
Acrylic on sawdust and glue
42 $\frac{1}{4}$ × 29 $\frac{1}{2}$ in (110 × 75 cm)
Courtesy the artist

SELMA AND SOFIANE OUISSI

Laaroussa, 2011
Video, color, sound
12 min
Courtesy the artists

JAMAL PENJWENY

"Saddam is Here," 2010
Selection of eight works
Chromogenic prints
23 $\frac{5}{8}$ × 31 $\frac{1}{2}$ in (60 × 80 cm) each
Courtesy Ruya Foundation for
Contemporary Culture in Iraq

MOHAMED LARBI RAHALI

Omri [My Life], 1984-ongoing
Drawings, collage, mixed media on matchboxes
Courtesy the artist

MARWAN RECHMAOUI

Spectre (The Yacoubian Building), 2006-08
Non-shrinking grout, aluminum, glass,
and fabric
88 $\frac{1}{2}$ × 165 $\frac{1}{2}$ × 31 $\frac{1}{2}$ in (225 × 420 × 80 cm)
Saradar Collection

ABDULLAH AL SAADI

Camar Cande's Journey, 2010-11
Video and 151 watercolor paintings
12 × 9 $\frac{1}{8}$ and 12 $\frac{2}{4}$ × 9 $\frac{1}{2}$ in (30.6 × 23.2
cm and 32.5 × 24.2 cm) each; color, sound,
59:41 min
Originally commissioned by Sharjah Art
Foundation
Courtesy the artist

HRAIR SARKISSIAN

"Execution Squares," 2008
Fourteen archival inkjet prints
23 $\frac{3}{4}$ × 30 $\frac{1}{2}$ in (60.5 × 77.4 cm) each

Courtesy the artist and Kalfayan Galleries,
Athens/Thessaloniki

HASSAN SHARIF

Jute, Cloth and Rope, 1985
Coir, cotton string, and jute
43 $\frac{1}{4}$ × 43 $\frac{1}{4}$ × 19 $\frac{3}{4}$ in (110 × 110 × 50 cm)
(approx.)
Courtesy the artist and Gallery Isabelle
van den Eynde, Dubai

Stapled Cardboard and Cotton Rope, 1986
Stapled cardboard and cotton rope
Dimensions variable
Courtesy the artist and Gallery Isabelle
van den Eynde, Dubai

Blanket and Wire, 1995
Blanket and wire
Dimensions variable
Courtesy the artist and Gallery Isabelle
van den Eynde, Dubai

Cotton and Wire, 1995
Cotton and wire
Dimensions variable
Courtesy the artist and Gallery Isabelle
van den Eynde, Dubai

Palm, 1995
Palm tree leaves
Dimensions variable
Courtesy the artist and Gallery Isabelle
van den Eynde, Dubai

Cotton and Wire-Net, 1996
Cotton and wire net
Dimensions variable
Courtesy the artist and Gallery Isabelle
van den Eynde, Dubai

Aluminum 2, 2005
Aluminum foil and cloth
Dimensions variable
Courtesy the artist and Gallery Isabelle
van den Eynde, Dubai

Cloth and Paper 2, 2005
Cloth, paper, and glue
23 $\frac{5}{8}$ × 47 $\frac{1}{4}$ × 37 $\frac{3}{8}$ in (60 × 120 × 100 cm)
(approx.)
Courtesy the artist and Gallery Isabelle
van den Eynde, Dubai

Jute, Cloths and Cardboard, 2005
Jute, cloth, and cardboard
Dimensions variable
Courtesy the artist and Gallery Isabelle
van den Eynde, Dubai

Jute String - Cloth - Cardboard, 2006
Jute string, cloth, and cardboard
17 × 11 × 10 $\frac{5}{8}$ in (43 × 28 × 27 cm)
Courtesy the artist and Gallery Isabelle
van den Eynde, Dubai

Sock, 2007
Cardboard, cloth, cotton socks, cotton rope,
and jute string
33 $\frac{7}{8}$ × 28 × 4 $\frac{3}{4}$ in (86 × 71 × 12 cm) open
Courtesy the artist and Gallery Isabelle
van den Eynde, Dubai

Dehydrated Copper, 2008
Aluminum and copper
Group of twelve works

4 × 37 ¾ × 8 ⅝ in (10 × 100 × 22 cm) each
Courtesy the artist and Gallery Isabelle
van den Eynde, Dubai

Four Bright and 555, 2008
Aluminum and copper wire
31 ½ × 67 × 63 in (80 × 170 × 160 cm)
(approx.)
Courtesy the artist and Gallery Isabelle
van den Eynde, Dubai

Plastic Sandals, 2008
Plastic and copper wire
Dimensions variable
Courtesy the artist and Gallery Isabelle
van den Eynde, Dubai

Press Conference No. 2, 2009
Newspaper and copper wire
Dimensions variable
Courtesy the artist and Gallery Isabelle
van den Eynde, Dubai

Boxes and Objects Part 2, 2011
Cardboard, paper, plastic, acrylic, and glue
Dimensions variable
Courtesy the artist and Gallery Isabelle
van den Eynde, Dubai

Newspaper, 2011
Cardboard, paper, glue, acrylic, newspaper,
and magazine
Dimensions variable
Courtesy the artist and Gallery Isabelle
van den Eynde, Dubai

Suspended Objects, 2011
Mixed mediums
137 ¾ × 63 (d) in (350 × 160 [d] cm)
(approx.)
Courtesy the artist and Gallery Isabelle
van den Eynde, Dubai

Cotton Rope No. 12, 2012
Cotton rope, rubber, and aluminum foil
Dimensions variable
Courtesy the artist and Gallery Isabelle
van den Eynde, Dubai

Four Bright, 2012
Aluminum and painted wood
Dimensions variable
Courtesy the artist and Gallery Isabelle
van den Eynde, Dubai

Email 2, 2013
Paper and glue
12 ½ × 11 × 9 in (32 × 28 × 23 cm)
Courtesy the artist and Gallery Isabelle
van den Eynde, Dubai

Glass and Copper Wire, 2013
Three glass and copper wire objects
9 ⅞ × 14 ¼ × 14 ¼ in (25 × 36 × 36 cm) each
Courtesy the artist and Gallery Isabelle
van den Eynde, Dubai

WAEL SHAWKY

The Cave (Amsterdam), 2005
Video, color, sound
12:45 min
Courtesy the artist and Sfeir-Semler Gallery,
Beirut/Hamburg

MOUNIRA AL SOLH

Now Eat My Script, 2014
Video, color, sound
24:50 min
Courtesy the artist and Sfeir-Semler Gallery,
Beirut/Hamburg

SUHA TRABOULSI

Untitled, 1943-49
Ink on paper, twenty-one works
8 ½ × 11 in (21.5 × 28 cm)
Courtesy Gallery 47, Birzeit, Palestine

VAN LEO

Untitled, 1942/2014
Digital inkjet print
11 ⅞ × 7 ⅞ in (30 × 20 cm) (approx.)
Courtesy Rare Books and Special Collections
Library, The American University in Cairo

Untitled, 1942/2014
Digital inkjet print
11 ⅞ × 7 ⅞ in (30 × 20 cm) (approx.)
Collection Arab Image Foundation/Van Leo

Untitled, 1942/2014
Digital inkjet print
11 ⅞ × 7 ⅞ in (30 × 20 cm) (approx.)
Courtesy Rare Books and Special Collections
Library, The American University in Cairo

Untitled, 1942/2014
Digital inkjet print
11 ⅞ × 7 ⅞ in (30 × 20 cm) (approx.)
Courtesy Rare Books and Special Collections
Library, The American University in Cairo

Untitled, 1942/2014
Digital inkjet print
11 ⅞ × 7 ⅞ in (30 × 20 cm) (approx.)
Collection Arab Image Foundation/Van Leo

Untitled, 1942/2014
Digital inkjet print
11 ⅞ × 7 ⅞ in (30 × 20 cm) (approx.)
Courtesy Rare Books and Special Collections
Library, The American University in Cairo

Untitled, 1942/2014
Digital inkjet print
11 ⅞ × 7 ⅞ in (30 × 20 cm) (approx.)
Courtesy Rare Books and Special Collections
Library, the American University in Cairo

Untitled, 1942/2014
Digital inkjet print
11 ⅞ × 7 ⅞ in (30 × 20 cm) (approx.)
Courtesy Rare Books and Special Collections
Library, The American University in Cairo

Untitled, 1942/2014
Digital inkjet print
11 ⅞ × 7 ⅞ in (30 × 20 cm) (approx.)
Courtesy Rare Books and Special Collections
Library, The American University in Cairo

Untitled, 1942/2014
Digital inkjet print
11 ⅞ × 7 ⅞ in (30 × 20 cm) (approx.)
Courtesy Rare Books and Special Collections
Library, The American University in Cairo

Untitled, 1942/2014
Digital inkjet print
11 ⅞ × 7 ⅞ in (30 × 20 cm) (approx.)

Courtesy Rare Books and Special Collections
Library, The American University in Cairo

Untitled, 1942/2014
Digital inkjet print
11 ⅞ × 7 ⅞ in (30 × 20 cm) (approx.)
Courtesy Rare Books and Special Collections
Library, The American University in Cairo

Untitled, 1943/2014
Digital inkjet print
11 ⅞ × 7 ⅞ in (30 × 20 cm) (approx.)
Courtesy Rare Books and Special Collections
Library, The American University in Cairo

Untitled, 1945/2014
Digital inkjet print
11 ⅞ × 7 ⅞ in (30 × 20 cm) (approx.)
Courtesy Rare Books and Special Collections
Library, The American University in Cairo

Untitled, 1945/2014
Digital inkjet print
11 ⅞ × 7 ⅞ in (30 × 20 cm) (approx.)
Courtesy Rare Books and Special Collections
Library, The American University in Cairo

AKRAM ZAATARI

*Objects of Study/Studio Shehrazade -
Reception Space*, 2006
Chromogenic prints in three parts
43 ¼ × 78 ¾ in (109.8 × 200 cm)
Courtesy the artist and Thomas Dane
Gallery, London

A Photographer's Window, 2013
Video, color
4:21 min
Courtesy the artist and Thomas Dane
Gallery, London

Twenty Eight Nights: ENDNOTE, 2014
Video, color, sound
Courtesy the artist and Thomas Dane
Gallery, London

PHOTO CREDITS

Unless otherwise noted, all images are courtesy the artist.

Courtesy the artist and Calicoon Fine Arts, NY: P. 44-45

Courtesy the artist and Sfeir-Semler Gallery, Beirut/Hamburg: P. 46-47, 60-67, 132-35, 154-56, 168-69, 180-83, 198-99

Photo: Rheims Alkadhi: P. 48-49

Courtesy Galerie Imane Fares, Paris: P. 50-51

Courtesy the artist and Selma Feriani Gallery, London: P. 52-55

Courtesy Galleria Continua, San Gimignano/ Beijing/Les Moulins. Photo: Sebastiano Pellion: P. 58-59

Courtesy the artist, The Third Line, Dubai, and Galerie Tanit, Munich/Beirut: P. 68-71

Courtesy the artist and Galerie Tanit, Munich/Beirut. Photo: François Fernandez: P. 72-73

Courtesy the artist and Albert Baronian Gallery, Brussels. © Mekhitar Garabedian: P. 74-75

© Tanya Habjouqa: P. 80-81

Courtesy the artist and Gallery Isabelle van den Eynde, Dubai: P. 82-85, 176-179

© Rana Hamadeh: P. 86-87

Photo: Bashar Alaeddin: P. 107

Courtesy the artist and Pi Artworks, Istanbul/London. Photo: Fg Studio: P. 108-09

© Nathalie Barki: P. 110-11

Courtesy Diala al Jabiri: P. 112-13

Courtesy the artist and Galerie Polaris, Paris: P. 114-17, 128-29

© Khaled Jarrar: P. 114-17

Courtesy the artist and Gypsum Gallery, Cairo: P. 130-31

© Jörg von Bruchhausen: P. 154-55, 157

Courtesy the artist and Athr Gallery, Jeddah: P. 158-59

The Khalid Shoman Collection, Amman: P. 160-61

© David Bouvard: P. 162

© Mongi Aouinet: P. 163

Courtesy Ruya Foundation for Contemporary Culture in Iraq: P. 164-65

© La Kunsthalle Mulhouse: P. 166-67

Courtesy Sharjah Art Foundation: P. 170-71

Courtesy the artist and Kalfayan Galleries, Athens/Thessaloniki: P. 172-75

Courtesy Gallery 47, Birzeit: P. 184-85

Courtesy Rare Books and Special Collections Library, the American University in Cairo: P. 186-7

Courtesy Arab Image Foundation. © Arab Image Foundation: P. 188-89

Courtesy the artist and Thomas Dane Gallery, London: P. 196-97

Courtesy the artist and Selma Feriani Gallery, London: Front cover

Courtesy the artist, The Third Line, Dubai, and Galerie Tanit, Munich/Beirut: Back cover

BOARD OF TRUSTEES

This book has been published on the occasion of the New Museum exhibition "Here and Elsewhere," organized by the New Museum's curatorial department, led by Massimiliano Gioni, Associate Director and Director of Exhibitions, with Natalie Bell, Curatorial Associate, Gary Carrion-Murayari, Kraus Family Curator, Helga Christoffersen, Assistant Curator, and Margot Norton, Assistant Curator.

New Museum exhibition dates: July 16-September 28, 2014

The catalogue is edited in collaboration with *Bidoun* magazine.

"Here and Elsewhere" is made possible by

THE ANDY WARHOL FOUNDATION FOR THE VISUAL ARTS

ELHAM AND TONY SALAMÉ

Major support provided by
Sirine and Ahmad Abu
 Ghazaleh
LibanPost
Saradar Collection
Maria and Malek Sukkar

Airline Partner

Special thanks to The Standard, East Village.

Additional support provided by Patrick and May Merville and the Robert Mapplethorpe Photography Fund.

The exhibition publication is made possible by the J. McSweeney and G. Mills Publications Fund at the New Museum.

New Museum Editors
Massimiliano Gioni
Gary Carrion-Murayari
Natalie Bell

Bidoun Editors
Negar Azimi
Kaelen Wilson-Goldie

New Museum Editor and Publications Coordinator
Sarah Stephenson

Graphic Design
Project Projects

Printed in Iceland

First published in the United States in 2014 by

New Museum
235 Bowery
New York, NY 10002
newmuseum.org

Front cover: Ziad Antar, *Burj Khalifa III*, from the "Expired" series, 2011. Gelatin silver print, 19 ¾ × 19 ¾ in (50 × 50 cm)

Back cover: Fouad Elkoury, *Color snapshot*, *Place des Canons (Beirut 1982)*, 2014. Digital inkjet print, 15 ¾ × 23 ⅝ in (40 × 60 cm)

ISBN: 978-0-915557-05-9